CORPORATE ART CONSULTING

Susan Abbott

ALLWORTH PRESS
NEW YORK

08 07 06 05 04 7 6 5 4 3 2

Published by Allworth Press
An imprint of Allworth Communications
10 East 23rd Street, New York, NY 10010

Cover design by Douglas Design Associates, New York, NY

Page design by Laura Lamar and Raymond Moreno, MAX.

Library of Congress Cataloging-in-Publication Data
Abbott, Susan
Corporate Art Consulting
Includes index
1. Manuscript preparation (Authorship)—Handbooks, manuals, etc., Susan Abbott. Title.
PN
1994
ISBN: 1-58115-034-2
Library of Congress Catalog Card Number: 94-72316

DISCLAIMER

This book is designed to provide accurate information with respect to the subject matter covered. It is sold with the understanding that the publisher is not engaged in rendering legal, insurance, marketing, or other professional services. If legal advice or other expert assistance is required, the services of a competent attorney or professional person should be sought. While every attempt has been made to provide accurate information, the author or publisher cannot be held accountable for errors or omissions.

This book contains a number of sample forms, contracts, and letters. The names and facts referred to are entirely fictitious, and any resemblance to actual galleries, corporations, or art consulting firms, etc. is purely coincidental.

A word about my use of gender in this book: you'll notice that I often use the masculine, especially when I'm talking about corporate clients. In all my years of consulting, I have had only two female executives as clients. I heartily hope this lopsided situation will one day be different, but in the meantime, I decided it would be more realistic and therefore more useful for the reader to visualize a male client.

Preface

The idea first struck me when I was standing in a storeroom overflowing with art that no one ever saw. It was in the late sixties, and I was working at the Los Angeles County Museum of Art. It's hard to imagine now, but the museum at that time had few visitors—we used to jokingly refer to it as "the mausoleum." It occurred to me then that if people weren't coming to the art, why not bring the art to them?

A few years later, Sid Felsen, one of the partners of Gemini G.E.L. where I next worked, encouraged me to chase my dream of bringing art into the workplace. The great challenge was convincing companies that art had a place in business. I met some brave executives in those early days. They weren't necessarily collectors, but they believed in what art could do for their companies and they welcomed it as a daily reminder of people's humanity and creativity. Each of these clients was a special person I feel privileged to have worked with.

Over the years, I have watched with satisfaction as the presence of art in offices has come to be taken for granted. It's gratifying to realize that today the smallest doctor's office would look naked without art on its walls.

There is no segment of the art consulting field I have not been involved with, either by working directly in it or consulting with it. This has given me an unusually broad perspective, and from this bird's eye view I see a field of great diversity, calling for many levels of skill and many different approaches to the challenges we face. In this book, I try to share the benefits of this perspective and to give solid advice to all the different kinds of art providers who might be interested in working with companies.

I feel strongly that all of us, however diverse and however regionally scattered, have a job to do together: to establish professional guidelines so that the art community gets the kind of support it needs and so that our profession enjoys the highest possible reputation.

People often ask me if it's too late or too crowded to enter this profession. I think someone with the right background and sufficient enthusiasm will always find a niche and succeed. For myself, I have found art consulting to be an immensely rewarding way to exercise my love of art and my desire to share it with others, and I wish you the same satisfaction and heaps of success.

Susan Abbott
Mill Valley, California

Dedicated to Pablo Isaac Abbott Jenkins

Acknowledgments

Writing this book has been a nostalgic journey. It has given me a chance to reflect back over twenty years of art consulting and all the people my path has crossed. I've been fortunate to have had such superb mentors and friends who have given generously of their time, their unique talents, and their enthusiasm for art. I would like especially to acknowledge Gardiner Hempel, Sidney B. Felsen, Franklin D. Murphy, Chris Frederiksen, and Peter Beren.

I want also to give special thanks to the readers of the book, or of certain chapters in the field of their expertise.

Huntington T. Block	Linda Reiger
Joanne Chappell	Tressa Ruslander Miller
Tad Crawford	Michael Phillips
Bonnie Earls-Solari	Joyce Pomeroy Schwartz
Thomas H. Garver	Tamara Thomas
Shirley R. Howarth	Katharine Smith-Warren
Anne Kaiser	Mary Zlot

Their comments have greatly enriched the book, although, of course, any errors in the text are mine. In addition to the readers of the book there have been many people who have contributed their time or who have let me draw on their material:

Louise Allrich of The Allrich Gallery

Tad Crawford, author of *Business and Legal Forms for Fine Artists*

Robert B. Egelston, The Capital Group, Inc.

Judith Esterow, associate publisher, *ARTnews*

Louise Jordon, corporate art curator

Peter H. Karlen, attorney-at-law

Pam Korza, coauthor of *Going Public: A field guide to developments in art in public places*

Jill Snyder, author of *Caring for Your Art*

Lothar P. Witteborg, author of *Good Show! A Practical Guide for Temporary Exhibitions*

Scott Woods, The Woods Group Architects

I'd also like to acknowledge the many participants of my corporate art consulting seminars who have candidly talked about their experiences so others may learn from them.

Finally, I want to thank Hazel Jaramillo, my research assistant, whose organizational abilities were invaluable to the project, and manuscript typists Nancy Havel and Rad Proctor. This project has truly been a labor of love, and it would not have been possible without the patience and loving support of my friends and family, particularly my son Pablo, who surely must think he has a younger brother named Corporate Art Consulting.

Introduction

"To further the appreciation of culture among all the people, to increase respect for the creative individual, to widen participation by all the processes and fulfillments of art— this is one of the fascinating challenges of the day."
—President John F. Kennedy

Over the past twenty years, the American public has been exposed to art as never before. Art has come into the mainstream—in offices and public places, in television advertising and feature films, and as curriculum in grade schools. Blockbuster museum exhibitions have become community affairs.

All this mass audience exposure and the growing sophistication it implies have presented an interesting set of challenges to corporate art consultants. These challenges and how to meet them are the heart of this book.

The first challenge for those in the field is to enhance their consulting skills and their knowledge of art. Because there are all kinds of corporate clients, there will always be different standards, both for the art programs and for the people who provide them, but the baseline for these standards is rising every day. Established advisors, as well as newcomers to the field, may need to create action plans to keep pace with these changes.

Another major challenge today is learning how to stand out in such a crowded field. One key is to tailor your service so precisely to each client that he is convinced you are the best art advisor to meet his company's needs. Projecting a successful image was sufficient impetus for many collections started in the seventies and eighties, but today's client may have much more specific needs in mind.

As consultants think beyond just filling corporate corridors with art, imagination and flexibility may prove to be their most valuable assets, allowing them to create programs more meaningful to employees and more eloquent in expressing each company's values to the community.

All sorts of people have entered the profession to provide a wide range of art-related services, and it is critical that you find the niche that suits you and that will bring you both success and satisfaction. Whatever niche you decide to fill, I think you will find this book to be a comprehensive guide, both as an overview of the field and as a discussion of the tools you will need over a whole career of consulting. Anyone who wants to bring art directly to companies will find this material useful, and galleries will find an additional section of notes at the end of most chapters.

Many of the techniques and strategies I discuss are geared to sophisticated clients, but they can easily be scaled down to meet less demanding projects. I hope you will adopt just the ideas that resonate with your own strengths and personal style and that seem right for the project at hand.

Table of Contents

BEING AN ART CONSULTANT PART 1

What It Takes

"An art consultant is about six people all rolled into one, with an art historian's knowledge, a CPA's precision, a designer's eye, a general's logistical sense, an entrepreneur's nerve, and a diplomat's finesse."

—Anne Kaiser, art consultant [1]

This quotation may seem daunting to someone just starting out, but the many facets of art consulting are exactly what make it such a challenging and exciting career. Various levels of the corporate market call for different levels of these skills, but to some degree all consultants need the range of talents Anne lists above, and they need to perform with solid professionalism in order to be taken seriously by their corporate clients.

AN ART CONSULTANT'S EXPERTISE:

- a working knowledge of art history since 1850;
- curatorial skills, including art handling and preservation techniques;
- knowledge of the art market;
- knowledge of and a good working relationship with support services—framing, shipping, restoration, conservation, insurance, security, appraisals, and public relations;

- personal integrity and ethical working procedures;
- knowledge of the diverse ways art has been successfully used to solve corporate needs: decor, image marketing and corporate identity, employee and public relations.

WHAT AN ART CONSULTANT DOES

An art consultant helps the client define the art program—its purpose and function in the company. The consultant may survey the space, decide on the scope of the program, and develop a budget, if one is not already set. He or she searches out the art work, then presents it in a way that the client can understand and that makes the experience enjoyable. The consultant oversees all the framing, shipping, and installation. Interior design skills often come into play—moving furniture around to make the space more attractive, working with designers and architects to develop lighting, and consulting on other aspects of the space that relate to the art.

Consultants also need administrative skills to manage large budgets, supervise installation crews, and provide logistical planning and art collection management. They may also produce public relations materials and catalogs, and may function as goodwill ambassadors for their programs either with employees or with the community at large.

The first skill mentioned here is difficult to describe: determining what the company needs and translating that into an art program solution. If you listen carefully, the clients will tell you what they need. There is no magical formula, but if you're good at solving problems, you can develop your ear and your instincts.

COMMUNICATION

One essential skill is knowing how to explore your client's business goals by asking the right questions and listening actively to the answers. Once you have come up with a creative solution to solve the client's needs, your ideas then have to be communicated in ways that are effective and appropriate for each client. You must know how to talk about art without using intimidating jargon and what to emphasize for a specific client so that he appreciates what an art program can do for his company.

It's also important for a consultant to know how to write up these ideas and concepts into a proposal that is clear, concise, and easily comprehensible to a business person. Specific skills in communicating are discussed in Chapters 5 and 9.

ON BEING SERVICE ORIENTED

Some corporate clients are just interested in buying art as a product, as something to hang on a blank wall. They want to buy the art retail, have someone arrange the framing and the installation, and be done with it. A salesperson with limited knowledge of art and little grasp of the corporate world may be able to survive with such clients, selling art as decor. But this approach is very limiting. Someone who simply sells art is never going to be able to work with the largest segment of the corporate market, which is looking for those who offer creative problem-solving. It doesn't matter so much how your business is structured—whether you are an independent advisor, a gallery consultant, or any other variation on the theme. What does matter is how you perceive yourself vis-a-vis your corporate client. Are you there to sell your client some art, or are you there to provide a problem-solving service? In the first instance, clients see that your first priority is to sell your art and that they are left to make decisions on their own. In the second, the clients think of you as an ally in helping them make the right decisions.

Meeting clients' needs is the essence of being a professional art consultant. This means, of course, that you will never manipulate or deceive your client. The tacit agreement between you is that you will act in his best interests. The client relies heavily on your judgment and advice, being unaware of all the options available or the full benefits he may derive from the art.

For example: You interview a client and find that Japanese art would be the most effective way to reflect their affinity with their client base, which is solely Japanese. You either agree to provide the appropriate art or you recommend someone who can. It would be unprofessional to try to convince them to buy American contemporary, say, just because that's the genre you know best or to which you have the easiest access.

There are no elaborate rules here to guide you; every situation will be different. But if you keep in mind that you must always put your client's needs above your own interests, you will be rewarded by the pleasure that comes from helping others meet their needs and with an endless chain of satisfied clients who will eventually do all your marketing for you.

KNOWLEDGE OF ART

A word about the importance of having a thorough knowledge of contemporary art history. The client is hiring you for your knowledge. He expects you to help him make decisions that are good not only for today but also for tomorrow. Many consultants have come into the field without any training in art. They may be able to tell whether something is pleasing and to help their client make what is essentially a decor decision, but many decorative works that look good on the surface will not hold up to the test of time.

> *When I was helping a law firm replace some pieces of art, one of the partners said to me, "This art seemed attractive and unintrusive when the art consultant brought it in. After living with it for fifteen years, I find it's so bland and insipid that it's more deadly than wallpaper. I wish we could get rid of it all."*

Training in art teaches you how to analyze any work of art and to tell if it is well conceived. Does it have an underlying structure that will hold up over time? Clients forget that they picked the art. They only remember that the consultant proposed it.

A firm grounding in art will help you develop what I call the client's VAT, or visual acuity and taste. If art consultants don't know why a particular piece works or doesn't work, they are at a loss to help their clients understand. The more skilled you are at helping your clients see and appreciate the art, the more challenging and exciting art you will be able to place.

It is not necessary to go back to college full time to get sufficient knowledge to function well in this capacity, but some courses and independent study are absolutely essential.

FEATURES AND BENEFITS

Even in the nineties, many clients have to be convinced about the benefits of art in the workplace before they can see the value of the consultant's service. You must be able to translate features of your services and the art you will provide into the benefits they afford the client. The premise of this approach is that clients make their buying decisions not so much on their understanding of your service or product, but for what they come to believe it can do for them.

Consultants often confuse what is a feature of their service and what is the corresponding benefit to the client.

For example:

Feature: You provide a complete professional service, including selection of the art, framing installation, documentation, and public relations.

Benefit: The client has not bought a professional service but rather the freedom from having to be bothered with all the details of an art program; he is getting the benefit of your trained eye in both selecting art of the highest quality and installing it in a way that enhances the overall image of his office.

Being able to frame a benefit clearly, presenting it from the client's point of view, is a key skill; a more complete discussion will be found in Chapter 6.

PERSONAL ATTITUDES

Successful consultants have a positive professional attitude—a winning way that is born of their confidence in their knowledge and skill and belief in the inherent value of their services.

The consultant's feelings of confidence are often transmitted in infectious enthusiasm or a persistence that stems from their faith in what they are doing. A client unfamiliar with art may not fully understand its value, but the positive attitude of the consultant will encourage him to make the leap, take the risk, decide to proceed. These qualities of pride and confidence can be the difference between someone who lands a few projects and one who

lands many. Enthusiasm and pride are not manufactured sentiments, but are rather the natural results of practicing creative problem-solving with your clients and sincerely believing in your offering.

IMAGE

In art consulting you are not only selling your expertise, you are also selling your good taste, as reflected in your own personal image. As soon as you walk in the door, before you can say a word—let alone help meet any needs—a client is evaluating whether your personal image is consistent with the image he wants to put across through his art program.

A consultant should project a personally powerful and successful image on the same level as the client. Since he is going to rely on you to set standards of taste in his art program, he will want to feel that your style and your personal power is similar to his own. Your personal image is conveyed in a number of ways—by your voice, the quality of your wardrobe, your accessories, and your marketing materials.

Your image is also fashioned in part by those personal attitudes that were just discussed, your confidence and your feeling of being a successful, competent person. It's a common misconception that someone has to be successful by business standards in order to feel successful. Your own feeling of self-worth and pleasure in your work will make you feel successful, and that will be reflected in the image you project.

FAIR STANDARDS AND PROFESSIONAL ETHICS

Many clients think of their art programs as a way they can help support their local art community. This is the driving force behind corporations choosing contemporary art from their own region. A logical extension of this trend is to assume that companies view their consultants as their goodwill ambassadors to the art community. Consultants therefore need to be aware of professional standards of ethics in the corporate world as well as what constitutes ethical practices in the art world. These two areas are discussed further in Chapters 7 and 16.

ENTREPRENEURIAL SKILLS

You may have consummate skills as an art consultant, but you will probably also need the skills of an entrepreneur.

> *"If you are going into business, it is necessary for you to have a cluster of attributes called tradeskill, or to join an individual who has it. Such an individual is persistent, responsive to factual evidence for decision, minimizes risks and learns by touching, doing and getting their hands into everything."*
> —Michael Phillips and Salli Rasberry[2]

I've found that entrepreneurs are self starters, stubborn and intense, but they get great pleasure from their achievements. If you persevere, you will see that corporate art consulting can be a very satisfying profession. The heads of big companies will look to you as their expert, and you will help to beautify the workplace and make it a more humane, stimulating place. You will be a vital link between two worlds.

■ ■ ■

Finding Your Niche

*"In the early days, when I first started consulting,
you got the job just for being there. Now you have to have a
whole game plan."*

—Marsha Campbell, art consultant

When a profession is new, its practitioners have to be generalists, providing whatever is needed, since usually there are not yet many potential clients or any defined niches. But gradually a segmenting process occurs and the professionals start to specialize. They gravitate to areas that suit their particular aptitudes and where their market analysis tells them they are most likely to succeed.

The profession of art consulting is now over thirty years old, and this more advanced stage of specialization has begun. Roughly five separate niches can be identified, though there are many overlaps and a consultant will frequently work in more than one niche.

Choosing what niche your intended offering is going to fill is called your positioning strategy and is the foundation of your marketing plan, the base from which you make all your marketing decisions. It helps focus your energies to develop new clients in the area most promising for you.

An analogy: A novice fisherman simply casts a line in the water with any old bait available and hopes for the best. A seasoned fisherman knows the water, knows the kind of fish he wants to catch, and chooses his bait accordingly.

One of the interesting trends in the nineties is for museums to become more entrepreneurial in an effort to raise more income to compensate for the loss of government and private funding, and for large corporations to become the modern Medicis, sponsoring projects and programs that in the past were exclusively in the realm of the fine arts nonprofit sector. This trend will continue to provide many interesting new opportunities for the independent consulting firm that wants to branch out beyond art acquisition projects. Another twist on this trend is that as museums downsize their staffs, they are hiring independent art consultants to curate museum and corporate outreach shows.

FIVE NICHES IN THE MARKETPLACE

This outline gives you an overview of the different segments of the profession. Remember that these categories may overlap.

1. TRADE CONSULTANT

Client: Interior designers, architects, and art specifiers.

Structure of the business: Art resource or gallery usually with a defined inventory, though consultants may go beyond their inventory to search for art for their clients.

Charge for services: Two different methods are common: Prices are marked up so the client can be given a twenty to forty percent discount, or the client is sold the art and framing at retail.

Services provided: Usually limited to being an art resource, searching for art, and sometimes supervising framing, providing delivery, and overseeing installation.

Special requirements: Understanding designers and their special needs and concerns; a high degree of flexibility and being service oriented. The projects are usually driven by the designer's taste and the project's decor brief. Jobs are often large volume orders that have tight budget restraints, such as hotels, model homes or hospitals.

2. DECOR CONSULTANT

Client: Small businesses, companies, and institutions that perceive themselves as needing art simply as a decor element. Often the contact person is a midmanagement person who has been put in charge of the new space, purchasing furniture and art. Rarely is the decor consultant selling to the top decision makers unless it is a small business or professional firm.

Structure of the business: Either independent consultant, publisher, retail gallery, or corporate service gallery. Usually the business has some attachment to an inventory and the consultant is perceived as a vendor of art and art-related services.

Charge for services: The consultant either charges retail for art and framing and keeps the profit, or takes a commission or percentage of the art and framing purchased (fifteen to thirty percent).

Services provided: All art consulting services plus installation supervision. One common problem occurs when the client needs other services not related to buying art, such as taking inventory and disposing of existing art. Some decor consultants charge an extra fee for these services, rather than have their profit margin eroded.

Special requirements: Access to a vast amount of inexpensive art. Decor projects are often cost driven, the client seeing no value to the art beyond its decor value. Commercial galleries are in many ways best suited for this segment of the market, since it is very difficult for independent consultants to negotiate sufficient discounts with all their sources to make their practice profitable. Volume is the name of the game.

3. IMAGE CONSULTANT

Client: Top management of midsize to large companies, professional firms, and institutions. These clients perceive the art as meeting an image need first and a decor need second.

Structure of the business: The trend is for consultants at this level not to have any attachment to an inventory that might be perceived as prejudicing them in making art program decisions. They are seen as providing a consulting service and are selling their good taste and expertise. Often these advisors are selling serious art purchased from galleries that can only offer a ten percent discount.

Charge for services: Usually compensated on a fee basis for actual time spent or a percentage of the art budget. The consultant usually passes on to clients professional discounts on art and framing.

Services provided: A full range of art consulting and related services may be expected, including art consulting, art program management, consultation on-site development (lighting, alcoves, site-specific development), deaccessioning art, and employee and public relations activities (such as lectures exhibitions, corporate catalogs, tours).

Special requirements: Image consultants must be able to understand business goals and translate them into complementary art program concepts. Typically more highly trained in art history, knowledge of art market resources, and corporate image and marketing strategies, they have the ability to sell at a high level in the corporate structure.

4. CURATOR

Client: Large corporations or institutions undertaking serious art collections or public art programs.

Structure of the business: Either independent consultant or employee of the client.

Charge for services: Either retainer, fee for project, or annual salary.

Services provided: The emphasis is on collection development and management—art acquisition, exhibition, and multisite art program management. The trend in large companies that already own large collections is to emphasize interpretive programs and employee education.

Special requirements: Excellent art history credentials, knowledge of museum registration techniques, and the ability to function well in a corporate culture or a large bureaucracy. Increasingly, corporate curators are being asked to redefine corporate collections to be in concert with the overall mission of the corporation and to utilize the collections more to the benefit of employees and the greater community.

5. FINE ART SERVICES CONSULTING FIRM

Client: Typically, large Fortune 500 companies or institutions such as airports, city governments, port commissions, and art and cultural centers that are undertaking serious art programs, often with a public component.

Structure of the business: One consultant director who hires other staff specialists, or two or more consultants with varying skills who join together to provide a full range of art-related services to companies—including art acquisition, exhibition, fine art public relations, and marketing projects, as well as employee involvement and educational programs focused on art or using art as a tool for organizational change.

Charge for services: Either fee for services, percentage of project budget, or retainer. Usually different services are billed at a fee appropriate for the skill level of the task as opposed to a straight consultant's fee, which is often too high for some of the more mundane tasks, such as writing up documentation.

Services provided: Programs might encompass any kind of activity that involves art or curatorial skills, such as putting together a collection of art, a lobby exhibition program, a milestone exhibition on a company's history, or an exhibition of artifacts to travel under the sponsorship of a company.

Special requirements: The consultant must have a full range of museum skills, including exhibition development and design, registration, public relations, and public education. Must also know how to interface with corporate public relations and advertising departments and agencies.

Although my company started out as an acquisition firm, after two years I expanded it to be a fine arts consulting firm. As our clients began to see the value of art in the workplace and the great public relations benefits it can have, they became interested in using art programs to help achieve their public relations and marketing goals. One company had us organize an exhibition from their print collection to travel to those hospitals and universities that used their cafeteria equipment in order to create goodwill for their services. Another asked us to develop an annual lobby exhibition program to help solve a community relations problem created by the building of their corporate headquarters. Another had us do a history of their company from their employees' point of view.

CLIENTS WHO SUIT YOU

WHAT KIND OF CLIENTS ARE YOU BEST SUITED TO SERVE?

Consider all the different kinds of clients who are part of the current art consulting field, and ask yourself which ones you are most interested in and best qualified to serve. The diagram on the opposite page is not comprehensive, but it will give you an idea of the diversity out there.

ANALYZE YOUR GOALS, RESOURCES, AND COMPETITION

Finally, you will want to do a careful analysis to see if your business strategy matches both your personal goals and the probable needs of your potential clients. Some examples of the ways new consultants have chosen to position themselves to best advantage:

A former museum curator launched herself first as an in-house corporate curator for a Fortune 500 company and then, when she had some private-sector experience, she went independent to provide exhibition and acquisition services to companies.

A landscape architect who became an art consultant decided to specialize in large-scale sculpture projects, since he had a lot of experience placing sculpture and knew all the intricacies of working with development teams and overseeing complex fabrication.

An interior designer who found specifying art to be the most enjoyable part of her work decided to position herself as a consultant specializing in serving designers and art specifiers. She was already familiar with the special needs of these kinds of decor-driven projects and had many contacts and trade resources.

Because I come from a museum background and was most familiar with galleries representing museum-quality art, it was natural for me to go after clients who were interested in having serious art collections. I was suited to these clients and, from a marketing point of view, I had the best access to them from my contacts with museum board members and art collectors. I decided to seek only this kind of client, figuring that I would get a reputation for high-level projects and that eventually the kind of client I wanted to work with would come to me.

All these examples have one thing in common. We chose our positioning strategies after analyzing the need for our services, our strengths, our personal goals, and our passions. This kind of analysis is the key to a successful plan. By positioning yourself carefully, you will be providing a service that is needed and that offers clear benefits to your clients, you will be qualified to provide the service and to do it better than the competition, your work will meet your personal goals, and—perhaps most important—you will be passionate about what you're doing.

Opposite page: *Different kinds of clients who are part of the current art consulting field.*

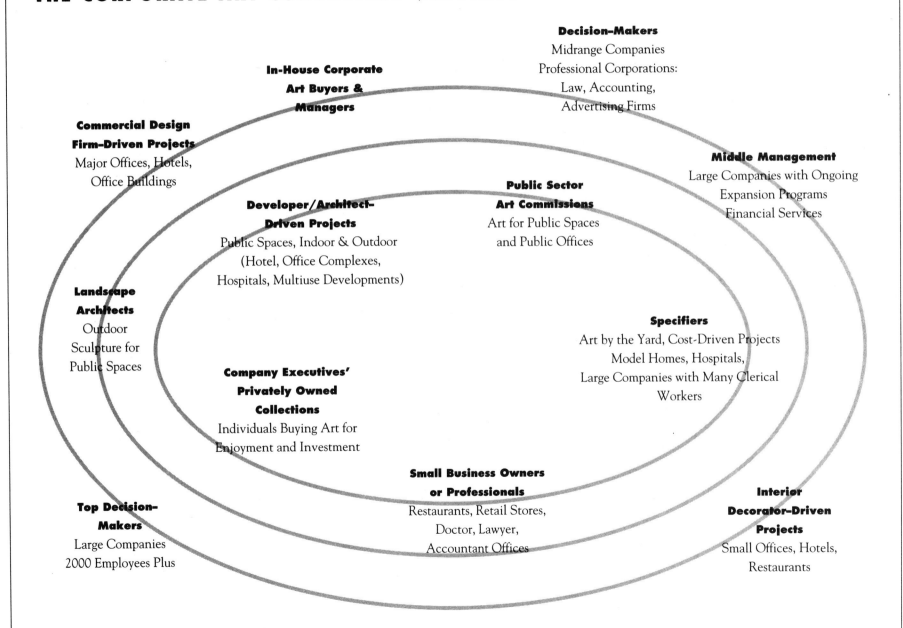

THE CORPORATE ART CONSULTING UNIVERSE

Decision–Makers
Midrange Companies
Professional Corporations:
Law, Accounting,
Advertising Firms

In-House Corporate Art Buyers & Managers

Commercial Design Firm–Driven Projects
Major Offices, Hotels,
Office Buildings

Middle Management
Large Companies with Ongoing
Expansion Programs
Financial Services

Developer/Architect–Driven Projects
Public Spaces, Indoor & Outdoor
(Hotel, Office Complexes,
Hospitals, Multiuse Developments)

Public Sector Art Commissions
Art for Public Spaces
and Public Offices

Landscape Architects
Outdoor
Sculpture for
Public Spaces

Specifiers
Art by the Yard, Cost-Driven Projects
Model Homes, Hospitals,
Large Companies with Many Clerical
Workers

Company Executives' Privately Owned Collections
Individuals Buying Art for
Enjoyment and Investment

Small Business Owners or Professionals
Restaurants, Retail Stores,
Doctor, Lawyer,
Accountant Offices

Top Decision–Makers
Large Companies
2000 Employees Plus

Interior Decorator-Driven Projects
Small Offices, Hotels,
Restaurants

MARKETPLACE POSITIONING

Your Personal Goals
- Desired income
- Security vs. risk factors
- Job satisfaction
- Aesthetics/standards of quality

Your Resources
- Time
- Expertise
- Staff
- Level of contacts

Your Competition's Weaknesses

Your Competition's Strengths

ANALYZE

The Structure of Your Business

Perceived Needs of Clients

Outstanding Qualities of Your Service
- Cost
- Quality
- Convenience

Weak Parts of Your Service

Left: *Positioning strategies should be based on an analysis of the need for your services, your strengths, your personal goals, and the strengths and weaknesses of the competition.*

NOTES FOR GALLERIES

Before a gallery director decides to position the gallery as a direct-to-company corporate art service, an analysis should be made to determine whether this is the best strategy for getting corporate business. The factors vary greatly from region to region, including how sophisticated the area is, how entrenched corporate art programs are in the local business community, how many consultants are already buying from the gallery, and the kind of inventory and resources the gallery has available or is willing to develop.

In small cities or less sophisticated areas where the concept of art in the workplace is just beginning to take hold, it may make sense for any gallery to market to companies directly. When the profession is more firmly established and experienced art consultants are on the scene, you may decide to turn your art consulting functions over to them.

The following discussion presumes your gallery is located in or near a fairly large, sophisticated metropolitan area.

DECORATIVE/COMMERCIAL GALLERIES

If your gallery sells relatively inexpensive art, such as posters and graphics or works by emerging artists, you will find a large percentage of two segments of the market receptive to your offering.

1 Small professional firms—whose buying decisions are made by either the owners or their decorators.

2 Model homes, medical centers, hospitality firms, and some companies that regularly expand, such as banks and stock brokerage houses. The common aspect in these diverse kinds of clients is that the companies have already decided the art is simply a decor item and they have designated designers or specifiers to purchase it for them.

Frequently these clients prefer to have their designers or specifiers deal directly with galleries. They are usually very cost conscious. They don't think they need an art consultant, just someone to find art for them at the lowest possible price. In these circumstances, gallery/frame shop combinations do very well if they are on a big enough scale to handle the volume.

The art specifier is often working on a commission basis, so you have to develop a separate discount structure whereby you can offer them a twenty to forty percent discount. Some galleries offer a twenty percent discount and let the designer rebill at a higher price.

HIGH-END GALLERIES

In the case of high-end galleries selling relatively expensive and serious art, it is usually best to gear your marketing efforts toward the art consultants and designers in your area. Of this group, you may need to focus on those who are working on a fee-for-service basis. Those on a commission often buy from trade galleries that give high discounts. Most high-end galleries can't afford to discount their art beyond ten percent and therefore are not in the position to work with the kind of consultant or designer who requires a twenty to forty percent art discount.

Beware: If you do decide to set up a corporate art service, be prepared to face the following:
- You may find yourself directly competing for a job with one of your valued art consultant clients.
- As the field gets more sophisticated and moves with the current trend toward independent art advisors, the fact that you are attached to an inventory may make your corporate art service unattractive to prospective clients.

Should a corporation approach your gallery directly, you can decide either to service them or to recommend a consultant you can trust to do a good job. Consider this latter strategy particularly if your gallery is already selling a considerable amount of art to art consultants and designers.

Most high-end galleries that try to start a corporate art division are unsuccessful because they are not willing to commit enough time or money and because they are reluctant to develop art resources that go beyond the scope of work they carry in the gallery. Given the variety of art that corporations want, just one consultant working on behalf of a gallery may not sell enough of the gallery stable's work to make the venture worthwhile. The galleries that have succeeded consider their corporate art service as almost a separate entity, not a stepchild of the gallery operation.

KEY POINTS TO CONSIDER

It's easy for independent consultants to be flexible in serving their clients, but galleries, who are frequently working with a hired sales force, should know which segment of the market they are best suited to serve and focus their sales staffs' efforts accordingly.

For example: A well-known trade gallery was asked to bid on a large hotel project. The gallery spent weeks preparing the survey and proposal only to lose the job to a gallery that operated in conjunction with a volume framer. Even though the gallery director could offer very good prices on her graphics, the real cost was in the framing and the project was very cost-driven. Either she should have not wasted her time or she should have approached a framer to do a cost-cutting bid and submitted a joint proposal.

By taking the time to evaluate realistically what your strengths and weaknesses are, you can identify the right kinds of companies to target. This analysis will also effect whom you hire and what kinds of services you offer and how you charge for them. Apart from the questions raised in the diagram on page 24, there are some further questions you should consider:

Will Your Consultants Search for Art Outside Your Gallery's Offering? Corporations vary greatly in their art needs. Increasingly we will see companies trying to personalize their images through their art. A consultant must be flexible and provide the company with what it needs or wants. Consequently, if a gallery is going into the market, it has to be prepared for its consultant to purchase art from other sources. The gallery must come up with a way of charging for these services that takes this situation into account.

Some galleries that are not willing to compromise have approached the corporate sector in a limited way. For instance, a gallery representing many sculptors may decide just to go after public art commissions. Or a poster/graphics gallery may decide to limit its clients to small professional firms that require only posters and graphics.

Who Is Going To Do the Corporate Consulting? Unless the gallery is being run by a manager or assistant director, I don't feel a gallery director should take on the role of art consultant. Projects require too much personal attention and it is not usually an effective use of the director's time. Often galleries try to use their salespeople or receptionists to handle corporate accounts. To be successful, a gallery consultant should not have any time-conflict between consulting and other functions in the gallery. Note that selling art on a retail basis and selling art on a consulting basis are very different. A salesperson trying to do both at the same time will probably do neither well.

What Caliber of Consultant Is Needed? The consultant must be able to sell at the level of the market the gallery has identified it is best suited to serve. He or she must have sufficient knowledge and training to be successful. Art consultants are perceived as experts in their field by their clients. A young, inexperienced consultant may be able to handle only the least demanding segment of the corporate market.

What Services Will You and Will You Not Provide? How will you handle those services a company needs that do not result in art purchases—reframing existing art, disposing of art the company no longer wants, acquiring special art such as Japanese prints for the international floor?

Take a look at all the services listed in the outline beginning on page 20 and come up with a policy for each. Remember that an employee who must always consult the owner on whether a service will be offered or how much it will cost will not engender much confidence among clients.

Right: *Here is an example of a well-conceived marketing letter sent to me by a gallery owner, reprinted with her permission.*

The Allrich Gallery
251 Post Street
San Francisco
California 94108
Telephone: 415/398-8896

June 15, 20__

Ms. Susan Abbott
ABBOTT & COMPANY
3315 Sacramento Street, Suite 114
San Francisco, CA 94118

Dear Susan:

We are back in our renovated space at 251 Post Street and are celebrating the opening of our twentieth anniversary exhibition. I wanted to invite you to visit at any time.

Our new space has expanded storage and presentation area, which we hope will make it more comfortable for you and your clients. An added bonus is also that in the last few months four other galleries have opened in our building, making it a "must do" stop in San Francisco.

As I mentioned in my last letter, we have made a concerted effort to search for young artists doing quality works on paper and think the new artists we have added have filled a big need in the gallery.

Please keep us in mind for any projects you are doing. We gladly can send slides quickly of appropriate, available work.

Yours truly,
THE ALLRICH GALLERY

Louise Allrich

LA/apo

SO YOU'VE DECIDED NOT TO START YOUR OWN CORPORATE SERVICE...

Many galleries, once they decide not to go after corporate sales directly, either give up altogether or develop a grumpy attitude toward inexperienced consultants who come into the gallery.

Since the corporate market is here to stay and is growing, I think it's wise to develop a corporate marketing strategy. If you try to work with the consultants in your area and at the same time educate the neophytes, you may find the results very beneficial to your gallery. Here are some suggestions:

- Have a close working relationship with an art consultant you trust so that you can pass on leads when they occur.
- Increase your inventory of small-scale paintings and works on paper that may appeal to consultants. Eighty percent of the works purchased for companies are framed under glass, and small paintings, say 5' x 5' and under $5,000, are also in demand. This is a way of helping out younger artists and even testing their market without having to make a commitment to represent their work. Many galleries think this increased inventory will take up too much space, but in the long run, offering a larger inventory creates more exposure and sales opportunities for the regular artists in the gallery. It also helps the gallery develop its image as a resource for the art consultant.
- Let consultants know you have these works and are willing to help them find others.
- Create easy art-on-approval policies.
- Be open and willing to educate the consultant on the art they are interested in—provide biographies, books, catalogs, and other reference material that will help them understand and sell the work.
- Offer your gallery as a meeting place for the local art consultant association. Promote joint networking projects between your local art dealers association and the local art consultants.

As a consultant, I always made a point of visiting the top galleries that kept works by younger artists in their back rooms. I felt I was getting the benefit of the dealer's eye, and it cut down on the time-consuming visits to emerging artists' studios. Of course, while I was in the gallery, I would also look at the work of stable artists as well.

DEALING WITH IN-HOUSE CURATORS

Trying to catch a busy curator at exactly the right time to interest him or her in your offering can be difficult. Putting each on your mailing list will give you some exposure, even to those curators who don't take telephone calls. You can send slides, but always include a self-addressed stamped envelope. It's also helpful to do some homework to be sure that your artists' work would be suitable for the particular corporation collection.

Even when you have made a successful contact, you will have to be flexible and understanding, for the curator is juggling a number of corporate factors, from budgeting pressures to employee biases to company taboos. Try to work out a system for loaning out art on approval that is nondisruptive for you and easy for the curator.

CAMERON WADE GALLERY

782 North Wells Street
Chicago, Illinois 60610

Telephone: 312/642-2968
Fax: 312/642-2970

June 15, 20__

Howard Emerson, Curator
Smith & Conington Brands
5498 W. Connert Street
Chicago, Ill 60610

Dear Mr. Emerson:

I have heard that Smith and Connington is putting together a collection of art by regional artists. Our gallery specializes in artists of the Great Lakes region, and I wanted to extend an invitation to you to visit us. A selection of announcements from our recent shows is enclosed for you, along with a slide of "Blue Bull," by Amate Brodo, 6' x 10', $3,500. The image is so close to your advertising image that I thought you might find it of particular interest.

We also have a large selection of works on paper, as well as a number of pieces of sculpture by local artists. Please call if we can be of service.

Cordially,

Cameron Wade

CW:mf
Encls.

Above: *An example of a letter to a corporate curator.*

CAMERON WADE GALLERY

782 North Wells Street
Chicago, Illinois 60610

Telephone: 312/642-2968
Fax: 312/642-2970

June 15, 20__

Sarah Constantini, Art Program Manager
Hank and Tromp
456 Michigan Avenue
Chicago, Il 60680

Dear Sarah Constantini:

I have just read the interesting article in the *Chicago News* on Hank and Tromp's collection of paintings of houses and barns. The slides enclosed are from an unusual group of paintings and silkscreens by Michigan artist Corby Whitney that deal with the subject of 19th-century farmhouses and barns.

Whitney has had an enduring interest in this subject, and I thought you might be interested in knowing about his work. In addition to the slides, I am including a biography and a recent catalog.

We also represent several other artists who have done works incorporating architectural themes. If you would like to visit the gallery, I would be pleased to have a group selected to show you. I'll give you a call next week to see when such a visit might be convenient.

Cordially,

Cameron Wade

CW:mf
Encls.

Above: *Another example of a letter to a corporate curator.*

DESIGNERS AS POTENTIAL CLIENTS

If you are reaching out to designers, here is a description of working methods that will put you in their good favor:

WORKING WITH DESIGNERS

1 You always operate in a timely fashion.

2 You can gear down to an economical approach when necessary.

3 You stay within the budget.

4 Trade discount is not negotiable—the discount is the same no matter how large or small the project.

5 You respect the designer's concept and control of the project.

6 Professionalism—your staff speaks the language of design. They read floor plans, color boards, and furniture specs. They are interested in helping the designers find the right look to complement their design concepts.

7 You are quality and fashion conscious. You keep abreast of the latest trends and styles.

8 You are trustworthy. You never sell to a designer's clients at wholesale or try to override the designer's concept by dealing directly with his or her clients.

9 You are accommodating and flexible. You will go to the designer's offices. You try to meet their special needs.

■ ■ ■

SELLING YOUR SERVICES

PART 2

About Companies

*"The pseudo-highbrow notion that the businessman is
uninterested in the artifacts of life and unmoved by beauty is
unhistorical and increasingly baseless. It is being recognized as
a stale caricature that has enjoyed quite excessive longevity."*
—*Armand G. Erpf, investment banker* [3]

A corporate art program is there for a purpose, and the purpose is
always business. There would be no art on the walls if the collection did not do something positive for the company, either by projecting a particular image, or by improving relations between the
company and the community, or by refreshing and stimulating the
company's employees. So an art program is an intersection of art
and business, and you will find that one of the most interesting
challenges will be mastering this meeting of two worlds—being
able to think in terms of the business value of an art program
while exercising your own intense interest in art.

Companies are just a collection of people.

You are stepping into the corporate world, which you may find
intimidating if you have never worked in its corridors. But the
average corporate person will find the art world even more intimidating. Without any training for the task, he must somehow
present the company through the art he chooses.

When so much is at stake for an executive, he or she relies
heavily on the guidance of an art advisor. "When I first started
consulting," art consultant Nancy Chamberlain says, "I couldn't
believe how much my clients depended on me. Here was the president of one of Japan's largest industrial companies looking to me
as his expert. It was a heady experience."

Corporate art consulting becomes a very personal interaction,
because the process of selecting art falls outside the client's usual
business ken. Therefore, the first job of the consultant is to build
rapport. The client must feel comfortable in what is essentially a
vulnerable situation for him. The second step is to build his confidence in your expertise and your interest in helping him solve
his problems. Rapport and confidence are the foundation of the
consulting relationship.

HELPING DEFINE A NEED

Clients usually have a clear idea of what is needed to achieve their business goals, but they often don't know how an art program can help them. Some may not understand the impact art can have, and others may have a very definite but mistaken idea of what art can do. It is up to the art consultant to advise them on the best way to use their art programs to answer their corporate needs.

> *A computer company wanted to commission a sculpture of a giant computer chip in bronze as the centerpiece of its new headquarter's plaza. The goals: to provide an outstanding landmark, to enhance the company's image as being at the forefront of software technology, and to contribute to the cultural richness of the community. It was my task to convince the people in charge that by taking such a literal approach to their public sculpture they were going to fall short of all their objectives, because:*
>
> **1** *any artist who would take on a commission to do a giant chip would not be the kind of nationally recognized artist they wanted to attract;*
>
> **2** *a better way to convey a vanguard image would be to choose the best contemporary sculpture available, which would communicate the values of the company in a more abstract way; and*
>
> **3** *given the rapid changes in computer technology, in five years they would probably have an expensive and obsolete monument to past technology, which would date them to anyone in the industry familiar with the changes. As you might imagine, the last was the most compelling reason for them not to go ahead with the idea.*

It is often necessary to go beyond the surface to find real needs so that you can provide real solutions. The more you know about your client, his business, and his future plans, the more effective you will be as an art consultant.

FROM DECOR TO AN ART PROGRAM

Some clients think of art only as an element of the decor, and they may not realize that the art says more about them than the furniture. They will spend $2,000 on a chair and balk at spending $1,000 on a piece of art. Sometimes a seasoned consultant can shift a client's perspective. Paying careful attention to the company's design objectives may lead the consultant to a solution.

It is often intimidating to the client to be asked what kind of art he wants, since he may not be able to verbalize what he wants, but it is safe to ask for the decor brief for the remodel. A marine insurance company prepared the following brief to communicate its decor goals to its design team:

> "The purpose of the remodeling will be to maintain Mantel and Thompson's traditionally conservative image while recasting it to fit 1990s concept of classic good taste."

The art consultant was able to extend the company's decor objectives into a complementary art program. Notice how the art program is able to achieve a marketing goal that was not possible through the decor: telling visitors about the company's historic role in nineteenth-century marine insurance.

> "The purpose of the art program will be to expand the company's collection of American maritime paintings and memorabilia. Art of all media and of the highest quality will be purchased to complement the design goals of the project and to maintain the nautical theme. Special acquisition of model clipper ships will be made for the visitors' reception area, reflecting the marine insurance handled by the company in the nineteenth century."

WHY COMPANIES BUY ART

"I believe enlightened self-interest dictates that a strong and profitable company should lend its support to those activities which assure the strength and vitality of the community. A sick and colorless society will eventually paralyze creativity and productive enterprise."

—*Otto Sturzenegger, Chairman and President of CIBA-GEIGY Corporation* [4]

There are often multiple reasons companies buy art. Here are five of the most common.

1 TO FILL BLANK WALLS

The clients have just moved into a new office or they have just remodeled, and the walls are blank. Depressingly, this is the primary reason companies buy art.

2 TO IMPROVE THE WORK ENVIRONMENT

One of the strongest motives for a company to buy art is to offer a more pleasant place to work. This may mean simply wanting the employees' offices to be attractive and comfortable, in which case the art becomes a stepchild of the decor. Or it may mean wanting to create a stimulating environment. Even so, companies can differ in their ideas of what "stimulating" means.

For example: Smith and Hawken, the mail order company that sells specialty items for gardeners, decided to use in its offices only contemporary abstract works rather than display images of flowers and botanical subjects. Paul Hawken, the president, felt this approach would give the employees a mind-and-eye break. Rather than reflect back the subject of their product line, the abstractions would stimulate them to be more creative.

A contrasting example: R. Dakin Toy Company decided to decorate its offices with a collection of antique toys displayed on modular blocks that can be moved and rotated.

3 TO ENHANCE THE CORPORATE IMAGE

All the perceptions that people have about a company add up to form its corporate image. These people include clients and customers, employees, suppliers, competitors, the press, and the community at large. Every firm wants to have a successful image, one that inspires confidence.

Two of the largest industries supporting art programs are financial institutions and manufacturing companies. The hospitality trade, such as hotels and restaurants, is fast expanding its use of art. According to Shirley Reiff Howarth, director of the International Art Alliance, Inc., "Most new first-class hotels now acquire or commission important art for their lobbies and public areas, and virtually all luxury hotels feature antiques or original art in their guest rooms as well."

4 TO SUPPORT THE LOCAL ART COMMUNITY

Companies are often concerned about being good community citizens and they view their art programs as a way to support local artists while enjoying the other benefits of the art.

Almost half of all collections are of regional art. For instance, Seattle First Bank collects Northwestern art, and First Interstate Bank of Arizona collects only Southwestern art. Some companies collect only contemporary art from their areas.

"Art collections offer important clues about a company, its taste, its financial stature, its relationship to the community (especially for site art) and its appreciation of the links among business, design, and the fine arts."

—*Robert Zinkhon, principal in Zinkhon Communications* [5]

WHY COMPANIES BUY ART

Art as values

"Our company values creativity and innovation—no better way to express them to our employees and public than through our art program."

Art as community

"We want to support our local art community by buying regional art."

Art as corporate theme

"Our company is in the paper business, and one way we can personalize offices is through our collection of outstanding works on paper."

Art as image

"Through our decor and art program we want to communicate a successful image to our customers."

Art as stepchild to decor

"We want an attractive, comfortable office and art is a part of the overall decor."

Art as wall decor

"We've got some empty walls and we want some pictures for them."

Companies often find it difficult to get favorable press, and many have discovered how easy it is through their art programs.

For example: First Bank of Minneapolis had a controversial collection full of usually taboo themes. The employee involvement programs were so innovative—with such features as a "controversy corridor" and employee "banishment" of unacceptable pieces—that the art program became a major factor in the bank's public image. The collection was covered in many mass-circulation publications as well as in art journals.

Often a company will want to say something more specific than just "We are successful." They will have a particular image they want to project, and they'll need help in selecting art that best expresses it.

For example: When planning their new headquarters, the chairman of the board of First Interstate Bank of California wanted to project two very different images—that of a dependable, conservative bank that was nevertheless on the cutting edge of current financial practices. The solution was to combine traditional furniture with strong contemporary art.

5 TO PORTRAY A CORPORATE THEME

As companies come to realize what a powerful tool art can be, many are seeking to personalize their image even further through a corporate theme.

Some examples: Consolidated Freightways developed a collection of American landscape photography that features roadways from 1929, the year the company was founded, to the present; the collection was so successful that parts of it were borrowed for a traveling museum exhibition. Piñata Foods, a division of Standard Brands, created an exhibition of Mexican folk craft that traveled to museums around the United States before returning to company headquarters for permanent display. Lang Communications, the publisher of *Working Woman*, *Ms.*, *Working Mother*, and *Sassy*, assembled a serious collection of prints by women artists.

Laura Carey Martin, of Carey Ellis Company, takes into account the whole range of her client's concerns when she conceptualizes an art program.

> *"We always develop a master plan, which is made up of individual components that can be deleted, enhanced, or expanded. This provides the maximum flexibility so that we can ensure we meet the objectives for the project—corporate image, aesthetic, and budget.*
>
> *When appropriate, we like to incorporate educational programs for both internal and external audiences. Additionally, when the client wishes to use the collection as a working asset, we provide them with public relations options, such as exhibitions, tours of the collection, and philanthropic opportunities geared toward their concerns.*
>
> *We adopted this approach so long ago that it's second nature to us now. It has helped us build a group of clients who see art as an integral part of their corporate culture and image."*

COMPANIES DO NOT USUALLY BUY ART FOR FINANCIAL GAIN

Companies have not traditionally considered their art purchases as investments for financial gain. They may take pride in the financial appreciation of their collections, but rarely do they buy art expecting it to appreciate in value so that it can be sold off in the future.

When companies have significant capital to spend, they are liable to spend it in what they know best—their own industry. But in the nineties art market, where entry-level prices are so steep, investment may become a greater factor in the corporate collecting consciousness. To start a significant collection today, a company must spend a great deal more than it would have thirty years ago, and the investment factor may weigh more heavily.

In any case, a consultant should interview the client about his goals and discuss the investment potential of an art collection only when it seems appropriate. Ethically, a consultant must beware of misleading a company into making purchases based on their expected appreciation.

In an extreme situation, an art consultant can be sued for negligence if he or she gives a client a misleading statement about the value of a work, according to fine arts lawyer Peter Karlen. Consultants should be careful to stress that they are expressing their opinions, not guaranteeing facts. Along the same lines, a gallery that misrepresents the value of a work is liable under commercial sales and warranty laws.

COMPANIES DO NOT BUY ART AS TAX DEDUCTIONS

Legally, companies are not permitted to deduct the expenses of purchasing art as they do other office decor items, such as furniture. The IRS takes the view that, since art theoretically appreciates in value, companies cannot call it an expense and depreciate it as they do other items. (However, some companies that buy inexpensive art get around this law by saying the art is simply wall decor, not art.)

COMPANIES DO NOT USUALLY BUY CONTROVERSIAL ART

All companies have a constituency or customer base they are trying to reach as well as an employee population they want to please. For these reasons, most companies are conservative about exhibiting controversial art, feeling that the role of presenting controversial art to the public should be left to museums and galleries. The boundaries of acceptable art are expanding, however, as the general public becomes more culturally sophisticated.

One early advocate of challenging art was John D. Harper, CEO of Alcoa, who said: "We cannot have human progress without the inspiration—intellectual, imaginative, disturbing—of the arts." [6]

Several subjects are usually taboo:
- art with nudity
- radical political matter
- work that is sexist or exploitive
- art so intensely expressed that it is disturbing

Corporate taboos can vary greatly from company to company and even across changes in management. In our exhibition program one year, we proposed a "History of the Farm," a photo survey from early farms to large agribusiness empires. Our oil company client turned the show down because of its unfavorable commentary on agribusiness, which uses lots of petroleum products. Our financial services client was pleased to show the exhibition because it did not relate in any negative way to its corporate image.

Employee education: Any serious art program must have an employee education component, delivered by a sympathetic art advisor who is willing to work with a diverse employee population. Just convincing top management to buy tough or taboo art is not sufficient to ensure the success of the program. The more radical the art, the more sensitively it needs to be introduced to employees.

A SAMPLE CHART OF CORPORATE DECISION-MAKERS

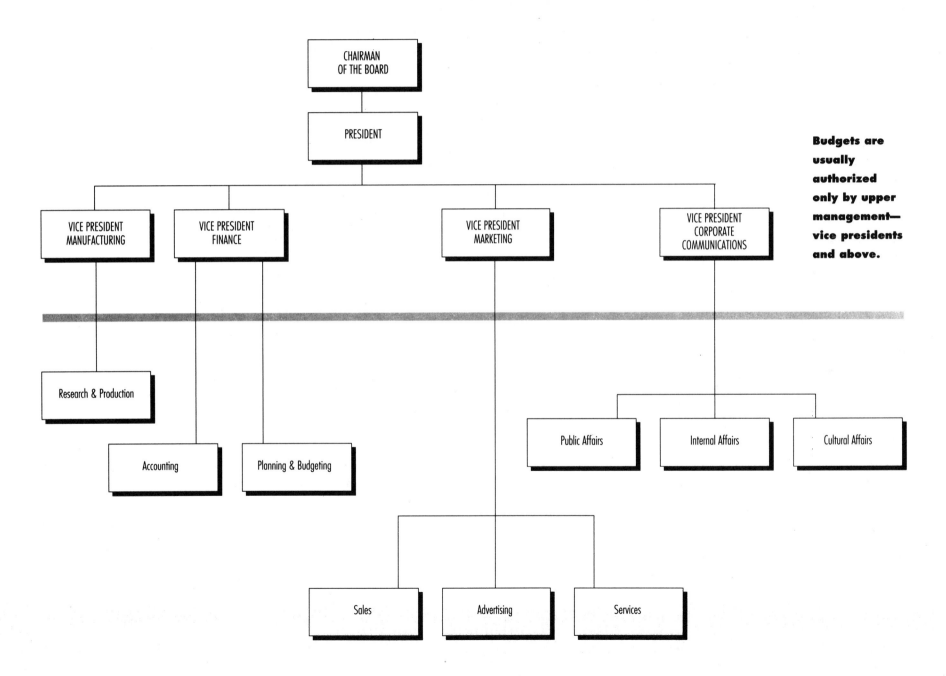

Budgets are usually authorized only by upper management—vice presidents and above.

CHAIRMAN OF THE BOARD

PRESIDENT

VICE PRESIDENT MANUFACTURING

VICE PRESIDENT FINANCE

VICE PRESIDENT MARKETING

VICE PRESIDENT CORPORATE COMMUNICATIONS

Research & Production

Accounting

Planning & Budgeting

Public Affairs

Internal Affairs

Cultural Affairs

Sales

Advertising

Services

WHEN COMPANIES BUY ART

Companies are most receptive when they are moving, remodeling, or expanding. It is the best use of your time to contact them at the beginning of this art-buying cycle, three to six months before they move or begin remodeling. On big projects, contact them one year in advance, so that you can collaborate with the design team on lighting or on making other structural modifications to accommodate the art. In the last decade, the trend has been to bring the art consultant in on the project much earlier than in the past.

Companies are least receptive to buying art when they perceive no need for art. That is, once they are cozily settled into a space, they usually will not consider an art program, partially because they will not have allocated any money for it when they worked up their budget the previous year.

ART BUDGETS

Few companies have a standard line for art in their budgets, unless it is a company that regularly expands.

> Two things should be noted:
> **1** If there is no art budget, they cannot purchase art.
> **2** Only top decision-makers can create or alter budgets; middle managers cannot.

If you have a proposal for a company, such as an exhibition program for its lobby, the best time to contact the executives is in early August, when they usually begin work on the budget for the following year. Toward the end of summer is an ideal time to start your campaign to get an art budget in the next year's budget.

FREQUENT BUYERS

Companies that have committed themselves to buy new art for their collections annually and companies that buy art every time they expand are particularly valuable as clients. Banks and other financial-service institutions frequently open new offices or new branches and have decor and art budgets allocated accordingly. These continually expanding companies make wonderful bread-and-butter clients, ideally representing forty to sixty percent of a successful consultant's annual income. When going after new clients, focus on these companies first.

OUT-OF-STATE PROJECTS

The scope of your business can be just as broad as you want it to be. You may get out-of-town projects by making contact with national and international companies that have facilities in your area. Remember that businesses are accustomed to flying in consultants from all over the world. As we enter the age of the global village, more foreign companies will be seeking an American image for their offices in the United States and more American companies will be expanding overseas.

Many consultants avoid developing overseas work because they are worried about finding resources in a foreign country, but local embassies, art galleries, and museums will all help lead you to the best resources in the area.

> *I liked overseas work and made it a habit to leave a few days at the beginning or end of a vacation to do some prospecting in the country I was visiting. In Japan, for example, where a great deal of patience is needed to develop business, it took two vacation/ prospecting trips before I was able to develop clients there.*

COMPANIES WITH EXISTING COLLECTIONS

Don't assume that because a company has a sizable collection they have a current art consultant. Often the designer or consultant who did the project has failed to follow up. Inevitably, within a year after the collection has been installed, a new vice president will want a painting for his office, or a division will expand to another floor, or a secretary will need to know how to update insurance. This may be a good time to get your foot in the door.

THE DECISION-MAKER

Usually the only people who can create or expand a budget are the chief executive officer, the president, or the executive vice president. If you are approaching a company that has no current art or decor budget, your approach must be at the level of top management. If you subsequently get delegated down the corporate ladder, at least you will go down with the referral of top management, which can mean the difference between getting that first appointment and not getting it.

WILL THE REAL PROSPECT PLEASE STAND UP?

Perhaps the most common complaint I hear from participants in my seminars is that they get the runaround from executives they thought were the decision-makers but who, in fact, were not. A sale can result from an art consultant's efforts only if he or she is talking to a "real" prospect.

Art is a difficult subject for most people to discuss, and few in middle management are willing to risk recommending something they don't fully understand. Furthermore, because of their inexperience, they are almost always inept at trying to sell your services up the corporate ladder. The key move in this situation is to convince your contact to put you in touch with the appropriate decision-maker. Strategies for doing this rather delicate maneuver are discussed on page 68.

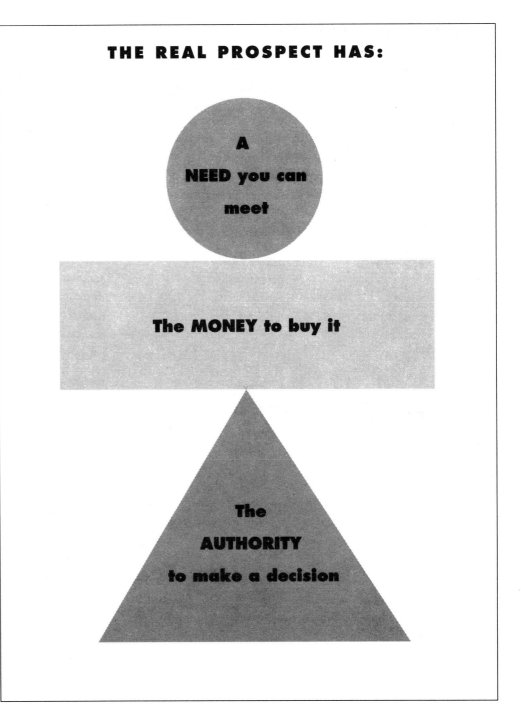

THE REAL PROSPECT HAS:

A NEED you can meet

The MONEY to buy it

The AUTHORITY to make a decision

THE HARDEST AND THE EASIEST SELLS

The hardest person to sell art to is the property facilities manager or the operations officer. Accustomed to buying supplies, they feel it is their job to keep a tight rein on expenses. They scrutinize every single expense and usually have little appreciation for the intangible benefits of art.

> *An art consultant's letter to the president of a bank was referred to the facilities department, which was in charge of the new move. With a tenacity born of desperation, she called the president and convinced him that, since the art program involved the image of his company, it needed his personal direction before he delegated it to someone else. I recommend that you do the same.*

The person who is most receptive to the intangible benefits of art is often the director of corporate communications or public relations, because his or her concern is the image of the company.

The chief executive officer (either the chairman of the board or the president) may be the hardest person to get to, but the easiest to sell. He holds the purse strings of the company, and he dictates the company's direction and image.

The exception to this may be in large companies where the corporate image has already been set and the design or facilities department is simply in charge of implementing it. An example would be a stock brokerage house decision that posters will be used throughout all of its new branches. In that case, it would be appropriate to contact the facilities department if you want to be the vendor for posters. However, if you think this decision is outdated or you want to recommend the company change its image, top management must be involved.

The advice goes for small companies, too. Often the job is delegated to the secretary of a small firm, and, once again, because art is so personal, it is advisable to meet directly with the owner of the firm. Many consultants have paid dearly in time and effort trying to work with someone other than the decision-maker.

WHAT COMPANIES NEED

Twenty years ago, companies wanting art for their offices had to search for a gallery or a museum person to advise them. Today, a whole army of professionals—gallery staff, independent art advisors, and curators—is knocking at their doors. Even museum rental and sales programs are competing for this business. It's becoming increasingly important that you understand what companies need so you can stand out in this competitive arena.

SERVICE, SERVICE, AND MORE SERVICE

More than anything else, companies want a complete art consulting service. A company will prefer to hire one expert to advise them on all the details, rather than waste time and money to educate an employee in a complex field, unrelated to their business. Most executives don't have any idea of how to put together an art collection, nor do they want to learn. They want to hire a consultant to advise them and to take care of all the facets of a successful program.

> *Rosanne Martorella has said, "The contents of corporate art collections are as diverse as the management styles and corporate cultures of the companies themselves… I discovered collections that included artworks and objects ranging from soup tureens, masks from preliterate cultures, American quilts, and English antiques to photographs, paintings by the New York school of abstract expressionists and present-day Italian neoexpressionists, prints by American conceptualists of the 1970s, huge outdoor sculptures, and an abundance of regional art."* [7]

The more types of art and services you provide, the better. You might review the list of art consulting services in Chapter 1, and see if any seem inappropriate to your business; then either avoid these or find a resource who can provide them as a subcontractor. But keep in mind that the more you expand your offering, the more you expand your prospects.

■ ■ ■

Generating Leads [8]

"A young man once asked a leading banker for his secret of success. The banker said, 'The secret is that you must strike when opportunity knocks.'

'But how can I tell,' asked the young man, 'when opportunity knocks?'

'You can't,' replied the banker. 'That's the secret.'"

The best way to generate leads is to make every move count by always being in a prospecting mode. People often think of themselves as working only when they are "at work," but a successful art consultant will look for leads almost anytime and anyplace.

TAKE EVERY OPPORTUNITY AND MAKE THE MOST OF IT

An art consultant brought a common problem into one of my seminars: "Once I land a job, it's so much fun to start pulling the art together, I forget to think about looking for new business. Then two months down the road, the project's over and I have to gear up for more work. It could be three months before another job comes through. How can I cure this tendency to settle into a project and fall out of the selling mode?"

Here are some organizational tricks to avoid this kind of up-and-down sales cycle, along with strategies to keep generating leads all year round.

TICKLER FILES

When you get a lead, enter it on a lead sheet and begin to gather as much information about the company as possible. Choose those leads that qualify as most promising each month and note on your calendar when they should be pursued.

Many consultants keep a steady momentum in pursuing leads by dropping notes to themselves in the following three files:

1 A Five-Year File assures that even those clients who will not have any need for your services in the near future will not be lost or forgotten. This is simply a folder for each year, five years into the future.

2 A Months-of-the-Year File allows leads to be filed according to the most appropriate time of the year to pursue them. Each month you can look over the leads in the current month's file and decide which ones to work on actively and which ones to put in the next month's file.

Five-Year File

Months-of-the-Year File

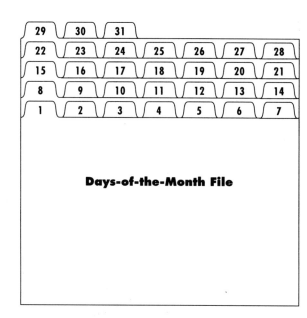

Days-of-the-Month File

3 A Days-of-the-Month File is a handy way to keep track of timely leads and other activities that need to be followed up within the current month.

Most stationery stores carry files already set up with monthly and daily labels. This system is also handy for keeping track of other marketing ideas and their deadlines.

SATISFIED CLIENTS

Once you are established, your clients can become your most valuable source of new leads. Top salespeople have long known that developing referrals is the best marketing technique. A satisfied client is your most valuable and effective form of advertising, and one bonus for doing your job well is that your client will be enthusiastic about recommending your services.

Tom Peters and Robert Waterman's seminal book, *In Search of Excellence*, shows that fulfilling the client's expectation of a quality product and good service is the number one reason the top American companies are where they are. When the book came out, the business community was astonished the authors had found, after so much research, that the formula for success was as simple as: "Put the customer first."

Putting the customer first means something different for every business and every client. When I first started my consulting practice, I landed a large project that took several years to complete. While I budgeted accurately for the time to acquire and frame the work, I completely underestimated the amount of time it would take to manage the collection, meet with employees, and install fifty-odd floors of art. I decided to absorb the expenses, and worked for almost a year significantly undercompensated. I was afraid that, faced with unanticipated expenses, the client might cut back on the employee education component, which I felt was critical to the program's acceptance. In retrospect, I can see that my efforts paid off many times over. Almost all my clients for the next ten years came to me in some way through the goodwill created from that job.

Some projects are quick and effortless, while others require much careful shepherding, and it is sometimes difficult to predict which jobs are going to be time-consuming. When a job runs over budget, rather than being resentful and thinking of ways to cut corners or to hold back on my efforts, I view it as an investment in

Above, left to right: *Keep a steady momentum in pursuing leads by dropping notes into a Five-Year file, a Months-of-the-Year file, and a Days-of-the-Month file.*

my overall marketing effort. I know the extra work will build goodwill toward future projects. The time to be cost conscious is during the budgeting phase—to be as realistic as possible and anticipate as much as possible, including things that can go wrong, like needing to do extra presentations. But if you do make budgeting mistakes, it is better in the long run to live with them and do a great job in a great spirit.

Often a consultant, in an effort to get the project, will make an unrealistic budget and then be resentful when it runs over and he or she has to either accept the loss or go back to the client for more money. Going over budget is seen as highly unprofessional and can be a factor in a client not wanting to give a referral.

EXPONENTIAL MARKETING MATH: CLIENTS AND THEIR REFERRALS

Right: *If you get just two leads from each project, you will soon be on your way to creating an endless chain.*

THE MAGICAL VALUE OF REFERRALS

You don't want to reinvent the wheel each time, developing every lead from scratch. Each time you call on a prospect cold, you must resell yourself and your services and establish your credibility. You don't have the benefit of a third-party endorsement. A satisfied client or enthusiastic associate can do all that groundwork for you, and much more effectively.

THE ENDLESS CHAIN

Apart from doing what's best for the client, there are some additional strategies for creating goodwill and helping to assure yourself of an endless source of leads from your past clients. Most of these involve keeping in touch and keeping your name in people's minds.

CHECKLIST OF GOODWILL STRATEGIES

- Follow up with visits to the collection and to the client
- Propose new components to the art program, e.g., tours or art lectures for the employees
- Send thank-you presents and notes
- Develop personal relationships with as many employees as possible
- Leave brochures and business cards with the receptionist
- Ask for and acknowledge referrals
- Attend the office party
- Send annual notes
- Put your identification on the art

Follow Up. Besides being a responsible business practice, a methodical follow-up visit on a completed project is actually a smarter way to spend your marketing time than pursuing new leads. By scheduling periodic visits to your clients, you set up opportunities to ask for referrals and to inquire about expansion plans.

For instance, I tell the client at the end of an installation that I'll come back in six weeks for a walk-through of the space to make sure that all the works are responding well to the climate conditions in the building and to see if the client has any minor changes he wants made. I also offer to reinstall art when employees or departments move. These visits give me access to current information on my client.

Furthermore, I ask him if we can pencil in a five-minute meeting, which I will confirm closer to the time. If I have a close relationship with the client, I may suggest we have lunch together. Before this meeting, I research any specific referrals I might ask him for. I'll even research the organizations of which he is a member, such as corporate boards, to see if any of them are planning expansions.

> *"What I'd really like is if someone remembered us a year or two later and got back to me when they saw something they know we'd like come up at auction, particularly something having to do with the history of our company."*
>
> —*New York corporate curator, quoted by Mary Anne Craft* [9]

Ongoing Employee Activities. Once the project is completed, plan a noontime tour or a lecture on the collection for employees.
Thank-yous. Send the client a thank-you present, perhaps a subscription to a collector-oriented art magazine to be delivered to his office along with a thank-you note. He will think of you every month for a year.

Send flowers and a thank-you note to the office manager, secretary, receptionist, or other primary contact who handled the arrangements and the myriad of in-house details for you. If the project was small, even a thank-you note will make a big impression.
Get to Know the Employees. A recommendation can come from anybody in the company, so try to get to know as many employees as possible, from the executive management down.

> *For many years, our company provided lobby exhibition programs for the Transamerica Corporation. We became very friendly with the secretary of the building office, who helped us coordinate deliveries and installations. Years later, when she became the facilities manager of another large building, she sold a lobby exhibition concept for our company to the insurance company that owned the building.*

Encourage clients to have staff involved in selecting art for their own office and work area. While the primary reason for this is to assure employee acceptance and appreciation of the art program, you also are indirectly marketing your services. After overseeing the installation of works in private offices, I give my cards to the employees and tell them not to hesitate to call me if they have any concerns about the art.

For example: Should a manager be ambivalent about the art selected for his office, consider telling him: "If you are not happy with it in a month, give me a call and I'll come over and rotate it for you." Knowing they are not stuck with a work for life will often allow employees to be more open and receptive to it.

Develop rapport with the receptionist, frequently the most undervalued individual in the company. Give her some cards and brochures on the not-so-off chance that visitors will comment favorably on the art, and she will be quick to give you the credit.

PEOPLE ENJOY SELLING OTHERS ON WHAT THEY THEMSELVES HAVE BOUGHT

Ask for Referrals. Don't be afraid to ask for referrals, because people who have been sold on your services will usually be enthusiastic about selling you to others. They want you to succeed to validate their decisions.

For example: Have you ever noticed at a party how someone who has just been to an acupuncturist will try to convince you of the glories of Chinese medicine?

It is always better to ask for a specific referral, such as, "I know you're on the board of CalBank, and I understand they're moving their headquarters next April. Do you think you might give me an introduction to Michael Phillips [the president]?" One of the nice things about asking top management for referrals is that people will usually refer you to others at the same level.

Whenever a referral comes your way, acknowledge your appreciation by sending flowers or some other small thank-you. Whether you land the job is not important; it is the act of recommending you that you want to acknowledge. If you then get the job, a second note will be appreciated and will encourage your contact to refer you again.

Office Parties. Request an invitation to your client's open-house party. When they've moved into a new space, companies often throw parties for their clients and vendors, or they may have social gatherings to which all the tenants in the building are invited. Lawyers, accountants, and ad agencies often give this kind of party to attract the business of other tenants. It's a great opportunity to meet prospects and show off your work. People will be complimenting the president on the new space, and if you're there, he will be liable to say something like: "Here's the terrific consultant who did the work for us."

Friendly Annual Notes. Write an annual personalized letter to past clients telling them how much you value their business and enjoyed working with them. Include information about some of your new projects. Be sure to tell them your version of marketing consultant Christian Frederiksen's favorite slogan: "Business is great, and we're looking for more." Avoid saying how busy you are, because they may not give you a referral for fear you might be too busy to do a great job.

Your Identification on the Art. Consider having a label with your company's name and phone number on the back of the art you install. This is also a convenient place to put the identification number for the work of art. We supplied these labels to our framers and they attached them at the shop. The numbers greatly helped to sort works at the time of installation.

Your contacts may no longer be around when it comes time for the company to relocate or remodel, and finding your name on the back of the art work may be the way a new manager connects with you. It is a strategy for maintaining your presence, and it can lead to repeat business.

CENTERS OF INFLUENCE

Centers of influence are people who are probably not your clients but could be. They are in a position to guide decisions on art projects, and when a recommendation comes from one of them, it carries extra weight. A center of influence is either someone who knows a great deal about art, such as a collector, museum director, or curator, or someone who is involved in a related profession, such as an architect or designer. Second only to a client referral, a referral from a center of influence is an excellent way to develop new leads.

CENTERS OF INFLUENCE

- Art Collectors
- Art Community Leaders
- Museum Trustees
- Commercial Real Estate Brokers
- Building Leasing Agents and Facilities Managers
- Architects, Designers, and Space Planners
- Galleries

Here are a few tips on how to make the most of your contacts with centers of influence—how to earn their allegiance so that they will want to help you by giving you valuable referrals.

PERSONAL ACQUAINTANCES

Make a list of all the people you know personally who might fit this category and decide on an approach for each one. For some close contacts, a lunch date may be appropriate; for others, an informational interview may be more appropriate; and for others, you may just send a letter letting them know about your services.

> *My business was launched essentially on personal meetings I had with two trustees I knew from my work at the Los Angeles County Museum of Art. Although they didn't hire me to help them personally, as I had hoped, their referrals were critical to my success.*

ARCHITECTS, DESIGNERS, AND SPACE PLANNERS

Increasingly today, these valuable contacts do not want to handle the art on big commercial projects, but they are in a strong position to recommend a consultant. Since they have already been accepted as advisors by their clients, their suggestions carry substantial weight.

One art consultant I know makes a point of calling the designer of any space she likes. "I was impressed with the job you did for Thompson and Hodges and I'd like to meet you," she'll say. "I'm occasionally asked if I can recommend a designer. On the other hand, you may need an art consultant from time to time."

Presentations. Some architectural firms and space planners sponsor noontime lectures for employees to keep them up-to-date on industry trends and special resources. When I started my consulting practice, I planned to do a lot of outdoor and site-specific sculpture placement. Since architects figure heavily in this area as a source of referral, I prepared a noontime presentation surveying outstanding sculpture placements around the country and then briefly talking about my services. I let them know that, were we to work together, they would be able to count on my respecting the integrity of their projects, that I would not undermine their design concepts or their client relationships. (This is every designer's worst nightmare about art consultants, and I decided to deal with it head on.)

BROKERS AND AGENTS

Commercial real estate brokers and leasing agents are another group that has an influence on company decision-makers. A business moving or expanding usually works closely with its broker.

And just as residential real estate agents get asked their advice on schools and myriad other things, so do commercial agents. These agents also are the first to know when a company is thinking about moving. They can be an invaluable source for leads.

> Consultants often ask me if they should pay a kickback fee to architects, designers, or other lead sources for referring them to a client. This practice has a way of escalating that can be harmful to the consultant. From an ethical point of view, it is inappropriate for a designer to gain personally from a recommendation to their client. It is best to steer clear of these situations. Instead, thank someone by referring them when the opportunity arises.

SCOUTS

Many people out there can serve as your advance men, without any effort on their part. Professionals in noncompetitive fields who service companies may know when a company is going to move or expand. Companies tend to upgrade their communications equipment—telephones and computers—when they move, so trainers for these systems can also be good lead sources.

These contacts will differ depending on the nature of your services and the kind of art you provide, but here is a list of professionals you may want to keep in mind:

- Accountants, lawyers, and bankers
- Corporate trainers and consultants
- Equipment and furniture vendors
- Plant lessors
- Personnel agencies and headhunters
- City planning department staff

Other leads can come from your own staff members. Be sure all your staff members have business cards with their names on them, and encourage them to hand them out to potential prospects as the opportunities arise. In the art world, business cards are still considered a little crass, but in the business world they are considered a valued communication tool, completely accepted and relied on for networking and socializing.

Bankers and lawyers, and of course, collectors, are always asked for their advice. Tell all those you know about your services and let them know you will appreciate any referrals.

PERSONAL OBSERVATIONS

This approach goes back to the aphorism: Take every opportunity and make the most of it. Always be in an opportunity mode, expecting to find a lead at every turn: at the gym, on the airplane, at an office product show, and at every social or civic event.

SOCIAL AND CIVIC EVENTS

At openings or parties of any kind, consider setting a goal of taking back to the office at least five business cards. Once you exchange cards with someone, you are friends, part of the network, with an invitation to call.

Cocktail party small talk is not everyone's forte, but there are other ways to generate leads and direct attention to your services. Museums on the West Coast, for example, often sponsor tours of corporate or private art collections as fund-raisers, and you might donate your services to conduct such a tour. Or you might donate your expertise to run an art auction.

Almost any activity that brings you into contact with corporate decision-makers or their spouses is bound to be beneficial.

I think the key is to follow your genuine interests and to get involved in the kinds of community activities that really engage you. In general, you will be more successful if you suit your marketing strategies to your own personal style. For example, while I do a great deal of public speaking and enjoy it, I am uncomfortable chatting at social functions and I would never include cocktail parties as part of my marketing plan. Someone else might find this context an enjoyable and effective means of networking.

CONSTRUCTION SITES

Getting in on the ground floor, before there even is a ground floor, can be a good move. One of my seminar participants described how she came across an impressive building under construction with a sign listing the major tenants. She not only canvassed these companies, she also called the leasing agent and asked him for the names of the other tenants, information routinely given out to prospective lessors.

OFFICE BUILDINGS

The directories of buildings, particularly new ones, can be a good source for leads. Write down the names of the tenants that seem to be good candidates. If possible, stop by their floors to take a look around and get a sense of their company images. It is a strong advantage to be able to refer to their "Italian marble floors," for example, when you call. It makes you an insider if they know you have already visited their offices.

INFORMATION SOURCES

Various sources of lead information are available, depending on the region of the country in which you are working.

PERIODICALS AND TRADE MAGAZINES

Newspapers and periodicals devoted to business issues, such as the *Wall Street Journal* and your local business and real estate journals, are valuable sources of information, but the business section of your daily newspaper may be the most valuable, since it focuses on local issues that have a direct impact on your marketing strategies. By scanning the headlines, you will find articles with good marketing information. See Chapter 20 for a thorough discussion of economic indicators.

MEDIA LISTINGS OF TOP ACHIEVING COMPANIES

An excellent way to get an overview of the companies in your area is through listings of the top achieving companies, which are usually published by local daily and business newspapers. Contact the PR departments of each paper to ask if they publish an annual roster of the state's or county's largest companies. Usually, for a nominal fee, they will send you a reprint of their listing. Often each name will be categorized by type of business and ranked by revenues, and the list may also include a brief description of each business, sales figures for the previous fiscal year, number of employees, headquarters address, and the name of the president and chief executive officer.

BUSINESS LEAD SUBSCRIPTION SERVICES

Some communities have business lead services for the general contracting industry. They provide commercial contractors (plumbers, electricians, and space planners) with the names of companies that have recently leased new space. As a subscriber for a monthly or yearly fee, you can buy this information for a whole region or for a particular segment, such as companies leasing more than 20,000 feet or hotels in your area. It may take some sleuthing to find these services, but it is worth the effort if you are looking for a sizable business volume. Call some of the commercial contractors in your area to see if they know of such a service. The real estate board, Chamber of Commerce, real estate brokers, or business services people, such as space planners or those in office equipment leasing, might help you identify what business lead services are available in your community.

CITY PLANNING DEPARTMENTS

Check with your city planning department. Often, if you provide them a self-addressed stamped envelope, they will mail you announcements of buildings under construction or renovation.

Office Building
Hawkins Banker Bldg at Drake Center
5600 Monway Street
New Mont, Alameda

Duffer Financial & Construction
Co-owner/contractors
Joseph Duffer
3725 Mt. Tay Blvd.
Lafayette, CA 94549
(415) 265-9674

Construction to be completed 1st quarter 93. Approved 60,000 sq. feet office space.

First American Bank and Charles Cutter Brokerage firm to occupy 7,000 sq. feet each as anchor tenants. Space available for lease, 3-25-93.

Left: *Here is a sample of the information you can expect from a business lead service.*[10]

INDIRECT MARKETING SOURCES

Indirect marketing is business that you do not get through direct marketing, but through one of the following:
- brochures and corporate statements
- public relations
- advertising

A brochure describing your services—and your client base, once you become established—can work for you by setting out your credentials and differentiating you from the competition. You can give it to prospective clients as well as to receptionists of existing clients. See Chapter 18 on marketing materials for a full description.

Corporate statements that you prepare can range anywhere from a brief program description that sits on the lobby table or in a wall holder, to an elaborate catalog that tells about the client's art collection and art program philosophy. These vanity pieces make a good impression on both employees and company visitors. It might be a message from the president about the art collection and why the company values such a program. It might also include a statement by the art consultant on the goals of the collection or some other aspect of the program. The statement or catalog becomes a public relations vehicle for both the company and the art consultant. See Chapter 18, page 192, for an example.

Chapter 19 covers the subjects of public relations and advertising, but note that talk-show interviews are easy to arrange. Producers are always in need of new and interesting topics and art is a high-interest subject these days. (See also Abbott and Webb, *Fine Art Publicity*, 1990.)

DOING YOUR RESEARCH

Once you have a promising lead, the next step is to learn about your prospect. The degree of research will depend on the scope of the potential project and the level of art you will provide. For instance, virtually no research is needed to place a small graphics program in a doctor's office. Some consultants have even been successful walking in off the street and making a sale.

For larger, more sophisticated projects, there is a direct correlation between the amount of research you do and your success rate. You will want to find out as much about the prospect as possible. Here you are not selling art but professional expertise, and your expertise lies in being able to translate a company's business needs into a viable art program. The first step toward this goal is understanding the company's business. The more you know before meeting with a prospect, the more likely he will be inclined to want to do business with you.

KNOWING YOUR PROSPECT

Before you approach your prospect, you will want to know most, if not all, of the answers to these questions:

1 What kind of business is it (manufacturer, service, hospitality, financial services, etc.)?
2 Is it publicly or privately held?
3 How many employees does it have in total? How many at the site in question?
4 In how many cities, states, or countries is it doing business?
5 What kind of employee programs or art programs does it have?
6 How is the business currently doing?
7 Who will visit the site in question, i.e., do the company's clients come to the site?
8 Is there anything new or exciting happening in the company or its industry, such as a brand new product, a hostile takeover attempt, a change in government regulation?

Imagine what the president of a company would think if you were not aware that it had just come out with some major new product that was highlighted that week in the business section of the local paper. This event is the center of his consciousness, and the fact that you know nothing about it can be very damaging.

Annual Report. All publicly held companies are required by law to publish an annual report for their shareholders. To have one mailed to you, simply call the public relations department and request a copy. Rarely will you need to say more, as this is a common request from potential investors who want some basic information about the company.

The information you get from an annual report will give you a picture of the company—where it is in the market and where it wants to be. Of course, this is the company's marketing tool for in-

vestors, so it will be its best profile and should be regarded as such, but annual reports are your most valuable source of current information as well as being one of the most accessible sources.

Anonymous Visit. If possible, stop by your prospect's branch office or headquarters. You can find out a great deal about a company just by stepping into its lobby.

Telephone Call. Call the receptionist or human resource secretary and ask if you can briefly interview him or her about the company.

Business Library. See if your city has a business library or business section in its main branch. The reference librarian may be able to look the company up in one of the library's many resources.

Personal or Business Contacts. Ask your friends and business associates for any information they might have on a company you are marketing. Usually, through networking, you will come across someone who has had contact with the company and can give you some valuable insights.

If you are seated at a dinner party next to someone in business, ask him how his industry is doing. Ask what the pressing issues are. I did this once when I was seated next to a man in the cement business. Several years later, I had a prospect who was president of a California cement company. I was equipped with a solid referral, but the fact that I seemed knowledgeable about the cement business stood me in even better stead. After the prospect had become my client, he confided that he could not believe his good fortune in finding an art consultant who seemed as interested in aggregate as she was in art.

NOTES FOR GALLERIES

Galleries have an ongoing source of leads and an information base in their regular gallery clients. Make it a point to ask clients where they work and create a cross-reference file by company. If you learn that a particular company is moving, you can check your file. Even if your client is not a top decision-maker in the firm, he or she can give you valuable insider's information.

COMMUNITY ACTIVITIES

Galleries are often in a good position to get involved in community activities, which are likely to produce valuable contacts. A Los Angeles dealer loans out her gallery space for meetings of non-profit organizations. She invested in a set of chairs and says the contacts that have resulted have more than paid for the chairs and the staff time required to coordinate the meetings.

LEAD CONTACT GROUPS

Some advisors, and galleries in particular, participate in lead contact groups to learn more about potential prospects. These groups usually meet monthly to network for new business referrals. Their sole purpose is to recommend one another to their clients, or to exchange marketing information. For example, an art dealer, a computer salesperson, and the head of a plant-leasing firm might meet monthly to exchange ideas for leads. This approach works best for small to midrange decor projects.

COOPERATIVE MARKETING

A trend in the hospital industry is for service providers to join together and hire a salesperson to represent each of their independent small businesses. A framer, an art consultant, and a plant lessor, for example, might hire someone to market their services. The client only has to meet with one person to line up three vendors. This approach works well for low-cost projects, such as model homes, medical centers, and some hospitals.

PRESENTATIONS

A participant in one of my seminars, the owner of a volume frame shop and graphics gallery, develops lead referrals for model homes and hotels through a forty-five-minute presentation to design firms on the newest trends in commercial framing. Included in her presentation is a ten-minute overview of the services her firm offers to designers, with slides of projects she has completed.

■ ■ ■

Getting the First Appointment

To recast an old aphorism: "Consultants are born with two ears but only one tongue, in order that they should hear twice as much as they say."

I know of art consultants who carry portfolios of their artists' work around with them from office to office, making cold calls. If the work they represent is inexpensive, and if they limit their scope to small firms with marginal budgets, they will meet with some success. Even with large firms, if you are presenting art mainly to meet decor needs, it may not be necessary to market your services to top decision-makers.

The more substantial your projects, however, and the more expensive the art, the more you will need to develop sophisticated marketing strategies. You'll have the best chance of success if your approach is in terms of corporate image, and that's usually the responsibility of top management. It's more time-consuming to pursue a chief executive, but the project as a whole will move much more smoothly and quickly, because you won't waste time later as the designer or the midmanagement employee tries to second-guess his president's wishes.

In a medium-sized company, the president may personally meet with as few as six consulting firms a year. These may include lawyers, accountants, architects, designers, computer system analysts, and ad agencies. Your approach must be highly sophisticated to be included in this select group and to avoid being delegated to someone less important, with less power to make positive decisions.

For each prospect, you will need to determine the best approach to take, one that fits the circumstances and also one with which you yourself are comfortable. Whatever the approach, the key to success is communication—clear, concise, and consistent. This theme runs through the eight steps for pursuing a project, the first four of which are covered in this chapter. Your ultimate goal is to sell your services, but your objective for these first four steps is to get an appointment. It's useful to keep this limited objective in mind when you are writing or speaking to your potential client.

STEPS FOR PURSUING A PROJECT

1 Canvassing
2 Contacting the Prospect
3 Follow-Up Telephone Call
4 Confirmation Call or Letter
5 First Visit with the Prospect (see Chapter 6)
6 Submissions and Acceptance of Proposal (see Chapter 9)
7 Survey of the Client's Office (see Chapter 10)
8 Assessing the Client's Taste (see Chapter 11)

STEP ONE: CANVASSING

The term "canvassing" covers all the activities in which a consultant engages to find leads and to verify that they are serious potential clients. Before contacting a prospect, you want to have some idea that the company is in need of art.

STEP TWO: CONTACTING THE PROSPECT

Should you call or should you write? Your technique for contacting your prospect will be a matter of personal style, circumstance, and the nature of the business you are developing, as well as the type of business you are pursuing.

A top decision-maker usually will take a call only after having received a letter of introduction, the first way he qualifies a caller as being worthy of his attention. If your call is not preceded by a letter, the executive secretary will often insist that you send one.

A middle manager or small-business entrepreneur will generally receive a cold call, but whether he or she is receptive will depend a lot on how you present yourself.

Facilities managers will usually take your call.

You'll make a favorable impression if you send a letter of introduction three or four business days before you place your call. If you hate cold calling, always send a letter first to warm up the contact.

WHEN YOU CALL

A cold telephone call has the same function as an introductory letter, but it also gives you a chance to qualify your prospect with a few pertinent questions. Cold telephone calling is generally poor procedure and certainly inappropriate for large accounts, but it may be suitable for smaller ones.

When you call, your objectives are to introduce yourself, to establish your credentials, to qualify the prospect in order to determine if he or she has a need for your services, and either to schedule an appointment or to set the stage for your letter that is to come.

I would follow up a telephone call with a letter to confirm my appointment, if one has been scheduled, and to establish my credentials and build confidence. In the world of sales, studies have repeatedly shown that the most important influence on people who buy is confidence—even more than cost or quality. And the most important factor in building confidence is familiarity, which is why companies have multimillion-dollar advertising budgets to build name recognition. In this one area, art consulting parallels mass merchandising. There is a direct relationship between your efforts to build confidence and your success as an art consultant.

WHEN YOU WRITE

Some things to consider when you write your first letter:

- A service that costs more than $500 can't usually be sold in a letter or brochure. I suggest you do not even try.
- People will seldom read a brochure until after they have met, or have agreed to meet, with you.
- Less is more. At this early stage, your objective is not to sell your services but simply to create enough interest so that your prospect will agree to meet with you.

Since a successful art program is based on a client's need, an experienced art consultant will never embark on a detailed sales approach before the client interview has taken place. Therefore, be concise.

Your letter will achieve what it should if you introduce yourself, establish your credentials, and set the stage for your call.

LETTERS THAT OPEN DOORS

Letters are great confidence builders. By the time a prospect receives a few letters from you, the two of you are correspondents, even though you may not have met and the dialogue has been only one-way. Jay Conrad Levinson, in *Guerrilla Marketing*, says, "The primary value of a personal letter is that it enables you to convey a truly personal feeling and reach a special place in the mind of the reader."[11] A well-written letter can break the "stranger barrier" and establish rapport with the prospect. Your prospect is prepared for your follow-up phone call and is more likely to perceive you as an associate, not a nuisance.

Presenting yourself as a professional is key to developing rapport and trust. Your letters should be businesslike, in both appearance and content. This is not the place to expound on the glories of art. The letter should be short, on one page, and airy. By "airy," I mean no laborious paragraphs or long lines that are difficult and tiresome to read. Keep the length of the body of your letter to about six inches, and allow ample margins to create a spacious feeling. If your letter is too long, your prospect will not take the time to read it and he will surely feel that a meeting with you would take too much time.

There is a second reason to keep this letter short. The objective is to give the prospect just a taste to whet his appetite. If you describe your services in depth, he may use this as the reason he is not interested in your services. "I read your letter and brochure, Ms. Jones, and we're not interested in that." By being brief, you can be oblique about what you have to offer.

> **Note:** One of the most frequent mistakes consultants make is to write a lengthy introduction letter describing their services in detail. This has the effect of suggesting to the client that you are a vendor with a particular product or service for sale and that your priority is your profit, not your client's needs.

Include as much specific data about the prospect's business or site as seems appropriate. These tailor-made references add a friendly tone to your letter and let your reader know you have done your homework. But be sure they are accurate, or they can backfire.

For example: A consultant writing to the president of a car rental company did not win points when she referred to the impact an art program could have on the customers coming to the company's headquarters. The company's customers only visit little booths in airports and parking lots. There are visitors and employees at their headquarters, but no customers. This seemingly minor faux pas immediately made the prospect feel the consultant didn't understand his business. Close the body of your letter by letting your client know when you will be calling. Most readers will make a mental note to expect your call, and when you do call, they will be more likely to reciprocate your professional courtesy by giving you five or ten minutes of their time.

If for any reason I am unable to call when I said I would, I send him a second letter saying I am going to be out of town or that I will be unable to call when I promised, and that I'll get back to him the following week. And I enclose an article of interest to him, either one I have written or one on the use of art in companies.

A handwritten postscript adds a friendly tone and can further personalize your letter. If I have something appropriate to say, I use a handwritten postscript to share with my reader some bit of information he'll appreciate, or to note that I've enclosed an article of interest. This tells him that I'm not just trying to make a sale but am already providing the benefits of my professional consultation services. Following are samples exemplifying letters that will open doors for you:

FINE ARTS CONSULTANTS

782 North Wells Street
Chicago, Illinois 60610

Telephone: 312/642-2968
Fax: 312/642-2970

Mr. John Carter, Chief Administrator
Montcrief Hospital
1102 9th Ave.
San Francisco, CA 94107

Dear Mr. Carter:
I noticed the other day that Montcrief has a cheery new coat of paint
and some new furnishings in the reception areas. I wonder if you have
also given thought to including art work.

Fine Arts Consultants has developed art programs for several health-
service organizations. We understand the dramatic changes that are
taking place in hospitals today, and are abreast of the current color and
decor trends that have been developed especially for the health-care
field.

I would like the opportunity to discuss your decor plans for Montcrief
and to describe the results we have achieved for such organizations as
Saint Francis Medical Center, Arwyn Professional Medical Center, and
Townsend Hospital. I'll call you in a few days to see if there is a
convenient time for us to meet.

Sincerely,

Margaret Pilar
Director

MP:mc

Above: *Sample direct mail letter— special industry*

Right: *Sample second letter for a two-letter personal marketing campaign, and an alternate letter with a more personalized approach.*

FINE ARTS CONSULTANTS

782 North Wells Street
Chicago, Illinois 60610

Telephone: 312/642-2968
Fax: 312/642-2970

Dear Mr. Carter:
I am going to be out of the office most of next week and will not be able
to call you as promised.

I'll give you a call the week of August 15th. In the meantime, a bro-
chure on our services and a reprint of an interesting article on the use of
color and art in the health-care field is enclosed for you with my best
wishes.

Sincerely,

FINE ARTS CONSULTANTS

782 North Wells Street
Chicago, Illinois 60610

Telephone: 312/642-2968
Fax: 312/642-2970

Dear Mr. Carter:
I read with interest the other day in the *San Francisco Reporter* about the
many fine staff programs you have at Montcrief. I'm enclosing an article
on art as an employee benefit that I thought might interest you. The art
work in your offices is another way of saying to employees and potential
new employees that you care about providing a good working
environment.

I am going to be out of the office most of next week and I will not be
able to call you as I promised, but I'll be in touch the week of August
15th to see if there is a convenient time for us to meet.

Sincerely,

PREPARATION SHEET FOR FIRST PHONE CALL

Note: *This advice also pertains to a cold canvass call.*

Be psychologically prepared and grounded. Reread all background information you have gathered on the client. Make notes on the following even though you will not use them all:

Special bond you have (i.e., person who referred you):

What type of office the client has and who his visitors are likely to be:

List the three most compelling reasons the client should meet with you:

1. _____

2. _____

3. _____

List three key features and benefits to the client in doing business with you:

1. _____

2. _____

3. _____

List four of the most important clients you have, preferably those in the client's industry:

1. _____

2. _____

3. _____

4. _____

Have your calendar out and two days chosen to propose a meeting with the client.

STEP THREE: FOLLOW-UP TELEPHONE CALL

The purpose of the follow-up call is to get a personal appointment. This may be the most critical and challenging part of art consulting marketing. If you don't get the appointment, the job is lost. I try to be as prepared—and as mentally focused—as possible before picking up the receiver.

Just before calling, I'll brief myself on the client, review my objectives, and remind myself that the goal of the phone call is to get a meeting, not to launch into a sales presentation. Like aiming an arrow before you shoot, this preparation can help you hit the target. If you find the idea of making the telephone call daunting, I suggest you fill in a prepared sheet of questions to give you something to fall back on and to mentally rehearse the conversation.

The only sales presentation that is appropriate here is to convince the prospect that he personally should be involved, at least initially, in setting the direction of the art program. But be sure that you offer some realistic benefit early on in the call, to answer the prospect's unspoken question, "Why should I see you?"

In each case, your reason will be slightly different, but two of the most compelling reasons are:

1 Art conveys the company's image. Since art is a matter of personal taste, you should be the one to set the direction for the art program. Costly mistakes—both in money and in staff time—can be made when employees are left to second-guess what you want to convey.

2 Art is the touch that ties the whole interior together and makes the place feel finished. If you leave it to the end, after you've moved in, the walls may be blank for many months before the art can be in place. It's best to get the ball rolling early on in the project.

WHEN TO CALL

The best time of day to call top management is when the executive secretary is not screening incoming calls, which is usually 7:30-8:30 A.M., 12:30-1:00 P.M. or 5:00–6:00 P.M. Many companies are now installing voice mail so that executives will not be bothered when their secretaries are away, in which case you should call the secretary back during business hours.

STAY IN CONTROL OF THE CALL

Avoid leaving a message to have your call returned. If the prospect has too many pink slips from someone he doesn't know, he will sometimes delegate someone in the firm to return the call.

Losing control of your follow-up call can be disastrous. Your call may be returned at an inopportune time. We all have our good days and our bad days, but you don't want to jeopardize your professional image by sounding ill prepared or distracted when that important call comes in. Stay in control of the call.

If the secretary informs you that your prospect is not available and asks you to leave a message, simply reply with something like: "I'll be out of the office most of the week, but I can try again later. When is a good time to reach Mr. Hamilton?" Then call back again. If he still is not available, come up with another reason for not leaving a message. Keep this up until you reach him. You can do this three or four times before it gets awkward. When it does, leave word and say, "A good time to reach me is…" And then set aside that time to receive prospect calls.

The increasing use of phone-mail has further complicated this process. Have a concise message already prepared so as to avoid being caught off guard: "Hello Mr. Jones. This is Margaret Pilar. I am calling you as promised. I'd like a five-minute phone appointment with you. I'll be in the office Tuesday and Thursday from 2 to 4 p.m. If this is not convenient, please leave word on when is a good time to reach you. My number is 486-3945."

WHEN TO POSTPONE CALLING

I recommend you do not make an important marketing call—even if your call is expected—if you are not at your best. You can always call the next morning to say you were unable to call at the appointed time. You will have only one chance to make a good impression. In addition to what you say, your voice will accurately project your feelings, energy level, enthusiasm, and alertness.

WHEN THE PROSPECT DOESN'T REMEMBER YOU

Very often you will call to say you are following up on your letter, and you will hear a dead silence on the other end. Your prospect does not know who you are or why you are calling because he never received your letter (his secretary may have forwarded it or put it in a pending file), or he never read it, or simply does not remember reading it. (If it was a good letter, there would not have been anything particularly memorable about it beyond the professional image it sought to create.) He may even be embarrassed. To prevent this awkward situation, help him out by repeating the important points of your letter, even though to you it may seem redundant and even silly. This has happened to me many times and I still feel awkward when I have to talk to the prospect as though it were for the first time, but by preparing myself for this situation, I avoid stammering indecisively.

AVOIDING BEING REFERRED TO SOMEONE ELSE

A common response, and an understandable one, is for your prospect to try to refer you to the designer or to some subordinate in the office. Explain to him that art conveys a great deal more information about a company than do other design elements, such as furniture. Explain also that, although you always work closely with the designer, most companies have found an art program too important to delegate before top management has decided the direction and tone the project should take.

For example: Sometimes the decor can be used to express one quality and the art another. You can give him an example to help him visualize this point, such as: A computer manufacturing firm wanted a sophisticated, high-tech look in their furniture to reflect their state-of-the-art hardware, but they decided that their art program, through its images and the textures of its tapestries and other handmade work, should convey warmth and friendliness to their visitors and employees.

THE VALUE OF BEING OBLIQUE

Again, your objective is to get the personal appointment, not to sell your services. Just as you avoided any hooks for your prospect to reject in your letter, avoid a sales pitch on the phone that might either give the prospect the idea you are trying to sell him something before discovering what he needs or that is so detailed he can say, "Oh that; we don't need that." The only thing you want to pitch is the importance of a personal meeting.

Be ready with a standard comment, such as: "It's really difficult to discuss an art program and what it might achieve for you over the phone. The issues are just too visual. And besides, our consulting services vary a great deal depending on our client's needs. In a short meeting, I can explain the options available to you and we can explore whether we are the right firm for your needs. If we aren't, I can recommend someone else and at the very least save you a lot of time."

MEETING OBJECTIONS HEAD ON

Even though you have successfully avoided being referred to someone else, a prospect may raise an objection, such as, "I'm not sure I have the time to deal with the art program right now." Objections reflect your prospect's concerns; they need to be acknowledged and addressed. They are a good sign of progress, for any prospect who is seriously considering meeting with you is likely to have objections or raise one to test you. If you have a prospect who does not express any concerns, you may not have a real prospect. (In this case, you may want to test his authority by asking if anyone else is going to be involved in making decisions.)

In our next chapter, Selling as a Consultant, we will be discussing in depth how to handle objections.

"I'LL BE IN YOUR NEIGHBORHOOD"

At a certain point in the conversation, the logical time will come to propose a meeting.

Close your conversation with the assumption that your prospect wants to see you, and that it is just a matter of finding a convenient time. "I'll be in your neighborhood next Tuesday and again next Friday. Would either of those days be good for you?" (Always refer to the following week.) Top executives are very time-conscious. I've found they will go out of their way to meet with me if they know I am going to be nearby.

If you sense resistance, back off a bit. Your prospect may have more pressing issues at hand. Suggest that you get together later when his calendar opens up, perhaps in two or three weeks. Then set an appointment that is mutually convenient.

Postponing the appointment to a future date will often cinch the appointment, not only because his calendar is more open, but also because somehow it seems to him to be less of a commitment.

This moment is perhaps the most difficult of all, because in some cases you are gently manipulating the prospect into a meeting with you. What sustains me is the knowledge that once he meets me, he will be pleased he agreed to get together.

RESPECTING YOUR PROSPECT'S TIME

As soon as you have agreed on an appointed time, say, "Great, I'll see you on the 9th," and get off the phone. This demonstrates your respect for his time. For the same reason, don't ask him for directions; call back and ask the receptionist. Be up-beat, professional, and time-minded.

The tone of your good-bye should avoid suggesting that you are grateful he has agreed to meet with you. You are, after all, providing a valuable service, and high-level corporate officers are used to dealing with their equals. A nonequal salesperson might say, "Thank you very much, Mr. Prospect. I look forward to the opportunity to meet with you," but you want to convey your confidence that you have something of real value to him, even if he doesn't know it yet.

DEALING WITH EXECUTIVE SECRETARIES

Private executive secretaries can be formidable barriers or formidable allies. In any case, they are to be respected. They are often highly educated, highly paid professionals with as much clout as a vice president. One of their chief responsibilities is to screen out all unnecessary interruptions. Some executives give their secretaries the power to decide which calls or letters to refer to other departments for handling.

My first recommendation is to show the executive secretary the same respect and professional attitude that you show a client. Use her (or his) last name. If it appears that she (or he) intends to refer you to someone else in the company, explain why it is important for the chief executive to be involved, at least initially, on a project. Some points to make:

- Art, far more than furniture, makes a statement about the image of the company.
- If done properly, an art program can be an employee involvement program; if done improperly, it can become a source of employee resentment.
- Involving top management saves time because the staff is not trying to second-guess the chief executive's taste.
- You are an expert, knowledgeable about all the various options a company has; and if you cannot be of help, you can recommend another qualified consultant.

The purpose of your executive secretary presentation is to convince her of the importance of setting up a meeting with her boss. If you are successful, you will have a powerful ally on your side who can not only arrange a meeting, but can also give you inside strategic information, such as the personal tastes of her employer, the best time to reach him, and the business goals of the company.

An interesting dynamic that can occur in companies on decor issues is that the chief executive will rely on the advice of his secretary. Often, to men in their sixties, the home and its decor is the sole domain of a wife, and they carry this concept over to the office by delegating a lot of decision-making power either to their private secretaries or to their wives.

STEP FOUR: CONFIRMATION CALL OR LETTER

The confirmation letter confirms the appointment made in your follow-up phone call, or your cold-call, and it builds confidence through familiarity. It is a nice professional touch. I confirm with a letter when I want to reinforce my contact with the prospect or send him promotional literature on my services. A phone call to the secretary the day before the meeting, however, is perfectly adequate.

Before I call the secretary, I ask the receptionist for the secretary's full name—if I haven't already gotten it—so that my call will have a more personal tone to it.

Selling as a Consultant

"You can see a client's enthusiasm really take hold when you bring in a vision that's appropriate for the company."
—Laura Carey Martin, art consultant [12]

This chapter will cover the first meeting with the prospect and how to approach selling your services as a professional consultant rather than as an art vendor. Of course, no two meetings are the same, but I hope this discussion will serve as a road map of the likely stops along the way.

Many consultants, when they are first confronted with a prospect, simply launch into a description of the features and benefits of having an art program and of using their services. This is highly ineffectual because the advisor is not speaking to the prospect's individual needs. Just knowing the prospect needs some art for his blank walls is not the same as discussing his business and how you can relate the art program to his company's needs.

> *"When I first started consulting, I'd start my presentation off with: 'Let me give you an overview of the art I represent.' I felt a little like a Tupperware lady laying out her wares. If things didn't go well, it was too late to start asking the prospect questions to see if I could uncover some need I could fulfill."*
>
> —Margaret Atite, art consultant

In the prospect's mind, if you start off a meeting describing your services, you are not interested in the company's needs but rather in your own need to make a sale. No rapport is developed and no progress toward trust is made. The prospect will inevitably devalue any advice you may offer, and frequently a door in his mind closes tightly. Your presentation becomes merely a sales pitch.

The reason this approach backfires is clear when you consider the two main factors that influence people's buying decisions:

1 They have a rational need. Some prospects don't know what they need or all that an art program can do for them. Most people don't make a purchase without knowing first that they need what they are buying. The advisor can help them uncover their needs.

2 They have a personal need. People tend to do business with people whom they trust and who support the positive image they have of themselves. Ask yourself why you go to a particular lawyer, hairdresser, or doctor; it's usually not just an issue of skill. When given a choice, people will always select someone with whom they have rapport and who also has the necessary expertise.

Competition for important projects is likely to be lively, and how sensitive you are to the prospect's needs may well be the deciding factor.

For example: When Bell Atlantic planned a twenty-six-floor project in Philadelphia, they interviewed fifty consultants from around the country. Ed Swartz, director of exhibits and events, says that he considered "how they interpreted the company values we described," and that the quality of their presentations was what determined the winners. "They put in an awful lot of work in nine to ten days to show us how they'd represent our values." [13]

The consultive approach described here makes the most of opportunities to explore the prospect's need and then sell to that need, having developed rapport and trust along the way.

THE TEN PHASES OF A SALES PRESENTATION:
1 Mental Rehearsal
2 The First Impression
3 Gaining Control of the Meeting
4 Exploring the Prospect's Needs
5 Verifying That the Prospect Is "Real"
6 Clarifying Needs
7 Developing an Art Program Concept
8 Presenting Your Services
9 Meeting Objections
10 Closing

MENTAL REHEARSAL

When I was a teenager and I wanted to go on a weekend trip with my best friends, I would practice asking my mother and imagine her questions like, "Where will you stay?" and "What grown-ups will be there?" In my mind, I would answer all the questions well and she would finally say yes! This process gave me confidence and prepared me for all the questions she would inevitably ask.

Mental rehearsal is one of the most powerful personal tools we have at our disposal. Olympic athletes and actors use it all the time. Athletes have said that their success is twenty percent physical preparation and eighty percent mental rehearsal.

> *Duke University conducted an experiment by having half the basketball team sit on the bench each day for a month and just mentally rehearse making baskets while their teammates actually practiced. When they compared shots at the end of the month, the benched players were only one point lower than their counterparts.*

As an art consultant, I use mental rehearsal to visualize the sales presentation going successfully. In my mind's eye I see myself going through the different phases of the meeting with confidence and a sense of direction, answering my prospect's questions adroitly, coming up with an art program concept he accepts, overcoming some objection he raises, and finally closing the meeting with a commitment to proceed to the logical next step. By the time I am actually in the meeting, I have an attitude of self-confidence and of being prepared for anything that may come up.

During mental rehearsal (which, by the way, should always be positive; never envision a negative outcome), review your goals for the meeting so that no matter what comes up you will have an internal sense of direction to help keep the meeting on track.

The key goals of the first visit are:
- to establish an art program need;
- to convince the client you are the one who can best provide it; and
- to get a tangible sign of your prospect's interest in working with you, e.g., approval of a working budget and floor plans.

In every consulting practice there is a symbol of a successful first meeting. For an accountant, it's that the client gives him his general ledger to look over, for a lawyer it's the brief or documents

pertaining to the case. By the end of an effective art consulting meeting, a prospect should have given you one or all of the following indications he is committed or interested in working with you: a working budget figure; a copy of the floor plans or the promise to send them; a thoughtful walk-through of the space, sharing his feeling about different areas; or the go-ahead for you to prepare a letter of agreement or survey of the site. Each case will be slightly different, depending on the demands of the project. But it is the job of the art consultant to decide what in each situation would be the appropriate commitment and to work to achieve it by the end of the meeting.

THE FIRST IMPRESSION

"I can tell the second I meet someone whether I want to do business with them. The rest of the time with them is spent justifying my first impulse." —Peter Hempel, advertising executive [14]

Your wardrobe and personal image are the first step toward creating rapport with the client.

I try to dress at the level of the person with whom I am meeting. If it's a doctor who's the head of a small practice, my outfit is more casual than the sophisticated suit I wear for first meetings with presidents of large companies. If I wore my suit to meet with the doctor, I'd probably intimidate him and he might not trust me to create a warm, friendly atmosphere in his offices. People feel most comfortable with people who are like themselves.

We communicate in three major ways: by what we say, by how we say it, and by all the other facets of our presence—how we dress, our grooming, our accessories, our facial expressions, our body language. It's been estimated that words themselves contribute only a small fraction of the meaning of our message. How we say them—tone, volume, pacing—contribute more, but the largest contribution is made by all the nonverbal things about us.

Important elements in closing a sale: [15]
7%—what you say
38%—how you say it
55%—how you look

In the critical first few minutes of the meeting I try to put the prospect at ease by making casual conversation that's relevant, maybe complimenting him on the marble entry or noticing a piece of art on the wall. Whatever I do say, I make sure it's sincere.

The best opener is to mention whatever mutual bond you have, such as the person who referred you.

"I had a meeting with Jack Thompson last week, and when I mentioned we were going to meet, he said to be sure to say hello."

One of the purposes of an opener is to let the client know you are not an art shark who is going to launch into a sales pitch the moment you settle into your chair. Clients want to know that you care about them as people first and about their business second.

GAINING CONTROL OF THE MEETING

Most of the time a prospect will just ask you to have a seat across from him at his desk. This is the location where guests of unequal status are most often seated. For several reasons, it is a poor position for a sales presentation. One reason is that the client tends to stay in a distracted business persona. Even if he doesn't take calls while you're there, he anticipates interruptions. It's more difficult to get someone sitting at his desk to become vulnerable, to visualize the benefits of art to his company and the benefits of working with you. It is also very difficult to get your prospect involved in any presentation visuals without messing up his desk, or completely turning over your visuals to him and thereby losing control of the presentation.

The second least desirable seating arrangement is the couch and coffee table setting, with the visitor on the couch and the prospect sitting on a hard chair that usually is five inches taller. Once again, this is demoting, and an awkward position from which to present materials. For a woman wearing a skirt, it can be almost impossible to maintain dignity and to move easily and gracefully.

The location of choice is either the conference table in the prospect's office or in a separate conference room. Here the presentation can be easily controlled. And because this is the location where most executives work with their staff, it creates a subtle dynamic of a working session, a feeling I try to encourage by making the first meeting as interactive as the situation will permit.

It's a judgment call as to whether a prospect would be offended by a consultant suggesting a seating arrangement. You might say, "I may have some visuals to show you; perhaps it would be less disruptive to your desk if we sat at your conference table."

Requesting a conference room at the time you confirm the meeting is another way of helping assure yourself of a seating arrangement that works. I always do this when I'm making a slide presentation and sometimes on a first visit when the phone call has gone extremely well.

HAVE READY YOUR RUDDER REMARK

A few minutes into the meeting, after you've been seated and you've chatted a moment, the prospect will usually, either directly or indirectly through a shift in body language, say the equivalent of, "Well, tell me about your service."

This is a critical moment in the meeting. Some prospects will want you to tell them about your offering before they will let you start asking them questions. You want to be accommodating but only in a very unspecific, general way—just enough information to satisfy them and, ideally, to arouse their curiosity. If you can hint about the results other companies have achieved from their programs you'll create the green light for going ahead with a line of questioning.

> The person in control of a meeting is the one who is listening and asking questions, not the one who is talking and answering them.

I have a standard phrase, which I refer to as my rudder remark, to help me steer the meeting back to the course I want—exploring the client's needs first before describing my services. It goes like this:

Client: "Tell me about what you do."
SA: "Well, I work with my clients to develop an art program that compliments their business."

Then I'll ask a little exploratory question, such as:
SA: "Over the years I have had a number of clients in the hospitality industry. Tell me a little bit about your new property and the market you see it serving?"

Or if it's a law firm I might say:
SA: "Tell me a little bit about the firm. I know you do commercial real estate because a number of my clients use the firm. What are some of the other aspects of the practice?"

If it is a larger corporation, where I suspect there may be business objectives that the art program could help solve beyond the most obvious one of decor, I'll have a longer rudder remark to pique the prospect's interest:
SA: "Well, I work with my clients to develop an art concept that complements their business goals. That might be as simple as finding art that expresses the particular image the company wants to project, or as complex as using the art program as a vehicle to improve employee morale or solve a marketing need. Tell me a little bit about the new building. Who's going to be working there and what different kinds of people will be visiting?"

SEATING ARRANGEMENTS

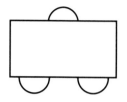

Desk
Seat of unequal power

Couch
Most awkward

Conference Table
Most equitable: equal power, best location

After the prospect starts talking about his company a little, you can lead him through an expanded discussion about his business and the plans for the site where the art will be located.

EXPLORING THE PROSPECT'S NEEDS

During this phase, the consultant asks the client general questions about the company's business and specific questions about the site and the art program. Questioning is the most important part of a sales meeting, but it is often misunderstood or neglected.

> *At first, when I started doing lengthy exploratory questioning, I worried that I wouldn't have enough time to cover my service adequately. But I found businessmen love to talk about their business, and sometimes I'd land the job before getting to my presentation. It's an error to think you have to work harder and talk more to be successful.*

WHY QUESTIONS?

Questions give you critical information, help verify assumptions, and clarify understandings. They involve the prospect, reveal his interests, special agendas, and personality style. They help to qualify the prospect as the correct decision-maker and, most importantly, they let you demonstrate your interest in the client's business.

A BASIC PRINCIPLE OF ART CONSULTING
People make decisions not so much because they understand your service or your art, but because they believe you understand them.

The prospect may perceive only that he needs some pictures for his blank walls. To him, this is not a very important need. By asking the right questions you may discover he has some business objectives that the art program could help solve, such as an employee morale or image problem. You both would have lost out if these much more important needs had not been uncovered. One of the goals of this phase is to discover the critical needs for an art program—the ones of greatest value to the client. In every situation they will be different.

Art is a pretty elusive subject in general and not high on most prospects' agendas. In order to get the prospect to make the art program a priority, the consultant must identify concrete benefits that he can visualize. These benefits are not in art terms but in business terms. It's the feeling the art will elicit, the interactive process it will create in the workplace, the image it will build, the values it will express.

KINDS OF QUESTIONS

You will usually ask a number of different kinds of questions in your conversation with a prospect. Some, often called "closed questions," anticipate a simple answer and may be directive ("Shall we walk through the space?") or just informational ("When is the move planned?" or "What is the art budget you have in mind?"). They are handy when you want to get the prospect's agreement ("Shall we set up a meeting next week to go over the proposal?").

Open questions are exploratory and invite an expansive response, providing the prospect the chance to describe a situation or explain a need. These questions usually start out with a "Tell me" or "Why does."

- Tell me a little about your business.
- What different kinds of people will be visiting the new headquarters?
- What special values do you want your new offices to express to visitors—to employees?

- What image do you want to project when people visit you?
- Is attracting quality employees difficult in this location?
- What plans have you made for the decor?
- Do you have any special concerns about the move? Will many older employees be asked to learn to use new communications equipment?

Questions can also be useful in confirming your understanding of what the prospect has already said. They often begin with phrases like, "Let me see if I understand you—is what you're saying…" Or you make a recap statement in your own words and follow it with something like, "Does that sound right?"

These questions are useful to clarify points that may need refining before you arrive at an art program concept. This process is discussed later on in the clarifying phase.

Usually in any exploratory discussion the questions will alternate between the three types, but the majority should be open-ended, those that encourage the prospect to talk.

A GIVE-AND-TAKE PROCESS

Any top executive knows that the person in control of the meeting is the one asking the questions, not answering them, so you want him to feel the conversation is an exchange. Intersperse questions with information, comments, and, when appropriate, anecdotes about other projects you've done. If this is done very sparsely—a comment here, a similar experience there—the prospect will get the impression you've had lots of experience. Seasoned consultants rarely have to make elaborate, lengthy presentations; they take their experience for granted and it just seeps out in the course of the conversation.

THE FIRST DEADLY SIN OF ART CONSULTING: INTIMIDATING THE CLIENT

With a few notable exceptions, my clients have little knowledge of art, its language, or the complicated process involved in putting together an art program. Even though, in the nineties, many more people have visited museums, purchased some art for their homes, and exhibited curiosity about art, they still are no more educated than the clients of the sixties and seventies. In fact, since art today has become socially chic, a status symbol in certain circles, some executives seem to be even more insecure about their taste in art.

TALKING ABOUT ART

Everyone has personal taste. If you showed ten paintings to a crowd of people, they could all tell you which ones they liked or thought were appropriate to their offices, but in the absence of a visual to respond to, people are usually inarticulate, and unlikely to know about the names of styles, techniques, or particular artists. It is therefore highly detrimental to the consulting process to ask direct questions of your prospect, such as, "What kind of art did you have in mind?" or "Do you like abstract or representational art?" By making direct inquiries about art, you put the prospect on the spot. Depending on his self-esteem, he may feel intimidated and clam up on you completely; at the very least, you can usually see a discouraging shift in his body language.

If a client is knowledgeable about art or has a clear idea of what he wants or doesn't want, he will usually offer this information to you early on. You can then proceed by responding at the same level, and verify it later on during the phase of qualifying the client's taste. (See Chapter 11.)

For example: A lawyer and art enthusiast who was a member of an art committee at his firm told me in the first visit that although they wanted to use contemporary art from the Bay Area, he was tired of seeing all the same abstract art in every law firm in San Francisco. They wanted art that communicated a personal image, and art that was friendly and inviting to clients—but it couldn't be so far out that it would offend their older, more conservative clients. I then explored what they perceived the image of their firm to be. When we actually started looking at visuals, the lawyer picked out brightly colored abstracts. Sometimes clients say one thing and mean another.

In almost all cases it is possible to have a successful exploratory conversation without ever using art jargon. I go with the assumption that I am going to talk to the client about art in business terms or in everyday language. This is one way to gain the confidence of your prospect and let him know you are going to be fun and easy (unintimidating) to work with. If he wants to converse in "artspeak," I'll cautiously pepper my comments with an equal amount. Sometimes executives will throw a few words of art jargon around and I'll later discover those are the only art terms they know—and they aren't even really sure what they mean.

> *Have you ever taken your car in to be repaired and had the mechanic look at you in annoyance because you are fumbling around trying to discover the gurgling of your engine instead of saying the _____ is _____? As you leave, you think irritably to yourself, why does he expect me to be knowledgeable about fixing a car? He's supposed to be the expert, not me. As consultants, we're asking our clients to do our job for us when we ask them to describe the kind of art they want. After the consultant and the prospect agree on a general concept for the art program—the values it will express, the environment it will create, the business goals it will help achieve, the decor needs it will solve—the consultant can then qualify the client's taste and opinions about what's appropriate by looking at some visuals together.*

Architects and designers proceed along this same course of exploration, because clients also lack the vocabulary to talk about whether they want neoclassical, art deco, or Santa Fe style. Through the process of listening to the client, some idea of the kind of style that complements the client's business begins to emerge. Later, visuals are used to clarify these ideas and a design brief is developed. Since art consultants usually come into a project after the designers are chosen, you can ask what the design brief or decor objectives of the project are. But keep in mind that an art program can go far beyond just complementing the decor goals.

VERIFYING THAT THE PROSPECT IS "REAL"

Whether the person you are meeting with is the real prospect or not, the exploratory part of the meeting is useful in getting information about the company and its needs. At some point in the discussion, however, it's crucial to check that the prospect is in fact a potential client.

Too often consultants assume they are meeting with a real prospect and not only waste their time in the meeting but even waste months putting together a presentation, only to find they were not dealing with the real decision-maker.

> In order for a prospect to qualify as a "real prospect" he must have the following: need, money, authority.

NEED

Is there already an established and acknowledged need for your service? Are there other needs you recognize the prospect may have? If so, how can you convince him to recognize the needs and to act on them?

When I first started consulting in the early seventies, most companies had to be convinced that art would be a valuable addition to the workplace and to their image. They had no recognized need. Today, companies recognize a decor need, but consultants who want to do more challenging projects must come armed with stories of what other companies have achieved by using art for more than just basic decor. Decor is not top priority for most executives; image frequently is.

MONEY

Does your prospect have a working budget or is he willing to create one? Is he willing to pay you to survey his art needs and help him create a working budget? Some prospects are very unrealistic about what an art program costs. Before you waste a lot of time, it's wise to get some initial commitment to how much the program will cost. Some art consultants shy away from talking about money, but this is an essential litmus test for whether a prospect is real, or at the very least for finding out what his sense of reality is.

For example: If a client has $50,000 in mind for a top quality art program for five floors of his new headquarters, you'll have to find out quickly what is more important to him, quality or cost.

If you're reluctant to talk about money too early and the client doesn't have an established budget, one approach is to use industry ranges. Art budgets for new construction are usually one to four percent of the construction budget. (This standard is usually for public art, the lobby of a building, and the plaza or grounds surrounding it.) Art budgets for interior spaces usually run seven to fifteen percent of the decor budget. Art budgets for remodels can be tricky to estimate because frequently, when a company buys art for the newly remodeled part, they will upgrade the art throughout the rest of the offices to unify the overall aesthetic of the space. There can also be hidden costs in the reframing of the client's existing art and reinstalling it with the new purchases.

Finding out how much money a prospect is willing to commit to is an essential step in selling your services. If the prospect has a liberal budget, there is plenty of room to present features such as individual employee art selection or a public relations component. But if the budget is bare bones, the focus of the presentation of features and benefits would be quite different.

AUTHORITY

Does this person have the authority to make a buying decision? If not, who does? A key question to ask is:

"Who in addition to yourself is going to be involved in the decision-making process for the art program?"

(See Chapter 3, page 41, for a more detailed discussion of who in a corporation has the authority to make buying decisions.)

Get this information as early as possible because once you make a full presentation to a person who is not the key decision-maker, it is difficult to go over his head to the appropriate person. Most good managers will not see someone their employees have already met with unless they are convinced by those people to meet with you. Therefore, you have lost control of the situation, and now a staff person has to sell you to his boss.

Beware of the Maybe or No Syndrome. Most managers only have the authority to say no or maybe. And sadly some of the people in these positions will keep putting a consultant through the paces making presentations (especially if the consultant does not charge for this) and then, in the end, lack the authority to say yes.

If it turns out there are other people who are going to influence the decision (such as the wife of the president, the V.P. of marketing, an executive who's an art collector, or anyone else who has power over the buying decision), it is critical that you make your presentation to them. As soon as I learn there are such others, I switch gears. Instead of presenting my services, I try to convince the person I am talking with that all the key players should be involved initially to set the course of the program. You can cite the following compelling reasons:

Art Expresses More Than Decor—it communicates the successful image of a company, the values it wishes to express to employees and visitors.

Art Programs Can Achieve Business Goals—such as employee morale and public or community relations. In these situations, an art program may have an impact on three or four departments in a company and therefore the initial mission statement of the project should be set by top management.

Art Is Very Personal—while the image of a company may be clearly understood by everyone in the company, opinions about what kind of art best expresses those qualities can be divergent. It is best to qualify all the decision-makers' opinions early on.

Time & Money—much staff time and company money has been wasted by corporate executives coming too late into the decision-making process.

Basically, instead of selling him or her on your services, you are selling this nonprospect on the importance of putting together a meeting of the top decision-makers.

OTHER FACTORS

Apart from the three essential elements to qualify a "real prospect"—need, money, and authority—there are a few other items that are important to nail down. For example: When can you expect to start working on the project? New construction art consulting jobs can have a two-year lead time, and it can take three to six months to close a contract for an art consulting job based on the interior design schedule. Reasonable questions to ask:

- When do you see us getting started?
- Are there any special deadlines that might influence the project, such as an office party for clients, a grand opening of the building, etc.?
- When's the move-in date?

Sometimes hidden factors that will have an impact on the project can only be uncovered with persistence and the hunch that they may exist. These factors can range from the president having a friend who's a gallery director to the chairman's wife wanting to be involved. It may be that a decision is pending to give the branches more autonomy in selecting a decor that matches their individual community rather than a cohesive image selected by headquarters.

There is another factor, too—that of your own assessment of the project. Are you convinced that your offering is the best solution and of greater value than your competitors? Is this really the right kind of project for you or should you give a good referral and just take a ten percent finder's fee? There's no use wasting a lot of time going after a job that's not really right for you and then losing it in the end to a better-suited competitor.

CLARIFYING NEEDS

The final phase of questioning is to clarify the needs of the prospect. This is an important and often overlooked step. The purpose of clarifying is to:

- make sure you understand what the prospect has told you,
- let the prospect know you heard and understood him,
- ask for refinement or clarification of certain points,
- present problem statements to see if you uncover additional needs the client may not have considered or to highlight already established needs.

The primary way to clarify needs is to ask questions summarizing your understanding: "Let me see if I understand you. The image you want to convey to the public is that you are a caring company, that you stand for the highest quality in product and service. And, if possible, you'd like somehow to have the art reflect the company's involvement in Western as well as Japanese-made gardening tools. Does this sound right? Is there anything you would add?"

At this point, I'm thinking I'd like to find out what their feelings are about buying art made in Japan. Some companies have strong feelings about either buying art in the countries with which they do business or buying art in their geographic region. I know there are a number of ways of reflecting this East-West dichotomy. One would be to buy works by American artists whose work has an affinity with Japanese art. So then I break this issue down into bite-sized questions. "How do you feel about actually buying some of the art in Japan?" This second mode of questioning helps to hone the art concept so that when you actually present it, all the key elements have already been accepted by the prospect.

In summary, in this last phase you echo the information the prospect has given you to let him know that you know what he knows. You also dig for any additional helpful information and check any ideas you may be developing to see if you're on track.

DEVELOPING AN ART PROGRAM CONCEPT

Before presenting your services, you want to get the prospect's acceptance of a concept for the art program, a mission statement of what the purpose of the art program will be. The concept takes the business needs the client has described to you and translates them into a complementary group of goals for the art program.

SAMPLE MISSION STATEMENT

The purpose of the art program will be to convey the image that the bank is successful and forward-looking in its financial practices. Contemporary works of the highest quality will be selected to complement the neoclassical decor. Employees will be encouraged to participate in the selection of art for their area.

The goals should be as specific to the prospect as possible and should speak to the needs you've identified as being the most important to the client. Key to selling the concept is your ability to be on-target with a solution that matches the client's needs, and to discuss the concept in nonthreatening, jargon-free language.

"I once sold a client on why a newly developing collection of sculpture should contain work by artists of international reputation as well as those who were less well known. I pointed out to him that what he was doing at his company was analogous to creating an expansion baseball club. To build his team he would require a certain number of 'superstars' to give the club credibility and strength, a larger number of solid, midcareer players to add depth, and some good rookies that showed great promise and were available for modest cost. It worked."
—Thomas Garver, consultant for Rayovac Corporation

Presenting the art program concept is the culmination of the exploratory questioning process. After you propose your solutions to the needs and problems you have delineated together, your prospect should be at least ninety percent sold.

I have had clients, in the first meeting, ready to go right to the proposal stage, after accepting the art program concept. They didn't feel they had to know any more about my services to make the decision that I was the right consultant for them. If you've had a good referral, built great rapport during the meeting, and come up with solid solutions to the company's needs, that is often sufficient to sell the prospect on your services.

PRESENTING YOUR SERVICES

All sales presentations follow essentially the same form, whether it is to one person in a first meeting or to an entire art committee. The goal is to sell the prospect(s) on the fact that you are the best possible person to implement the company's program.

Some firms have been known to invite several consultants in to make a presentation to their art committee. Always request a preliminary private meeting with one or two members of the committee, so that you are making an informed presentation addressing the needs of the company. Even by making this request, you will stand out from the competition.

How do you decide what to present? Ask yourself what benefits your prospect still needs to hear described in order for him to be ready to take the next needed action.

MATERIAL TO HAVE AT HAND

Although you may present only a tenth of your offering, having all the essential information mapped out will give you the kind of confidence achieved only by thorough preparation. This basic information will be used over and over for presentations as well as proposals, brochures, and PR articles, so compiling it is well worth the effort. (For a more detailed discussion of presentation materials, see page 76 of this chapter and Chapter 18.)

■ Services You Offer—Their Benefits

■ Specialities—Unique Aspects of Your Offering

■ How You Work (Discounts, Terms, Billing Procedures)

■ How the Competition Works—Major Differences

■ Common Client Objections and Responses

Below: basic information you will need to compile for your presentations.

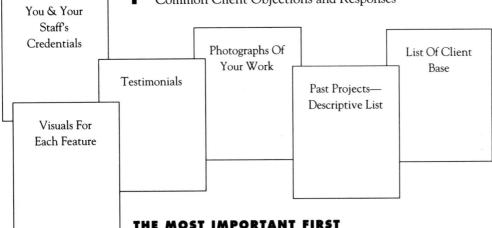

THE MOST IMPORTANT FIRST

Before presenting, focus your presentation by setting goals for yourself.

Since you've done a good job of questioning, you have a clear idea of the prospect's definite needs and concerns. Sift through these needs and concerns and prioritize them according to what is most important to the prospect. Now you have the agenda for your presentation in the order of importance to the prospect.

By starting out with the most compelling facets to the prospect first, you're assured of grabbing his attention. Many prospects will be ready to go to the proposal stage if you have answered their primary concerns.

Every consulting job is driven by some overriding factor or combination of factors—price, quality, experience of consultant, convenience, speed, resources, etc. If the overriding factor is cost, speak first about the ways you can deliver the most reasonable prices possible. If it's experience, then speak first about your credentials and reputation. Sometimes a concern may have already been addressed during the exploratory phase. If so, then present it only slightly and go on to the next point.

Since the presentation comes at the end of the meeting, if the main needs are spoken to first, you don't run the risk of running out of time before you've had a chance to persuade the prospect to take the next positive step. Frequently a brochure that you leave behind or send later will take care of all the less important aspects of your offering. But the critical information that may affect the client's decision is always best delivered in person.

Note: Many executives have no knowledge of the art consulting field and the choices available to them. You may want to start your presentation off with a brief overview of the field. Describe how different types of consultants work, then how you work, pointing out the relative strengths of your service, always relating it to the prospect's needs. It's never a good idea to speak negatively about the competition, but the prospect can usually draw the right conclusions if you describe the positive benefits of your way.

For example, I might say:

"As my fee, I take twenty percent of the estimated budget for art and framing, and I pass on to you any professional discounts I receive. I've found this to be the most equitable way of working. This way, when I recommend something to you, you know I have no vested interest in whether you buy it, except of course my interest in getting the best works for you." If a consultant's fees are tied to a commission on the actual works purchased, there is an inherent conflict of interest.

GETTING THE PROSPECT TO VISUALIZE

Unless a prospect can visualize himself receiving the benefits of an art program and of your services, it is highly unlikely that he will buy from you. We help people visualize by telling them stories, by walking them through a situation in their imaginations. For instance, you might suggest what it's going to be like for an employee to be able to select his or her own art, and how that employee will feel receiving the president's letter announcing this feature of the art program. In this case, you might show the prospect a particularly winning letter written by the president of another company about an art program and a photograph of you meeting with an employee.

FEATURES VERSUS BENEFITS

Features are often confused with benefits. A feature is some aspect of your service, and a benefit is what your client gets out of it, the answer to the often unexpressed question, "What's in it for me?"

For instance, there is nothing particularly exciting about saying that you can facilitate employee selection of art for their work areas—a feature. But when this feature is described in terms of benefits to the client, it becomes compelling. For example, employee selection:

- demonstrates the company's respect for the individuality of each person;

- gives the staff a say in their surroundings;
- achieves a goal very difficult to achieve with other aspects of decor;
- builds goodwill as opposed to the negative attitudes that can arise when employees do not have a say; and
- becomes something the employees perceive as a fun fringe benefit, when in reality it is an expense the company would incur anyway.

So much of art consulting is foreign to executives that I just assume they are not going to be able to draw the connection between a feature and its specific benefit to them. Making this leap is a skill that many art consultants haven't mastered. Given that most executives have never been responsible for an art program before, why should they know anything about its multi-level benefits?

HYPE NEVER HELPS

The president of a large development company in Los Angeles mentioned over lunch one day that he would never have believed me—let alone hired me—if I had told him the rotating outdoor sculpture park we were proposing for his new property was going to fill up his new building with tenants. Although the overall business goal was to do just that, the purpose of our project was to give the building a cultural identity, to set it apart from other office complexes in the area. The client wanted upscale professionals as tenants. The sculpture program offered a noncommercial opportunity to contact prospective tenants, who were sent fancy invitations to each opening, which also included brief marketing statements on the property. The PR campaign focused on the exhibits but also helped to promote the complex as a special location. There was no way I could guarantee full occupancy; too many contributing factors were out of my control. But I was certain the program would create a prestigious image for the property and provide the necessary marketing opportunities to reach their audience, so this was what I promised, and nothing more.

Businessmen tend to be skeptical about art programs and what they can do for them. I think they also consider that art consultants want to turn their offices into museums. For this reason, when I project results, I come armed with concrete examples of similar successes, and I am careful not to overstate the possible results. When consultants exaggerate the results they can achieve, they run the risk of losing credibility even for the benefits they can in fact deliver.

MEETING OBJECTIONS

A prospect raising objections is very likely a prospect actively engaged in the buying process. He is challenging you to sell him. Sales motivation research has shown that prospects who raise objections are twenty percent more likely to make buying decisions. Think how many times you have made a purchase after raising a few objections and had the salesperson satisfy your concerns. Sometimes objections raised at the end are a way of asking to be convinced that the decision to buy is the right one. Other times, the prospect may not be raising an objection but asking for either more information or clarification of a point.

"Problems are only opportunities in work clothes." —Henry J. Kaiser

Objections can occur anytime throughout a sales presentation. Usually, if you use the opportunity to demonstrate serious concern for your prospect's query and deal with it effectively by being well prepared, you will be in a significantly stronger position than before. Here are a few steps to follow in responding to objections:

Step 1 Learn to recognize the difference between a real objection and a bogus one. Bogus objections can be excuses to put off having to talk with you or a need for more information on a particular point. If the objection seems vague and insubstantial, ask a question to help make it more concrete.

Prospect: "I need a little time to think about your proposal."
Consultant: "May I ask what are some of your concerns?"

Step 2 Clarify your understanding of the objection by restating it in a question that shows you have been listening carefully and that you understand the prospect's point of view.
Prospect: "I've got to make sure our workstations are in, and then I'll be in our Tokyo office most of the month before the move. I don't have time to think about the art now."
Consultant: "It sounds like the move is putting a lot of demands on your time and you feel you can't really give the art program your attention now, is that right?"

Notice the answer is not judgmental or argumentative or solution oriented. Its purpose is to let the prospect know you've heard him and you empathize. This also gives the prospect a chance to expand on his statement, to clarify it in case you haven't heard him correctly, and it buys some time while you gather your wits. It also serves to get the prospect off the defensive. When someone raises an objection, he instinctively braces himself for a rebuttal. It makes it difficult for him then to hear any logical reasoning. By slowing down and being reflective, you put him at ease. He doesn't feel he is going to have to deal with a consultant disagreeing with him or trying to talk him into something he doesn't want.

Step 3 Turn the objection into a question. Once you are sure of the real objection, turn it into a problem statement.
Consultant: "So the issue is really how we can either minimize your involvement in the art program or delay it completely until after you move in?"

Step 4 Offer a solution to the problem. Tell the client how someone else solved this problem and help him visualize himself doing so too. Or you can offer him a choice of solutions.

It is also sometimes useful to ask questions that will lead him to see the consequences of delay or inaction. For instance, the need for art in the new building will not simply go away, and by not planning for it now, he'll be staring at blank walls for months after the building is open.

Consultant: "Are you planning any special office party or visits by important customers before then? The reason I ask is no matter how beautiful the decor will be, the place will look unfinished, rather makeshift, until at least some art is up."

Having a Winning Attitude: A winning attitude is definitely needed in dealing with all phases of the sales presentation, but particularly with objections. Too often consultants respond defensively to objections or panic that they are going to lose the sale. They may even slip into a nervous, aggressive attitude, when in fact just the opposite stance is needed.

> *I anchor myself in an easygoing mental state and my body language naturally changes into a more reflective pose. Even though I may think I know exactly what the prospect should do, and I give him examples of what other companies have done, I never assume that this is the right answer for him. I do assume, however, that between the two of us—with my experience and his knowledge of his company—we'll figure out what's best.*

When you shift from a presentation mode to a problem-solving mode, it demonstrates that even when you feel the sale is in jeopardy your first priority is doing what's best for your prospect. This goes a long way in building confidence. One almost has to be ready to lose the sale to win it.

In a real sense, you can't have this attitude if any single sale seems so important as to have a monumental effect on your well-being. One way to avoid this tension is to have sufficient prospects so that any one loss is not significant. But it also has to do with putting the desire to land the job on the back burner of your mind.

When you actually enter the presentation, your priority should be helping the prospect solve his problems and convincing him you're the best one to do it.

CLOSING—MUCH ADO ABOUT NOTHING

In traditional high-pressure selling, there is much ado about closings. Usually the salesperson is so busy trying to talk the prospect into making a buying decision that he has no idea where the real needs of his prospect are and whether he is close to solving them with his offering. It becomes a crap shoot, the possibility for rejection is at least fifty percent. No wonder so much has been written about the awesome "close." In consultive selling, asking for the job or the next positive action is the natural outcome of all the preceding steps. It is the only logical next step, whether it is making a date to review a written proposal you are going to prepare or having the prospect take a thoughtful walk with you through the space. If it's a small project, it may just mean getting his signature on a form contract for you to proceed with the survey and art selection.

Let's review all the steps that have led up to this point:

- All the key decision-makers and others who may have a strong influence on the project are involved in the process. Each person understands how he or she will benefit from your proposal.

- The prospect has acknowledged having definite needs and has accepted your art program concept.

- A working budget or a way to establish one has been agreed upon.

- You have decided in your own mind that you are the right person for this job and that the terms (budget, time frame) are acceptable.

- You have presented the features of your service in terms of benefits to your prospect.

- You have answered his questions and handled any objections.
- Throughout the selling process, you have demonstrated your concern for the prospect's needs, established trust, and developed his confidence in you.
- You have gained his agreement throughout the process on all key points.

CONSULTING IS A DANCE AND YOU'RE THE LEADER

Never in twenty years of consulting have I had a prospect ask me to take the job. Most people have to be lead into making a buying decision. It's part of the unspoken ritual of selling. Business people know consultants want their business, and they expect you to ask for it; otherwise, the prospect may even wonder whether you have confidence in what you are offering.

Since you have painstakingly developed a program that focuses on your prospect's best interest, and since you know that you can deliver a quality program, you should not hesitate to take an unabashed leadership role in closing the sale. In a sense, you are doing the prospect a great favor by doing whatever is necessary to get his business—he just may not know it yet.

TIMING THE CLOSING

Watch and listen to your prospect. People usually give some kind of verbal or nonverbal signals when they are ready to take the next step. Some positive signs might be the prospect saying,

"When could you make a survey?" or "Can I see some samples of your work?" or "Let me see if I can get Bob Jones, our facilities manager, up here" or "How do you charge for your services?"

There are other nonverbal or less overt signals. Perhaps the prospect takes you for a walk through the space where he shares his ideas with you, or he has a more relaxed personal demeanor, or he asks very specific questions about a special area of interest.

If you are paying attention to the prospect and not distracted by thinking about what to say next, you will instinctively know when the right moment comes to bring the meeting to a close. If necessary, summarize the three or four key benefits he's agreed to and casually and confidently ask for the next logical action.

DIFFERENT CLOSING TECHNIQUES

The proper attitude at this stage is that of course the person is going to say yes. A self-confident stance can be just the ingredient to convince him he's made the right decision. "She's so confident, she must be good." Of course, the confidence must be born of true grit, not false bluster.

Assumptive Here you assume the prospect wants to go ahead. You just ask for the next step.

"Shall we do the walk through today?"

"I'll have a proposal by next Tuesday. Shall we set up a short meeting toward the end of the week?"

"If you can just sign this agreement and get me a copy of the floor plan we can get started right away."

"Which building do you want us to start with?"

Choice This is my favorite technique. It's very effective and a little less aggressive than the assumptive close. You give the prospect a choice between two positive actions, both of which confirm his willingness to proceed.

"Do you have time to do a walk through with me today or should we schedule it for later in the week?"

"Would you like to do all of the art on the lease purchase plan or just the pieces for the plaza?"

The Minor Point For the reluctant prospect who exhibits difficulty in making a major decision, you ask him to say yes to some small point while he gets used to the idea of working with you.

"Do we need to use plexiglass on all the art throughout the hospital or just in areas where patients and gurneys will be?"

"Will there be anyone else besides yourself at the presentation?"

"Shall I call the designer, or would you like to first?"

Uncovering a Hidden Objection If you feel everything has gone well and the prospect wants to say yes but is holding back, ask him head on, "It seems that something is troubling you. Is there anything you have doubts about?" or, "Is there anything you want to discuss a bit more?"

PRESENTATION VISUALS

Most executives have no frame of reference for talking about art programs, so much of what you describe will be foreign and hard for them to comprehend. Visuals are therefore critical for a presentation. They not only illustrate what you are about, they also engage the client's sense of sight, making the experience richer and more satisfying.

Try to have a visual for every feature or benefit. For large sculpture commissions, for example, I have a series of visuals demonstrating different phases of the process to lead the client in his imagination through every step ahead. These include:

- a photo of the unimproved site
- a photocopy of the artist's first sketches
- a photocopy of the rendering of the selected piece in the site
- a photo of maquettes
- a generic contract
- a board with sample materials
- fabrication plans stamped with approval by a civil engineer
- a photo of the piece being constructed at the foundry
- a photo of the piece installed
- a reprint of positive PR on the piece
- a testimonial letter from the CEO of the company

If I have a very green prospect who is nervous about or doesn't understand the commission process, I can use these visuals to tell the whole story of a commission from start to finish. By having things like the fabrication plans showing the approval of an engineer, you demonstrate to the client that you will provide professional project management.

Note: It's good to keep visuals out of sight until they are needed. Otherwise, curious prospects will ask to see them and control of the meeting can be lost.

TWO KINDS OF VISUAL PRESENTATIONS

The Fifteen-Minute Presentation. First meetings usually take between twenty-five and forty-five minutes. Given that half the meeting is taken up with exploratory questioning, a consultant needs a fifteen-minute presentation that can be expanded or contracted as necessary. A presentation binder with flexible inserts is ideal for this kind of basic meeting.

Be sure to arrange the materials to suit the type of prospect you are meeting with. Poster-graphic clients have no interest in knowing that you have managed a large scale sculpture project; in fact, it may be detrimental to your getting the job, because they may think you are overqualified and overpriced.

The Half-Hour Slide Presentation. Usually a slide presentation is made on a second visit, perhaps to an expanded group. In addition to showing slides of past projects, features of your service can also be illustrated in slide format.

NOTES FOR GALLERIES

The approach of selling to the needs of the prospect works as well for gallery advisors as for consultants. It is sometimes difficult for galleries to grasp this concept, because they feel their inventories are their strong suits and they want to make them the main focus of their presentation, as they are when they are selling to art collectors. But it is even more critical for you to demonstrate concern for the needs of your client since you have to overcome the fact that you have an inventory, which you would obviously like to sell. A client-centered approach will make you stand out from other competitors.

For a complete discussion of presentation visuals, see Chapter 18.

■ ■ ■

Charging for Your Services

"While the commission is by no means dead, in some sectors the trend toward fees is clear. Certainly it can be said that how you charge today will determine who your clients are tomorrow."

—Mark Frankel, art consultant

There is no standard way to charge for art consulting services. As the field has expanded to include diverse projects, so has the variety of ways consultants charge for them.

In deciding on the best way for you to structure your fees, here are some factors to consider:

- your marketing arena,
- the worth of your time and experience,
- the going market rate in your area,
- the psychology of charging, and
- the ethics of charging.

YOUR MARKETING ARENA

Chapter 2 discusses some of the different segments of the art consulting field and how they are distinct from one another. One of the qualities that tends to differentiate projects today is how fees are billed. Many small businesses, with cost-driven and decor-driven projects, are more inclined to want to work with a consul-tant on a commission basis. These clients perceive themselves as primarily needing a product—art—and are resistant to the concept of paying a consultant a fee for their time. This is particularly true in the small-business sector, where the proprietors are unaccustomed to hiring outside consultants. The image-driven sector, on the other hand, is increasingly moving toward wanting independent art consultants who work for a fee. For the highest level projects, a fee-based structure has become the accepted way of doing business, but in the middle range, a great variety still exists. How consultants choose to charge for their services increasingly effects who their clients are now and who they will be in the future.

Several consultants who have left gallery positions to go independent have commented that when they cross over to charging a fee for their time they are not able to work with the same client base. It can be a difficult transition, but a worthwhile one if you're keen to take on more challenging projects and you feel you have the necessary expertise.

THE WORTH OF YOUR TIME AND KNOWLEDGE

One of the most difficult tasks when starting out or changing from a commission-based structure is to determine what you are worth in the marketplace. One useful formula is to take an annual salary for comparable work and use that to calculate your hourly rate. Incomes can vary in different regions, but, for example, a successful gallery consultant can usually earn at least $35,000 the first few years and then up to $90,000 or more as he or she gains experience. Calculating from this $35,000 estimate (fifty-two weeks, five days a week, eight hours a day) you can reach an hourly rate, which you then must triple. Remember that your rate must be considerably higher when you are in business for yourself because of your overhead, so this figure is the lowest you should charge.

Another way to determine your proper fee is to research the projects that are the size you wish to do and find out, first, what the interior designers earn and, second, what the lawyers of the client corporations earn.

Your fee per hour should be, at the very least, as high as the designers but rarely higher than a corporate counsel's. The reason for this is that corporate clients place more value on their lawyer's advice than on their art consultant's services. In California, for a midsized company, these ranges are $65–$250 an hour, and the majority of experienced art consultants working in this sector of the market are billing out in the range of $65–$150 per hour.

Your Comfort Zone. The best rate is the one you feel comfortable asking for while still knowing you can make a living. In the beginning, particularly, it's best to go with a rate that will help you get some experience and build up a client base. If you decide to start low, you can always raise the price for the next prospect.

Another factor to consider is the scale of clients you want to work with. If your fees are too high, small companies may not be able to afford you. Conversely, if your fees are too low, large companies may think you are not sophisticated or experienced enough for them. Probably the best price for you, then, is the highest you feel you are worth without being uncomfortable asking for it.

> *One year I raised my hourly fees and found price resistance with some clients I wanted to work with, and when I lowered it just $30 I had no problem getting the kind of projects I was seeking. Adjusting for inflation, I've kept this rate for some time now, and I charge more only for consulting that requires expertise beyond art consulting.*

Client Perceptions. Some clients will value the job completed at a certain amount, let's say $20,000 or twenty percent of the art budget, but they will resist an hourly rate, particularly if it is higher than they themselves receive per hour for doing their job. In these instances, don't quote an hourly fee, just a flat rate or value rate. Tell them what the total is and that different tasks are billed at different rates.

Other clients perceive the hourly fee as your pure profit. They don't realize all the work you are doing for them. Here you should have a very detailed proposal outlining all the steps, and break out professional fees for special parts of the project, such as employee selection or commission supervision, so they can see where the dollars are going.

Still other clients, particularly those in small businesses who are decor-oriented, think exclusively in terms of product and understand only direct expenses. They resent paying a professional fee for intangibles. With these, it's best either to work on a commission basis or not to work with them at all.

ETHICS

There are many ethical issues that affect charging for your services. Conflicts of interest may arise in the process of working out an equitable fee. I believe strongly that if you are being paid a fee as an independent consultant, you should act exclusively as an agent for your client, without commissions or fees from any other sources. Regardless of your arrangement, however, the issue of overriding importance is that there be *full disclosure to your client,* who has a right to know so that he or she may make an informed decision about your services. Whenever there is a secret kept from the client, there is an ethical issue involved. The main reason consultants fall into this trap is that they haven't worked out a way of charging that works financially for them and that also is the appropriate method for the segment of the market in which they are working. Others simply are naive about what constitutes professional ethical relationships. I urge you to read Chapter 16 before deciding how to charge for your services.

SELECTING THE RIGHT FEE STRUCTURE

Note: If you are working on a commission basis, you may want to refer to the section for galleries at the end of this chapter. Below are the most common ways fee-based consultants charge for their services.

A FEE BASED ON TIME

This can be either the actual time you spend on a project, computed on an hourly, weekly, or monthly rate, or the time you estimate the project will take. I prefer to do a combination of both, to give my client the best advantage. I submit a proposal which estimates my time and guarantees that I will not exceed the estimated time, but I only bill for actual time spent (up to, of course, the guarantee). In this way, if the client is motivated to work more efficiently, or if I am able to finish early, the client benefits. There is also a clause about events beyond my control and additional work the client initiates so I am protected.

Special Time Rates. If a consultant is asked to do a short job, sometimes it is appropriate to give the client a special discounted rate. I have a half-day rate and a whole-day rate. The whole-day rate is eight hours for a six-hour fee. The half-day rate is four hours or less for a three-hour fee. The only time I quote these is if the client wants me to do all the work at a stretch, such as spending the day at their office rotating art. The reasoning behind a consultant's giving this kind of special rate is that it is an efficient use of their time. To actually do eight individual hours of consulting takes about sixteen or twenty hours, considering preparation, traveling, etc. But when you deliver it all at once, there is room for both you and the client to profit.

A FEE BASED ON A PERCENTAGE OF THE BUDGET

This can be based on either the projected cost or the money actually spent. Less conflict of interest occurs when you base your fee on the projected budget rather than on the actual money spent. In the event you are able to save the client money on the art and framing, there is no temptation to encourage the client to buy more expensive art so that your percentage is higher. There is nothing worse than being in a presentation trying to convince a client to buy a particular work and having him doubt your integrity—wondering whether you stand to make more if he buys the work you are recommending. This is the bane of the commissioned consultant's existence. So always try to disassociate your

fees from the actual money spent. The client will appreciate your integrity. Furthermore, you deserve to be paid based on the scope of the project and size of budget you are administrating, not penalized for saving the client money on portions of the budget.

Percentages usually decrease as the art budget goes up. The average percentage for midsized projects is twenty percent. On a very small project, where a lot of searching may go into finding just a few works, the percentage may go up to twenty-five or thirty percent. On high-budget projects, the percentage goes down.

Art and Frame Budget	Percentage Taken for Professional Fees
$10,000–$100,000	15–20%
$100,000–$500,000	10–15%
$500,000–$1,000,000	5–10% or flat fee

There is no hard and fast rule about these percentages. They should be based on what you think is fair for the amount of work involved. Even if I am working on a flat-fee basis I make up an actual time estimate for my own information. Sourcing one sculpture costing $1,000,000 is not much more work than finding one for considerably less, but if you are putting together a whole collection of art for that amount, then twenty percent may be more fair.

A RETAINER

In this arrangement a set fee is paid to the consultant (usually monthly) in return for services to be provided. This works particularly well for ongoing art program management. Because the consultant benefits by having a regular stable income, usually he or she gives the client a discounted rate, such as a whole-day rate.

Most common are retainers that put you on staff at the company for a specified time each month to perform specific tasks. In other arrangements, a company will just want to have access to you when they need you. In this case, they have a specified maximum number of hours per month to call on you. If they don't use up all the time, it usually doesn't accrue to the next month. To avoid any misunderstandings, it is a good idea to describe in the agreement the exact scope of the retainer (work to be performed and number of hours it covers) and include a rate of pay for any additional work that is done over and above the retainer. Also include a process for expediting additional work, such as having tasks up to $500 approved by phone, tasks over $500 approved in writing, etc.

FLAT-FEE CONTRACT

This is similar to a retainer but is usually used when you are going to be managing a substantial program for a company on an ongoing basis, such as an annual rotating exhibition program. Both your fees and the direct expenses of the program are estimated and then regular periodic (usually monthly) payments are made. For example, for an $80,000 program, there would be twelve monthly payments of $6,666 ($80,000 ÷ 12). Usually the first payment is in advance to help cover start-up expenses.

VALUE RATING

This is a relatively new concept in fee structuring that a lot of lawyers are adopting and which works very well for certain kinds of art consulting. In value rating, different services you perform have a different fee attached to them according to the amount of expertise the task involves. For example, if you charge $75 per

hour and work by yourself, you may not want to charge your client $75 per hour for typing up documentation sheets or sending out letters to galleries. For these tasks you may place a value of $20 per hour and bill them out as direct expenses. One way to figure out value rating is to find out what the going rate is to hire someone to perform the task and then charge the client that amount or slightly (ten to fifteen percent) more since you are either hiring and supervising another person or doing it yourself when you might be doing something else at your professional rate.

AN ANNUAL SALARY

Some corporations arrange for the full-time services of an advisor, usually an "in-house" advisor. If you are negotiating an annual salary with a company, one important thing to consider is your department's status. If you are hired as an employee in a much larger department, such as facilities, then your destiny and the art program's destiny are under the control of others. The optimal situation is to have a separate department created of which you are the head with budget authority. In this way you are responsible for presenting a budget for your department and making decisions when cutbacks are necessary. Otherwise, the art program is often the first thing to be cut out of a larger department's budget. The closer you are to reporting to top management, the more you can stay in touch with shifts in the corporate wind and the more influence you can have over your project's future.

ANY COMBINATION OF THE ABOVE

Sometimes a project will have diverse parts or phases that will be best charged for in different ways and you can combine several of the preceding methods.

For example: On a straightforward art consulting project, you might charge a percentage of the estimated art and frame budget for services having to do with the purchase of new art and an hourly rate for special components of the project, such as employee art selection and dealing with the client's existing art.

For example: You might charge the art acquisition phase on an estimated fee basis, then the ongoing art program management of the collection might be done on a retaining structure, the large-scale sculpture for the plaza might be handled on a flat-fee percentage basis, and if the company then asked you to put together an annual rotating exhibition program for the lobby, you might choose an annual contract.

QUOTING YOUR FEES

You have just finished a great presentation. The client seems ready to go ahead and he asks you the deadly question, "How much will your part of this cost?" or, "We've put aside a separate consultant's budget of $10,000—how does that sound?" There is a compelling urge for most people to want to respond quickly and decisively, as is important in other parts of the presentation. The impulse is to blurt out any off-the-cuff amount, just to appear on top of things and to find out if the prospect will then say yes. Unless it is a small project that you are trying to close in the current meeting, it is good policy to delay your response whenever the subject of money comes up. Have a standard answer like, "I need to review all the things we've discussed today; I'll get back to you tomorrow with a figure," or "I need to review the project as we've shaped it and take another walk through before giving you a price."

When you are in a selling mode, it's very difficult to switch gears and start thinking about price. First, you don't have the time to give the project a thoughtful analysis and, second, your price will probably be quoted to please the prospect, not necessarily to

suit your needs. The other problem with quick prices is that it puts you in a very weak position to negotiate if the figure you quote is high. Without having done sufficient homework you're not armed with the data to either justify the price or reevaluate it and reduce it. If a prospect wants to work with you, he will respect the fact that you want to take the time to figure out the best possible price for him. Off-the-cuff estimates are always a win/lose situation: either the client pays too much or the consultant doesn't get sufficiently compensated.

Although you won't want to quote your fees, sometimes it's necessary to give the prospect a ballpark figure so he knows your fees will be in a range that is acceptable to him.

> *"Usually on this kind of project, professional fees don't exceed twenty-five or thirty percent of the art and frame budget. After I see how many employees I'll be meeting with and have a chance to check the number of works there will be to survey in the collection you already have, I'll be able to give you a more exact figure."*

Note that the range I've given is actually higher than I anticipate coming in on. It's much better psychologically to come in under a stated range than over.

HANDLING EXPENSES

There are three kinds of expenses that occur in art consulting services: professional fees, direct expenses, and reimbursable expenses. We have already discussed professional fees.

DIRECT EXPENSES

Direct expenses include all art-related services needed to complete the project. They might include any or all of the following:

- art purchase, rental, or lease fees
- transportation
- framing
- installation labor
- viewing room rental
- label preparation
- logistical documentation
- insurance
- packing
- civil engineer
- wall labels and security mounts
- photographic services

The most common way to handle these expenses is to pass them on directly to the client for payment. Usually all bills are sent to the client in care of our office so that we can approve them for terms (the client has no idea if the vendor billed correctly), and then we forward them to the client for payment. On certain items, such as installation labor where the crew needs to get paid promptly or secretarial services we actually provide or subcontract, we pay those bills and rebill the client. We ask the client at the beginning of the project whether he wants to advance us a direct expense check to cover these incidentals or have us bill them for the service plus an extra administrative cost.

> *"For the direct expenses, such as transportation, presentation space rental, and framing, we propose a maximum budget of $_____. We will review all invoices for correct terms and discounts. We will then approve and forward all invoices to you for payment. When it is necessary for us to prepay a direct expense invoice, such as that for installation labor, we will bill these expenses to you at their expense to us (cost plus ten percent of the net invoice for administration)."*

The administrative cost is a standard business practice that simply covers the cost of using your money to manage a client's program. The rate should be based on the current prime lending rate. This rate can be determined by calling your bank or looking in the daily newspaper.

REIMBURSABLE EXPENSES

Reimbursable expenses, sometimes called indirect or out-of-pocket costs, are expenses that you incur for items or services that are not directly related to the project but are nevertheless incurred while implementing the program. They include:

- travel expenses, taxis, and car rental
- entertainment
- secretarial
- photocopying
- parking
- long distance telephone calls and faxes
- postage

It's good to have an "expense philosophy" for each category because of the nature of reimbursable expenses. They are not easily passed on directly to the client; usually you pay them out-of-pocket and then rebill the client, plus an administrative fee. Most consultants find after being in business for a while that it is not cost effective to keep track of every little out-of-pocket expense, to write down every phone call or photocopy they make. They just absorb it as part of their overhead. For any expense you wish to have reimbursed, you should have complete documentation, either a log or a receipt.

Here are some of the categories to consider:

Telephone. You may want to bill only for long distance calls. Either keep a log by the phone or note calls on the client time sheet. Many new phone machines have an electronic clock built in that lets you know the length of the call.

Fax Machine Charges. If you have your own machine, you may want to just bill for nonlocal transmissions; if you do not have a fax machine, bill for all faxes, since staff time is involved in taking the document to a service center.

Postage and Messengers. For a project that is going to need a lot of postage, we buy stamps, keep them separate, and bill the client. On small projects we absorb the expense. All messenger services are billed.

Photocopying. Anything over ten copies we bill out at our cost, six cents per copy.

Travel. Travel expenses include hotel, airfare, taxi, car rental, and other incidental expenses incurred while traveling. Usually a consultant gets approval in advance on all out-of-state trips. Most bill airfare at coach class, even if they travel first class.

Entertainment. For food expenses during traveling, you might consider putting a cap on each meal and on daily totals, such as $25 per meal or a total of $50 per day. If you decide to go out for an extra-fancy dinner, bill just a portion of it back to the client. Other necessary entertainment expenses, such as business lunches or dinners, are noted with the persons' names and the purpose of the meeting.

Prorated Expenses. Periodically a consultant will take an art buying trip on behalf of several clients. All the expenses can be tallied up at the end of the trip and a percentage charged to each client in relation to the amount of effort expended on his behalf.

SUBCONTRACTING—HIRING OTHERS

There are many circumstances in art consulting where it may be necessary to hire others to perform tasks for you or your client. These situations can be divided into two distinct categories.

WHEN THE CLIENT KNOWS

In art consulting, there are certain direct expense categories in which the art consultant may function as a contractor who hires others—installation labor or clerical help, for example. For the consultant's trouble of locating, training, and usually paying these people, there is an acceptable markup of between fifteen and twenty percent. Usually your proposal will just state a total figure for the category and when you submit bills they will be for the marked up amount rather than the money you paid out in advance. When you budget, you must remember to figure these amounts at the billable rate, not at your cost. In some cases, there is a big gap between the amount art world people are used to receiving for a task and the comparable amount that corporations are used to paying for similar services. In this situation, doing a little bit of research on the going corporate rate may be to your advantage.

For example: When we were providing several corporations rotating exhibition programs, we found they preferred us to use our art handlers and installers whenever possible because their building engineers are paid a minimum of $42 per hour. Our staff and subcontracted labor was billed out at $30 per hour, although we were paying them at industry museum standards of $18 per hour. The client felt they were getting a good deal and our profit margin, forty percent, was very good as well. Given that so much special training and supervision was necessary to teach art handlers how to work in a corporate space rather than a cloistered museum environment, I felt the markup was fair.

WHEN THE CLIENT DOES NOT KNOW

A project budget encompasses a myriad of tasks. Some you may not wish to perform personally. An art consultant is contracting to be responsible for the overall quality, integrity, and fiscal responsibility of the project, not to lick every stamp and label every piece of art. Even scouting for art can be delegated. If you hire someone to perform a professional task, such as scouting for art, what you pay them is your business. The only thing that matters is that you deliver the project at the level and price promised. Neither your proposal nor the bill you submit would make any mention of this expense. This is one way successful consultants can leverage their time and profit not only from their personal work but also from the work of others they supervise. Note that there are important accounting, tax, and insurance issues involved in subcontracting. Be sure to check with your accountant and insurance agent about liabilities and record keeping.

Staff Time. Handle staff time the same way as subcontractors. Either value rate the work they do and bill the appropriate amount for the task or absorb their salary into overhead. A good rule of thumb for billing out staff time is to double their hourly rate to cover the administrative overhead that you absorb.

TRADE DISCOUNTS

Part of structuring how you work is developing a discount policy. Consultants who charge for their time usually pass on all their professional discounts to their clients. This is a powerful selling tool. For an average art acquisition project, if the consultant is working with a volume framer who gives a forty percent discount and working with galleries, artists, and publishers who give discounts of ten to twenty-five percent, the client usually winds up paying about the equivalent of what the art and framing would cost retail and still has the services and expertise of a professional. This is a compelling sales point for the independent consultant working on a fee basis. Discount policy, like other terms, should be discussed with the client and then summarized in the proposal. There are several important ethical issues concerning discounts that should be considered before developing a discount policy. See Chapter 16.

SALES TAX

In some states the Franchise Tax Board requires art consultants to charge tax on their fees. See Chapter 17.

TERMS AND BILLING

Apart from having a charging structure, you also need to have a method of getting paid for different kinds of projects. The schedule may vary. One thing, however, that should remain constant is that you get partially paid in advance. This is standard practice for business consultants. When a client pays you up front in good faith he takes you more seriously. He doesn't waste your time, he respects it, and he works more efficiently because he trusts you to advise him. Consultants who work speculatively on a commission basis complain that clients are not as motivated to make art buying decisions. They keep their unpaid consultants searching for that mythical "perfect painting in the sky." Or even worse, they call in one consultant after another to make presentations to them. Usually these executives are unsure about their design taste, but they also don't trust the art vendor who derives profit from the sale, so it can be a relentless, unrewarding process for everyone.

Here are some suggestions of terms to consider with regard to your professional fees.

SMALL, SHORT-TERM PROJECTS

Ask for one-third of the professional fees at the commencement of the job, usually when the contract is signed, the balance to be due within thirty days of completion of the job. Note: You need to be sure to invoice the client for the remainder due. Usually companies pay within thirty days from the date of the invoice, so billing must be prompt after the job's completion. An alternative for this is a three-step approach: one-third at the start, one-third at the end of the selection process, and one-third at the completion of the job.

LARGE, LONG-TERM PROJECTS

The Milestone Approach. One-fourth up front and one-fourth at various milestones in the project. Payment terms on a large scale sculpture commission might look like this:

- 1/4 at commencement
- 1/4 at approval of the first maquette
- 1/4 at fabrication
- 1/4 at completion

The Periodic Approach. Payments are scheduled at certain regular time intervals, usually monthly (e.g., the 15th of every month) or the same day of the month the contract is executed. For example, an annual art program management contract fee of $30,000 would be divided into twelve equal payments of $2,500 each. The first payment is paid in advance and the remainder are billed monthly.

Expenses. There are three common ways to handle expenses. First, they can be billed in the month they occur. If the professional fees are also billed monthly, they can just be added onto the invoice as separate line items. Second, if they are not substantial, you can hold them for submission at the same time as your professional fees. Third, if they are substantial you may want to ask the client for an expense advance and submit bills against it as they occur. For example, on overseas art buying trips, where reimbursable expenses might be as high as $6,000, I will sometimes ask for a travel expense advance.

Billing. Briefly mention to the client how you bill and inquire about any special person to whose attention bills should be directed. Then, in the proposal, state again exactly how and when the client will be billed and what your expected remittance period is. Most companies are not able to respond within less than thirty days. If prompt payment is critical, give the accounting department a call to find out their vendor paying cycle and be sure to get your invoice in at least one week prior to that date.

```
┌─────────────────────────────────────────────────────────────┐
│  ███████████████████████                                      │
│  FINE ARTS CONSULTANTS      782 North Wells Street   Telephone:│
│                             Chicago,                 312/642-2968│
│                             Illinois 60610           Fax:       │
│                                                      312/642-2970│
│                                                               │
│                                                               │
│  November 15, 20__                                            │
│                                                               │
│  John Holton, V. P. Public Relations                          │
│  Tafco Corporation                                            │
│  256 Mission Street                                           │
│  San Francisco, CA 94118                                     │
│                                                               │
│  INVOICE                                                      │
│                                                               │
│  For Professional Art Consulting Services                     │
│  Oct 15–Nov 15, 1991—20 hours          $2,000                │
│                                                               │
│  Direct Expenses:                         625                │
│  (Presentation labor, viewing room rental,                    │
│  photo reproduction)                                          │
│                                                               │
│  Reimbursable Expenses:                   175                │
│  (Long distance phone, secretarial, parking)   ____           │
│                                                               │
│  Total Due                             $2,800                │
│                                                               │
│                                                               │
│  Thank you                                                    │
│  Terms: 30 days net                                           │
└─────────────────────────────────────────────────────────────┘
```

For big companies that are on a sixty-day pay cycle, it may be necessary to request payment one month in advance. If you have a good relationship with your client, he can usually arrange something.

When preparing an invoice, it's a judgment call on how much information to give the client. Copying every receipt and submitting it for reimbursement is very time-consuming, but with new clients that may be just what is necessary to gain their confidence. Invoices should always show a separate line item for:

- professional fees
- direct expenses
- reimbursable expenses
- sales tax (if applicable)

It's best not to round out the cents for three reasons: it makes it more difficult to match up receipts, it costs the client more, and the more thorough you are in your detail, the more confidence it builds in your client.

Left and opposite:
Here are two sample invoices, one showing the minimum amount of detail and the second the maximum amount.

FINE ARTS CONSULTANTS · 782 North Wells Street
Chicago,
Illinois 60610

Telephone:
312/642-2968
Fax:
312/642-2970

November 15, 20__

John Holton, V. P. Public Relations
Tafco Corporation
256 Mission Street
San Francisco, CA 94118

INVOICE

For Professional Art Consulting Services per June 15, 1991 agreement

Oct 15–Nov 15, 1991 $2,000

10/16 m/w* John Holton, 2.5 hours
10/17 m/w Galleries: Berg & Fort, Rothman, Hooper Cowles,
 Dun & Crane, Mary Coop, 8.5 hours
10/18 m/w Art Services Framing, 4.75 hours
 m/w Dellem Art Freight, 2.0 hours
10/20 m/w Art Committee (preparation & presentation),
 2.0 hours
10/21 p/m** Rothman, Hooper Galleries, 0.5 hours
10/21 p/m Art Services Framing, 0.75 hours
10/22 m/w Dellem Art Freight, 1.5 hours
 Total: 20.00 hours

FINE ARTS CONSULTANTS 782 North Wells Street
Chicago,
Illinois 60610

Telephone:
312/642-2968
Fax:
312/642-2970

Page 2

Direct Expenses:	625.00
Presentation labor	$450
Viewing room rental	150
ABC Photo Mat	25
Subtotal	$625.00
Reimbursable Expenses:	$175.00
Long distance telephone	$55.25
Secretarial	115.00
Parking	4.75
Subtotal	$175.00
TOTAL DUE	$2,800.00

Thank you.

Terms: 30 days net

* meeting with
** phone meeting

It is perfectly acceptable to use the minimum format and then charge the client clerical time if they want more detailed bills submitted.

RECORD KEEPING

There are many good systems available for keeping track of consulting time. Ask your local business stationery store to show you samples. The time logs lawyers use are very good for art consulting.

Receipts for every expense you are billing should be kept together with a copy of the bill. This way, if there is ever any question, they are handy. Not all clients require copies of the receipts, but if your client requests them, don't send the originals. Always keep copies in your file. For any single-item expense over $150, such as a display case/pedestal, the client will want a copy of the receipt so that his accountant can decide whether to depreciate or expense the item.

OTHER QUESTIONS FREQUENTLY ASKED ABOUT FEES

Here are the three most common questions asked of me.

Q: What should I do when a project is over budget?

A: It depends on why it is over budget. If you simply underestimated how much time it would take you to do it, then the overtime should be absorbed by you. As a professional, a consultant is supposed to know how long things take, and should stand behind his or her judgment.

Never wait until you're over budget to tell the client. You are the person responsible for monitoring the budget. As soon as a budget problem is identified, advise the client, give him his options, and ask for his decision.

Many times, the cause of the overruns are due to changes in the client's plans—construction delays, for example. It is still your responsibility to keep your client posted on expenses that extend beyond the approved budget.

An Example of How to Address One Common Situation With Your Client: "We budgeted all your art to be installed in one day but because the construction won't be completed on the second floor on time, we will either need to postpone installation for both floors, or arrange to have the art for the second floor installed on a later day. An additional installation day will cost about $800. How would you like us to proceed?"

Q: When a client doesn't have a working budget and needs a survey to create one, should I do this for free?

A: This is a judgment call. A lot of big consulting firms, like advertising agencies and design firms, do work speculatively. Inexperienced consultants often do so as well, but many successful, experienced consultants who are independents won't work on a trial basis. Their attitude is that if the client has seen samples of their work and participated in an exploratory meeting where an art program concept has been agreed on, then the client should be willing to make a firm commitment. My approach to this dilemma is to tell the client I never work speculatively, but that I would be happy to do a survey for him for a flat fee of $____. The survey would entail walking through the space, identifying all the areas that need art, figuring out what type was best suited, doing an inventory of their existing work, giving them floor plans with this information indicated as well as an operating budget and a proposal (for which there is no charge). Whether they decide to go ahead or not, they will have an action plan.

To calculate my flat fee, I figure out how many hours the survey will take and then arbitrarily charge one half of that amount. It's best not to let a client know that you have discounted your rate but just to quote it as a flat fee. Then, when I budget the project, I figure in the remaining half of the survey as part of the professional fees. The lower rate is an incentive for a hesitant client to proceed while still maintaining his respect for my time. When a client has no prior knowledge of your work or your worth, one important way to establish it is by the way in which you value yourself.

Q: How do you charge a valued ongoing client when your rates have gone up?

A: When clients are particularly valuable—so easy to work with and such a good source of referrals—you may not want to raise your fees on them, at least not for several years. However, if they are giving you referrals, it's a good idea to let them know you have raised your rates for new clients. This indirectly lets them know you are giving them a good deal and it avoids the awkward situation of them quoting an old rate to a potential new client. If you feel you must raise your rates to an existing client, it's a nice practice to set a date three to six months in the future and let them know in person and also in writing.

For clients who come back to you after many years, there are two solutions that seem to be equitable.

First: Tell them what your current rate is, and then give them a discount based on their value to you as a client. The minimum discount should be ten percent.

Or, second: Tell them what your current rate is. Then calculate what their rate was plus a fifteen percent annual increase for each of the intervening years. Whichever rate is lowest, that's their rate.

Businessmen understand about annual cost-of-living increases as well as the notion that a more experienced consultant works faster and has greater resources at his or her disposal. It never hurts to gently remind them, however, that you are familiar with their collection and that your knowledge of it will save them time and money.

NOTES FOR GALLERIES

How a gallery decides to structure its corporate art business is largely determined by three factors:

1 The type of gallery it is (trade or retail) and the inventory it carries.

2 The segment of the corporate market best suited to the gallery's offering.

3 The geographic location of the gallery and the relative sophistication of the area.

DISCOUNTS

Because galleries have access to art on a wholesale basis, they have greater leeway in the discounts they can offer corporate clients. In communities where one or more galleries have greatly discounted their art to companies, it has undermined the whole integrity and economic stability of the art community. Before making what seems like a harmless short-term financial decision, I urge you to consider some of the ethical and economic ramifications of discounting discussed in Chapter 16.

Here is a summary of the four most common types of gallery operations and how they structure their services.

Trade Gallery to Art Consultants and Designers/Architects	Commercial Gallery Selling Decorative Art to Private Clients, Designers, and Corporations	Corporate Art Service, with Inventory, Selling Primarily to Corporate Clients, No Private Clients	Gallery Selling Museum-quality Art to Collectors, Art Consultants, and Interior Design Firms
Trade Discounts: 30–40% discounts on art to the trade. Commission to sales staff: 15–20% commission. **Discounts to corporations:** Often these galleries do not sell directly to companies, but if they do they usually give 15–30% volume discounts. **Services provided:** Services are primarily limited to art sourcing, with some framing and installation services.	**Trade discounts:** 15–30% discounts on art to the trade, usually 30% for volume. This range infuriates designers, since not all their projects are large and they make their living off the discounts. It's better to have one discount and stick to it. **Commission to sales staff:** Draw $500–$1500 monthly against commission, 15–20% commission on sales. **Discounts and fees to corporations:** These galleries vary in the way they deal with companies. Some charge retail for the art and framing. Some give volume discounts of 10–30%. **Services provided:** May provide full services to companies. Some now charge an hourly fee for non-art-related services, since they have found it unprofitable to absorb the expense in overhead. Fees average $35 to $75 per hour, usually half the going hourly rate for an independent consultant.	**Trade discounts:** 30–40% discounts on art to the trade, if they sell to them. **Commission to sales staff:** 15–20% commission. **Discounts to corporations:** Often these consulting services give volume discounts to their corporate clients in the range of 15–35%. They can afford this because they do not have the same overhead expenses as an exhibition gallery. **Services provided:** They provide a range of consulting services, with the emphasis on making art sales versus providing services. Usually they work on a commission basis selling the art and framing at retail and making as large a commission as possible.	**Trade discounts:** Discounts on art to the design trade and art consultants, 10–20%. **Commission to sales staff:** 10% straight commission. Some receive a monthly draw for other gallery duties they perform or against their commission. **Discounts and fees to corporations:** Most galleries in this category can only afford to give a 10–15% discount to corporate clients; some may give volume discounts up to 20%, but they are more the exception than the norm. Art collectors are the primary target audience for these galleries, and many do not want to sell their best works to companies at a discounted price. **Services provided:** Only about one in twenty of these galleries have corporate art services, the remainder primarily sell to art consultants and designers working on a fee-for-service basis. Those galleries with an in-house corporate program provide full services, sourcing art from other galleries and usually charging a separate fee for extra services.

Budgeting a Job

Sign in the window of a vacant shop: We Undersold Everybody.

Once your method of working and your fee structure are established, the next step is to estimate your time and the direct expenses for the program.

Beginning consultants tend to underestimate the time it will take them to do projects until harsh reality teaches them. At the outset, I suggest you keep close records of your time.

> *I find that I use my time more efficiently when I'm working on several projects at once. Clients often benefit, too, because such things as out-of-town searching for art can be prorated among the projects.*

BUDGETING PROFESSIONAL SERVICES

For every work of art needed, allow a certain number of hours to process it, including:

- specifying it in the survey
- sourcing the work
- presenting it to the client
- selecting the framing
- deciding where it will be installed
- supervising the installation

Usually the higher priced and more unique the work, the more time it will take to find the right piece and to get your client's approval. Everyone works at a different pace and when you are more experienced you know where the art is buried, so to speak. Therefore, have a descending estimate of hours. For posters that you have right at your fingertips in catalogs, the time is very little compared to searching every gallery for just the right painting for a board room. If you are searching for just one or two works of art, you may want to either budget on a flat fee basis or double or triple your usual time estimate. A consultant looking for two paintings will have to do almost as much searching as for ten works. There is an economy of time when you are looking for many works at one time. Businessmen usually understand that less doesn't always cost less.

Another factor in deciding what number of hours to use for each category is your hourly rate and how experienced you are. Experienced consultants with a high hourly rate will charge fewer hours per piece because they know where the art they need is located. The search process is not as time-consuming for them. For example, the following guide is for a consultant with a $75 per hour rate who knows his or her own local art community well.

ART AND FRAMING

Hours per Piece	Type of Piece	Art & Framing Price Range
16	Paintings, tapestries, sculpture	$7,000-$20,000
12	Small paintings, tapestries, sculpture	$5,000-$7,000
8	Major graphics or drawings	$3,000-$7,000
6	Small graphics or drawings	$1,000-$3,000
2	Decorative art	$150-$300

These figures are based on works already existing. For commissioned works, either budget them on a flat-fee basis or double or triple the time, depending on the complexity of the commission.

Here is a hypothetical art budget showing how professional fees would be tallied up using the guide above.

Qty. of Art	Medium	Average Cost	Total Est. Art Budget	Hours
1	Painting	$12,000	$12,000	16
3	Small paintings	6,000	18,000	36
3	Major graphics	5,000	15,000	24
20	Graphics or drawings	2,000	40,000	120
	Total Art Budget		85,000	196

196 hours x $75 hourly rate of consultant = $14,700 professional fee. This amount does not include inventorying the client's art, or meeting with employees. These services are budgeted separately and then all added up to get a total for professional fees. But as you can see, we already have more than 17 percent; with additional services we will be right up around 20 percent of the art budget.

Note: If you have not conducted an art survey, and all you have is an overall art and frame budget, you can create an estimate by using this simple formula:

Art and frame budget x 15% (or 20%)
÷ by your hourly rate
= the number of professional hours available.

Example:
$95,000 art and frame budget
x 15% ÷ $75 hourly rate
= 190 hours.

For suggestions on how to determine the average cost of art, see the sample budgeting schedule, page 95.

SUMMARY GUIDES FOR BUDGETING

PROFESSIONAL SERVICES

Art consulting	Est. Rate Range
(survey, selection, presentation, framing supervision, installation supervision)	$60–$180/hour

Your hours will vary according to your knowledge and experience.

Hours	Medium/Price Categories	
8	Major paintings, tapestry, sculpture	At your
6	Minor paintings, tapestry, sculpture	consulting
4	Major graphics & drawings	rate per hour
3	Minor graphics & drawings	
2	Decorative art	

A meeting usually takes about fifteen minutes. You need some time afterward to record the selection and to find your next consultation, and sometimes you have to wait to meet with the employee. One half-hour per employee gives you time for the whole process. Have the office manager set up the meetings for you in advance.

Meeting with employees to select art for their offices per employee — 1/2 hour of your rate

Rotation of installed art — 1–2 hours per piece

This includes planning the rotation, overseeing installation, changing records.

Organizing the company's art — 2–4 hours per piece

Selecting framing for client's art — 1 hour per piece

If many of the works need reframing or deaccessioning, allow the higher figure. This covers surveying the collection, deciding which pieces can be used, making an inventory, reviewing the company's records, and helping the company decide how to dispose of unwanted pieces.

Meetings with designers, architects, lighting consultants — at your rate per hour

Out-of-town travel time — 1/2 your hourly rate per hour

This allows time for unpacking and sorting art, bringing it to the place of installation, installing it and cleaning the art, as well as cleaning up all the unpacking materials.

Some presentation spaces insist you use their staffs.

Art may need to be stored at a fine art storage facility until the site is ready.

This is written like an exhibition policy and varies depending on the total value of art you intend to have at one time. This is not to take the place of your own liability insurance. (See Chapter 17.)

DIRECT EXPENSES

Installation labor	$20–$45 per hour
Time: 1/2 hour per framed paper work	
1 hour per larger work	
Installation materials	
Plexi label holders	$3–$5 each
Hooks	$0.50 per piece
Security mounts	varies
Labeling and documentation of collection including current market value for insurance purposes	
Wall labels	$2 each
Art labels	$1 each
Documentation sheets	$4 each
Photographing collection, either with a Polaroid or by professional photographer	varies
Rental of presentation space, usually from a fine art packer & shipper	varies
Presentation labor—art handlers to help show art at a presentation; same range as art installers	varies
Art transportation—from galleries to presentation space, then to framer's or client's space	varies
(1 man and a van)	$45–$75
Storage	
Project insurance (e.g., Bailee's Customer's Insurance) when the art concerned is very valuable, to protect you and your client while the art is in your possession for presentation purposes.	

BUDGETING FOR ART, FRAMING, AND DIRECT EXPENSES

You may want to fill out the following budgeting schedule with prices that fit the scope of your offering.

After interviewing a client, you will have an idea of the quality/cost level for the art work and framing. You can then pick the appropriate average cost of each generic type of art and the framing it will need. Some will be considerably less and others more, but if you settle on a realistic average cost, and select a few more works than you actually need at the presentation, you can easily balance the budget after the presentation. This practice also allows the client to pick things they like and not worry about their relative cost. Of course, it requires that you be knowledgeable about art and framing prices so that you can estimate averages accurately. Even though the estimates for all works should include the cost of framing, many times framing will not be necessary, and this will give you a little play in the budget as well.

SAMPLE BUDGETING SCHEDULE—ART AND FRAMING

Media	Framing		
	Price Range	**Modest**	**Custom Fabric Mats**
Posters			
Works on paper			
small			
major			
Paintings			
small			
large			
Textiles			
small			
large			
Sculpture			
desk top			
large, indoor			
outdoor			
Ceramics			
desk top			
large			
Other			

REIMBURSABLE EXPENSES

Reimbursable expenses are estimated by taking a standard percentage of the estimated professional fees and are billed as they actually occur, as long as they don't go over the maximum amount you estimate.

- 10% of total professional fees for local travel
- 15% of total professional fees for travel that involves other cities within a 150-mile radius and/or when considerable long distance phone calls will be necessary
- 20% of total professional fees for travel that is within your state but beyond easy driving distance
- 25% (or more) of total professional fees for national and international travel

Usually, when considerable travel will be necessary, it is better to budget it specifically. For instance, expenses to travel to Japan could be five times those to Mexico.

PULLING IT ALL TOGETHER

Writing up the final art program budget just involves pulling all the figures together from the four sections:

Professional Fees
Reimbursable Expenses
Direct Expenses
Art and Frame Budget

Once these figures are all defined, I run a little test to see if the project is a good value to the client and in the ballpark of industry averages. Here is a helpful rule of thumb for checking an estimate:

Art and Frame Budget	Percentage Taken for Professional Fees
$10,000–$100,000	15–20%
$100,000–$500,000	10–15%
$500,000–$1,000,000	5–10% or flat fee

If the professional fees are much higher than these averages, review the budget and see why. For example, if a client has five hundred employees they want you to meet with personally or five floors of existing art to be rotated and reframed, then of course the professional fees will exceed twenty percent. But on an average consulting job, the discounts you pass on to the client will usually be roughly equal to your professional fees, so you can comfortably say to your client that he is getting your services at no cost beyond what he would pay if he were paying retail prices. This makes you competitive with a commissioned consultant, but with the advantage of not being encumbered with inventory and a perceived conflict of interest.

■ ■ ■

"All words are pegs to hang ideas on."

—*Henry Ward Beecher*

A written agreement is usually required in business for any project or sale over $500. In art consulting, a proposal serves this contractual function. It protects you in case your corporate contact leaves the company or is transferred. It also lays out all the terms and conditions of your services so that if there is ever a misunderstanding, a written document will be there to refer to. Finally, a proposal is a summary of your understanding of the scope of the project and the purpose of your services. For a prospect who is a little hesitant to proceed, a well-conceived proposal may be the nudge that gives him the confidence to go ahead.

WHEN IN ROME DO AS THE ROMANS DO

When I started consulting, one of the first things I noticed was how threatening and alien art was to many executives. I decided one way to put my clients at ease was to present them with documents that would seem familiar. Having businesslike proposals without a lot of art-world jargon also meant they weren't as likely to call in their legal counsels to review them.

Beyond these practical reasons for having a good solid proposal, the other main reason is that it is the final sales tool—the last presentation of your professionalism. It's not so much that the proposal is selling the prospect on your services—this is only the case in one type of proposal, "The Sales Proposal" (see page 108)—but that when the prospect reads through your agreement he says to himself, "This is a fine, solid agreement; I've made a good decision." He can congratulate himself that you're the professional he judged you to be.

PRESENTING YOUR PROPOSAL

Because proposals are the last negotiated step before entering into a relationship with a client, they should always be delivered in person. It's greatly to your advantage to be able to watch your prospect review the proposal. If there are any objections or queries about price, you are there to respond to them. Even if you are destined to lose the job, at least you can ask why if you are present.

Before going to the meeting look over the proposal and have several ways the client can cut back at least twenty percent on the art budget and on your service. It's always wise to have a graceful way to cut costs if necessary. You don't want to be flustered in the meeting or have to reschedule while you figure out possible cuts.

Have a copy of the proposal for everyone expected at the meeting, so no one has to look over anyone else's shoulder. Before handing out the proposal, review any key points or changes that are different than the prospect anticipates. The reason for this is that once you hand over the proposal, you run the risk of losing control of the meeting. It's not uncommon for everyone to go speed reading through the pages to the final financial page. Before you hand the proposal over, you have their undivided attention; afterward, you're lucky if they are listening to you at all.

Here is a sample of the kind of opening information that I would give the client before handing the document over.

"When you look over the proposal, there won't be any big surprises from our last discussion, but there are two things I wanted to tell you about. The first is that the wall over the escalator is not sufficiently strong to support the company-owned steel sculpture we had hoped to place there. So I've given you two options: one, to have the wall reinforced—your architect tells me that would cost roughly $10,000 to $15,000—or, two, to purchase a tapestry for the area, which I estimate could be around $12,000. The sculpture could be used on the West Hope Street entrance without reinforcement, and then the art budget for that wall could be used toward the escalator tapestry at no additional art budget expense.

"The only other surprise was that when your office manager calculated the number of private offices, and therefore the number of individual employee art selection meetings, it was actually thirty-five people more than we estimated, so that figure is a little higher than we discussed.

"That's really all. May I suggest that we just read through the proposal together and, if you have any questions, we can talk about them as we go along."

Then hand out the copies of the proposal and silently read, following along with your prospect. At the end of each page or section, make some comment relevant to what he has just read, to get his acceptance.

"Does the description of the art program concept sound right to you?"

"You'll notice under the list of services that I put in lighting consultation. Your designer asked if I would meet with her and the architect to go over the lighting plan, particularly for the lobby and sixtieth floors. I presumed that was agreeable with you."

While reading along with your prospect, keep a close eye on his facial reactions for any telltale signs that there is confusion, disagreement, or dissatisfaction. If there is, make an inquiry.

"Do you have any thoughts about this section? Do you have any questions?"

WHEN THE BUDGET IS A SURPRISE

If you can possibly avoid it, don't go to the proposal stage without an agreed-upon budget. If you're doing a survey for the purpose of establishing a budget, I recommend calling the client and saying, "It looks like we're in the area of $80,000. Does that sound about what you expected?" Based on what the prospect says, either continue to do the proposal or set up a meeting to review the survey and discuss some options.

Besides calling in advance for a reality test, there is another way to handle this issue. Hand the client the proposal but, in all the places on the financial page where money is supposed to be stated, leave it blank. Usually the client will make a joke like, "Oh, I see you're not charging me for your services."

Your answer can then be, "There are several areas where the options could have a significant impact on the budget, so rather than guessing, I brought in a budget worksheet and I thought we could go over it together." You and the client can then go through

the process of making the estimate together, which helps insure the client's acceptance of the overall budget. Note: this process should take no more than fifteen minutes. By advance preparation, you can streamline the process so there are just a few decisions or calculations to make.

At right is a sample budget worksheet. If the professional fees or direct expenses of the program are in question, you can make up similar worksheets for those areas.

PROPOSALS FOR ALL OCCASIONS

Every proposal needs to have certain standard information:

- The client name, address
- Location of the site where the work is to be done
- Purpose and scope of services
- Schedule
- Terms and Conditions
- Budget summary

Beyond these basics, different situations call for a variety of proposals. We will discuss here three basic types that cover the range of most art consulting projects: the form contract, the letter of agreement (both long and short forms), and the sales proposal.

Note: A sample agreement for the commissioning of a work of art is discussed in Chapter 13. The proposals discussed here relate only to fee-based consulting services; commission-based contracts appear following page 115 in the Notes for Galleries section.

FORM CONTRACT

Small or low-budget projects can prove to be profitable only if you are careful to conserve your time. Your profit margin will diminish considerably if you spend too much time meeting with the client or preparing a proposal. Many consultants shy away from small jobs thinking they are a waste of time, but if you handle them efficiently, they can be profitable; and small jobs have a way of turning into bigger ones later on. The key is efficiency.

SAMPLE BUDGET WORKSHEET

LOBBY

Paintings _____

Major Graphics/Drawing _____

Drawings _____

Posters _____

Optional Commission Piece _____

 for Window _____

Total Works of Art _____

SECOND FLOOR _____

Paintings _____

Major Graphics/Drawings _____

Drawings/Graphics _____

Posters _____

Total Works of Art _____

THIRD FLOOR _____

Paintings _____

Sculptures _____

Major Graphics/Drawings _____

Drawings/Graphics _____

Posters _____

Total Works of Art _____

BASEMENT _____

Drawings _____

Posters _____

Total Works of Art _____

TOTAL ESTIMATED ART BUDGET _____

FINE ARTS CONSULTANTS

782 North Wells Street
Chicago, Illinois 60610

Telephone: 312.642-2968
Fax: 312.642-2970

ART PROGRAM PROPOSAL

Date: _____
Name: _____
Firm: _____
Address: _____

The following is a proposal to the company named above for
Fine Arts Consultants to provide art program services as described and
checked below.

☐ "SITE SURVEY," a walk-through of the site to: Estimated Fee
 1. Identify appropriate areas for art
 2. Develop criteria for selection (review of
 architects' drawings, designers' color boards)
 3. Discuss client's desired effects, image, etc.
 Remarks: _____
 Rate per hour: _____

☐ SELECTION OF ART & SUPERVISION
 OF FRAMING
 1. Prepare preliminary selections
 2. Make presentation to client
 3. Arrange for framing to client's specifications
 Remarks: _____
 Rate per hour: _____

FINE ARTS CONSULTANTS

782 North Wells Street
Chicago, Illinois 60610

Telephone: 312.642-2968
Fax: 312.642-2970

Firm:
Art Program Proposal
Page 2

☐ INDIVIDUAL EMPLOYEE SELECTION Estimated Fee
 Our consultant will meet with individual
 employees to help them make selections for
 their private offices or work areas. Selections
 can be made from a management preselected
 inventory.

 Estimated number of individual consultations: _____
 Estimated time per consultation: _____
 Rate per hour of consulting time: _____

☐ ORGANIZING CLIENT'S EXISTING ART WORK
 Estimated number of artworks: _____
 Estimated time and rate per hour _____ @_____

☐ FRAMING OR REFRAMING OF CLIENT'S
 OWN ART WORK
 Our consultant will coordinate the framing to
 be consistent with the rest of the artwork.
 Actual framing expenses will be billed directly
 by the framer to the client. Special framing
 or logistical requirements: _____

☐ PICK UP AND DELIVERY OF ART
 Remarks: _____
 Rate per hour: _____

Above: *Form Contract*
Sample Proposal

FINE ARTS CONSULTANTS

782 North Wells Street
Chicago, Illinois 60610

Telephone: 312.642-2968
Fax: 312.642-2970

Firm:
Art Program Proposal
Page 3

☐ INSTALLATION, OPTIONAL SERVICES Estimated Fee

 1. Art consultant and professional art installer.
 Rate _____
 2. Professional art installer only. Rate _____
 3. Installation materials (est. number of pieces
 at price per piece): _____@_____
 Remarks: _____

☐ LABELING AND DOCUMENTATION
 Artwork is assigned an identification number
 that corresponds to its designated location on
 architect's blueprints and art inventory cards.
 Also an appraisal of fair market value is provided
 for insurance purposes.
 Rate: _____

☐ OTHER SERVICES
 Description: _____
 Rate: _____

TOTAL ART SERVICES ESTIMATE $ _____
TOTAL ESTIMATED ART BUDGET $ _____
TOTAL ESTIMATED ART SERVICES
 & ART BUDGET $_____

FINE ARTS CONSULTANTS

782 North Wells Street
Chicago, Illinois 60610

Telephone: 312.642-2968
Fax: 312.642-2970

Firm:
Art Program Proposal
Page 4

DURATION AND TERMS: A period of _____ should be allowed from the acceptance and signing of this agreement in order to frame all works and provide the other designated services.

Upon acceptance of this proposal, a prepayment of 1/3 of the professional fees is due, $_____. The remainder will be due at the completion of the job, 30 days net from receipt of the invoice for professional fees.

(Optional clause if consultant is billing for artwork) At the time of your approval of the artwork, a prepayment of one-half (50%) of the total value of the artwork will be due, and the remaining balance will be due 30 days net upon receipt of the artwork. Custom framing fees of the client's own artwork will be billed directly to the client from the framer. Special ordering of artwork and framing will commence upon receipt of the prepayment.

EXPENSES AND TRADE DISCOUNTS: We are prepared to set these outlined expenses as a maximum budget, subject only to changes that you initiate. Due to established relationships with artists, dealers, and framers, Fine Arts Consultants receives discounts up to 25% on art and ____% on framing. These discounts will always be passed on to you as savings with no administrative markup.

ACCEPTANCE: If this agreement is acceptable to you, please sign and return a copy to our office. I will devote our best efforts and resources to making the art program a great success.

Very Truly Yours Accepted By:

_____ _____

For Fine Arts Consultants

 Date: _____

Above: *Form Contract*

Sample Proposal,

continued

If you close your sale in the first meeting, and the size or budget of the project does not warrant a full-scale proposal, you can pull out your form contract and simply check with your client the services or products that are needed. You can then calculate the estimated budget, or excuse yourself for ten or fifteen minutes while you prepare the contract for your client's signature. After the agreement is signed, you and the client can either make preliminary selections from the art resource books you have with you or make a date for you to return with material.

This is an ideal way to handle smaller projects that require only eight or ten works on paper. I suggest that all consultants carry a form contract with them so that they can accommodate a small project, and also serve a past client who needs just a few pieces for new employees.

The form contract is particularly valuable for publishers, galleries, framers, and independents who represent less expensive graphics and posters; but all art consultants will find it useful for smaller jobs.

LETTER OF AGREEMENT

This type of agreement is the workhorse of most art consulting jobs. It is ideally suited for the situation where the prospect is sold and merely wants you to create a working document summarizing the critical terms and conditions of your service.

If the project is substantial and there are highly individualized benefits to the art program, you may want to include a benefits section, such as that in the following sample. This should only be included when you are absolutely certain of the benefits and they are specific to the company.

Note that this type of agreement is not a sales proposal, but an agreement summarizing the terms of your working relationship.

Right: *Sample*
Letter of Agreement
Long Form

FINE ARTS CONSULTANTS

782 North Wells Street
Chicago, Illinois 60610

Telephone: 312.642-2968
Fax: 312.642-2970

January 15, 20__

Mr. Daniel Webster
Webster Political Campaigns, Inc.
13 Republic Street
San Francisco, CA 94111

Dear Mr. Webster:

The following is a letter of agreement for art consultation and curatorial services for the Webster Political Campaigns, Inc. new offices at 13 Republic Street, San Francisco, California 94111. Approximately 43 works of art will be acquired for display in public areas, conference rooms, work stations, and private offices.

ART PROGRAM CONCEPT
A curatorial focus for the collection will be works that relate to the American political scene. This will be interpreted broadly to encompass works of art that incorporate traditional political symbols, such as the American flag, or that are issue oriented, or that good-naturedly poke fun at politics, or that are symbolic in some way of the American Dream or of Jeffersonian values.

GOALS AND BENEFITS

- The collection will be created as a conversational focus for visiting political figures and as a backdrop for tours and receptions. A press release on the collection will be sent out to the local and national media.

- The core collection will also be available for loan for local political events and receptions as well as university political science departments as a way of indirectly promoting the image of the firm.

- The art will reflect the qualities of integrity and sophistication for which Webster Political Campaigns has distinguished itself in the political consulting arena. The high level of art will contribute to the firm's overall image as working only in the most prestigious campaigns.

- The art will be framed in the highest quality materials to complement the other neoclassical decor elements being used. The overall effect of the art and framing will be to create an environment of good taste and stability, the antithesis of the makeshift pushpin poster decor of so many political consulting firms.

- All employees on staff at the time of installation will be given a chance to be involved in selecting the work of art for their stations or offices.

FINE ARTS CONSULTANTS

782 North Wells Street
Chicago, Illinois 60610

Telephone: 312.642-2968
Fax: 312.642-2970

Daniel Webster
Page 2

SCOPE OF SERVICE

FINE ARTS CONSULTANTS will provide the following services for your firm. We will:

1. Designate areas for artwork;

2. Decide on the type of art best suited to each location;

3. Locate appropriate works of high quality and review selections with you for your approval;

4. Obtain the artwork at reasonable expense through negotiation and professional discounts;

5. Oversee framing, shipping, and installation;

6. Meet with employees to help them select artwork for their offices;

7. Provide documentation, insurance specifications, and photo reproduction rights for artwork;

8. Review all direct expenditures of art program funds to assure that they are correct and forward invoices to you for final approval and payment;

9. Develop ways to make the art program meaningful and a source of enjoyment to employees (after the installation is completed, we will provide an informal tour for all interested staff); and

10. Develop a publicity package on the collection and an art program statement for the lobby information table.

FINE ARTS CONSULTANTS

782 North Wells Street
Chicago, Illinois 60610

Telephone: 312.642-2968
Fax: 312.642-2970

Daniel Webster
Page 3

DURATION AND COST SUMMARY

We anticipate that the project described above will take a maximum of six months to complete, from purchasing all artwork to having it framed and installed at your site.

For the professional services outlined, we propose a budget of $28,150. We are prepared to set this amount as a maximum budget, subject only to changes that you initiate. Our charges for professional services are based on the actual time spent on your behalf. In the event we encounter extraordinary circumstances or conditions, such as supplier delays or additional presentations having to be scheduled, we would obtain your approval before proceeding or incurring expenses over those estimated.

Additionally, we will bill you for reimbursable expenses and out-of-pocket costs, such as travel, telephone, and secretarial services, at their expense to us (cost plus 10% for administration). Experience on comparable projects indicates that these expenses will be in the range of 15–20% of the professional fees, or $5,630 (estimated at 20%).

For the direct expenses, such as transportation, presentation space rental, and framing, we propose a maximum budget of $19,752. We will review all invoices for correct terms and discounts. We will then approve and forward all invoices to you for payment. When it is necessary for us to prepay a direct expense invoice, such as that for installation labor, we will bill these expenses to you at their expense to us (cost plus 10% of the net invoice for administration).

Invoices will be submitted monthly and will show a single item for professional services, a single item for reimbursable expenses, and a single item for direct expenses. Direct expenses will also be detailed and the appropriate administrative costs will be a separate item for each expense category.

Above and right:

Sample Letter of Agreement
Long Form, continued

FINE ARTS CONSULTANTS

782 North Wells Street
Chicago, Illinois 60610

Telephone: 312.642-2968
Fax: 312.642-2970

Daniel Webster
Page 4

TRADE DISCOUNTS

Due to established relationships with artists and dealers, FINE ARTS CONSULTANTS receives discounts of 10–25% on artwork and 40% on framing. These discounts will always be passed on to you as savings with no administrative markup.

TERMS

Upon acceptance of this agreement, a prepayment of $_____ (1/4 of professional fees) will be due. Invoices will be submitted monthly against the advance payment, payable 30 days net from receipt of the invoice, and covering time and expenses incurred. Both parties shall have the right, upon 30 day's written notice, to terminate this agreement. Otherwise this contract will be for a period of six months, commencing from the date this agreement is signed.

ACCEPTANCE

If this proposal is acceptable to you, please sign and return a copy to our office. I personally look forward to working with you and will devote my best efforts and resources to making the art program a great source of enjoyment to the staff and clients of Webster Political Campaigns.

Sincerely,

Margaret Pilar

FINE ARTS CONSULTANTS

MP:bf

Accepted for Webster Political Campaigns, Inc.

By: _____

Date: _____

Above: *Sample Letter of Agreement Long Form, continued*

FINE ARTS CONSULTANTS

782 North Wells Street
Chicago, Illinois 60610

Telephone: 312.642-2968
Fax: 312.642-2970

Daniel Webster
Page 5

ESTIMATED BUDGET
ART BUDGET

LOBBY			TOTALS
1	Painting	$20,000	
2	Major Graphics/Drawings @ $4,000	8,000	
15	Drawings/Graphics @ $2,000	30,000	
2	Political Posters @ $100	200	
20	Works of Art		$58,200
SECOND FLOOR			
1	Painting (small)	10,000	
2	Major Graphics/Drawings	8,000	
3	Drawings/Graphics	6,000	
1	Political Poster	100	
7	Works of art		$24,100
THIRD FLOOR			
2	Paintings (small)	20,000	
2	Sculptures (desk top)	15,000	
3	Major Graphics/Drawings	12,000	
2	Drawings/Graphics	4,000	
1	Political Poster	100	
10	Works of Art		$51,100
BASEMENT			
2	Drawings/Graphics	4,000	
4	Political Posters	400	
6	Works of Art		$4,400
	TOTAL ESTIMATED ART BUDGET		$137,800

Above: *Estimated Budget in Sample Letter of Agreement Long Form*

FINE ARTS CONSULTANTS	782 North Wells Street
	Chicago, Illinois 60610
	Telephone: 312.642-2968
	Fax: 312.642-2970

Daniel Webster
Page 6

ESTIMATED BUDGET (Continued)

PROFESSIONAL FEES BUDGET		TOTALS
Professional Fees		
Art Acquisition (154 hours @ $150)	$23,400	
Employee Selection	2,550	
(34 meetings, 17 hours)		
Art Program Statement and		
Public Relations Package	2,200	
TOTAL PROFESSIONAL FEES:	$28,150	$28,150
Reimbursable Expenses		
(maximum 20% of professional fees)	$5,630	$5,630
Direct Expenses		
Viewing-Space Rental	$200	
Transportation	2,000	
Labor for Presentation	1,600	
Installation Materials	43	
Framing (43 works @ $300)	12,900	
Label Holders	194	
Labeling and Documentation	215	
Photographing the Collection		
(Key works for P.R. Package)	250	
Project Insurance	350	
Direct Expense Contingency	2,000	
TOTAL ESTIMATED EXPENSES	$19,752	$19,752

See following page for note on computing your professional fees.

ART PROGRAM BUDGET SUMMARY	
Art, 43 works	$137,800
Professional Fees	28,150
Reimbursable Expenses	5,630
Direct Expenses	19,752
TOTAL ESTIMATED BUDGET	$191,332

Note: The professional fees for this budget are computed in the same way as described on page 93, with the following three adjustments:

1 Because the consultant is more experienced and more highly paid ($150 per hour versus $75 per hour) the hours allocated for each work are about one half those in the budget described on page 93.

2 The average estimated cost of artwork reflects the consultant's perception of the prices in this specialized political genre. In this case, graphics and drawings tend to be less expensive since the works often do not have as broad an audience collecting them. The paintings are estimated at a higher price since a goal of this project is to have some stellar works by artists with national reputations.

3 Framing is separated out from the art budget and appears as a line item under expenses.

The professional fees for this budget would be computed as follows:

173 hours total x $150 hourly rate = $25,950 subtotal + $2,200 public relations professional flat fee = $28,150 total professional fees.

See Chapter 8, page 93, Summary Guides for Budgeting Professional Services.

Left: *Estimated Budget, continued*

FINE ARTS CONSULTANTS

782 North Wells Street
Chicago, Illinois 60610

Telephone: 312.642-2968
Fax: 312.642-2970

January 15, 20___

Mr. Michael Weisberger
Weisberger & Weisberger, CPAs
1256 Maple Street
Stamford, CT 06901

Dear Michael:

The following is a letter of agreement for FINE ARTS CONSULTANTS to provide art consultation services for Weisberger & Weisberger. Ten original works of art (paintings, drawings, and graphics) by Connecticut artists will be acquired for display in the lobby and public areas of the firm's new office, at 62 Hawthorne Street, Stamford CT 06901.

SCOPE OF SERVICE

FINE ARTS CONSULTANTS will provide the following services for your firm. We will:

1. Decide on the type of art best suited to each location
2. Locate appropriate works of high quality
3. Oversee framing, delivery, and installation
4. Provide documentation for each work of art
5. Create wall labels for each work of art
6. Review all direct expense invoices to assure that they are correct and forward invoices to you for final approval and payment

Right: *Letter of Agreement Short Form*

FINE ARTS CONSULTANTS

782 North Wells Street
Chicago, Illinois 60610

Telephone: 312.642-2968
Fax: 312.642-2970

Weisberger & Weisberger

Page 2

DURATION AND COST SUMMARY

DURATION: We anticipate that the art consulting services described above will take a maximum of 60 days to complete, from purchasing all artwork to having it framed and installed at your new office.

PROFESSIONAL FEES: For our professional services outlined above, we propose a budget of $4,800. This amount will be a maximum budget, subject only to changes initiated by you. (NOTE: The following is optional.) Our fees are based on the actual time spent on your behalf. In the event we encounter extraordinary circumstances or conditions, we will obtain your approval before proceeding or incurring additional expenses.*

REIMBURSABLE EXPENSES: You will be billed for out-of-pocket expenses, such as travel, telephone, and secretarial services. These expenses are estimated to be in the range of 10% of the professional fees, $480.

DIRECT EXPENSES: Expenses such as transportation, presentation space rental, and framing will be billed directly to you. Should we need to prepay any expenses, they will be billed to you at their expense to us (cost plus a 10% administrative fee).

BILLING: Our invoices will show a single item for professional services and a single item for both reimbursable expenses and direct expenses.

TRADE DISCOUNTS: Due to established relationships with artists and dealers, FINE ARTS CONSULTANTS receives discounts of 10–25% on art work and 40% on framing. These discounts will always be passed on to you as savings with no administrative markup.

*Note an alternate commission approach: For our professional services, we propose a budget of $4,800, 20% of the total estimated art (or of the art and frame) budget.

FINE ARTS CONSULTANTS

782 North Wells Street
Chicago, Illinois 60610

Telephone: 312.642-2968
Fax: 312.642-2970

Weisberger & Weisberger

Page 3

TERMS AND ACCEPTANCE

Terms: Upon acceptance of this agreement, a prepayment of $1,000 will be due. The remainder will be due upon completion of the project. An invoice will be submitted against the advance payment and will cover time and expenses incurred. Invoices will be due net 30 days upon receipt.

Acceptance: If this proposal is acceptable to you, please sign and return a copy to our office. I look forward to working with you to make the art a great source of pleasure for your staff and clients.

Sincerely,

Margaret Pilar
Director

MP:mc

Accepted for Weisberger & Weisberger

By:_____

Date:_____

Above: *Estimated Budget, continued*

FINE ARTS CONSULTANTS

782 North Wells Street
Chicago, Illinois 60610

Telephone: 312.642-2968
Fax: 312.642-2970

Weisberger & Weisberger

Page 4

ART AND FRAME BUDGET*

Seventeenth Floor			Totals
2	Paintings	$ 10,000	
2	Major Graphics/Drawings	6,000	
6	Graphics & Drawings	9,000	
10	Works of Art	25,000	
	Framing (10 works)	2,500	
		$27,500	

Total Est. Art and Frame Budget:	$27,500

EXPENSE BUDGET

Professional Fees (84 hours @ $65)		$ 4,800
Reimbursable Expenses		480
Direct Expenses		
Viewing Space	$ 50	
Presentation Labor	200	
Transportation	200	
Installation Labor	350	
Materials, incl. labels	60	
Documentation	40	
Contingency	500	
Total Est. Direct Expense	$ 1,400	$ 1,400

TOTAL ESTIMATED ART PROGRAM BUDGET	$34,180

Above: *Cost Summary*
Note: If you prefer, you can call this "Art Budget" and list framing under Direct Expenses

THE SALES PROPOSAL

There are times when a proposal must do more than just summarize your working relationship. When a large committee is making a decision on a project, or when several consulting firms are being asked to compete for the same job, the proposal often must function as a sales tool, and it must speak for you in your absence.

Although I urge you always to try to present your proposal in person, here are some strategies for situations in which a proposal must represent you in the sales process. This format is also suitable for large projects that are either long-term or complicated, such as a large-scale sculpture commission or rotating exhibition program. Usually, the more substantial the project, the more substantial the proposal.

The distinguishing aspects of this kind of proposal is that it has a cover letter, an elaborate features and benefits section, and more detailed information on your services, as well as more detailed background on you and your staff.

ELEMENTS OF A SALES PROPOSAL
Cover Letter
Opening Statement of Proposal
Background or Statement of Challenges
Objectives
Benefits
Purpose and Scope
Approach
About Our Company and Members of the Project Team
Cost and Duration
Cost Factors Not Estimated under the Proposal
Extraordinary Circumstances Clause
Billing
Terms
Termination Clause
Acceptance
Budget Page

Note: *Depending on the size of the project a sales proposal may have all or some of these parts*

Cover Letter. This should be a letter of one or two pages (no more), listing the compelling reasons for the client to do business with you from the company's perspective and with special reference to the job at hand. The reason for the cover letter is that, when large committees are reviewing several proposals, people will often read only the first two pages and just skim the rest or even go straight to the financial page. The cover letter has to sell them on why you and only you should be given this project. It should list two or three reasons why you are eminently qualified for the job and the special talents and experience you will bring.

I also always include a statement about how much our firm will value the business and give it our best resources. Clients like to know their job is important to you and that you will work hard to make it a success.

FINE ARTS CONSULTANTS

782 North Wells Street
Chicago, Illinois 60610

Telephone: 312.642-2968
Fax: 312.642-2970

Art Committee
Tyrol, Inc.
230 Brant Street
Seattle, WA 98370

Dear Committee Members:

We are pleased to present this proposal to provide art consulting services to Tyrol, Inc. This proposal will serve to explain Fine Arts Consultants' qualifications and our commitment to providing you the best public sculpture program possible. Our meeting earlier this week indicated to me that there are several ways in which we are especially qualified to work on this project. These include the following:

- Commissioning large-scale sculptures is a complex endeavor and Fine Arts Consultants is the only firm located in the Northwest that has had sufficient experience to handle a program of this magnitude.

- As your agent, we will oversee the entire project, coordinating with the development team, protecting your interests and financial investments, shepherding each piece through all phases (design, fabrication, installation), and arranging all engineering consultations to insure public safety.

- You will have the benefit of an outstanding group of local and national resources—artists, fabricators, engineers—whom we have tested through our past projects.

FINE ARTS CONSULTANTS

782 North Wells Street
Chicago, Illinois 60610

Telephone: 312.642-2968
Fax: 312.642-2970

- The community relations goals of Tyrol calls for an effective public relations campaign. Our firm has extensive experience in fine art PR. We will work in concert with your Public Affairs department to develop a series of strategies, including VIP events, news releases, feature articles, and television coverage for each phase of the project that will heighten community and employee appreciation of the park.

Tyrol's sculpture park will be a major cultural addition to the city, and all of us at Fine Arts Consultants would value the opportunity to work with you on the project. We will devote our best efforts and resources to making the park a huge community success and a source of pride for your company.

Sincerely,

Margaret Pilar
Director

MP:mc
Encl: proposal

Above: *Sample Sales Proposal Cover Letter*

Opening Statement. This is a straightforward statement of the who, what, why, where, and when of the project. Carrying on from the preceding cover letter, the statement might read as follows:

> "This is a proposal for art consulting services for the development of a sculpture park at the new headquarters of Tyrol, Inc. located at Tyrol Plaza, Fremont and Hyde streets, Seattle, Washington. The overall objectives of the sculpture park project will be achieved over a three-year period. However, the scope of this proposal will be the initial three sculptures planned for the core of the park and will cover an eighteen-month period."

Background or Statement of Challenges. This is an optional section. It states the history of the project, why it came into being, its general objectives or challenges. Perhaps the company has received negative publicity because it has torn down a historic building to build its headquarters. Company officials have decided to build a sculpture park for public use as compensation to the community. You would simply summarize these facts and what the goals of the company are in creating this park as a community resource. This section is an opportunity to show the prospect you understand his needs and motivations.

Objectives. This section describes the goals of your part of the project from the prospect's perspective.

> "It is our understanding that the general goals of Tyrol, Inc. in engaging our services are these:
> - to have an experienced fine art consulting firm oversee the commissioning of the three major sculptures and interface with other members of the development team in order to attain Tyrol's overall goals for the park;
> - to help create a public relations campaign that will...etc."

Benefits. The art program's benefits to the prospect's company should be summarized here. Include only three or four key benefits that the prospect has already accepted. A key benefit in the Tyrol proposal would be increased positive corporate visibility and the improvement of its image as a good corporate citizen contributing to the cultural resources of the area. Another benefit might be the physical enhancement of the property, making it a more attractive, prestigious location for other tenants.

Purpose and Scope. Here, a description of the art program concept and the parameters of your work is followed by a listing of the actual services you will provide. An optional subsection might be "Services Not Covered under This Proposal." If there is any potential for misunderstandings, or if there is a particular service you don't feel qualified to provide, make sure you state clearly the scope of what you are and are not providing. An example of this might be general contracting for the electrical and plumbing work for a fountain in which a sculpture is being placed.

Approach. On very large projects, it is often appropriate to describe further how you are going to do the job. This can either be done with a step-by-step description of the process, or by listing the resources you have and saying how you will put them to work for the client.

Here is an excerpt from a public sculpture proposal.

> "At this point we will work with you to establish criteria for the selection of art, including social, economic, and aesthetic considerations, maintenance factors, environmental considerations, quality and reputation..."

About Our Company and Members of the Project Team. This section includes a brief description of your company (one paragraph) plus reference to members of the staff who will be working on the project. Staff member descriptions can include brief resumes of each consultant within the body of the proposal or you can put the resumes in an appendix and refer to them here. The resumes should be very brief, one paragraph or so, and customized to include the experience they have had that relates to the work they will be doing on the project at hand. Eliminate any extraneous information.

> "Margaret Balestreet will have responsibility for the financial administration of the project. She will oversee the fulfillment of commission, lease, and loan agreements, all project expenditures, and the quarterly financial reports and billing.

> "After receiving her degree in business administration, Margaret trained in accounting with Thomas Deriksen & Company. Prior to joining Fine Arts Consultants, she had an accounting position with Simon, Warwick, Bean & Company. Since 1980, Margaret has administered the budgets of all our projects."

Independent contractors who are key to the project and whose services you subcontract may also be included, but it's advisable to get their permission in advance.

Cost and Duration. The cost section is composed of a brief written summary of all expenses broken into broad categories:

- Professional fees or commissions
- Reimbursable expenses
- Direct expenses

Note: The art budget is not included in the cost section, though it often appears in the financial pages at the end of the proposal. The reason it is not included here is that the proposal commits the client to buy your services and to pay the expenses involved, but it is not a legal commitment to spend a specific amount on art.

"To implement the program described above, we recommend a total budget of $_____.

$_____ for professional services such as curatorial, documentation, fabrication and installation supervision, and fine art public relations consultation. Charges for professional services are based on the actual time spent on your behalf and will not exceed the budget amount except by mutual agreement.

$_____ for reimbursable expenses such as long-distance telephone, secretarial services, travel, and entertainment. "Experience on comparable projects indicates that these expenses will be in the range of 15–20% of the professional fee.

$_____ for direct expenses such as framing, installation, transportation, etc."

Note: When stating a range in a proposal for budgeting purposes always use the high end of the range as the estimated amount.

A duration statement spells out the time period the project covers and any pertinent dates or milestones.

> "We estimate that it will take no longer than eighteen months to complete the above work, starting from the date of acceptance of this proposal. We understand that putting in place the East Plaza sculptures is a top priority, and we are pleased to commit ourselves to having them completed by December 21, 1997, as long as acceptance is received no later than March 25, 1995."

Cost Factors Not Estimated under the Proposal. When there are significant expenses involved in a project and there may be confusion as to whether they are covered under the proposal, it is best to enumerate them.

"The areas outlined below will require Blancorp staff involvement and capital expenditure and should be anticipated in the overall cost of the program.

1 Survey of plaza area to determine cost of structural modifications.

2 Cost of structural modifications to develop the exhibit area, e.g., lighting and wall panel system.

3 Assistance of building maintenance crew in maintaining exhibition area."

Extraordinary Circumstances Clause. On large jobs, and sometimes even on small ones, there are circumstances beyond a consultant's control. Sometimes these can be extremely costly if the consultant has to absorb the additional costs involved.

The purpose of the extraordinary circumstances clause is to protect you from these events that are beyond your control. It is not protection against an error in your professional judgment, such as underbudgeting your time when preparing the proposal. I try to think through the project in detail and anticipate where things might break down, such as construction delays causing additional installation days to be scheduled. If I've been told by the designer that the client travels extensively and cancels presentations at the last minute, I may put in a qualifier about extra presentations:

"We will always try to accommodate your time schedule and the special needs of your project; however, in the event that postponements initiated by you create additional direct expenses or professional fees to be incurred, these may need to be over and above the estimated amounts that are listed on the attached art program budget. We will do everything possible to advise you of any extra expenses before proceeding or incurring additional costs."

The following is a more common type of clause.

"We are prepared to set these amounts as a maximum budget, subject only to changes that you initiate. In the event we encounter extraordinary circumstances or conditions, such as delays due to construction or additional presentations having to be scheduled, we would obtain your approval before proceeding or incurring additional expenses."

Billing. The billing section consists of a detailed description of how all expenses will be billed, the frequency of billing, the amount of detail that will be given, and markups for administrative costs. It may also explain how commission calculations will be made and/or how prepayments will be handled.

Terms. Terms vary from project to project, but usually the section will state when the contract commences, the prepayment arrangement, and a summary of any special agreements, such as confidentiality or that the consultant has the authority to acquire works within a certain price range on behalf of the company.

The following is an excerpt from the terms section of a corporate lobby exhibition program:

"Upon acceptance of this agreement, a prepayment of $5,500 will be due. Invoices will be submitted monthly against the advance payment.

"In the event the Bank wishes to sponsor, host, or undertake an outside exhibition or related visual arts activity in the lobby exhibition gallery, under the terms of this agreement Fine Arts Consultants will participate in the selection and coordination of such activity for the purpose of maintaining the project's overall objectives and standards of quality.

"The installation of art work requires certain sensitivities and knowledge of the proper care and handling of art objects. Should building engineers be assigned to assist in the installation of art work, under this agreement they will be given extra time to be trained by Fine Arts Consultants personnel. We estimate training time to be six hours."

Termination Clause. On any substantial project, six months or longer, it is customary to have a termination clause describing the process in which either party may cancel the contract. If a project goes sour, a client can always find a way out, so don't fear that this is asking for trouble. Rather, a termination clause is a sign of professionalism. It makes the client feel more comfortable signing on for a big project knowing he has an escape hatch if things don't work out.

In twenty years of consulting and giving seminars, the only time I've heard of this clause being used was when the client was sexually harassing an art consultant and she used the clause to cancel her commitment to the company.

Sample termination clause:

"Both parties shall have the right, upon 30 days' written notice, to terminate this agreement. Otherwise, this contract shall be for a period of six months commencing from the date this agreement is signed."

If a client exercises the clause, the consultant is paid for all the work done and expenses incurred up to the date of receiving written notice. If additional services are needed to close down the project, this is negotiated with the client.

Acceptance. This is simply a closing statement and your signature followed by a designated area where the client can sign the document and indicate his acceptance.

Sample:

"If this proposal is acceptable to you, please sign and return a copy to our office. We personally look forward to working with _____ and will devote our best efforts and resources to making the art program a great success."

Sincerely,

Margaret Pilar
Director
MP:mc

Accepted for Blancorp
Name: _____
Title: _____
Date: _____ "

Budget Page: The budget page summarizes all the expenses of the program in as straightforward and easy to read a manner as possible. See pages 104 and 105 for sample budget pages.

TIPS FOR WRITING WINNING PROPOSALS

I can almost feel my prospects' appreciation of my proposals that are attractive, concisely written, professionally formatted, and devoid of art jargon and extraneous philosophizing. I am certain that my professional style has contributed greatly to the proposals' speedy acceptance.

Here are some additional tips from business consultant Christian Frederiksen's marketing seminar.

1 Write Proposals from Scratch.

Proposals are more personalized when written from scratch than when mixed-and-matched from previous proposals. If you try to combine phrases from several sources, the finished product will undoubtedly show it—or worse, something might be left in that is irrelevant or inappropriate.

2 Use the Look Test.

A proposal should be attractive and inviting to read. Here are a few tips:

- Leave ample margins—left and right as well as top and bottom.
- Keep paragraphs short and easy to digest.
- Select a type and a type size that is easy to read.
- Use headings to break up the page and help outline the contents.

3 Check the We/Our Versus You/Your Ratio

There should be a one-to-one balance of the we/our to the you/yours. Most proposals are more likely to be twenty to one—"We do this," and "We do that," and "We will do that, too," and on and on. Surprisingly, clients don't care so much about what you do, they care about what they need. And even though they know all about themselves, they want to know that you do, too. It is important that you let them know you understand their company and their needs. Besides, clients, like everyone else, love to hear about themselves.

4 The "So What?" Test

After every sentence in your proposal about what features you offer, ask yourself, "So what?"

Most proposals make all kinds of claims that are neither substantiated with facts nor clearly related to the issue at hand, the client's needs. We come again to the importance of emphasizing the benefit to the client rather than the feature you provide. By spelling out the benefit with the feature, you tell the client what they want to know: "What good is that going to do me?" Here are two examples.

- "We are the largest private art consulting firm working in the Pittsburgh area..." (This may be a fact the director is quite proud of, but a corporate client may wonder if the firm is too big and too busy to give the kind of personalized service his company needs.)

So what?

"...so we have extensive resources, both locally and nationally, that we can draw on to deliver an art program customized to your needs."

- "Hawkins Corporate Art Services was established in 1969, making us the first corporate art consulting firm in the Atlanta area..."

So what?

If being the first or the oldest firm in town does not really make you better in some way that benefits the client, don't bother saying it.

For each feature relevant to a project, check to see that the direct benefit to the client is also stated. This can be done in one of two ways: You can either state the benefit directly after each feature, or you can summarize the most compelling benefits of your offer in a separate benefit section.

5 The Laugh Test

My favorite. When a proposal is completed, take it home and ask someone unconnected and unfamiliar with the content, a friend or spouse, to read your proposal draft. If they burst out laughing with comments like, "Are you serious?" or "What does that mean?" then you have failed to bridge the gap between yourself and your reader.

CLOSING ON THE PROPOSAL

I always like to have some appropriate closes in mind so that, once we have gone over the proposal together and I feel a consensus has been reached, I can close the sale rather than leave wondering whether I have the job. I like to use assumptive closes because they flow with the spirit of mutual agreement—if we agree, then the question is not a decision, which always adds an element of stress, but simply a matter of taking the next step.

For every situation the close is different, but essentially it is just a matter of suggesting the logical next step in the same way you do in a first meeting with a client. (See page 74.)

I always go into a proposal meeting assuming the client is going to sign the proposal right in front of me. Although this doesn't always happen, the positive attitude goes a long way toward giving the prospect confidence to proceed.

The next assumption is that he's going to sign it and send it in a few days, so I propose our next appropriate meeting. "Before I start actually looking for art I'd like to meet individually with each of the three members of the art committee. Would next Thursday be a good day for you?" At the very least you want to leave the meeting with an indication that you plan to followup. "I'll give you a call next week to line up our next step." This lets the prospect know you are not dropping the proposal into a black hole. You expect a response from him and will be following up.

NOTES FOR GALLERIES

Many commissioned consultants and galleries don't use proposals, they just get a purchase order from the client after some selections have been made. The problem with this way of working is that the client does not respect the consultant's time and may not even respect the relationship. Seminar participants have told stories of thinking they were working exclusively with a client, only to find out that three or four other consultants were also chasing around searching for art on the same project. By having a letter of agreement and a nonrefundable deposit for surveying the space and putting together the presentation, you get a commitment from the client that you are his consultant, and he will usually treat the relationship with more respect. If you have approached the consultation from the perspective of solving the client's needs, and seem confident you are the right one for him, he should not have any hesitation in signing an agreement. In fact, it may make you appear more professional and successful in his eyes.

A word of warning: Some people in small businesses are very contract phobic. Explain that the contract only obligates them to pay the nonrefundable advance, which is usually about $150.

The biggest mental shift for inventory-based consultants is to this concept of selling a service versus selling their inventory. In this approach, you land the job when the client signs your agreement rather than after you show him the art you have selected. More effort has to go into the sales presentation and then, of course, you also have to deliver an appropriate selection of art works, but the rewards of having the client's commitment are considerable.

CAMERON WADE GALLERY

790 North Wells Street
Chicago, Illinois 60610

Telephone: 312.642-2911
Fax: 312.642-2913

This is to confirm that you have hired the Cameron Wade Gallery to provide art consulting services. We will:
- conduct an art survey and designate areas for art,
- locate and present art for your approval,
- oversee framing, shipping, and installation,
- provide documentation and insurance specifications for all art acquired.

CWG will bill you directly for all art and framing expenses at their retail cost (optional—less a 10% courtesy discount.) A maximum budget for art and framing will be set at $_____, subject only to changes that you initiate.

Direct and reimbursable expenses of the art program are estimated at:

Installation labor	$_____
Installation materials	$_____
Transportation	$_____
Out-of-pocket (parking, tolls, photocopying)	$_____
Other	$_____
TOTAL EST. EXPENSES	$_____

Client agrees to pay $150 as a nonrefundable advance against the art and framing budget. At the time of your approval of the artwork, a payment for the total value of the art selected will be due. The remainder of the framing and direct expenses less the nonrefundable prepayment will be due and payable within 30 days of completion of the project.

Art consulting services will commence upon CWG receiving a signed copy of this agreement along with the prepayment.

The Cameron Wade Gallery staff and I will devote our best efforts and resources to making the art program a success.

Very truly yours,

For the Cameron Wade Gallery

Accepted by:

Company

Address

City, State, Zip

Date

Left: *Here is a sample form letter of agreement for an inventory-based art consulting firm/gallery with a set service that is provided for many clients. A standardized letter like this is particularly useful for small jobs where time is critical to your profit margin.*

CAMERON WADE GALLERY

790 North Wells Street
Chicago, Illinois 60610

Telephone: 312.642-2911
Fax: 312.642-2913

November 29, 20___

Mr. Martin Fried, President
Martin Fried & Associates
410 Hudson Street
Chicago, Illinois 60612

Dear Mr. Fried:

The following is a proposal for the Cameron Wade Gallery, Corporate Art Services Division, to provide art consulting services for your new offices at 410 Hudson Street. Approximately twenty-five works of art by contemporary Great Lakes artists will be acquired for display in the main lobby and reception area, conference rooms, and work stations.

We will:

- interview members of the art committee and survey your site and existing art collection;
- decide on the type of art best suited to each location;
- locate appropriate works and review selections with you for your approval;
- oversee framing, shipping, and installation;
- provide documentation and insurance specifications for all new art work; and
- review all direct expenditures of the art program to assure that they are correct and forward them to you for final approval and payment.

CAMERON WADE GALLERY

790 North Wells Street
Chicago, Illinois 60610

Telephone: 312/642-2911
Fax: 312/642-2913

The above described services are provided as a part of the art and frame budget. CWG will bill you directly for the art and framing expenses at their retail cost less a 10% courtesy discount. A maximum budget for art and framing will be set at $_____, subject only to changes that you initiate.

Special services and direct expenses of the program are estimated as follows:

1. We will survey your existing artwork and decide which works of art can be recycled into the new art program. We will oversee the transportation and reframing of some of these works as needed.

Survey of 50 works of art	$_____
Reframing of est. 10 works	$_____
Transportation	$_____

2. Presentation labor — $_____
3. Installation labor — $_____
4. Reimbursable expenses (parking, tolls, secretarial) — $_____
5. Direct expense contingency (10% of itemized expenses) — $_____

Total Est. Expenses — $_____

Plus Art and Frame Budget — $_____

TOTAL ART PROGRAM BUDGET — $_____

Above: *Here is a sample letter of agreement for a more elaborate art program in which special services unique to the project require a more personalized proposal*

CAMERON WADE GALLERY

790 North Wells Street
Chicago, Illinois 60610

Telephone: 312.642-2911
Fax: 312.642-2913

DURATION: We anticipate that all the art consulting services described above will take a maximum of 90 days to complete.

BILLING: Our invoices will have a separate section for art and framing expenses, direct and reimbursable expenses. All entries will be individually itemized.

TERMS: Upon acceptance of this agreement a nonrefundable prepayment of $($300) will be due as an advance against the art and framing budget. At the time of your approval of the artwork, a payment of 50% of the total value of the artwork selected will be due. The remainder of the art and framing costs and direct and reimbursable expenses less the nonrefundable prepayment will be due and payable within 30 days of completion of the project.
(Optional clause)

CANCELLATION: Both parties shall have the right, upon 15 days' written notice, to terminate this agreement. Otherwise, this contract shall be for a period of three months commencing from the date this agreement is signed.

CAMERON WADE GALLERY

790 North Wells Street
Chicago, Illinois 60610

Telephone: 312.642-2911
Fax: 312.642-2913

ACCEPTANCE: Art consulting services will commence upon CWG receiving a signed copy of this agreement along with the prepayment.

The Cameron Wade Gallery staff and I will devote our best efforts to making the art program a great source of pleasure for your employees and visitors.

Sincerely,

Barbara Wing
Art Advisor

BW:mr

Accepted for Martin Fried & Associates

By: _____

Title: _____

Date: _____

Above: *Sample Letter, continued*

The Survey

"Art is reaching out into the ugliness of the world for vagrant beauty and the imprisoning of it in a tangible dream."
—George Jean Nathan, critic

Most corporate art programs require a survey of some kind to determine the art needs of the company. This is when you roll up your sleeves and begin to visualize the art. This is when the fun begins. Even though the firm may have a definite art budget, usually there is no clear idea of what kinds of art are needed or even all the locations where it should be placed. Here are five key questions you will want to find answers for in the survey:

1 How many works of art are needed?
 Before figuring this out, you'll have discussed with the client all key areas and whether they should have art:
 - reception and waiting areas
 - boardroom
 - executive offices
 - executive dining rooms
 - conference rooms
 - corridors
 - cafeteria
 - employee lounges
 - bathrooms
 - staff offices
 - employee work areas

Note: Some companies setting up high-level programs will establish an art budget and proceed to buy works of quality that fit their art program concept. It will be up to the consultant or corporate curator to decide where to place them.

2 What general medium of art is appropriate?

 Certain locations demand a specific treatment. For instance, a crowded corridor may be big enough for a painting, but not safe enough. Perhaps you would want to indicate a large graphic instead.

3 What approximate size and format? Is vertical or horizontal appropriate?

 Because of all the equipment in offices, many more horizontals get used than verticals.

4 What are the general decor objectives and space modification or construction factors?

Prior to doing the survey, you should either interview the client on the decor objectives or have a meeting with the designer to get an overview of the general scheme and any wood and metal details. The object here is not so much to match these details as to be able to contrast or harmonize with them at framing time.

When reading the plans or walking through the site, note if any walls have special installation requirements or need additional lighting. I once showed up for an installation with four art handlers to discover that all the perimeter walls of the building were concrete and needed special concrete hangers. Some walls are magnetized and need special magnet hooks. It is horrendously time-consuming to find out these things on installation day, and the installation budget can be blown if the special item needed is not readily available.

> Sunlight Patterns: These should be noted in special areas such as boardrooms where there are limited choices about where to put the art. The key wall for a big painting may get direct sunlight and you will have to develop another solution.

5 If there is existing client art, what should be done with it?

If you are updating an art program, you'll need to inventory the client's existing art to decide what art should be eliminated and what can be used, what needs reframing or restoring, etc.

HOW TO CONDUCT A SURVEY

Sometimes, with small, older spaces, there will be no floor plans available and you simply have to sketch out a rough plan on graph paper. Other times, you will actually be able to walk through the finished space with floor plans. More and more often, art consultants are being called into jobs early in the construction phase, when only floor plans exist. There is a good reason for this. In the past, lighting and walls were laid out without art in mind; when you went to install the art, the lights were invariably in the wrong place. Today, when a company has made a significant commitment to art, their advisors are being hired earlier to consult with architects and space planners on wall treatments, such as recessed walls for paintings, and on electrical installations, such as special spots versus wall washers, where art is indicated.

An art consultant should be able to read a furniture floor plan as well as an electrical and elevation plan. If you are working from an undeveloped space, request a furniture plan rather than just a floor plan. Many times, bookcases and credenzas will determine what size and type of art to specify.

An excellent, simple book on how to read floor plans is Frederic H. Jones's *Interior Design Graphics*, listed in the bibliography.

WHAT YOU WILL NEED
- Floor plan (or graph paper)
- Self-adhesive labels
- Tape measure
- Note pad/clipboard
- Calculator
- Pencil

LOCATION AND MEDIUM SELECTION

As you walk through the site, place a self-adhesive label on the plan wherever you want to designate art. I use either color-coded labels or those I have marked in advance with the codes listed below. These codes relate to budget amounts for each category. Color-coded labels work well because they stand out from the plan and allow you and the client to review the selections easily.

If possible, before creating a budget based on your specifications, you should walk through the space again with the client, showing him in reality where you have indicated art on the plan. This process helps him to visualize the art in place and gets him invested in the allocations before you present your budget; he'll be more receptive if he's perceived the need himself. Of course, this approach only works on smaller projects and with a client who wants to be closely involved.

Medium	Abbreviations
P	Poster
G	Graphic or drawing, 30"x 40" or smaller
MG	Major graphic or drawing, 30"x 40" or larger
PTG-S	Painting–small, 40"x 50" or smaller
PTG-L	Painting–large, 40"x 50" or larger
S	Sculpture
T	Tapestry (fiber or other textured wall piece)
O	Other (e.g., decorative art or furniture)

Above: Office
floor plan. Courtesy
of the Woods
Group Architects.

CHAPTERS:

PROVIDING YOUR SERVICES PART 3

Assessing the Client's VAT

"When I go to search for the art, I feel like I'm playing Russian roulette. I'm never really sure the client will like it—never sure whether I'm picking a winner or a loser."

—*an art consultant who shall remain anonymous*

About forty percent of corporate art is selected to suit the art program concept and sixty percent is selected to please the client's personal preferences. You can see how critical it is, before starting to search for art, to have a clear reading of your client's taste, biases, and knowledge of art. I refer to these combined elements as a client's VAT—Visual Acuity and Taste.

Many consultants show a group of slides, reproductions, or even actual art to get readings on what their clients like. This isn't really helpful, because just learning what someone likes or dislikes without knowing why he feels that way doesn't arm you with enough information to go out and find art that you are sure he's going to approve.

Keep in mind that in a successful presentation at least eighty percent of the art you present should get the client's approval and be purchased. And when you are shipping works across the country or from overseas, the percentage of acceptance should be higher, closer to ninety-five percent.

WHAT AREAS TO EXPLORE

The goals of the VAT test will be a little different in each situation, but here are some areas to explore.

APPROPRIATE SUBJECT MATTER

The taboos will differ with each client. Chapter 3 discusses the usual corporate taboos—religious, political, or highly emotional work. For some companies, these may not be taboos at all, but there may be others, such as humor or subject matter with a "feminine" feeling (for example, a vase with flowers). In order to test for these taboos, include examples from each relevant category.

One client of mine thought a water lily by artist Joseph Raphael was too feminine for the office, but didn't mind the explicitly masculine human X ray in Robert Rauschenberg's lithograph, Booster. *There is really not much defensible logic involved in some choices.*

AESTHETIC BENTS

Aesthetic bents are the personal likes and dislikes of the client that may influence his choices, sometimes unconsciously. If a consultant can identify these preferences early on, it will greatly help the presentation process. When you see that a client has a clearly one-sided taste, such as preferring all geometric pieces or pieces in

a narrow range of color, you can point this out to him and diplomatically ask whether he wants the collection to represent his rather limited spectrum of taste or whether you should recommend works that are perhaps outside his taste preference but that will appeal to a broader range of people.

Some of the areas in which people are very one-sided are:

- Symmetry—some clients may prefer symmetrical compositions to asymmetrical ones
- Color—for example, pink is out, everything blue is in
- Style—a client might like only abstract geometrics, or literal landscapes, or impressionism

An in-house corporate consultant attending one of my seminars told us that her chief executive took a hands-on approach, selecting every piece of art himself. His taste was reasonably good, but limited to abstract geometrical, highly intellectual works. All the paintings he purchased were similar in style. Employees would glare at her in the halls and some finally came up to her and complained that the collection was too intense and boring, and they didn't like any of it.

While you may not be able to change a client's taste dramatically, you can often convince him not to hold other people hostage to it and to let you provide any missing aesthetic balance. You'll find that having clear art program goals will be enormously helpful in this situation. Businessmen understand goals and their purpose. Rarely would a goal be as limited as: to purchase fifty abstract geometric works of art. It would be something more like: to develop a collection that enhances our work space and is stimulating or pleasing to our employees. The client can understand that one person's taste would be unlikely to please everyone.

Often a person's taste can be expanded with exposure. By finding out how limited your client's taste is, you can decide how many presentations to make and whether you should do some art education/exposure activities before actually showing him works to buy.

Note: Sometimes company needs that haven't been mentioned before will surface during the process. One client in charge of selecting the art for a mediation firm brought up the need to have all the conference room art be in the hues of red, orange, and violet and to be intense and stimulating on an emotional level. The firm's research had shown that these colors heighten emotions, and stimulating emotions was the company's hidden agenda for the art program. Apparently, in order for people to be willing to settle a dispute, they have to be willing first to face the emotional reasons for bringing suit.

VISUAL ACUITY

This refers to the broad, hazy area of a client's general knowledge of art and the breadth of his taste. Does he have style preferences? And what kinds of art does he have trouble understanding and appreciating: figurative, realistic, neorealistic, pop, geometric, expressionist, conceptual, color field, action painting? If you are considering presenting any challenging style of art, show him a few examples during this assessment process.

MEDIUM

Finally, if you are planning to present an object of unusual construction or unfamiliar medium—such as neon, shaped canvas, multimedia construction, or wall sculpture—show an example to see how the client reacts to something new and different.

THE VAT TEST

For this assessment process, I have a large group of reproductions cut from books on contemporary art, from magazines, and from gallery announcements and catalogs. They are mounted on 5x7 cards. These visuals are of the highest quality art, often financially out of reach of the client, but still in the style and feeling of the work I'll be presenting.

By showing famous seminal artists, you avoid the client mistaking this process for anything but an information-sharing exercise. He's not judging your examples as recommendations. Another benefit of this approach is that it's flattering to the client when he says, "I like this one, how much is it?" and you quote the $150,000+ price. It also sets the visual standards high right from the start.

I prefer these reproductions to be on cards rather than on slides, because they are less intimidating. When you splash a big image on the wall and ask someone what he thinks of it, he will probably think it must be pretty important. Comments like "It's too feminine" or "My kid could do that" are difficult to say when the image is an imposing five by six feet.

Set the stage for eliciting comments from the client by telling him that whatever he tells you will be helpful and will save time during the art search, no matter how silly or inconsequential his comment may seem to him. I give some examples of helpful information and throw in some typical comments to break the ice and encourage him to say what he's really thinking.

For example: I might point to a Rauschenberg reproduction and, playing the role of a client, say, "This piece has too much detail and I'm distracted trying to figure out what's going on. I wouldn't want it in a conference room when people are trying to focus on a meeting, but it might be nice in a reception area." On a Joan Mitchell: "This is too messy; it looks like something my six year old brings home from school." Or on a Helen Frankenthaler color field painting: "I like the colors of this one."

A client's comments, no matter how off-the-wall, will give you insight into his personal taste and how much he will be able to separate that personal taste from the job of selecting works that achieve the art program goals.

WHAT TO SHOW

With each client, the selection of what to show will be different. If foreign art is out of the question, clearly Japanese prints won't be included. If you think photography might be a good medium for the project, show a selection of different kinds. Clients without much exposure may be anchored in the Ansel Adams school and may not be aware of the evolution the medium has experienced in the past two decades.

Although you should try to choose a range of works from the most conservative to the farthest horizons you can imagine for the project, and you should include examples of all media and styles you plan to use, a presentation of twenty reproductions is usually sufficient to accomplish a VAT test. It's more important to have time to get thoughtful comments on a few works than it is to get a yes/no on many.

Here are some of the categories I might use in my test for the client's reaction to a contemporary American art collection:

Varied and Unusual Media or Construction
- Fiber pieces
- Handmade paper
- Multimedia
- Photography
- Sculpture
- Neon

Subject Matter and Style
- Abstract expressionist—with no easily recognizable geometry
- Abstract with recognizable geometry
- Appropriated
- Feminine subjects
- Figurative
- Humor
- Narrative art
- Traditional subjects, e.g., landscape

In actuality, I just go through my samples and pull out whatever I think will be helpful in getting a reading on a client.

SAMPLE SEGMENT OF VAT TEST

I want to test reactions to:	I use:
Humor	Claes Oldenburg
	Jim Dine
Abstract with obvious geometrical elements	Richard Diebenkorn
	Frank Stella
Abstract with no obvious geometrical elements	Joan Mitchell
	Helen Frankenthaler
Figurative	Joan Brown
	David Hockney
Tough (challenging) art	
emotionally	Joan Snyder
intellectually	Jasper Johns
politically	Jonathan Borofsky
socially	Alexis Smith
Ceramic sculpture	
abstract	Peter Voulkos
figurative	Viola Frey

Clarify the Questioning. Along the way, ask questions to clarify your understanding of why he does or doesn't like a work. "What is it you don't like about this piece? What is it that you like? Why do you feel it is inappropriate for a reception area?" Sometimes the reasons can be very personal, such as "Blue is my favorite color" or "That shape reminds me of the pyramid shape of our headquarters." Sometimes you find that you really haven't learned anything that can be applied to other works, but usually patterns emerge. Test them with questions if you are at all unsure about your assumptions. "I notice you've rejected all three of these works that have some humor in them," you say, laying out the three cards. "Do you feel humor is inappropriate for the art collection or is it just these particular works you don't like?"

INTERPRETING THE INFORMATION

After this meeting, you should have a clear idea of exactly what kind of art the client will love, what he will hate, and what the current parameters of his taste are. You will also know how open he is to dialogue and how elastic his intellectual curiosity is.

 One of my colleagues read this chapter and muttered. "I've seen many a business executive in my day whose glass was full, but whose VAT was empty."

Some clients look on the art program as an art adventure—they approach the process with openness and interest. Others have the opposite response; they feel threatened by having to make decisions on something about which they know nothing and which is so subjective. Once you know where a client stands, you can then and only then assess how far it will be possible to take him to select an outstanding group of works. Most clients need some education, but how much is only revealed through this kind of assessment.

Armed with this information, you can plan how to proceed. On small projects, it's difficult to stretch a client's taste, because exposure to art is what develops connoisseurship. If your project will have, say, only fifty works, and the client has traditional taste, your chances of expanding his taste through showing him seventy-five works of art in one presentation are minimal. In this case, I would probably select the finest works I can find in the proximity of his VAT range. If I felt, however, that the art program concept

urgently called for a more expanded vision, I might schedule two presentations and show him slightly more work, the most challenging work being in the second presentation after his VAT is more developed.

> *An akido master once told me that, in order to jump from one point to another, a person has first to know exactly where he or she is starting and then imagine flying through the air and landing at the desired place. Many people imagine themselves somewhere farther along than they really are and therefore fall short of their target. This has always seemed a good metaphor for the situation of an art consultant and client. A consultant must accurately assess where the client is in order to know where he can go. Some consultants operate on denial of the client's poor potential for growth.*

If the project is large enough and you break it up with several presentations, each time working up to more difficult art, it is possible to take a client a long distance down the road toward selecting interesting art of lasting value.

If there isn't time or money to do several presentations, you might want to give the client a slide presentation, an overview of some of the key issues in art that relate to this project and the kind of art you will recommend. Or you can take him on a museum and gallery tour. The atmosphere in some galleries can be very intimidating, so it's best to call ahead and tell them exactly how you would like them to respond to the visit.

In general, the assessment process helps build rapport and trust between you and the client so that, when things get tough in a presentation, the two of you have a bond of mutual respect.

ASSESSING THE VAT OF LARGE GROUPS

If an art committee consists of four or more people, or rotating groups of people, it's usually not productive to try to assess each person's VAT. Instead, focus on the top decision-maker on the committee, since members of unequal power will often be swayed by his opinions. Try to get agreement in advance on the role the committee is to play. Are they to be a rubber-stamp forum for the decision-maker or are they there to help create diversity in the collection?

The most effective way to raise the visual quotient of a group is through a slide presentation, video, or lecture. Although it is impossible to give a whole history of contemporary art in a noontime lecture, it is possible to present five to six ideas. (If you're not a comfortable public speaker, see about hiring one of the professors at your local college. Their fee might range between $200 and $300.)

I usually start out with a brief statement of the art program concept and how it ties into the overall mission of the company—this gets their attention with something they both care about and understand. Then I show the kind of art I will be recommending and some of the newer concepts that may be unfamiliar to them. The presentation might include what's happening in photography today or the concept of a shaped canvas. Or I might discuss appropriation, where an artist borrows a pre-existing image from another art context to make a new image and show how traditional artists such as Picasso and Manet did this and then show some of the contemporary artists who are doing it now.

Another issue to cover is abstract expressionism or action painting, pointing out some ways to see a painting other than simply in terms of its color, literal content, or surface structure. You might also point out that sometimes the simplest looking paintings are the ones that reveal themselves slowly and are therefore the most pleasurable to live with day in and day out.

At the end of the presentation, review the slides without comment to heighten recognition and reinforce learning.

Note: Slides can be borrowed for lectures from art museums and university art department slide libraries. Each year, *Art in America* sells slides of everything reproduced in the magazine. There are also art slide catalogs from which you can order slides. Ask your local museum's slide librarian to see some of their resource catalogs.

IS THERE SUCH A THING AS CORPORATE ART?

I'm often asked about "corporate art" by seminar participants. There seems to be a preponderance of mediocre art placed in companies. I make a distinction between poorly conceived decorative art and art that is conservative in its style or subject matter, but nevertheless is well conceived and has lasting value.

There are two factors contributing to companies' propensity for "bad art" or "corporate art," as it is sometimes called. The first is that clients with an uneducated eye gravitate unconsciously toward things they understand. These usually divide up into three categories:

1 Art that is representational and easily recognized as familiar: a landscape, seascape, or still life.

2 Abstract art that has a strong geometrical composition, usually where the geometry can be perceived by the viewer. At the basis of everything in nature there is an underlying geometric structure. If you look outdoors or around the room you are sitting in, every form can be reduced to a simple ●, ▲, ■ or a combination of these three elements. This is why a client with a low VAT will gravitate toward the abstract paintings with a few floating squares or triangles rather than toward color field paintings where the geometry is not as obvious and that look to the untrained eye as simple canvases of color splashes.

Trained consultants can help their clients see paintings with X-ray vision. They can point out the underlying compositions, the subtle relationships of the colors, or the sensory triggers of the paintings. If a client can perceive the underlying structure in a work or can perceive its meaning beyond the response he has to its surface, he is on the road to understanding it and appreciating it, even selecting it.

3 Color. Research into art-buying patterns show that people are very influenced by color. The more limited a client's VAT, the less information he has at his disposal to engage with a work of art. Therefore, color becomes a driving force in selection. With a serious collector who has a high level of connoisseurship and an extensive vocabulary for understanding art, the role of color in selection is greatly diminished.

The second reason for "bad art" in corporations must be laid at the feet of art consultants. Untrained art consultants are not able to tell the difference between a work of art that is well conceived and of lasting value and one that is not. And even when they are able to perceive these things for themselves, they may not have the skills to help their clients see what they see. In this case, the art that gets selected invariably falls to the lowest common denominator of the client's VAT combined with the consultant's poor communication skills.

The foundation for success in placing superior art on office walls—both for the good of those who will live with it and appreciate it more each day and for the continued growth of the art community—will be your own knowledge of art and your own skill as an advocate.

■ ■ ■

Presenting the Art

"Every man carries his own inch-rule of taste, and amuses himself by applying it, triumphantly…"

—Henry Adams

The first decision to make about presenting art is how many presentations to schedule given the art program goals, the total number of pieces to be acquired, and any goals you may have set for developing your client's taste.

Sometimes, if the project is small and my client's VAT (visual acuity and taste) is low, I resign myself to simply finding the best work possible in the client's range. On the other hand, if the project has some substance and the client has some growth potential, then I'll take the time to work out a series of presentations that will gradually develop his eye.

WHEN TO PRESENT

Organize a presentation when you feel you have located enough work that meets the art program objectives, and not a moment before.

Perhaps the biggest mistake I have ever made was for a suite of offices I was doing for the publisher of a major newspaper. He had a narrow VAT, with a stubborn allegiance to his personal preferences. He liked only abstract art, with some underlying geometric structure and no emotional content. Artists Robert Motherwell, Ron Davis, Larry Bell, and Richard Diebenkorn would be his cup of tea.

Since the job was his private suite of offices, I felt the art should reflect his personal taste as much as possible. There was no opportunity to develop his VAT and he was interested only in getting the job done quickly with quality art. I searched every gallery in the region and turned up only three works I knew he would like. We needed fifteen pieces. I suggested that we would either have to wait a month or so for some new work to appear or I would have to go to New York. He insisted on having a presentation immediately. Newsweek was coming to interview him in six weeks and he wanted his office done. Against my better judgment, I proceeded with the presentation, included varied works, and hoped he'd discover in the presentation process some new aesthetic bent. It was a dismal but enlightening day when he selected only the three works I was certain he would like.

Rather than waste a client's time or money in putting together a presentation that is doomed to fail, there are short-term solutions for those situations when an office party or press interview is imminent. Works can be borrowed or rented from museums, rental galleries, artists, and even galleries or publishers.

WHAT TO PRESENT

The rest of the chapter expands on "what" and "how," but here are a few general notes.

As a rule, the less clients know about art, the harder it is for them to look at a lot of it. They can easily get "visual overload." Seventy-five works per presentation seems the top limit for most clients, beyond which they get an acute case of the "no's." They just stop seeing and have a negative reaction to everything.

Whenever possible, show the actual art, but consultants will often show large works first by slide or reproduction and then have only the selected ones brought for presentation.

Note: Slides can be very deceiving. A painting may look spectacular in a slide and dreadful in person and vice versa. It's best always to see the work before presenting it in a slide to a client so that you can be an appropriate advocate.

WHERE TO PRESENT

Where you should present depends on the size of the project and the facilities available.

THE CLIENT'S OFFICE

For limited projects that involve only works on paper, many consultants present in the client's office, but I feel it's the least successful place, because it is so easy to lose control.

You want a client to feel relaxed when he's selecting art, which is a right-brain activity. If he's in the middle of his normal routine, he will probably find it difficult to shift gears. Breaking away from analytical, left-brain thinking is difficult to achieve when a client is on his own turf. If you must present in the client's office building, do so in an isolated area, such as a training or conference room or a boardroom, away from curious staff and the usual distractions of his office.

For the same reason, try to schedule the presentation for hours when the client is not immersed in business, either at the end of the day, 5:30–6:30, or at the beginning, 8:00–9:00.

Bring cardboard or other materials to cover up the art so that you have control over what you show and when to show it.

> **Note:** It can be dangerous to leave art on approval over night at a client's office building. Curious employees or the cleaning crew may accidentally damage the work. It's wise to take whatever precautions you can, preferably leaving the art in a locked room, but at the very least making signs asking that it not be touched and putting cardboard between works.

NEUTRAL PRESENTATION SPACE

The best place to present is a neutral space specially created for viewing art—with gray carpets, white walls, track lighting, and a sufficiently large area to view seven-by-ten foot paintings or tapestries. Some art consultants have created their own viewing spaces in their offices. Another place that can work is a closed gallery or a framer's back room.

Consultants who work in large metropolitan areas have access to presentation spaces created by fine art shipping and packing companies. These viewing rooms rent from $50 to $150 per hour. The advantage they offer is that the shipping company can pick up all the art from your different sources. They also assign an employee or crew to assist with the presentation by carrying the works in and out, which allows the consultant to stay focused on the client. At the end of the presentation, the shipper returns all the eliminated works and takes the ones selected to the framer or stores them until the works are needed for installation.

See "Shippers and Handlers" in the Resource Directory in the Appendix for a selected national list. If you don't have a presentation space in your community, discuss getting one started with either your framer or art forwarder of choice. If several art consultants get together and agree to use such a service, the request will be even more compelling.

THE ARTIST'S STUDIO

On occasion, I've brought the client to an artist's studio—to see a major sculpture, for example. There are three factors that contribute to my decision to do this. First, I judge the artist's ability to be personable and develop rapport with the client. Some artists are the best salespeople for their work and others are the worst. Second, when the client is hooked on art, he'll enjoy the opportunity to meet with an artist. Third, when the client has seen the artist's work and is predisposed to like it, I can be reasonably confident that the purpose of the visit is to select a piece, not to decide whether we like the work. If all these factors are positive, an artist studio visit can be the brass ring of an art consulting job, an experience that really helps to personalize a client's involvement.

SETTING UP A PRESENTATION

The critical role of the consultant during the presentation is to help the client to see the art—to give him a visual or interpretive hook, so that he is not just looking at one piece after another. (See page 139 for a fuller discussion.) This is true even for someone who has a high visual quotient. To play this engaging role, you must be free of all the details of handling the art. For this reason, I recommend that you have help on any project with more than fifteen works of art. Your assistant can keep an alphabetical list of all the works you're presenting, along with the prices, discounts, important provenance, and other pertinent information, so that any questions by the client can be readily answered. In addition, you need at least one other person to carry paintings in and out of the room. If you're working with large-scale works, you may need two or more assistants for this task.

AVOIDING VISUAL OVERLOAD

One of the important considerations in organizing your presentation is to avoid overloading your client visually. When a client becomes fatigued, he has difficulty focusing on the art and will be liable to reject everything in sight.

The human brain works by automatically categorizing visual elements. Therefore, when you arrange the art, try to present it in some logical order, such as all works on paper for employee offices. It's much easier for the client to make a comparative choice from like works than it is for him to look at a painting one minute, a print the next, and a drawing the next. The fatigue-induced "No" Syndrome takes over much more quickly when the client spends his energy adjusting to different media and scales rather than focusing on the merit of a particular work.

VISUAL OVERLOAD EXEMPLAR

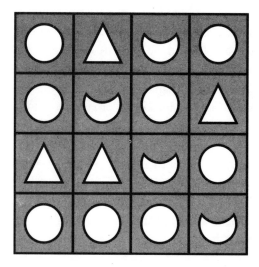

Look at each of the squares at left for five seconds.
Which one can you recall most clearly in terms of internal elements?

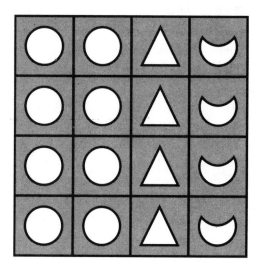

ORGANIZING THE ART

There are three primary ways to organize the art.

By Specific Location. This is the best way to present if it is a small project, say just a reception area and a few offices on a maximum of two floors.

By Generic Areas. Present the art in groupings suitable for general areas. You might say, "Let's look at all the art for private offices," or "Let's look at all the art for the reception areas…", or for public areas, or employee work stations. In this way, the client can visualize the particular generic area and develop a criterion. Or you can even remind him of the particular nature of the area. For example, you could say, "These are work stations staffed predominantly by women doing word processing." This approach works well for midrange projects.

As consultants we may be able to visualize twenty individual floors in a project, but most clients can keep only one or two floors in their mental recall. They become confused and bewildered if you start saying, "Now I was thinking of this painting for the eighth floor reception where the maroon brocade couch and the Chuck Arnoldi sculpture is going." "Huh?" he asks, trying to visualize it all. On the other hand, every client knows what he thinks is appropriate for a conference room, a reception area, a board room, etc. After the art is selected, you can figure out where it should go and make it look great. If you spend hours before the presentation trying to arrange clusters of matching art for each area, then, when one or two pieces fail to get selected, the whole scheme is thrown off. In the end, most clients only care that their offices look good. They may have special areas where they want to control exactly what pieces of art are going where, such as the board room or entry lobby, but generally on midsized projects the consultant can assume the lion's share of responsibility for where things go by simply implying to the client that that's the best way to proceed.

Art for Art's Sake. In this approach, the client is encouraged to select what he likes and what fits the art program goals. Later, the consultant figures out where it should go. This approach works well on some large projects, and many serious corporate collections are developed in this way. An annual art budget is set and the curator presents recommendations to the art committee.

On most large projects, however, a combination of these approaches is used. For example, on one bank project, I made specific group recommendations for the main floor lobby areas, generic selections for all work areas, and we selected, on an art-for-art's-sake basis, important paintings for the reception areas and executive floors, which were to be rotated every three months.

In all these methods, it is helpful to get approval for more art than you actually need so that after the presentation you can review the selections in relation to the needs of the project.

PRESENTATION AS PERFORMANCE

Presentations for small jobs do not need to be elaborate. On larger projects, where you are trying to raise the level of the client's VAT, a measure of planning and creativity will go a long way toward helping you achieve your goals. I like to think of the presentation as a performance, which should last two hours at the most, with a break at least every half hour. On the next page is a rough outline for such a presentation.

OPENING REMARKS

It's helpful and grounding to review the goals of the day. When you have been so absorbed in preparing for the presentation, it's easy to forget the client has not been thinking about the art program and may need to be oriented. "Today we're going to be looking at art for the Tacoma and Hudson branch offices."

If it's the first presentation, or a presentation before a revolving art committee, I give a little pep talk with some guidance about the process of the presentation and a few points about selecting art for a company. "Even for a professional, the presentation can be trying because you are looking at so much art in a compressed time. Be on guard for visual fatigue, and if at any time you feel you are not really seeing any more—when everything seems like a no—let me know and we'll take a short break or change media." A good art consultant will learn to anticipate this state and take those breaks before they are needed. Remember when you start to get a bunch of no's, it may be an indication that your audience is tired. The reason for mentioning this "negative syndrome" in the beginning is so that you don't seem defensive when you bring it up later.

The Personal Versus the Company. People tend to buy art as though they were buying a piece that would hang over their own living-room couch for the next twenty years. Explain that everybody has personal taste, and that in putting together a collection for the whole company you are trying to get a range of art. Encourage them—even if they do not particularly like a work and would not buy it for their own home—to broaden the horizon of what they say yes to. The way I phrase it is, "Some things that aren't your favorites may be somebody else's favorites. Let's have not only yes, no, or maybe, but also 'I can live with it.'" People need to be able to say that they don't like a work without saying that they don't want it in the collection; this freedom to express their opinions acts like a valve on a pressure cooker.

> I usually suggest that each person select one piece that is his or her favorite so that right from the start it is clear there won't be consensus on everything. Those who were prepared to be annoyed by other people's opinions lighten up.
>
> —Anne Kaiser, art consultant [16]

A PRESENTATION OUTLINE

REHEARSAL:

What, if anything, will be hanging in the room? Set the stage.

In what order will things be shown?

What will be shown together?

What are the tough works that will need special explanatory visual aids, such as scale drawings or books?

Review what I can say about each work, something unique to the piece that will help the client see it with new eyes.

Make sure the presentation crew has clear instructions.

Check client comfort: chairs, food, etc.

OPENING REMARKS:

Welcome client(s).

Establish rapport.

Review the art program goals or concepts (if necessary).

Give instructions on how we will work together.

Help the client feel comfortable about the process.

FIRST ACT—THE WARM UP:

Easy, less expensive things first.

Graphics, drawings, art for offices or work stations.

SECOND ACT—MORE DIFFICULT WORKS:

Middle-range works.

Small paintings, textiles, major drawings or graphics.

Art for conference rooms, reception areas, executive dining rooms.

INTERMISSION—REFRESHMENTS:

Visual break.

Remove art selected from the room.

THIRD ACT—MORE CHALLENGING DECISIONS:

Art for key areas, such as the main entry lobby or executive floors.

Any remaining difficult selections.

BREAK:

(People get tired at the end, so they need more breaks)

FINAL ACT—SOMETHING FUN AND EASY

A change of pace or medium.

Perhaps a slide presentation of paintings or sculpture to be viewed at the next presentation. Here they are being asked what they want to see rather than what they want to buy, which is an easier decision. And sitting in the dark is a nice change of pace.

Review the "maybe" pile of works on paper.

Make choices between two chosen works.

Look at ceramic pieces or small sculpture.

When you have a committee, it's good to have an agreement to disagree. I always ask if anyone has tried to select art with their spouse, and people nod their heads and say it is the hardest thing they have ever attempted. I explain that it is much more difficult to select art with people you're not married to, because you don't have as strong a motivation to reach a consensus. Art by committee, if we reduced everything to the lowest common denominator in the group, would make a very boring art program. The value of having a committee is that you get divergent points of view so that the collection has a range and dimension to it. Make it clear that it is deadly to pick art by consensus.

Price. The cost of art is very confusing to most clients and the issue can be detrimental to their making good selections. People who are not used to buying expensive art are shocked, sometimes paralyzed, when they hear the prices. They look at each piece and ask themselves, "Is this worth it?" and they think, "This painting costs more than my boat!"

I try to deemphasize the price of individual works by telling them I have the costs written down but I'm not going to encumber the presentation by stating prices each time. I point out that the relative cost of a given work can be misleading because of the differences in discounts and the stages of the artists' careers. If they are curious about the cost of a particular item, they can ask you to look it up. Or if a work is an extremely good value and will help stretch the budget, you can mention this positive point as you present the work.

WARMING UP

In the "first act," try to start with easy, less expensive works, such as graphics or drawings, to get the client visually warmed up and feeling comfortable. It's helpful when you are showing works on paper to have a white mat corner and even a generic frame-moulding corner to put next to the corner of the work. For some works of art this greatly helps the viewer focus on the piece. These corners can be purchased from any framer and they often have discontinued samples they will give you. The purpose of this is not to show framing but to help punch out a work that may be difficult for the client to visualize.

Remember to give lots of encouragement to the client and to make the process fun. After he is warmed up and feeling confident, then you can switch medium or scale and begin to show some of the middle-range works.

PRESENTATION HURDLES

There are certain hurdles that repeatedly come up in art consulting, and there are also visual traps or patterns into which clients fall. Here are some of the most common ones and strategies for dealing with them.

The Client Says "No" to Something Good or Important to the Art Program. Some works need more exposure than others to be appreciated. One strategy is to hang the piece up on a side wall and say, "This work is subtle; at first it seems very simple, but the more you look at it, the more it resonates. Why don't we just put it over here on the side and come back to it?" Very often in the process of being in the room with it, people will begin to appreciate it more.

A similar strategy is just to have the artwork hanging on a side wall from the beginning of the presentation. During a break, take it down and have it brought over to the presentation wall. Often, this exposure unconsciously develops an appreciation for the work.

Loud, Colorful Works versus Quiet, Soft Works. Often a client will approach each piece as if it were the one piece he would have to live with each day. Any work that is not a bright, colorful statement is rejected, particularly anything in a monochrome or black and white. It's helpful to put several of these bombastic works beside one another and show how hard they are to look at all together. You can say, "You don't want your office to look like an art museum where each work punches off the wall demanding equal attention. There needs to be texture, as in

music—loud notes and soft notes." (They love this comment because many clients secretly think their art consultants are trying to turn their offices into museums.)

Another simile that works well with men is a loud plaid suit, a loud tie, and spectator shoes. They wouldn't wear all these items at one time. Put a black-and-white work between two colorful pieces and let them see how much better they all look. Then show them several quiet works together and let them pick their favorite ones.

Sometimes quiet works show better together than interspersed with colorful pieces. "Quiet works are rest spots for the eye and they often grow on you after you've lived with them for a while. So let's pick some quiet works to help balance the collection."

Important Works You Want Selected. For any number of reasons, a consultant may think a particular work is critical to a project. One strategy is to ask the client to pick from three works by the same artist. Include a mediocre work, one that is inappropriate for the space, and the outstanding one you want them to select. Given a choice, the client will usually pick the best work, and this process helps to develop their eye. Also clients have to have something to say no to or they don't feel they are doing their job.

The Client Vetoes a Poor Work. If you have mistakenly borrowed and presented a piece that is not very good and a client says no to it, admit your mistake and tell him that he is absolutely right and the piece should not have been in the presentation. It helps validate the client's eye. "I must have been tired that day—this work is not very good," and describe what's wrong with it.

Visualizing Commissions or Major Installation Pieces. If you have a major work to select that requires the client to visualize it in its proposed location (such as over an escalator), it is helpful to have a scale drawing made of it in its proposed location. It's not expensive to have an artist's rendering done; architects do this all the time. I think we forget that our ability to visualize works out of context is a particular skill that we have as professionals and many clients simply are not able to make the translation in their mind's eye.

Everything Selected Looks Alike. Take several works out, line them up, and point out the aesthetic similarities. Ask permission, as the consultant, to be the counterbalance in order to expand the horizons of the collection.

Deference to the Chief Executive. In a situation where one person is senior to the other people on the committee, everybody may be looking to see what he likes before they express their opinions or they say nothing for fear of being judged. This can be crippling to the integrity of the art program. One effective way of dealing with this is to have a paper with the numbers of every work you are presenting and let people mark down their decision on the paper. On the works that are maybes, take them out again for a second vote.

Japanese clients, in particular, can be very challenging because, although they do everything in groups, it is impolite in public for a junior executive to express a personal opinion contrary to his senior. So at a presentation everyone will be looking at the top executive for direction. If your client truly wants to have the benefit of committee input, then doing it silently by paper evaluation is the best way. You can tally up the works and review them at the end if necessary. Also, Japanese clients have great respect for teachers and professionals with expertise. It is considered impolite to make negative comments or express their opinion publicly the way Americans do. For example, in classrooms, children don't question information the way they do in American schools. When working with Japanese clients, adjustments need to be made in your style and techniques to accomplish your goal.

GIVING YOUR CLIENT A VISUAL HOOK

As art consultants, particularly those of us fortunate enough to have formal art history training, we take for granted what we are seeing when we look at a work of art. It is difficult for a client with a low VAT to look at one work after another without some visual hook to hang his judgments on. One crucial role of the consultant during the presentation is to point out some aspect of the work that will help the client see beyond its surface.

Your comment doesn't need to be profound. "Notice how much energy emanates from this work simply because the artist used these short, circular brush strokes and juxtaposed the colors. It almost feels like a tornado is coming through the canvas." Or a comment on why you think the work would be good in a specific location: "I thought this would be a good piece for the small reception area outside your office. Since the space is so narrow, this piece with such a deep perspective will create the illusion of there being more space than there actually is."

When I look at a work of art, it's as if I were looking at it with X-ray vision. I might first note the sensory dimension—how does it make me feel? Then I might notice some plastic dimension of the painting, the technique with which the artist has applied the materials, say the heavy impasto of the paint. I might then look at the composition—what are its dominant elements? This is an automatic assessment of the work on several different levels at once. As soon as I hit the most interesting or easily accessible aspect of the work, I translate it into laymen's terms. Instead of the "Van Gogh gestural impasto," it becomes "energetic brush strokes that feel like a tornado." This is a visual hook, something the client can perceive and that helps him understand the impact of the work. The more diverse the comments the better.

Some examples:

"…The perspective in this work draws you into the picture. It will create the illusion in your boardroom of more space than there actually is."

You might discuss something about the painter's technique. "By making several underpaintings and slowly building up to the surface of the work, the artist has created a painting of great depth that reveals itself the more you look at it."

You might want to make a comment on the color, e.g., why Thiebaud uses pastel colors, or how the use of pastel colors creates a certain nostalgic effect.

Or you might want to comment on the artist's reputation or style, e.g., how Oldenburg became famous for making common objects the subject of his art.

You can comment on the use of rhythm or how one element is used in repetition to create balance in the work.

You may want to use a decor point: "I chose this work because it has a lot of the colors that are in your decor and it ties together the interior of the space."

You may want to talk about the subject matter of the piece. If you are trying to select a work for the conference room or for a busy stock-trading room in a bank, you might say, "I chose this work because it's very peaceful, very calm, and it would be a counterbalance to the frenzied activity of the room." In contrast, you might say you chose a piece for the reception area, where the client's customers often have to wait for half an hour, because it is active and lively and should offer an engaging focus of interest.

On the other hand, you don't want to deliver an art appreciation lecture. Some clients are in a hurry and just want to get on with the art program. Assess how much information they need and what their level of interest is. Certainly you don't need to comment on every work, but it's helpful if you can say something to focus the client's visual interest.

Perhaps the most valuable part of art history training is the ability to analyze a work of art. This is a critical skill that separates a decor consultant from a professional art consultant. If a consultant is unable to help the client see and appreciate a work on many levels, then the only dimension left is decor. One of the most gratifying aspects of consulting is expanding a client's horizons. It's like giving someone with poor eyesight a pair of glasses. The world is revealed in a multitude of new ways.

NOTES FOR GALLERIES

If you are using the gallery to do a presentation, schedule it when the gallery is closed. If you don't have a separate viewing room, remove the current art on the walls except what you are showing the client. Art on the walls is very distracting and can cause visual overload. The client unconsciously will be working to block out other stimuli.

■ ■ ■

CONCEPTUAL HANDLES FOR YOUR CLIENT

Here are some conceptual handles for evaluating art with your client.

Technical Dimension: Some aspect of the skill, technique, or craftsmanship of the artist in creating the work.

Expressive Dimension: Not everyone realizes that art embodies human expressive qualities, that it can actually take on human traits. By commenting on what the painting expresses to you and eliciting a response from the other viewers, you can demonstrate that there is no "correct" expressive response. Everyone brings his or her own experience and associations.

Sensory Dimension: Any element or quality of the work that makes it interesting to our senses. These qualities are visual elements such as colors, shapes, size, line; tactile elements such as texture, medium; and kinetic elements.

Formal Dimension: The structural properties of the artwork, that is, the pattern or design in terms of composition—themes and variations, balance and symmetry. Form is what ties the work together and gives it the feeling of "unity." If you can point out pattern or relationship between the various parts, it helps the viewer understand what is pleasing or what makes the work successful.

Intellectual Dimension: A direct or indirect reference in the work to an idea, theme, style, object, or even another artist's work. Giving the viewer insider information on the intellectual context of a work may help him or her appreciate it on another level. Likewise, some works have a cultural dimension—their understanding is enhanced by knowing details of the cultural climate in which they were created.

Contemporary or Historical Significance: The reputation or importance of an artist or the special significance of a work. Sometimes showing a book or an article on the artist will help illustrate the point you are trying to make.

Corporate Theme or Decor Concern: Some aspect of the work that relates either to a corporate theme, value, or quality or to a decor concern that the work helps solve.

Commissioned Art

"Conceptual art, environmental art, earthworks, and reclamation monuments brought art out of the cloistered museum and gallery orbit into public spaces—from vast rural American landscapes to urban streets. Parks, plazas, waterfronts, airports, train stations, hospitals, hotels, schools, courthouses, playgrounds, shopping malls, street corners, and parking lots became suitable sites for museum-quality artworks."

—Joyce Pomeroy Schwartz, public art consultant [17]

The increasing presence of art in public places has had its impact on corporate executives, and the growth of art works commissioned by companies is one of the most exciting changes taking place in the art consulting field. In part this growth has resulted from the percent-for-art program mandated by cities and counties. Art is now not only seen everywhere, but also all sorts and sizes of firms are commissioning it, and the range of media considered suitable has opened up. It can be a huge outdoor kinetic sculpture, a suite of lithographs for a small hotel, landscape art, play equipment in a park, a tapestry in a reception area.

Thirty percent of all U.S. corporations have commissioned art work. Beyond the benefits to be derived from other art programs—enhancing the space, projecting a desired company image, and making a satisfying and stimulating place to work—commissioned art can give companies some very specific benefits:

- the work can be conceived with the company image or theme in mind,
- the work can solve an unusual space problem, and
- a work by a regional artist will not involve heavy travel and shipping expenses.

COMMISSIONS, PERCENT OF TOTAL CORPORATE ART PROGRAMS

1960s—14%
1970s—24%
1980s—38% [18]

In this chapter, we'll walk quickly through managing a large commission, from the first notion that commissioning art may well suit your client to the final press release when the art is in place. A more detailed discussion of many of the technical aspects of the process can be found in a useful book by Jeffrey Cruikshank and Pam Korza, called *Going Public*. [19]

You should be managing smaller commissions, particularly at first. They follow the same path, though they are significantly less complex. In a dentist's office, for example, it would be a strange wall hanging indeed that would need a structural engineer. You can easily scale down the process described here to suit the size and nature of your commission.

A large commission can put a strain on your relationship with your client. The process may be long and difficult, and the client is spending a lot of dollars on something invisible, something that has not yet been created. Thomas Garver, consultant for Rayovac Corporation, says, "Basically, the client is buying the respect he feels for you." I recommend you offer large commission services only to those clients with whom you have developed a strong working relationship and only after managing many smaller commissions.

> "A large-scale commission is a minefield of aesthetic, political, legal, and insurance problems. And when a project is mandated by the city, it calls for expertise in dealing with the bureaucracy, not to mention the occasional overly sensitive artist, egotistical architect, and panicky client. These commissions should by no means be undertaken lightly."
> —Tamara Thomas, art advisor [20]

If you feel you are not qualified to handle a commissioned project on your own, consider calling an experienced consultant in your region, who may be willing to consult with you on implementing the project.

On the other hand, small-scale commissions can be a lot of fun, both for you and for your client, because you have a more personal involvement in the creative process. The key is in making sure they are well managed.

THE CONSULTANT'S ROLE

Since one of your basic tasks will be to translate the company's needs into an art concept, a working knowledge of all media and all genre is useful. You will also need up-to-date information on art law, insurance requirements, and, when appropriate, local percent-for-art regulations.

Once the selection process has been completed, you will want to give the chosen artist full support in creating the artwork. You'll find yourself at the hub of the wheel, coordinating the efforts of all those involved in bringing the project to a triumphant conclusion. In this process, sensitivity to people's various needs is critical. You will work with as many people as the scale of the project requires: the client, the company's legal staff, consultants, designers, architects, and community safety representatives, not to mention the artist, lawyer, foundry, craftsmen, and installation crew. You will have to call not only on your knowledge of art and artistic resources, but also on your diplomacy and organizational skills.

DEFINING GOALS

When you are working with a number of people from different fields, setting a common goal is the key. First you must set your own long-term goal, with a clear idea of what the client needs and what you can ask of an artist. Then you should consider holding informal interviews with each of the major players, including such people as the designer, the architect, the contractor, and the landscape architect.

> *"The consultant had better have some knowledge of the different fields and the language thereof, lest she or he be dismissed as a dilettante and the client so informed."*
> —*Tamara Thomas, art advisor*

These conversations will help clarify their concerns and will give you a chance to hear their suggestions. If you are receptive and listen carefully at this point, you may avoid disastrous conflicts later. Their views may be conservative—for instance, an architect may fear that the art you bring in will do something awful to his beautiful building—but usually their insights are valuable.

These interviews will also give you a chance to present them with an overview and instill a sense of being involved in a larger team effort. And this is a good time to make clear, as diplomatically as possible, that you will be a firm advocate for the integrity of the artwork, however sensitive you are to others' concerns.

> *"It's important to start out by going through the processes, by comparing timetables and flow charts, by defining common jargon."*
> —*Patricia Fuller, public art consultant* [21]

SELECTING THE ARTIST

You want an artist whose work is appropriate to meet the client's goal, whose work is of the highest quality, and who can respond to the particular demands of the site, carrying out the commission in a timely manner. Other considerations will probably come into play, such as the company's interest in supporting a local artist or a preference for a particular material or subject matter.

The initial selection process will vary depending on the scope of the project. The following steps might be used for a small to mid-range project:

- You narrow a field of possible artists to about ten.
- You make a slide presentation to your client of the works of these ten; this presentation serves to review the artists' work and also reinforces the decision to commission an art work by showing existing examples.

- If there is no one artist who seems the obvious choice, you and your client narrow the list to three.
- These three finalists are invited to compete for the commission and are given a fee to submit models of their concepts.

Depending on the size of the project, you may want to set up a blue-ribbon committee to help advise the client during the final selection process. Besides you and the client, the committee should include several trained art professionals, such as museum directors or curators. (Usually an honorarium is paid to each member on the committee.) The commissioned work will become part of the art treasures of the community, and these objective art experts will support your efforts to get the very best art possible.

INFORMATION THE ARTISTS NEED

To develop appropriate concepts, the artists need certain basic information about the site, the budget, the schedule, the goals of the company, and any sensitive social factors that have to be considered. They should be given any information that seems at all germane to how they will approach the project, including any relevant corporate or local history and any environmental concerns. If they are unable to visit the site for any reason, they should be provided with photographs and plans with traffic patterns, etc.

THE PROPOSAL STAGE

There are three main elements in a proposal, and each of them may need your supervision. These elements are: a description of the artwork, a time frame for completing the project, and a detailed budget. Now is the time to walk the artist through his or her proposal and anticipate any problem that could possibly arise.

A Description of the Artwork. The visual support may be just rough sketches showing the theme, media, colors, and so forth. Such a rendering is often sufficient for the client to decide that he or she likes it and that it is appropriate. For large projects, the artists usually make maquettes.

"There are many different ways in which artists work. Some do lots of quick sketches, while others slowly develop very finished presentation drawings. Some artists do a lot of research, while others work in a more internal fashion. It is important that we do not establish rules for how artists create."

—*Joyce Kozloff, artist* [22]

A prototype for a painting or a wall hanging will simply be a more fully developed drawing. For a three-dimensional work, the artist will do a maquette. Perhaps a number of prototypes will have to be developed before the client can clearly visualize the project. One Hawaiian hotel owner walked into the lobby of his hotel and ordered the entire sculpture installed on its ceiling to be removed because it didn't look as he had expected it to. Perhaps an architect's rendering of the piece in place could have avoided this unhappy outcome. But you must also guard against asking the artist to work his concept to death in these early stages. Sometimes there's a delicate balance between building up the client's confidence and wearing down the artist's creative energy.

Be sure to ask the hard questions now, at the maquette stage. Are there any unaddressed safety issues? Are there any particular problems about how the work will be moved and installed? Whenever appropriate, a structural engineer should be consulted, who should then sign off on the fabrication drawings and the installation plan.

A warning: Not all works translate well from small to large scale. Tom Garver, consultant for Rayovac Corporation, says: "Watch out for the problem of the cute little puppy turning into the big ugly dog. One of the worst works of public sculpture I've ever seen is in Minneapolis, put up in the late fifties or early sixties. In its original form, it appeared to be a beaten brass scroll, so it suggested the forerunner of the book, but when the thing was scaled up to twenty-five or thirty feet high, it looked like a refinery that had exploded."

The sketches and maquettes for proposals that are not accepted remain the property of the artists. The ownership of those made for the winning proposal is open for discussion, and should be settled in the contract. Sometimes a corporation has no interest in storing such material and ownership can revert to the artist.

A Time Frame for Completing the Artwork. This should include key stages in the fabrication process. You should work carefully with the artist to make this time frame as realistic as possible. If the company's proposed schedule doesn't seem reasonable, the artist should discuss the possibility of revising it.

Check with the artist to be sure that all materials and supplies necessary for the project will be available to meet the schedule. Sometimes an artist who is not very experienced in the collaboration involved in fabrication, or who hasn't done a project on such a large scale, will underestimate the time involved. I review every step of the creative process with the artist to anticipate all possible delays and technical problems.

A tapestry artist didn't realize that, on a commission five times the size of her usual pieces, she would not be able to get the wool from her Irish mill in two months as usual. The mill would have had to create a special order, matching dye lots, that would have taken six months, way beyond the tight schedule for the commission.

A Detailed Budget. This may be the hardest thing for an artist to address, but budgets are things businessmen understand very well. You and the artist should work together to produce one that is careful and complete and that includes the following expenses:

- artist's fee
- labor costs
- studio and operating costs
- travel and per diem expenses for site visits and research
- fabrication costs
- contracted work, such as plumbing or wiring
- site preparation costs
- transportation of artwork to the site
- installation costs
- insurance
- documentation
- maintenance
- public relations campaign [23]

Artists have a habit of underestimating the expenses of a project. To avoid the artist having to make up the difference out of his own fee, or having the project suddenly run out of money, make sure the budget is really feasible. It is also a good idea to have a contingency line in the budget to cover such things as increased costs of materials.

The line item for ongoing maintenance reflects the responsibility of a company to maintain a work in the way it was intended. For instance, if the artwork is a fountain, it must be in working order. There is also federal legislation, The Visual Rights Act of 1990, to protect art as it was constructed by the artist. (See page 170 for an anecdotal example.)

PREPARING THE CONTRACT

It is usually time and cost effective to have the client's legal staff develop the contract, but you can provide them with an outline of important terms that should be incorporated and a sample contract. Tad Crawford has prepared both a checklist and a standard contract for his book, *Business and Legal Forms*; the checklist is reprinted in the Contracts and Forms section of the Appendix. If the project is very large and complex, you might want to get a copy of the New York City Bar Association's Model Agreement, "Commissioning a Work of Public Art."

PRODUCTION AND INSTALLATION

Once the work of creating the art is underway, your role will be to shepherd the project through to completion, keeping your client informed about the project's status and helping the artist keep everything going on schedule and on budget. Be prepared for trouble somewhere along the way.

The various approval stages set forth in the proposal will help both to reassure the client and to keep the project on track. The artist, art consultant, and client (and the structural engineer, when applicable) should all sign off on the final approval.

The installation of a large piece can be a complex and even dangerous undertaking. An insured and bonded professional installation crew should work under the supervision of the artist. Don't be tempted by the "cost savings" of an artist with a flatbed truck and ten friends. Your client would not be impressed with the savings if he knew the litigation risks this could involve. To locate professional installation crews in your area, call your local galleries and museums.

In the same vein, when the installation requires plumbers, electricians, masons, and so forth, the responsibility for coordinating their work should be entrusted to a licensed general contractor. You have neither the training, the proper licenses, nor the insurance coverage to accept this responsibility. Beware of developers who try to pass this job on to you.

Note: There are high risks involved in commissioning large-scale works. An experienced fine art insurance agent should be consulted regarding proper protection for both the art consultant and the artist.

PUBLIC RELATIONS

Large commissions present many opportunities for effective PR, and small commissions may have their own appeal to the media. Imagine what aspect of the project would be likely to engage the media, beyond the usual opening gala, which may or may not be an exciting event. Is there anything particularly interesting about the artist? If the artist is adept at PR, he or she might give an interview.

You might involve the local art or architecture writer early in the process, setting up opportunities to cover the different stages of fabrication. The installation of a large piece can offer dramatic material for television coverage. For example, in Oregon, when Raymond Kaskey's huge sculpture, Portlandia, was taken down river and then driven through the streets of Portland to be placed on the Portland Building, it was a national media event.

How to capitalize on PR opportunities is discussed in Chapter 19. For a more thorough discussion, see Abbott and Webb, *Fine Art Publicity: The Complete Guide for Galleries and Artists.* This book has in-depth advice, as well as such practical aids as sample press releases and work sheets for publicity planning. (See the Bibliography for the full citation.)

Most people learn about art through the news media. A well-planned public relations campaign will have a direct bearing on the enthusiasm with which employees and the public at large greet the commissioned work. PR is crucial to the success of the project, both to achieve the client's goal and to support the artwork. Public relations is one of the critical ways you can serve as a link between the art world and the other segments of the community.

■ ■ ■

Art Sources and Support Services

"Tis well said, but we must cultivate our garden."
—*Voltaire*, Candide

Say you have a new project: You are to provide an art program for a major hotel, and you must find more than six hundred works in two months, including three hundred works that are similar in style and medium. You know of several artists who work in the graphic medium you've chosen, so you contact their representatives and set up appointments to see what's available. You also contact ateliers who work on contract. Before you're through, you will have contacted galleries, framers, shippers, a lighting advisor, an insurance agent, a photographer, and you'll have assembled a first-rate installation crew.

An art program may be your brainchild, but it will never materialize without the help of others. These "others" will range from the people who make the art to those who install it, and the more you know about them all, the more successful you will be as a consultant.

This chapter briefly discusses galleries, art dealers, and artists and their representatives, and lists other sources of art. It then covers the vital support services, as well as those on which you will probably call only occasionally, such as exhibition design firms and sculpture foundries.

In the Appendix, the Resource Directory lists specific resources, mainly in large metropolitan areas. But you will want to build your own file, from research in magazines and newspapers and through networking.

GALLERIES

Galleries are usually a consultant's primary source of art, and your relationships with them are invaluable. But most galleries operate for retail customers, and they find it difficult to commit the time necessary on a drop-in basis to show art consultants through their entire inventories. Make the process as efficient as possible by calling ahead and making an appointment to view their offerings. Tell them what you are looking for so they can organize an appropriate selection. Let them know your price range, the company's taboos, the level of the client's taste, and any other information that might help them expedite the viewing.

Galleries have been hurt by unprofessional art consultants who don't understand how the gallery business works. For most consultants, galleries are essential resources, and I think of them with the same kind of respect I have for my corporate clients.

"I depend on galleries, and always have, as the single most important resource for seeing the work of young emerging and established artists."

—*Lynne Sowder, art advisor*

As you work with a gallery staff, if you acknowledge the fact that their top priority must be retail sales and if you adhere to their policies about art on approval and about discounts, you will earn their trust and you will gain important allies.

RESPECT FOR THE ART

To those accustomed to handling major pieces of art, it may seem ridiculous to mention how important it is to exercise meticulous care, but I've seen beginning consultants really endanger pieces by careless handling. The Appendix has information on the handling of specific kinds of art, but you may want to consider auditing a museum course in proper art handling techniques. At the very least, you should follow these rudimentary rules when you are looking at a gallery's art:

- no food
- no pens
- no smoking
- don't handle the art unless you are asked to assist and you are certain that you know the safe way to handle the work in question

ART ON APPROVAL

When you are borrowing art for a presentation and transporting it yourself, have a proper carrying case, as well as acetate sleeves and acid-free tissue paper to protect the art. (These can be ordered either directly from the sources listed in the Resource Directory of the Appendix or from a framer.) Having proper materials demonstrates to the gallery that you are professional and will take good care of their art.

In the Contracts and Forms section of the Appendix, there is a sample Art on Approval form, which identifies your client, notes the purpose for which the art is being borrowed, and says whether the art is insured.

The use of such a form also speaks to your professionalism.

> Be frank with your gallery contact if you are taking out a work because you want to show it to a client (perhaps as part of your assessment of his VAT), but you don't expect him to buy it. Candor about such things builds trust.

Insurance. Usually, a gallery will have insurance coverage for works of art out on approval; often, artists do not. I carry legal liability insurance as an art consultant, but when I borrow works of art over an extended period for a large project, I take out Bailee insurance for the project so there is never any chance that my client will be held liable for damage that may happen in transit or during a presentation. You can arrange this insurance through a fine arts insurance agent. (See page 179 for more on insurance, and see the Resource Directory for a listing of fine art insurance brokers.)

Timeliness. Galleries often complain bitterly that art consultants don't return art taken out on approval when they promise to. There are many valid reasons for delays, and it's easy to see how this could happen—snags in the project, postponed client meetings, etc. But in the meantime, the work is out of the gallery's inventory and isn't available for sale to the gallery's regular retail customers. If you have an unavoidable delay, call your gallery contact and discuss your dilemma. This level of courtesy will go a long way in building a relationship of mutual respect.

WHO SHIPS?

It is the responsibility of the art consultant to arrange for the transportation of the art from its source to the presentation space and back. Sometimes, however, a gallery or an artist will deliver the art for you.

FINDING THE BEST WORK

Galleries will usually be glad to have your business and to cooperate with you any way they can, but their main focus is their retail clients. For this reason, they often prefer to save any outstanding work of art to sell to a museum or one of their best collectors. If they sell to you, they will not only have to offer you a discount, they will also lose the opportunity to build their reputation with their favorite clients. I try to be sensitive about this, but I am also representing my client in the search for the finest art I can find that suits the goals of the art program and its budget. If it is really an outstanding work of art, I may pay full market value.

> If I feel a gallery is holding back on me, I ask to see the very best work they have by the artist in question. If the piece is truly museum quality, I often waive any discount.

Disparity of Price and Quality. Be forewarned that the price and quality of a single artist's work may vary wildly from gallery to gallery, particularly in today's art market. Some galleries inflate prices far beyond the reasonable market. Furthermore, some galleries planning an exhibition will accept all the current work in the artist's studio, while others will take only works they believe are outstanding and that they are prepared to stand behind.

The best works of an artist may be shipped off to his or her New York gallery. A conflict arises when your client wants regional art but you have to buy the works in New York or Europe at New York or European prices. One of my clients in California wanted to showcase regional artists, but he was in a great hurry to get the core of the collection complete. I had to fly to New York, Chicago, and Toronto to find all the works of quality we needed.

DISCOUNTS

Discounts can be a serious bone of contention between a gallery and an art consultant, unless each respects the other's economic realities. (See Chapter 7 for a further discussion of discounts.)

Most high-end galleries have a fifty/fifty or sixty/forty relationship with their artists, but their actual profit margin, after overhead, is usually quite small, between ten and twenty percent. You can see that the maximum discount they could ever give would be about fifteen percent. For a consultant working on a commission basis and needing a twenty to twenty-five percent discount, a conflict is inevitable.

Some trade galleries deal only with designers and still work with forty percent discounts. In essence, they mark the art up so they can mark it down again for the designers' invoices. If you are working on commission, you may have to limit your selection to these galleries. Some consultants try to overcome this problem by buying directly from artists, but this is very time-consuming and creates bad will with any galleries that handle the artists.

SECONDARY MARKET GALLERIES

A secondary market gallery is a relatively new phenomenon. The inventory is usually art from the sixties and seventies that has appreciated in value and is either on consignment from a collector or an estate or has been purchased at auction. The profit margin here is even smaller than in a regular gallery, and there is little room for professional discounts. When you are buying from a secondary market gallery, or even when you are buying secondary market art from a regular gallery, be prepared to receive no discount.

ART DEALERS

Art dealers are in the business of selling art, but don't have gallery space. Since their overhead is usually low, they can sometimes offer larger discounts than can galleries. Over the past ten years, as the cost of running a gallery has skyrocketed, many gallery owners have closed their doors and now deal privately. You will come to know these dealers as you network with your colleagues and your other sources. Some of them advertise in regional art publications. There is also an association of private art dealers listed in the Resource Directory in the Appendix.

ARTISTS' REPRESENTATIVES AND AGENTS

An artist representative is someone who handles a group of artists. He or she represents the artists in their dealings with galleries and, in some cases, in their direct sales to private or corporate clients.

An artist's agent works with an artist on an ongoing basis and represents him or her in negotiations with a gallery. This function has developed in the past ten years and is expanding rapidly, as galleries find they have less time to be concerned with how their artists' careers are developing and what the artists' special needs might be. Some agents sell art and others do not.

ARTISTS

Many artists today have decided to market their own work and not to have a gallery affiliation. If you buy art from one of these artists, I recommend that you not take a full dealer discount, since you won't be in a position to provide the same services to the artist as a gallery would. (See Chapter 16 for a fuller discussion of the ethics involved.)

Making a studio visit can be very helpful in finding just the right work for a project. I schedule at least an hour and a half for the visit and, to avoid wasting both my time and the artist's, I tell the artist in advance the size and medium of the work I am interested in. If I have seen the artist's work at a gallery, I always let the gallery know I intend to visit the studio.

Visiting an artist's studio is much more personal than looking through a gallery inventory. You are often looking through someone's life work and your comments, positive and negative, carry a great deal of weight.

"I like it when consultants come and set aside enough time to really see the work. It takes time for them to not only absorb the work but my involvement with it."

—Charles Fuhrman, *painter*

An artist gets psyched up for a studio visit and usually can't work that day, either before or after you come. And no matter how experienced or accustomed to celebrity the artist may be, the visit is intrusive to his or her normally solitary work environment. Artists complain that consultants treat their studios like drop-in galleries, often canceling at the last minute or not even bothering to call if they aren't coming or are going to be late.

Another complaint is that some consultants ask artists to pack, deliver, and pick up works on approval without compensating them for the expense and the time involved. And often a consultant, after being paid by the client, will not pass on payment to the artist promptly. These are all marks of disrespect toward those who are the *sine qua non* of our profession.

OTHER SOURCES OF ART

In addition to galleries and artists and their representatives, there are several other sources of art. They include the following:

Antique Stores

Art Expositions An increasingly valuable resource is the art exposition, where galleries come together to exhibit their artists in one place, offering the viewer a chance to see the broadest range of art possible. The big expositions also put out catalogs, which can serve as useful resource material. These expositions range in size and quality from the Venice Biennale and the sophisticated Chicago Art Fair to Artexpo, which serves the decor market.

Art Museum and Community Slide Registries Not-for-profit art organizations, such as art councils and galleries funded by local governments, often have slides of works by regional artists for you to view.

Art Museum Rental Galleries

Art Rental Galleries Many regular galleries will lease art, and not-for-profit art rental galleries can be helpful when you have to stretch a budget or you have a client who is still tentative.

Auction Houses Astronomical sales by auction houses are occasionally in the news, but the average price is usually within the range of an art program. You may want to review the works of a major auction house offering or get a copy of its catalog. Auctions are announced in the newspapers, or you can get the schedule of upcoming art auctions by calling the PR representatives of the houses.

Collectors of Art These people may be valuable sources of art, and they can also be valuable conduits of information.

> *"One of the most important ways I learn about new artists is word of mouth. Those extraordinary jungle drums beat as one collector after another finds artists who are just beginning to be represented…"*
> —*Douglas Cramer, collector*

Computer Art Indexes These are art databases, usually represented at art expositions (see below).

Publishers of Fine Art Graphics

Regional Artist Publications These offer surveys of artists and photographs of their works. They are usually compiled by style or by region.

Sculpture Foundries They often share promotion with their sculptors and may even have exhibition space on their premises.

University Art Departments and Art Schools These have faculty and student exhibitions. Since their overhead is absorbed by the school, prices are often more reasonable than in commercial galleries.

FRAMERS

Framers are one of an art consultant's most important support services. Corporate projects often have tight deadlines, and it is not uncommon to need, say, five hundred pieces framed in six weeks. A small, or even medium-sized, frame shop can't handle this kind of volume and still maintain quality control. It's important to develop a relationship with a quality volume framer. In fact, it may be useful to establish such relationships with several framers who have different specialties, such as acrylic, welded aluminum, and custom wood finishes. All of these should provide museum-quality conservation framing.

Some framers specialize in servicing galleries and designers. They usually work on a twenty-five–to–forty–percent discount structure. If you are located where there is no frame shop set up to handle volume projects, you might find it easier and more cost effective to ship your art to such a framer in a larger city.

INSTALLERS

Depending on the volume of your practice, you may have installers on your staff or you may contract with them on an as-needed basis. Today, almost every major city has at least one fine art forwarder who specializes in handling art. Apart from providing packing, shipping, and pick-up/delivery, many forwarders also provide art viewing rooms and installation services. They will deliver an eight-foot painting, install it on site, and then take it away if it is not approved. These people are usually skilled, insured contractors. Galleries and framers can often refer you to first-rate installers.

Another good source is your local museum's preparations department, which often has a cadre of workers on a part-time basis.

A word of caution: Just because an installer works for a museum does not necessarily mean he or she is skilled in all the tasks of fine art installation. In museum work, preparators are usually specialized; one might build cases, while another hangs tapestries, and so forth. If you describe the nature of your project, whoever is referred to you by the museum is more likely to have the skills you need.

TRAINING INSTALLERS

Even though the installers you hire may have worked at a museum or a gallery, it's still your responsibility to supervise the crew and set your own standards. Installing art in a corporate environment is different from installing in a gallery or a museum where there is no contact with the public during the installation. Installers are powerful potential goodwill ambassadors. They have one-on-one contact with the client's employees and by their demeanor they can make or break employee acceptance of the art program. See Chapter 15 for a further discussion of working with installers.

> **Note:** I find that the best installers and goodwill ambassadors are friendly, outgoing artists who have had professional art handling training. They seem to take more interest in the art and in answering employee's questions than do carpenters or others who are not involved in the arts themselves.

ARCHITECTS AND INTERIOR DESIGNERS

Occasionally, an art consultant will be hired first and then asked to recommend a good designer; or a modification to a space will be necessary to accommodate a work of art. It is helpful to have a few designers and architects in mind whose work you respect and whom you feel confident recommending.

Additionally, it's crucial for a consultant to know the basic concepts and skills of reading color boards, design briefs, furniture plans, electrical plans, and elevation plans. An excellent book for lay people on this subject is Frederick H. Jones's book, *Interior Design Graphics,* cited fully in the Bibliography.

LIGHTING ADVISORS

As art programs are taken more seriously by clients and their designers, art consultants are being brought into projects earlier to consult on lighting and other design issues affecting the display of art. Although a consultant shouldn't give technical lighting advice, he or she should be able to recommend someone who specializes in museum/gallery lighting.

When you are researching a lighting advisor, try to find someone who is not attached to any particular product line (i.e., someone who doesn't earn a commission from a company for specifying that company's products). Museum and top galleries or even retail stores are good sources for referrals to qualified lighting advisors.

There are many aesthetic and conservation issues involved in lighting. John Reeves's book, *The Art of Showing Art* (cited fully in the Bibliography), discusses many of the obstacles that should be avoided when planning lighting.

SHIPPERS, PACKERS, AND ART HANDLERS

Almost every major city now has shippers and packers who specialize in handling fine art. Check your Yellow Pages or call the registrar of your local museum for a recommendation. There is also a nationwide list in the Resource Directory of the Appendix.

Some of these handlers have rental presentation spaces with track lighting, neutral floor and wall coverings, etc. This is an ideal setting for presenting art. (See Chapter 12 for more detail on presentation spaces.)

FABRICATORS AND FOUNDRIES

Companies that specialize in servicing the art community, whether they cast large-scale sculpture or make plexiglass labels, should be included in any list of support resources.

The concerns of the artist are often different than those of commercial clients. Serious mistakes and communication failures can occur when you use an industrial fabricator for an art project. It is worth the time and effort to seek out someone who is experienced in art-related fabrication. Fortunately, there are many companies that specialize in art products, and it is usually worth going outside your community to work with them if there are none locally. A selected listing appears in the Resource Directory.

APPRAISERS

A major collection should be appraised every few years by a qualified appraiser for insurance purposes. This appraisal is also valuable information for the serious collector who may consider his art program as a financial investment.

Appraising is a highly specialized skill that requires training, certification, and broad experience. Two things to look for in selecting an appraiser:

1 Is he or she certified by either The Appraisers Association of America or The American Society of Appraisers? (See Resource Directory in the Appendix.)
2 Does he or she have knowledge and experience in the period and type of art that you want appraised? A specialist in eighteenth-century French art who is asked to appraise a twentieth-century American collection could take twice as long and be twice as expensive as a specialist in contemporary art.

INSURANCE AGENTS

Local insurance brokers and carriers who are unfamiliar with insuring art won't have rates as reasonable as those of the national firms specializing in fine art, and their staffs won't be as good a source of advice on art-related matters. The national firms now all have 800 numbers. The fact that these firms may not be local to your area should not deter you. You will find that their staffs understand the special needs of an art consultant. (See the Resource Directory for a list of fine art insurers.)

LEASING AND FINANCING SOURCES

There are occasions when the cash flow of a client is tight and leasing or financing can be a successful strategy for stretching the budget. (See Chapter 21.) The Resource Directory in the Appendix lists Art Leasing and Financing Resources.

PHOTOGRAPHERS

From time to time, you will need to photograph an art program for publicity, for a catalog, or for documentation. Photographers specialize in different kinds of subjects, so research those in your area for the one best suited to the project at hand. (For example, you may want someone who specializes in portraits to photograph your client with a piece from the collection, while a shot of a large outdoor sculpture might need someone with very different skills.) Call local galleries or the publications department of a local museum for their recommendations.

ATELIERS (PRINT SHOPS) AND PUBLISHERS

Today, many companies, particularly hotels and hospitals and other service industries, are finding it more cost-effective and practical to commission a suite of limited edition graphics or monotypes than to purchase many prints from different sources. This is a growing trend, and one to keep in mind for those projects that require similar art in large volume.

You will need to know of the graphic resources in your area, as well as the best shops throughout the nation that print contract work. Some publishers work on an invitational basis only, while others will consider contract projects. Usually if you call a publisher in your area, he or she can direct you to the appropriate atelier for your project. Sometimes artists already have a favorite shop where they like to work.

EXHIBITION DESIGN FIRMS

There are companies that design, construct, and install exhibition booths for trade shows, annual shareholder meeting displays, and other kinds of exhibitions. Similar companies specialize in handling permanent exhibitions and dioramas for museums. You may want to contact one of these resources if a client asks you to develop a product display or to mount a special exhibition to mark a corporate milestone—an anniversary, say, or a merger.

TRAVELING EXHIBITION COMPANIES

Traveling exhibition companies provide services for taking an exhibition on the road and in some cases may even provide curatorial services. (See the Resource Directory in the Appendix.)

Twenty percent of all the U.S. companies that have collections are engaged in some type of art exhibition program. I think that number will double as corporate collectors begin to feel they have collected enough and now can concentrate on getting the most out of their art. They will be interested in exploiting the outreach possibilities through both home office exhibitions and traveling exhibitions.

■ ■ ■

Art Program Management

"No Method nor discipline can supersede the necessity of being forever on the alert."

Henry David Thoreau, Walden

A consultant has a role to play that goes beyond the time frame of the project. Art work requires long-term maintenance, and a consultant's job as a professional is to make an effort to provide for its safekeeping. The consultant is also responsible for seeing that the collection is as thoroughly documented as any other asset of the company, and for setting up the collection in such a way that it will serve the client well however his plans for it may change.

As a consultant, your first step is to determine in your own mind what you think is the appropriate level of art management, taking into account the quality of the collection and its potential future value.

> **Note:** Even a poster collection in a medical center may one day be valuable. It is not uncommon for turn-of-the-century industrial posters or 1930s fine art posters to sell for several thousand dollars at auction. Today's decor can be tomorrow's fine art or valuable memorabilia.

A consultant may decide the project is only worthy of a "bare bones" plan with minimal strategies for art management: documentation, record keeping, maintenance, and preservation. On the other hand, he or she may decide to develop a more elaborate collection-management plan, which would include a statement of purpose and philosophy of the collection, a definition of the collection, acquisition and loan policies, and strategies for all management tasks.

This chapter covers the basics of good art program management—those steps every consultant should take—and then suggests how these "bare bones" can be fleshed out to provide a comprehensive management plan should the collection be serious enough to warrant one.

DOCUMENTING THE ART

> *"My clients are so excited about getting the art and moving into their new offices, they just can't visualize themselves or their successors needing to make changes. It's a challenge to get them to provide a budget for maintenance and preservation."*
>
> —Robert Danote, art consultant

Sometimes clients are so caught up in acquiring the art that they fail to see the day, down the road, when they may want to upgrade or dispose of it, but art placed in companies turns over far more often than art in museums or in private collections. A company may remodel and change its image, or it may merge with another company and change its identity altogether. In some cases, the art has been known to increase so much in value that it becomes an embarrassment to the company, so it is either sold or put on long-term loan to a museum. Whatever the reason, when deaccessioning is necessary, documentation becomes critical.

A record should be kept of the travel history, technical composition, condition, placement, and fair market value of each work of art. A photograph should also be included. This core of information is needed to document the work for future curatorial needs, such as insurance questions, loan conditions, tax matters, and deaccessioning.

Collectors and auction houses can be understandably wary about poorly documented art.

Each piece in the collection should have its own documentation sheet. The names of its previous owners and its travel history are critical to the work's value and future sale, particularly at auction.

> *I have been called as late as eighteen years after completing a job by a client who wants to sell a work of art and who cannot find any documentation. Staff often toss out documentation papers unaware of their importance. It is a good practice to keep duplicates in your office for at least twenty years. Also put a note on the client's box of records or files that these papers are important to keep.*

DO NOT DESTROY THESE FILES AT ANY TIME!
These records are important documentation for the (company's name) art collection. They may have tax implications or significant impact on the value of the collection, and the ability to sell the collection (if necessary) at its fair market value. These records should be kept in a safe-deposit box or other place for storage of financial assets of the company. If there are any questions concerning the contents of these records contact
- Consultant's Name
- Company
- Address
- Phone
- Date

DOCUMENTING AUTHENTICITY
Increasingly, galleries, publishers, and artists are giving authenticity documents for works of art. Always request one and attach it to your documentation sheet.

SAMPLE DOCUMENTATION SHEET (FRONT)

COMPANY/Division Name INVENTORY Number _____

Date of Purchase: _____

Artist: _____ Purchase Price: _____

Nationality: _____ Dealer/Source's Name: _____

Life Dates: _____ Address: _____

Phone: _____

Title of Work: _____

Description, if untitled: _____

Date of Work (or approximate date): _____

Medium: _____

Edition: _____

Dimensions: Height _____ Width _____ Diameter _____

Signature: _____ Location: _____ _____

Titled Signature: _____ Date: _____

Previous Ownership:

Letter of Authenticity:

Photograph: ☐ Polaroid ☐ black & white

☐ color print ☐ color transparency

Location: _____ Date: _____
 (write in pencil)

Present Fair Market Value $ _____ Date: _____
 (Write in pencil and update every 2–3 years)

SAMPLE DOCUMENTATION SHEET (BACK)

Conditions at Time of Purchase (box is for diagraming damage):

Exhibitions:

Bibliography:

Special Remarks (care and maintenance):

COLLECTION INVENTORY

Each work of art should be assigned an inventory identification number for cross-referencing with the collection's records. There are numerous ways to do this. The simplest is a system of chronological numbering, e.g., 001–999. This works best on small collections.

A more elaborate system will be necessary for a collection that is larger or that may be expanded in the future. A common model is to assign a letter for each medium (for instance, G for graphic, D for drawing, T for tapestry, P for painting) and a number to each work in that category. The year of purchase should also be indicated.

It also helps accuracy to assign numbers within a field of 999 potential entries. A standardized system, with shorter numbers, will help minimize errors. For example, paintings purchased in 1991 might be P91.001, P91.002, etc.

If the collection is purchased by several different divisions of the company, it may also be necessary to assign each division a code so that, if the assets of one division are sold off, they can easily be identified; for example, P91.001A (medium, year, category number, company division).

If a work of art has several parts, further categorization may be necessary. For example, the second part of a five-part tapestry might be numbered T91.020.a–e.b, showing that a tapestry acquired in 1991 was comprised of five parts (a–e) and that this is the number for the second part (b).

Numbers are a far more reliable way to keep track of art than words, particularly with so many contemporary works being titled "Untitled." Record keeping is also much easier if the number is noted on the art object. Of course, marking or writing directly on an art object may decrease its value or disfigure it and should be avoided. There are established safe ways to label different media. If you are uncertain about a specific medium, check with the registrar or conservation department of your local museum.

PHOTOGRAPHIC RECORD

Whenever the art is of investment quality, a good black-and-white documentary photograph of the work should be obtained. Often the art dealer or artists can supply the photograph at no charge. A Polaroid or video is also acceptable for insurance purposes.

 "A photograph is sometimes the only way to identify a work, particularly serial images. It is also useful for proper installation."
 —*Tressa R. Miller, first vice president, Security Pacific Corporation*

CONSERVATION AND PRESERVATION

A consultant must be knowledgeable about basic art conservation and preservation issues. The Bibliography lists a few good sources for in-depth information, and the following discussion covers the key issues of concern.

FRAMING AND MATTING

In addition to its aesthetic role, a frame also functions as protection from handling, display, and storage. It keeps the object free from dust, dirt, and excessive changes in temperature. Today, both glass and acrylic glazing products can be specially treated with ultraviolet filters to cut down the harmful effects of light.

A painting or graphic should never be permanently affixed to its backing and never placed directly against the glazed surface. The normal condensation of moisture that accumulates on the inside of a frame can cause mold or staining. A mat or frame liner protects the work of art by creating a space between the art work and the glazed surface. Request that your framer use conservation-approved, acid-free materials. Works in pastels or charcoal should never be framed in acrylic glazing products because of static. Non-glare glass and den-glass are treated with acid and are not conservationally sound, so they should be used only with works of no investment value.

PLACEMENT

Certain locations can be very detrimental to art. Extreme fluctuations in temperature and relative humidity, along with direct sunlight, are probably the most common factors that threaten the well-being of art objects. Many corporate offices have fairly stable environments, but some older buildings, where air cooling systems are turned off entirely on weekends, can wreak havoc with the art.

Here are some basic ideas art consultants should keep in mind when creating a safe environment for the art.

Direct sunlight—never place a work where direct sunlight will hit it.

Excessive heat or cold air—never place a work over an air conditioner, heating vent or fireplace, or on upper floors of buildings that do not have 24-hour climate control.

Highly trafficked areas—avoid placing unframed works where the surface of a work may be damaged.

Exposure to the elements—e.g., don't place a tapestry in an open-air atrium.

Excessive exposure to fluorescent light—this is particularly damaging to works on paper. Ultraviolet rays of fluorescent light, while less than sunlight, will cause works to become brittle and to fade. Incandescent light is the best since it has few ultraviolet rays. For their protection, works on paper exposed to fluorescent lights should be rotated every six months, preferably out of direct fluorescent light. Companies with serious art collections should have a lighting consultant advise them on alternatives to fluorescent lighting.

HANDLING ART

Each medium has its special handling and storage requirements. For example, bronze and other metal sculptures should always be handled with gloves. The moisture and the oil from finger tips can cause rust and disfigurement. (See the Appendix, page 229, for correct ways to handle art.)

MAINTENANCE

At the very least, cleaning instructions should be left for the building maintenance crew. Many companies use acrylic glazing and then neglect to inform their cleaning crews not to use traditional glass-cleaning products. For a collection of any value, it is recommended that a professional art handler come in and clean the works every six months. Frame borders can be dusted in the interim by the company's cleaning crew. If a company does not wish to incur the additional expense of ongoing professional care, the consultant can contract to train a company employee.

INSURANCE UPDATES

For collections of value, the art should be reappraised for insurance purposes every three to five years. Appraising should never be provided by the consultant unless he or she is also a certified appraiser. (See Appraisers, Chapter 14.)

INSTALLING THE ART

The installation is an important process, both in the physical activity of handling valuable art and in the public relations opportunity offered by the presence of the team in the company's corridors. I suggest you have a prepared sheet outlining what you expect of your installers. I always make sure they understand that responding well to any employee questions is just as important as installing the art. A polite and informed response can do wonders toward building goodwill for the program.

They will almost surely be asked the names of the artists and the progress of the program, and even such questions as, "How do you figure where eye level is?" If the installer doesn't know the answers to some of the more esoteric questions and you are not on the scene, the employee should be given your business card, with assurances that you will be glad to answer any question.

INSTRUCTIONS FOR INSTALLERS

- Observe the dress code—be well-groomed and wear long-sleeved shirts; no jeans or short skirts. Always wear and use work aprons.
- Respect the fact that the client is conducting business.
- Clean up as you go.
- Do not leave art or tools around where damage to the art or injury to others might occur.
- Always put down a board or a cloth under any art that may have to rest temporarily on a piece of the client's furniture.
- Take art packaging materials and other garbage with you or dispose of it in an appropriate place.

At the beginning of a project, brief your installation crew on all the important details that may be of interest to the employees, such as who selected the art, any rotation plans, and any plans for employee programs. Review with them any special installation techniques you want them to follow, such as double hooking so that art work doesn't move. A separate sheet should be prepared for installers doing cleaning. (Plexiglas, for example, cannot be cleaned with glass cleaner.) And you may want to give instructions for applying your company logo to the back of each work.

Each installer should have his or her own toolbox, apron, and gloves. Because it is so disastrously inefficient to run out of materials or to stop midway to go buy a special installation tool, it's a good idea to have at least one master toolbox with everything you might possibly need—extra drills, measuring tapes, concrete hangers, extra hooks, tamper-proof screws, security mounts, etc. (See Appendix for a complete master toolbox inventory, page 233)

For a thorough background on the issues of art handling and installation, I recommend two books listed fully in the Bibliography: *The Art of Showing Art*, by John Reeves, and *Good Show! A Practical Guide for Temporary Exhibitions*, published by the Smithsonian Institution.

SECURITY

There are many situations in which a consultant is asked to provide a security installation. Hotels and hospitals, for example, require security mounts for safety and security reasons. Most framers and museum preparation departments have catalogs of different kinds of security devices to prevent vandalism or theft. A good general resource is Donald L. Mason's book, *The Fine Art of Art Security*. (See Bibliography.)

LABELING

Labels on works of art can increase the appreciation of the art both by employees and by visitors who may have access to the collection.

> *"The fact that we are making the effort to post labels implies that both the information and the artwork are important. Labels give a viewer information about the art that would not be readily apparent otherwise."*
> —Bonnie Earl-Solari, director of the art program, Bank of America

Labels in acrylic mounts or etched in acrylic or in bronze (for more traditional art) can be installed alongside the art to give the viewer a little information about the work as well as the subliminal message that the art is important. So that the labels don't interfere with viewing the picture, it's often best to match the label paper to the wall covering. Plexi or acrylic label holders can be purchased through most volume framers.

John Dunglas	American, B. 1949
"Running"	
1969	
Oil on canvas	

Whenever possible, labels should be hung at the same level throughout the space, so that they tend to disappear. They should also be hung below the horizon line or eye level of the work of art. This positioning gives the viewer the subtle message that the art is more important to look at than the label.

SAMPLE LABEL INSTALLATION

Individual pieces

Series

Vertically stacked works, two alternatives

Note: never install labels between two vertically-stacked works. It creates a gaping hole at eye level and is very distracting to the viewer.

EMPLOYEE ART SELECTION

Any consultant who's been working in the field for several years will tell you that the real challenge is not getting a signed art program contract, but winning employee acceptance of the program.

Almost every corporate client who chooses quality art does so with the idea that it will enhance the work environment, making a more impressive space for visitors and creating a more stimulating place for employees. However, employees perceiving the art work as an enhancement or a fringe benefit depends on how the art program is handled on a human-resource level—how the program is packaged to employees, how it is implemented.

> *Years ago, I asked a receptionist at a Manhattan bank about the artist of the painting in the lobby. She said, "I don't know, they put up one awful thing after another." I thought to myself how sad the company's director would be to have this response from an employee. The art wasn't earning its keep. Somehow a link was missing between the good intention of the bank's management and the end result. The art in this situation wasn't a working asset of the company.*

With a little bit of thought and effort a company can get a lot of employee goodwill out of an art program. And the opposite is true as well. If the program is mishandled, it can have a bunch of disgruntled employees endlessly nit-picking and snickering under their breath about the art, which doesn't achieve the client's goals and doesn't create a positive climate for the art consultant who would like additional jobs or referrals from the client and his staff.

THE NIH SYNDROME

NIH or "Not Invented Here" is the phenomenon of employees not supporting projects or decisions that they did not participate in making.

American management has made great strides in the last twenty years toward decentralizing decision-making, or at least toward involving employees in the decision-making process. This less autocratic management philosophy was born in part out of the

hard economic lessons American companies have learned from their Japanese competitors, that the only way to assure performance or service is to have each employee feel personally responsible so that they will go the "extra mile" whenever it is needed. The way successful companies achieve this prized feeling of identity with the company is by employee involvement.

An art program, whether it's for a small doctor's office or a Fortune 500 company, can be a powerful tool for employee involvement. I'm not suggesting that employees be involved in forming the art concept, or in the primary selection of the art, but that they be involved in selecting from preselected work the art that hangs in their offices or work areas.

Art has a transforming effect far beyond its aesthetic role. These employee programs are more beneficial than they may at first seem. Just the idea that one exists creates a dynamic spirit in the workplace. It communicates the company's interest in each person as an individual. It's one of the few areas where a staff person's opinion is equal to that of the boss.

ART IS A PERSONAL THING

Unlike the furniture, the rug, or the computer, art elicits a much more subjective response.

> I once did a job for a small insurance brokerage firm—two executives, a secretary, and two female agents. The owner was almost a caricature of the chauvinist boss (I thought they went out of fashion in the sixties), snapping his fingers for coffee, yelling orders from his desk, treating everyone with disrespect. I'll never forget the secretary's face when I gave her a choice from two preselected works. They were almost identical—same artist, same subject, one was more blue, the other red—but she was visibly moved to have a choice. "Oh, I much prefer the blue; I don't like the color red. Thank you so much for letting me pick." When I told her Mr. Whatsit wanted her to have a say since it was she who looked at the piece most during the day, she seemed very pleased and a little surprised.

If the art is all preselected and installed before the employees move in, you can bet that at least a third of them will be seriously unhappy with the selection and that a good portion of the remaining employees will not appreciate the art simply because of the NIH syndrome. They will see the art as just another thing management has imposed on them.

ART AS THE SCAPEGOAT

Frequently when a company moves to new offices, communications equipment is upgraded, work stations change, even departments get shifted. It's not uncommon for employees who have been with the company for twenty years to no longer have private offices since the new building has an open floor plan. They have to learn new computer and telephone systems, and they may even report to a new boss. While employees may not feel they can complain about all the inconveniences of the new office, they will often virulently criticize the art. The art program becomes the scapegoat of the move, essentially the only thing one can criticize without running the risk of being fired. For all these reasons it makes good sense to package the art program as an employee involvement opportunity rather than as a way to enhance the image of the corporate autocracy.

HOW TO MAKE IT WORK

On large projects, where the art is preselected by a committee or single person, the art can be photographed (a Polaroid is fine) and the pictures placed on wedding album pages. They can be arranged by subject matter for easy reference. The consultant then has the receptionist/secretary in each department schedule a personal fifteen-minute visit with each person.

For work areas such as secretarial pools, bring a selection of works to the area on an art cart and let the group select a work together. Tell them there is no way they will all agree, that even most husbands and wives can't agree, but that at least there should

be a majority who like the work and nobody who can't live with it. If you have also convinced the company to let you rotate the works in six months or a year, this will greatly ease the decision-making process.

Visiting offices like this is my preferred method because, by being in the actual space where the art is to be placed, I can aid the person(s) in making a good aesthetic decision. Also, people are more relaxed and less intimidated in their own space. The alternative is to have the art in a storage room and set up appointments for people to come to make a selection. For people with untrained eyes the large number of art works can be overstimulating and the selection much more time-consuming, because they feel they have to see everything before making a decision.

For small projects an art resource book can be used. This is a book similar to the one described above, but it shows works of art for sale from publishers and galleries. This sort of book works best for posters and prints, but they can also have photos of drawings. Each image is cut out and pasted on a three-by-five index card with the source code numbering and the price noted in such a way that no one but you can read it. At left is a code for a Robert Rauschenberg poster.

This system has to be continually updated, but it means that a client can look through a notebook and make preliminary selections, which are then moved to a special book just for your employee selection meetings. Whatever is selected is then purchased. If availability is an issue, employees can make first and second choices.

Most publishers and galleries will either supply you with a reproduction of a work or a 35mm slide from which prints can be made. The minimal time and expense involved in creating an art resource book will be paid for many times by the flexibility it allows you in doing employee selection and getting paid for providing this extra service.

PE.RR325.50

Publisher:
Poster Editions;
Artist: **Robert Rauschenberg;**
Publishers I.D. Number: **325;**
Price: **$50.**

IS EMPLOYEE SELECTION A PANDORA'S BOX?

One of the questions most frequently asked by clients and their interior designers is whether an employee selection program will cause more problems than it is worth. But employees are so pleased to have a choice that they always find something to pick. Their rationale may be unusual or highly personal, but in twenty years of consulting I have never had an employee say, "I don't like anything. I want the company to buy me something special." Employees are so accustomed to working within the limitations of their companies that just having a personal choice is an appreciated change.

> *"Choosing the art was a kick. It helped me put my own stamp on the place I spend my days."* —*Tony Robbins, Jenkins and Associates*

On a big project, you'll always find a taker for even the most unusual works, particularly when many employees are taking part in the selection. When I was doing a large project for a bank, we bought more than one thousand two hundred works just for employee offices and work stations. The range was wide open, from lyrical abstract Robert Motherwell prints to neorealist pictures of pickup trucks by Robert Bechtle to more intellectual works by Bruce Nauman and Jasper Johns. All the works were eventually selected by employees, sometimes for the strangest reasons. One very conservative man chose two black-and-white Motherwell prints because his father was a banker who worked with Motherwell's father, also a banker. Another very conservative man chose a neorealist drawing of a Dodge powerwagon because it reminded him of his first truck. The point, if there is a point, may be that there is no accounting for personal taste and that as long as you provide a broad range of choices, usually all the employees will find something they like or feel they can live with.

> *I'll never forget having to coerce members of a bank's stock trading department into accepting an Ellsworth Kelly print. I thought it might have a calming influence on their frenetic work area but be strong enough to hold the space. When I went back in six months to rotate the print, some of its staunchest opponents wanted to keep it. After living with the work, they'd grown to like it. One trader said, "There's more to those orange and blue squares than meets the eye."*

STRETCHING THE BENEFITS—THREE STAGES

The best way to maximize the employee goodwill benefits of an art program can be perfectly summarized by paraphrasing the old advice to essay writers:

- Tell them what you're going to do
- Tell them what you're doing
- Tell them what you did

What You Are Going To Do. Once an art program concept has been decided on, even if it's only graphics for a branch office, have the chief executive or manager send out a memo telling the staff about the art that is coming. At the time of employee selection and before installation, other memos should go out. I offer to draft these memos for my client so the description of the art is correct and, more importantly, so the right spirit is communicated. (See samples in Chapter 18, pages 190 and 191.)

When possible, leave the walls blank for a few weeks before installing the art. This heightens the effect when the art is finally put in place and emphasizes how much it enhances a space. Employees tend to appreciate the art much more when they have experienced the space without it.

What You Are Doing. Schedule the installation during working hours. This allows for communication between the staff and the installation crew as well as with you. Rather than think of employees as a nuisance in the way of a smooth installation, think of your team as goodwill ambassadors for the program. See page 159 on how to train installers for this role. Be ready to answer employees' queries in a gracious way.

What You Did. Plan an art tour or lecture. Depending on the size of the project, an informal tour of the art or even a noontime lecture may be a way of amplifying the significance of the art and demonstrating that it is meant as an employee benefit.

For in-house curators or consultants who have an ongoing relationship with their clients, building in a process to encourage employee responses to the art is an interesting way to keep the program vital.

> *The First Bank of Minneapolis initiated an innovative program for employee involvement and feedback. It held informal meetings, handed out printed questionnaires, and made educational videotapes available. As an adjunct to the employee selection part of the program, a "Controversy Corridor" was set up to exhibit art the employees chose to ban, stimulating ongoing discussions. Art therapy workshops got employees involved in creating art themselves and in exploring issues of artistic expression.*

MAKING THE MOST OF MARKETING OPPORTUNITIES

While your greatest benefit from having employee selection is winning acceptance of the program, there are marketing reasons that make it a profitable as well as a rewarding activity.

A consultant can charge extra for the time it takes to meet with employees, as well as to provide art tours or to draft art memos for the president. (Depending on the situation, I like to provide some of the less time-consuming activities gratis.)

When you meet with employees, give them business cards at the time of installation and tell them not to hesitate to call you if there are problems with the art. After all, a referral can come from anyone in the company.

And finally, if you have a flexible way to handle employee art selection, a company will be more inclined to call on you when they have small orders, which will allow you to keep an active relationship with the company. This is a good opportunity to find out what their expansion plans are and to ask for referrals when

appropriate. Even though these little jobs are something of a nuisance in the art consulting sense, they are still an easy way to do marketing research and get paid for it at the same time.

DEACCESSIONING

"Deaccessioning" is the term for removing a work of art from the collection's inventory. For various reasons, consultants may be asked to help a client dispose of unwanted art. When the art in question is valuable, the first step is to have it appraised. (See Chapter 14 for notes about appraisers.)

> **Note:** Your local resale laws should be checked. For example, in California, an artist must receive five percent of the sale amount. This may figure in determining sale or donation.

The following are a number of ways to dispose of art, depending on the value of the art and on the goals of the client.

Consignment to a Gallery. Many galleries will take art on consignment. They will usually retain twenty to thirty percent of the sale price when the works sell. If a work is a very expensive secondary market piece, a gallery may take as little as five percent commission.

First approach the gallery where the work was purchased or other galleries around the country that represent the artist, for they already have a built-in clientele for the work. If the work is good, of course, other galleries will be interested as well.

A valuable source for information on which galleries represent an artist is *Art in America's Annual Guide to Museums, Galleries, and Artists.* (See Bibliography.)

Auction. The work can be put up for auction. (See Chapter 14 for more information on auction houses, and see the Resource Directory in the Appendix for a listing.)

The Artist. Sometimes artists are interested in buying back their early or best works.

Trades. A gallery or the artist may be willing to exchange works for new ones.

Employee Purchase or Auction. The works can all be hung in a special place and employees given the opportunity to purchase them. This can be fun, a painless way to dispose of unwanted art. If there is no documentation available and the work is not worthy of appraisal, it can be divided into categories, such as $50, $150, and $500.

Donation to a Not-for-Profit Institution. Hospitals, public television auctions, and cultural and senior centers will often be pleased to accept art donations. And, of course, museums are always ready to accept valuable works of art.

MANAGING A SERIOUS COLLECTION

Entire books are devoted to each art management task involved in maintaining a serious art collection. If you feel a collection is worthy of a comprehensive plan and you don't have the curatorial training or experience to develop one, several options are available to you. You can take a few courses in museum studies. Or you could do a course of self-study by reading up in the areas where you need more information. (See the Bibliography in the Appendix for a list of key art handling and management books.) The registrar or conservator of your local museum may be available to consult with you on specific issues of concern.

THE STEPCHILD SYNDROME

One major problem for corporate curators is that the art collection is often the stepchild of another unrelated department. The budget can shift with the corporate wind. If the department head likes the art program or if it's a good year, then resources are adequate. If times get tough or the personnel changes, the program's budget can be in jeopardy. If you are working in-house, the best strategy is to see that your own department is created. If you are an outside consultant, try to report to top management so you can make your concerns known at budget time.

ART PROGRAM MANAGEMENT PLAN

The purpose of the collection
how it relates to the overall mission of the company
how it relates to the community at large and to employees

Parameters of the collection
periods of art
national/international exposure
regional exposure
media
limitations (corporate taboos, etc.)
special definitions (theme, values, etc.)
locations

A budget and funding plan for the art collection

Special goals for the program (e.g., employee benefit, tool for organizational change, community relations, etc.)

Strategies for implementing each goal (e.g., employee selection, art dialogue and banishment, opening event, etc.)

Ways to keep the program and collection vital (e.g., rotation, employee feedback, acquisition schedule, deaccessioning, etc.)

Physical management of the collection
documentation and record keeping
ongoing care and handling
installation
preservation
storage
security
insurance
loans
art reproduction rights (see Appendix for sample contract)
staffing

Outside services and resources

Budget and funding for program management

Provisions for periodic review of the program
by whom
when
how

Here is an outline for all the areas you might want to consider in developing a plan.

Professional Ethics

"Today, with the amount of money involved in art, the temptation to be unethical is probably greater than ever before in the whole history of art."

—Sylvan Cole, print dealer [24]

CONSIDER THE FOLLOWING SITUATIONS:

1 You see a painting hanging in a gallery, a painting that belongs to a collector you know. You call him and ask if he is interested in selling it to you for your corporate client.

2 You're working on a very tight budget, so you bypass the galleries, which would give you a ten percent discount, and go directly to the studios of local artists, hoping to buy works at a forty percent or fifty percent discount.

Demonstrate your respect and support for dealers by not bypassing them. When it is necessary to buy out of an artist's studio, ask only for an art consultant's trade discount, no more than half of a dealer's discount.

3 You have a wonderful David Hockney print in your own collection that is just right for the job you are doing. You had planned to put it up for auction in the spring anyway, so you decide to give your client first dibs on it.

Maintain an arm's length in all art transactions. In other words, avoid situations where you stand to gain personally from the sale of a particular work of art to a client.

4 You are being paid a modest hourly fee by your client, so you try to negotiate a double discount with your sources, ten percent for the client and another fifteen percent for you that the client "wouldn't need to know about."

Accept compensation only from your client and always fully disclose your financial arrangements to your client. Negotiating secret discounts or payments to be paid to you, as well as accepting or asking for an art gift in exchange for your patronage, is simply a form of double-dealing.

5 A grateful artist makes you a present of one of the monoprints in the series you have commissioned for a hotel project.

Gifts from galleries and artists are generally inappropriate, to be considered as conscious or unconscious efforts to influence your choices. This can be a tricky judgment call when real friendships develop.

6 While you are going through the inventory of a gallery for a big project, you fall in love with a little drawing of outstanding quality. The gallery gives you a substantial discount on the piece as an expression of appreciation for all the purchases you've made during the year.

When you are looking at art on client time, your client should have first claim to the art you find and you should not gain personally from your role as his agent.

7 A sculpture by a renowned artist is permanently installed in a hotel atrium above a shallow reflecting pool that the artist designed and considers to be an essential part of the piece. The hotel owner has decided to have the pool removed, since two people have accidentally fallen into the water. The architect and the art consultant are designing a new platform for the sculpture. It seems unnecessary to consult with the artist, particularly since he lives in Europe and it may be difficult and expensive to involve him.

The consultant's role is to protect the moral rights of the artist to have his or her work shown and maintained in the way it was designed to be seen. The artist or the artist's heirs should always be consulted. In some states this is mandated by law. (See page 170 for more on artists' rights.)

The art world is like a small village in many ways. Trust is the binder that makes everything work, rumors are rife, and everyone knows everyone else's business. Also, as in a small village, a newcomer may have a hard time figuring out the rules. New art consultants may feel isolated, bewildered by the unspoken code. Or they may even be unaware that such a code exists and that intricate alliances and loyalties make up the warp and weft of art world relations.

As a corporate art consultant, you link two worlds, and you have a responsibility to each. You must respect and protect your colleagues in the art community at the same time you represent your corporate clients and safeguard their interests. If you are good at what you do, you will be able to bring these two worlds together in such a way that everyone wins—the two worlds learn to respect each other, the art community is invigorated, and you get a reputation as someone on whom everyone can rely.

These breaches of ethics may seem trivial beside the scandalous tales of fraud and questionable provenance that haunt the art world, but even these more subtle ethical failures can undermine the essential trust that must exist not just between buyers and art sources but also among art sources themselves. In the last analysis, your own integrity is the most important contribution you can make to the health of the art community.

The Association of Professional Art Advisors, Inc. has put together valuable, succinct guidelines for professional practice and conduct. The association only takes members who have had three years in the profession, but you might see if you can get a copy of these guidelines.

The following pages will serve as a guide through the tricky shoals of ethics in art consulting, but it is well to remember what Ralph Colin, one of the founders of the Art Dealers Association, said. The whole code of ethics, he said, comes down to two words: "Be honest."[25]

ETHICS AND YOUR SOURCES

Artists usually need to sell their work to live, but galleries and auction houses also need reasonable compensation for the crucial roles they play. The art world, like any other market, has an economic structure that needs to be maintained in order for the community to thrive, and a code of ethics helps maintain it.

WORKING WITH GALLERIES

Sometimes galleries and independent consultants seem to be working against one another, viewing themselves as competitors rather than as collaborators. When this happens everyone suffers.

Gallery directors scour the art world for artists who they then nurture along and eventually bring to the attention of the community. Successful consultants usually don't have the time to discover many artists or to make speculative studio visits—their primary business is servicing companies. Furthermore, seasoned consultants prefer to purchase from galleries so they can easily consign works if they choose to deaccession them in the future. They regard dealers as valuable resources and treat them accordingly.

When a relationship between a gallery and an artist exists, it should be regarded as sacred. Whatever direct dealings you have with an artist should be under the gallery's auspices, and you should avoid seeking private deals. Building up a reputation as someone galleries can trust will facilitate your access to artists and to their best work.

A gallery usually has considerable overhead and dealers depend on prompt payment. Sometimes the consultant must be aggressive in seeing that the client pays his art program bills in a timely manner. Although the client is the buyer, you are the person galleries and artists look to to protect their interests.

Art handling is another area where trust is involved. When you take art on approval for your client, demonstrate your respect and professionalism by handling the art with the highest standard of care and returning it promptly. A consultant's role is to take whatever measures are necessary to safeguard the art. Although the gallery insurance may cover the work while it is on approval, an accident can be detrimental to the gallery's insurance costs.

> *When a bomb went off in a client's office building, I had to get an art forwarder out of bed on Sunday to pick up some works on loan that were in potential risk of being damaged by leaking water pipes. I also personally called each of the dealers to let them know their works were safe.*

WORKING WITH AUCTION HOUSES

An in-house curator or anyone managing a large corporate collection is liable to work with an auction house at one time or another, particularly given today's volatile art market.

Auction houses complain that collectors—and by extension their art advisors—do not deal ethically with the houses. You should not expect an auction house to take back a piece you have successfully bid on, and you should not expect any special privileges when you leave a piece on consignment.

> *John Marion, President of Sotheby's has said: "The ethics of the client are worse these days because the numbers are so much higher. One of the worst things that happens here is that they don't tell you the truth about what they have done with the object, where it has been and so forth."* [26]

By seeing that the documentation is complete when you acquire a piece, you will assure honest information being available when the piece is deaccessioned. This full documentation is particularly important with corporate collections because their managements and staffs turn over so frequently. By the time a company wants to sell a piece, there may be no one working at the company with any recollection of the work's acquisition or provenance.

WORKING WITH ARTISTS

One of the joys of working as an art consultant is your interaction with those directly involved in making art, but your relationship with an artist should never shoulder aside a gallery that is working conscientiously to guide the artist's career.

Although artists are becoming increasingly involved in promoting their own work, their principal task has to do with the art, not with marketing, and their time should be respected. Consultants often ask artists to do things they would never ask galleries to do without offering any compensation, for instance, delivering and installing their work. The financial difficulties in many artists' careers also need to be kept in mind and, here again, seeing that they are paid promptly is a sign that you are an ethical professional.

A consultant also has a responsibility to represent the artist and the artist's perspective as accurately as possible, both to the client and in any curatorial decisions, such as how a work is installed or how it is described in label or catalog copy. Furthermore, if the work is to be reproduced, proper copyright permission must be acquired.

There is a more subtle obligation as well. When you acquire a piece, you assume some moral responsibility toward its creator. Although you will buy and sell with your client's interest at heart, you can never correctly feel that the piece totally belongs to your client. Federal legislation has been enacted protecting contemporary art of recognized quality. And even before the Federal legislation was passed, a number of states also moved to protect the moral rights of artists in their work. To an extent, a work of art remains the artist's, if not in terms of ownership, then certainly in the fact that the art is an expression of the artist's creative impulse and is an element of his or her career.

For example: Brian Ura brought suit against an art consultant, an interior designer, and a framer in Los Angeles for allegedly spraying, varnishing, and shellacking his paintings that were commissioned by a hotel. The paintings were altered supposedly because they were "too brilliant" for the hotel's dining room. Ura's suit was brought under California's 1980 Artists Rights Act.

One noted collector makes sure that he does not sell a work at a time when it would be detrimental to an artist's career. This sort of sensitivity should at least be a consideration, one that you should be prepared to discuss with your client. Many corporate clients who know little about art and care even less about artists find that they become devoted collectors themselves. By discussing an artist's career, you may give your collector insights into the workings of the art world that he will find intriguing and that will gradually inform his decisions.

> When the Chagall mosaic installed in First National Plaza in Chicago had to be restored, a watercolor portion, unsuitable for the outdoor installation in the first place, was decided to be irreplaceable. Art advisor John Hallmark Neff took great pains to see to it that all interested parties, including Madame Chagall and the Chagall family, understood the issues and agreed with the decision.

CULTURALLY SENSITIVE ART OBJECTS

I'm sure it's obvious that consultants should never knowingly be involved in buying or exhibiting fakes, forgeries, or stolen works of art. This is one good reason for insisting on thorough documentation. In the same way, a consultant needs to be sensitive to the problem of traffic in cultural art and artifacts that have been illegally exported or improperly collected. As a consultant, you are responsible for seeing to it that a collection is in line with all international, national, and local laws. You can consult the UNESCO Convention, and such specific guidelines as the American Indian Religious Freedom Act.

If you have any sacred objects in your collection, be willing to discuss them with representatives of the culture from which they came and exhibit and interpret the objects with their concerns in mind.

ETHICS AND YOUR CLIENTS

As your client's ambassador to the art world, try never to do anything the client would not do directly.

Your client has accepted your role as advisor, putting his trust in your honesty as well as in your knowledge. It would be foolish to jeopardize this relationship by being less than candid or by working against his interests.

Corporate art collections may be started for a number of reasons—to make the workplace more stimulating, to improve the company's image—but often a major objective is to support the local art community. Some eighty percent of U.S. companies focus on regional art, in part because it's an economical way to build collections, but also to support their local artists and dealers. You can see that it would be working against your client's objective to do anything unethical that would undermine the very art community the client wants to support.

Thinking they should save money or stretch their budgets, misguided consultants ask artists and dealers to make deals that could threaten their survival. The great majority of corporate clients would be horrified to know that this was being done in their names.

PRICES FOR CLIENTS

An art consultant or in-house curator is entitled to a discount in the trade discount range, ten to twenty-five percent off the full gallery price. This discount is usually passed on directly to the client, and appears on their invoice.

Some small firms, and even a few large ones, will pressure their consultants to deliver the cheapest program possible. They are either unaware of the damage this causes or they don't care. Consultants may have to educate their clients about the impact of buying art at large-volume discounts. When this is made clear, most clients will comply, for business people know very well the need for everyone to make a profit. There are always a few rotten apples who care only for themselves, but art world practices must not be geared to the lowest common denominator. In some communities, where galleries or advisors have consistently discounted art, corporate clients take such discounts for granted and have lost confidence in their local galleries because the prices seem so high.

AVOIDING CONFLICT OF INTEREST

Fully disclose to your client whatever financial arrangements you make with your resources. An independent consultant should be paid for his or her services by only one party, the client. If you are receiving additional compensation from your art sources and your client does not know this is the case, a situation of inherent conflict is set up between what may be in the best interest of your client and what may be in your best interest. Structure your business so that, in all your dealings, you are representing your client, not yourself. Even when you are working on a commission basis this can be done by taking a percentage of the estimated budget rather than of the actual budget.

The conflict of interest arises when consultants gain personally on their client's time or from their client's buying power. For this reason, accepting gifts from resources, or hefty discounts for your personal purchases, is also considered unethical.

If business people understand the need for profit, they also understand conflict of interest. Your need to avoid any conflict of interest extends to your family and friends. If there is a question of your acquiring a piece for your client or acquiring that same piece for yourself, a member of your family, or a personal friend, the art needs of your client should take precedence if you first see the work on his time.

If you want to acquire a deaccessioned piece from a corporate collection you helped to assemble, do so only after the piece has been appraised and dealers have had a chance to buy it.

DOCUMENTING THE ART

Many clients don't see the need for thorough documentation. They just know they need the art. They may not look ahead to the time when the company might be sold or merged and the art would have to be dispersed. Any art consultant who has been called by a past client for information on a collection, or who has been asked to dispose of a collection, knows how important careful documentation can be. Dealers and auction houses require a clear statement of provenance.

Documentation is also important at the time of acquiring art, of course. A little care at this time could avoid your unintentionally becoming involved in fraud or in buying works of art that have been illegally acquired. An art consultant has a professional obligation to provide proper documentation. (See Chapter 15 for a full discussion.)

HONEST PRESENTATION OF THE ART

You know about the pieces you are presenting to your client. Your own enthusiasm and knowledge is an essential part of your job, but be sure that you don't pretend everything is a masterpiece. One of your most important functions as an art consultant is to educate your client. Whenever one person knows a lot and another knows only a little, and money is involved, exploitation is tempting. You have the same duty as any teacher to give your student accurate information.

You also owe the artists some sensitivity to their intentions and the cultural context of their art when you make your presentation. In your other dealings, you are serving as a practical link between the corporate world and the art community, but it is in the presentation that you are able to link your client with the spirit of the art itself.

WORKING WITH OTHER CONSULTANTS

Maintaining a high level of professionalism is a challenge for art consultants because, for the most part, they are so isolated. There is little dialogue among them to clarify issues and control breaches of good faith. Too often, gallery back rooms are the only forums, and gossip is the only medium of communication. New consultants have no one to guide them through the ethical pitfalls of their field.

In some areas independent art consultants are coming together and forming local groups to share information, to help train new consultants, and to work with galleries in a cooperative way. If your area does not have such a group, see if you can form one. At least two or three times a year have meetings to discuss topics of mutual interest and to compare notes. Don't worry that you might give secrets away—remember, everyone knows everyone else's business anyway, but sometimes distorted by rumor. Candor benefits everyone.

Inexperienced or unscrupulous art consultants have burned both corporations and galleries, giving the profession a bad name. Furthermore, any time one consultant speaks disparagingly of another, it reflects on the profession as a whole. Many of these problems can be avoided if all consultants do their share in setting standards, advising novices, exchanging information, and agreeing not to cling to a competitive stance.

■ ■ ■

TOOLS OF THE TRADE PART 4

Starting Out

"In the beginning, survival is more important than success. Survival is staying on the field, playing the game, learning the rules, and beginning to grow."

—*Paul Hawken* [27]

Once you have analyzed your entrepreneurial skills and decided to take the plunge, you should research your market and choose your niche. (This process is described in Chapter 2.) You should also decide how you are going to charge for your services. (See Chapter 7.) There are then a number of logical and practical steps you must take to set up your consulting service.

START-UP CHECKLIST
1 Decide on the legal structure of your business.
2 Develop a business plan.
3 Obtain the necessary permits and licenses.
4 Select and register your fictitious name.
5 Obtain business insurance.
6 Open a business bank account.
7 Get a business telephone and address.
8 Create your marketing and presentation materials.

DECIDE ON THE LEGAL STRUCTURE OF YOUR BUSINESS

The first decision is what legal form of business you are going to have: a proprietorship, partnership, or corporation. If you are considering anything beyond the simplest sole-proprietorship, I recommend that you discuss the pros and cons with your lawyer and accountant. Two other good sources of basic information on this subject are *Small-Time Operator* by Bernard Kamaroff and *Running a One-Person Business* by Claude Whitmyer, Salli Rasberry, and Michael Phillips.(See Appendix.)

DEVELOP A BUSINESS PLAN

Business plans vary greatly depending on their purpose. If you want to raise start-up capital from friends or family, you may need a more traditional financial business plan than the one outlined here. But most art consultants starting out simply need a road map to show where they plan to go and how they are going to get there. The initial description of your business and its goals will be that road map for the first two years of your business. It will get you off to a strong start and will help focus you along the way.

Here are some of the major elements of your plan:

A MISSION STATEMENT AND MARKETING PLAN

Based on your research of the market, develop a mission statement and a marketing plan. Write out a concise description of how you envision your business. This will include:

- the purpose of your corporate art service,
- the special niche or target audience for your services,
- the secondary markets for your services,
- how the service will be described and promoted—its most compelling aspects from the clients' point of view.

Then create a brief one- or two-page document that starts off with this mission statement and lists the objectives of your marketing effort and the strategies you are going to use to achieve them. Also include your primary and secondary strategies for lead development, client referrals, public relations, and advertising.

When this is complete, a monthly promotions budget can be developed based on the strategies you've outlined.

A START-UP BUDGET

Assembling the costs of a start-up budget should be done as thoroughly as possible. Before you make any major purchases, get prices from at least two or three different sources. This goes for professional services as well as for furniture, materials, etc. You want to find an insurance broker, a lawyer, and an accountant who have some knowledge of the art world and entrepreneurship so you're not paying them for their on-the-job education.

If you haven't been in business before, you may not know about all the discount houses for office supplies and business equipment that service small companies. You can save as much as forty percent on all your supplies and equipment just by shopping effectively. Your best advisor in these areas is an experienced small business owner who can show you the ropes.

ACCOUNTING AND BOOKKEEPING SYSTEMS.

Select the systems you plan to use. And if you are going to be charging by the hour, choose a time-keeping system. There are no time-keeping systems designed for art consultants, but those used by lawyers work fairly well and can be purchased at any good business office supply store.

YOUR WORK LOCATION

Some consultants start out working from their homes while others rent office space. If you are going to rent space, there will be lease negotiations and possibly necessary improvements to the site. Plan these all out in advance, since the expenses can be steep and non-ending. Make your lease contingent on getting a contractor's estimate of the improvement you wish to make. Keep in mind that improvements can be a negotiable item with the landlord. Sometimes they will agree to pay for them or to give you a reduction in rent for a period of time.

Rarely will a corporate client come to your office, unless you plan to carry inventory or to use your space as a neutral presentation site. Most of the people who will come to visit will be your subcontractors. When planning a location, think about who will visit you there and the image you need to convey. It is not necessary to have a fancy financial district office to be successful as an art consultant. Many consultants function very well from their home offices.

START-UP BUDGET

START-UP COSTS

Start-up Investment $_____
Equipment (phone, typewriter, personal computer,
answering machine, fax) _____
Installation of Equipment _____
Marketing Materials _____
Remodeling and Decorating _____
Licenses and Permits _____
Professional (legal and accounting) _____
Deposits _____
Accounting System and Checks Printed _____
Cash Cushion _____
TOTAL _____

OPERATING EXPENSES 3-MONTHS

Monthly Draw $_____/Mo x 3 _____
Outside Services $_____/Mo x 3 _____
Rent $_____/Mo x 3 _____
Telephone $_____/Mo x 3 _____
Utilities (heat, light) $_____/Mo x 3 _____
Office Supplies and Equipment $_____/Mo x 3 _____
Advertising (Yellow Pages) $_____/Mo x 3 _____
Debt Interest $_____/Mo x 3 _____
Maintenance $_____/Mo x 3 _____
Taxes $_____/Mo x 3 _____
Legal and Accounting Services $_____/Mo x 3 _____
Insurance $_____/Mo x 3 _____
Answering Service $_____/Mo x 3 _____
Miscellaneous $_____/Mo x 3 _____
Promotion $_____/Mo x 3 _____
Entertainment and Travel $_____/Mo x 3 _____
Training/Professional Conferences $_____/Mo x 3 _____
Out-of-Pocket Expenses $_____/Mo x 3 _____

TOTAL ESTIMATED COSTS FOR START-UP
AND 3-MONTH OPERATION $_____

BREAKDOWN OF START-UP COSTS

MARKETING EXPENSES Estimated Cost

Stationery Suite, Printing $_____
Business Logo Design _____
Portfolio and Briefcase _____
(Optional) Art Carrying Portfolio _____
Marketing Materials _____
Wardrobe _____

BUSINESS ORGANIZATION COSTS

Accounting Fees _____
Decorating and Remodeling _____
Insurance _____
Legal Fees _____
License and Permits _____
Telephone Installation _____

OFFICE OPERATING EXPENSES

Supplies _____
Answering Service _____
Outside Secretarial Services _____
Photocopying _____

FURNITURE/EQUIPMENT

Desks and Chairs _____
Filing Cabinet _____
Typewriter/Personal Computer _____
Telephone/Fax _____
(Optional) Installation Toolbox _____

OUT-OF-POCKET EXPENSES

Gas _____
Bridge Tolls _____
Parking _____

Zoning restrictions vary wildly from place to place, and you can easily find yourself in violation of residential zoning ordinances by running your business out of your home. Whether your neighbors would care enough to report you may depend on such things as how many people come in and out of your house and how often the UPS picks up and delivers. Get good, experienced advice, because zoning often seems illogical, based as it is on history and the vagaries of local politics.

OBTAIN THE NECESSARY PERMITS AND LICENSES

LOCAL AND STATE LICENSES

Many cities, counties, and states require that an art consultant obtain a permit or license to do business. Check with your local governments to see if this is so in your area.

FEDERAL IDENTIFICATION NUMBER

A business is required to identify itself on forms and licenses by either of two numbers: a Social Security number or a Federal Employer Identification Number.

A Social Security number is all the identification you will need as a sole proprietorship until you hire employees, in which case you will have to get the Federal Employer ID Number. If you plan to have no employees at the start, file Form SS-4 with the IRS. No fee is charged. If you do file for and receive a Federal Employer Identification Number, the IRS will automatically send you quarterly and year-end payroll tax returns that you must fill out and return even if you have no employees, so don't apply until you become an employer.

Partnerships and corporations must have federal and/or state identification numbers whether they hire employees or not.

SALES TAX LICENSE

Not all art consultants need a resale license; some pass all their invoices directly to their clients for payment. You will need one if you are planning to work on a commission basis whereby you will be marking up invoices on a resale basis.

Apply to the state board of equalization in the county in which you operate. Note that if you do get a sales tax license, you will have to fill in quarterly returns whether you use the license or not. If the license is not used, in time it will be revoked.

A word of warning: In California, the State Board of Equalization has ruled that art consultants who pass on all their professional discounts to their clients must charge sales tax on their consulting fees that relate to the purchase of art. Be sure to check the current policy in your community. If there is a similar type of ruling in your town, then you may want to consider separating the actual art consulting you are doing that relates to the direct purchase of art from the other services that you provide. This way, your client is only being taxed on the portion of your fees that relate directly to art purchases. If you are in doubt about the correct way to respond to the policies in your area, check with your accountant.

SELECT AND REGISTER YOUR FICTITIOUS NAME

When you are essentially selling your personal taste and expertise, a firm name that uses your full name is the most effective. Margaret Winton, Fine Art Consultant, or Margaret Winton and Associates, Fine Art Services. Your name is the name your client will remember most readily when he is recommending you to others. No matter how great a company name may be, unless hundreds of dollars are spent on advertising, people tend to forget it, particularly today when most of us suffer from information overload.

If you plan perhaps to sell the business at some point or to have several assistant consultants working for you, it may be better to have a generic name that is more easily transferred with the goodwill of the business when you sell it.

As you choose a name, be sure it says what you do and what you hope to grow into doing. Ask yourself: is it simple to pronounce and understand over the phone? Naming your company is not like naming a dog, where you can indulge your whimsy or use a favorite name that has meaning only to you. You want something easy to remember than indicates what your service is. Test it with your friends and advisors before you make a final decision.

If the name you choose is not your own personal name, you must contact the secretary of state in your state for a name check. Once you get clearance, you must register the name with the state and pay a small fee to have it published in a newspaper.

After being in business for a few years, I started a separate fine art exhibition business called Art Programs Inc., which I sold twelve years later. When I started the company, I thought the name was perfect since it said exactly what we did—provide art programs to companies. But even clients in whose lobbies we had been doing exhibition programs for years, and with whom I did not personally have that much to do on a daily basis, still referred to the company as Susan Abbott & Company. They seemed to have a hard time remembering the name Art Programs Inc. (For this reason, I kept a secondary listing in the Yellow Pages under my personal name.) On the other hand, the fact that the business had a generic name made the goodwill value of the business much greater in the eyes of the woman who purchased it.

OBTAIN BUSINESS INSURANCE

When you are getting insurance for your fine arts business, it will save you a lot of money and hassle to deal with a broker who specializes in fine arts coverage. These brokers deal with carriers familiar with the special risks and industry statistics, so their bids will often be lower and their service more knowledgeable. Most of the large fine art insurance companies have 800 numbers and are just as easy to deal with as agents in your own area. Ask your local museums and galleries for the names of their insurance brokers. A list also appears in the Appendix.

Most practices need several kinds of insurance—personal liability and general liability—and the price will depend on where you live and the types of places in which you will be working. Your broker can best advise you regarding the kind of insurance you need. Here are a few types of insurance you should consider if the situation applies to your activities:

SMALL BUSINESS PACKAGE POLICY

This covers all your office contents, equipment, and business personal property, and provides general liability in case someone is injured while visiting you. Note: If your office is in your home, you should be aware that usually standard homeowner policies do not cover business property or business-related injuries.

FINE ART INSURANCE

You should have coverage for the maximum amount of art you will have in your custody at any one time.

BAILEE OR PROJECT-RELATED INSURANCE

At the beginning of a major project, consider taking out a Bailee policy for the total amount of the art budget, in the name of both you and your client. This covers specifically all the art you take out on approval on behalf of the client. After the client purchases the art, he will want to arrange for a separate fine art policy or self-insure. Having project insurance avoids the embarrassing situation where a work is damaged during a viewing, either by you or the client, and then the gallery who lent it out on approval either has to submit the claim to its insurance company or the client must pay for the loss; if it's an expensive piece, your client won't be happy.

When an art consultant takes responsibility for the works of art involved in a project, a bailment contract comes into effect, whether it is explicitly written or not, because "bailment" means that objects delivered by one party to another are held in trust for some specific purpose and returned when that purpose is satisfied.

Huntington T. Block, the fine art insurance broker, compares the situation to taking clothes to the cleaners. "When one leaves suits and dresses with the local cleaning establishment, it is the responsibility of the cleaning establishment to care for these garments until they are returned to the customer. If the clothes are destroyed in a fire or other calamity, the customer is entitled to reimbursement. This is why cleaning establishments buy what is known as Bailee's Customers Insurance—and it is why art consultants need similar insurance."

It is very important that the fair market value of any art you have in your custody be agreed on in advance between you and the owner of the art.

LIFE INSURANCE

If you are doing a major commission and the client is investing a sizable amount of money up front for the design and fabrication costs, consider taking out a policy on the artist to protect your client's investment until the completion of the project.

DISABILITY INSURANCE

This gives you protection in case you are temporarily or permanently injured and are unable to work. Check with your state Employment Development Department, DI Elective Coverage Unit. Some states offer very favorable disability coverage for self-employed people. The rates are far below the market standard.

OPEN A BUSINESS BANK ACCOUNT

Have a separate checking account for your company so that all business income and expenses are easy to track. Furthermore, should you ever be audited, the IRS will not look favorably on business and personal expenses being comingled.

Before you order checks, decide on the type of bookkeeping system you will use. Your accountant may have a system that he or she feels would be best for you. Many of the convenient one-write

systems, a combination of checks and ledger, have their own checks and must be ordered directly from the office supply company rather than from the bank. If your office is computerized, there are some very simple bookkeeping systems that are great timesavers, such as Quicken, designed for both IBM and Macintosh systems.

GET A BUSINESS TELEPHONE AND ADDRESS

The telephone is a main communication conduit. You must have an efficient system for receiving calls, because much of the time you will be out of the office. If you have secretarial help, two lines are preferable, one for incoming and one for outgoing calls, or you may have some variation using an answering machine or voice-mail device.

Answering Machine. If you decide to use an electronic answering machine, the outgoing message should be brief, professional, and current. This may be the first impression a client will have of your company. If your voice doesn't sound good on tape, ask a friend to record the message for you.

Sample message: Hello, you've reached Martin Scorely and Associates, Fine Art Consultants. Please leave a message of any length, and we will get back to you as soon as possible. Thank you.

Don't tell people to "have a good day," or give an itinerary of where you are and what you're doing. It may be helpful to imagine what tone would be appropriate for your message if the president of Alcoa Corporation were calling. For more information on different ways to set up your phone system and answering devices, see *Running a One-Person Business,* by Claude Whitmyer, Salli Rasberry, and Michael Phillips. [28]

A Postal Address. You want to avoid using a post-office box, which does not look professional, but reprinting stationery and contacting clients and suppliers every time you move is expensive, time-consuming, and can reflect negatively on your image.

If you are starting out in a home office or plan to change offices frequently as you expand, I recommend that you subscribe to a mailbox service. A rented mailbox costs about $13 a month or $100 a year. This service allows you to have a prestigious address in almost any part of town you like and have your mail forwarded to you. There are many companies that offer this kind of service. Sometimes answering services have mail forwarding services. Check the yellow pages under mail receiving. There is also a national franchise called: Mail Boxes Etc., 5555 Oberlin Drive, Suite 100, San Diego, CA 92121; (619) 452-1553.

CREATE YOUR MARKETING AND PRESENTATION MATERIALS

Before you can go out and prospect, you need to have a stationery suite and all the tools you will use in your sales presentation. These are discussed in detail in the next chapter.

Note: Your marketing materials should be designed to help you implement your specific marketing plan. Too often art consultants, who are very visually oriented, get so excited when they are starting a business that the first thing they do is design and print the stationery. It's as if seeing the logo in print will make the business a reality. But this can be a very costly mistake if your target audience is out of focus.

A Seattle art consultant sent me his business card and expensive brochure, which were targeted to interior designers, architects, and corporate clients. After interviewing him about his marketing goals, I saw that he should be going after corporate clients in one brochure and after designers and architects in another that had a more focused approach. He could have avoided this time-consuming $2,500 mistake by completing his business plan before charging ahead on marketing materials.

NOTES FOR GALLERIES

When you are setting up a corporate consulting service in your gallery, the importance of precise positioning based on careful market research cannot be overestimated. This is the foundation on which you make all the other business decisions, such as whom to hire—what level of experience they need, what sort of people they should be—as well as what policies and services are going to be a part of your offering. The clearer you are, the easier it will be for the people you hire to successfully represent the service in particular and the gallery in general.

Too often, a gallery director will just tell one of the gallery's sales staff to develop corporate jobs. Or worse yet, the director will make a loose deal with an independent contractor to represent the gallery. These half-hearted attempts to go after corporate business can seriously backfire. A company's loyalty is to the consultant who solves its problems, not necessarily to the gallery for whom the consultant works. So if the gallery wants to benefit from the goodwill developed with the corporate client, it must have a strategy for building the consultant's own loyalty to the gallery. Such a strategy may consist of offering the consultant training, providing marketing support, setting up clear lead and territorial guidelines, and arranging a compensation plan that is at once fair and full of incentives for the consultant to expand his or her performance goals.

SALES FORCE MANAGEMENT

The art advisors you hire will represent the gallery to important clients and potential collectors of art, who may also patronize the gallery. These sales representatives are goodwill ambassadors and their training is important. Even if they have worked in other galleries, take the time to communicate whatever professional standards and expectations are important to you. A general business book on the subject of managing a sales force is John Fenton's A to Z of Sales Management.[29]

THE ART ADVISOR'S WORK SPACE

For busy galleries and frame shops, consider having a separate telephone with an answering machine for art consulting inquiries. Gallery staff answering the phone on the fly do not have the correct attitude toward these important inquiries.

A corporate art consultant needs a quiet separate space where his or her conversations can't be overheard by gallery visitors. The first critical communication with the client is usually by phone and the advisor needs to have total concentration to get that first appointment. Frequently the best time to reach corporate clients is very early in the morning, long before most galleries are open. A consultant must have access to his or her office from Monday to Friday, 8:00 A.M. to 6:30 P.M.

SAMPLE MARKETING PLAN FOR A GRAPHICS GALLERY ART CONSULTING SERVICE

The purpose of The Print Gallery's Corporate Art Services marketing is to develop the maximum number of potential customers interested in purchasing art and framing services.

The target audience will be small to midsize Madison-based companies and professional firms that are moving or redecorating their offices; and the secondary target audience will be large companies in the hospitality and health-care fields that are planning volume, cost-driven art purchases. Additional prospects will be advertising agencies, public sector organizations, designers, and specifiers of facilities expansion projects.

The contract service will be positioned as the most experienced service for the customer seeking a quality, professionally planned and administrated graphic fine-art program at the most moderate prices available. The convenience and economy of having all services available, including manufacturer/custom framing services, will also be emphasized.

Marketing strategies and tools will be a combination of yellow page advertising, personal direct mail, targeted special market advertising (such as in the hospitality trade and ASID newsletters), free seminars for designers and specifiers, and publicity in local newspapers. Marketing will also be done personally by the sales force by canvassing gallery and frameshop customers.

Our primary reasons for marketing the corporate art service are:

- to attract new corporate clients
- to promote framing services
- to promote art sales for the personal collections of corporate clients
- to increase visibility in the high-income sector community
- to stimulate old clients to be new customers

MONTHLY MARKETING AND PROMOTIONS BUDGET FOR A GALLERY CORPORATE ART SERVICE

Marketing Method	Monthly Cost	Notes
Canvassing	$ -0-	construction sites, building directories, offices (main investment: time)
Lead Development	$ 50	cost of $600 lead subscription service amortized, research time of director and staff
Personal Letters	$ -0-	staff time
Brochures	$100	yearly printing cost of $1200 amortized
Yellow Pages (Display Ad)	$125	listing, one directory
Newspaper (Display)	$ -0-	tag our gallery ads
Direct Mail Postage	$ 26	cost $260 amortized +
Referral Gifts	$ 41	cost $500 amortized
Free Seminars	$ 50	design trade lectures, distribute brochures
Public Relations	$ 25	cost of materials and photos; only staff handles

Marketing Materials

When I started out, my former employer bought me a very expensive Gucci briefcase. It was a little flashy for my taste, but to honor the thought behind the gift, I used it for several years. A client of mine, the president of a large development company, mentioned several years later that I was so young-looking when I first called on him—I was twenty-three years old—he couldn't gauge how much experience I had, but he figured if I had a $600 briefcase I must be pretty successful.

This was a valuable lesson to me on just how important art presentation materials can be, particularly when you are starting out and you don't have a client base to give you credibility. Your presentation materials accomplish four important tasks. They:

1 communicate your successful image,

2 establish your credibility,

3 demonstrate that you stand for quality, and

4 provide visual reinforcement to your presentation.

Marketing materials encompass all the power clothes, visual aids, presentation cases, brochures, stationery, and other items you assemble to help promote your business. Because art consulting is about providing quality visual objects and a successful image to clients, your own packaging and the materials you use must reflect these qualities. They comprise the first impression the client has of you. Corporate people are extremely image conscious and first impressions are lasting.

MARKETING MATERIALS
Your Wardrobe and Accessories
Presentation Cases and Equipment
Visual Aids That Demonstrate Credentials or Features
 of Your Offering
Stationery
Business Cards
Brochure
Publicity and Advertising
Articles on Corporate Art
Art Program Statements
Publications Connected with Your Art Programs
 (Catalogs, Etc.)

WARDROBE AND ACCESSORIES

Your attire is the first thing that conveys your personal taste and image. In the last two decades, the corporate world has become highly sensitized to the importance of personal image. This awareness has spawned a whole industry of people who consult with employees on how to "dress for success."

There are many good books and videos on corporate dress and image issues. Check your local library and bookstore. Basically, it's safest to dress on the level of the top management of your target company. Your clothes should give you personal power. They should say in effect, "I am successful, competent, and here on business." They must also convey an image of quality, since the essential aims of most art programs are to enhance the quality of the workplace and to convey a successful image for the company.

If you are just starting out, I recommend assembling at least three power outfits, complete with appropriate accessories, which you wear for your high-level meetings with prospects or clients. Corporate cultures vary considerably; some are highly conservative and would, for example, look disparagingly at a woman wearing fancy costume jewelry or a man not wearing a tie. More casual companies might not object. In a sense, a consultant must assess the prospect and dress at the level of the image it is likely the client will want to project. When you're getting dressed, it's helpful to think about how you want to be perceived.

A word of warning: Select clothes you are personally comfortable in and that make you feel good about yourself. If you buy an outfit that is so far from your regular style or taste, it may rob you of your personal power.

Accessories, such as jewelry, belts, shoes, briefcase, and purse, are very important and should be of the finest quality you can afford.

I often get asked, "Isn't it all right for people in the arts to be more flamboyant than their clients?" To a limited extent, the answer is yes. However, since the client is looking to you to create a corporate image, he is judging you by corporate standards.

When a bus totaled my Saab recently, I arranged with the Saab salesman to bring a car to my home for a test drive. When he showed up, he had on a blue pinstripe suit, red power tie, and horn-rimmed glasses. He looked like a caricature of the corporate president dressed to address his stockholders. I thought to myself at the time, "This guy must have a meeting with his banker." The next time we met, he had on an expensive-looking cashmere sportscoat and gabardine slacks. It dawned on me that this wasn't a coincidence; the man was dressing at the level of his customers. If car salesmen are dressing for success, what must we do as art consultants?

PRESENTATION CASES AND EQUIPMENT

A seminar participant once asked me, "How do I keep from looking like a bag lady, dragging in all my stuff—my purse, briefcase, slide projectors, slide trays, and portfolio?" Three strategies can help to alleviate this problem.

1 Plan out all your presentation cases and equipment in advance, including your briefcase. Even if you are not going to purchase them all at once, decide on a unifying color, usually black, gray, or brown. Make sure all the pieces you need come in that color so they will blend in together and seem less like disparate baggage.

2 Streamline your materials. For example, if you do both outdoor and indoor projects, have a small presentation portfolio that you can use for photos for smaller projects rather than having them all in an oversized portfolio that your prospect has to wade through.

3 Leave some materials, such as an art portfolio, in the waiting room or lobby with the receptionist and get them only if they are needed.

Depending on the type of presentation, any or all of the following materials may be needed:

- briefcase
- leather note-taking pad
- one-inch-thick, three-ring presentation portfolio, preferably of quality leather and small enough to fit in the briefcase (the best are those that zip and have a secret pocket where you put other visual aids; they also have built-in places for cards, calculator, and pens)
- slide projector and spare bulbs (optional)
- slide-viewing magnifying device
- art carrying portfolios
- vinyl art protection sleeves

VISUAL AIDS

To make buying decisions, people have to be able to visualize themselves enjoying the benefits of the product or service in question. In the sales presentation, a picture really is worth a thousand words, because many of the features and services you offer will be unfamiliar to your prospect. To avoid his eyes glazing over as you describe the fifth feature he's never heard of, such as logistical documentation or employee selection, have a photo or some other visual aid to bring the whole thing to life.

> By labeling each aid with the name of the project to which it belongs, you discreetly let your prospect know who some of your clients are. For instance, to show him how you label a floor plan in a survey, have an actual completed floor plan from a past client. Put a typed self-adhesive label at the corner of the plan identifying it, e.g.:
>
> First Bank of Blaton
> 32nd Floor, International Division
> Art Survey Plan

For every feature and service you offer, plan how you can effectively demonstrate it. This section covers some ideas and some samples of visual aids to use in a sales presentation. However, just because you have them all doesn't mean you will use them all in each presentation. It's important to show only what is appropriate to the client.

Continually update visual aids so they are current and in good condition. Clients are expecting their art programs to make their spaces sparkle; dog-eared, shabby presentation materials give the wrong impression. In the case of letters and photos, placing them in acetate or having them plasticized keeps them from getting dingy and crumpled from lots of handling.

Note about framing samples: It is not necessary to bring samples of framing. Most clients aren't interested in pouring over mouldings. Installation photos (see below) of tastefully framed works are usually sufficient. The exception to this is when you are working with a designer who wants special mouldings produced and when the job is high-volume/low-cost and the quality of the framing may be an important issue.

VISUALS OF FORMER PROJECTS

Installation Photographs. Five or six eight-by-ten-inch color blowups of already completed projects are useful visual aids during presentations.

When you are just getting started and don't have any client photos, you can put together a portfolio of reprints from commercial interior design magazines, such as *Designer's West* and *Interior Design*, that demonstrate a variety of approaches to the use of art in the workplace.

> **Beware:** I am not suggesting that you in any way imply that these are your projects. The photos are used only as an educational tool, to show the prospect the variety of approaches he might take and to elicit his comments. You must be very careful to mention that these are other people's installations.

Once you have been in business a few years, you can use photographs of your own previous projects. You may want to have a slide presentation of the best jobs you've done (see below), but it is still helpful to have a photo presentation for those situations in which the prospect is in a hurry and doesn't want to commit himself to viewing a whole slide show. I always try to show as much variety as possible so that my prospect doesn't feel that every job I do looks the same. And I take the time to explain the goals of each job and how the art accomplished them.

Note: On big jobs, the interior design firm often sends in a professional photographer to shoot the project. You can piggyback on the photo shoot, either by just paying for extra prints or by having the photographer shoot a few extra shots for you. You can also get 35mm slides to use in a slide presentation. Be sure the photographer is experienced in shooting architectural interiors.

Sheet of Slides. With a hand viewer, a sheet of slides can be a useful supplement in case the prospect wants to see more or you want to make a special point. Each row across the vinyl sheet can be of a different client's office, with the company's name appearing on a label.

Slide Presentations. After you've been in business for a year or so and have a range of projects completed, a slide presentation is a good investment. Keep in mind that people get overstimulated when they are shown too many slides at one time. From five to eight jobs seems right, and it's better to show four or five shots from each project at a time rather than jump from one project to another.

> **Some tips:** Leave a blank space between different projects to create a visual rest stop for the viewer. The first slide of each new project should either be a shot of their logo or, even better, a prepared slide with just the name of the company; at the end, some slides might demonstrate different features of the program, e.g. employee selection. Sometimes for contrast it's effective to have these feature slides done in black and white.

With the advent of videos, slide projectors have become obsolete in many corporate storerooms. It's best to bring your own with spare bulbs, an extension cord, and a circular slide tray.

Videotapes. A number of art consulting firms have used videos successfully as a way to showcase their services. But unless you are willing to spend the money to produce a first-rate piece with music and professional talent, you are better off staying away from this medium. If you do prepare such a tape, remember than many smaller firms don't have video monitors or even televisions on hand, so be prepared to bring all the necessary equipment.

LISTS OF CLIENTS AND PROJECTS

You should have available a running list of all or some of your clients. Be sure their names are spelled correctly and include their home cities.

SAMPLE LISTING:

Taiko Corporation, Madison
Art Acquisition Program

We designed a marketing program for the Taiko Square office complex, developing promotional events and a rotating series of outdoor sculpture exhibitions. The program served to identify Taiko Square with cultural activities, contributing to its upscale image and strengthening marketing efforts to professional firms. We also provide similar kinds of programs for Tutonate Properties in Seattle and the RENCO group in San Francisco.

If you do notably diverse projects, it may be helpful to have a sheet listing seven or eight types, each summarized in three or four sentences, as shown above. Note that you should get the clients' permission to use their names in your promotional material.

SURVEYS, DOCUMENTATION SHEETS, AND ART LABELS

Visual examples of services you provide are often useful at various stages of a presentation to give a client some sense of the reality behind all the abstract terms.

Here are some of the most obvious examples to use:

- A survey in the form of a floor plan (a blueprint) with labels indicating the recommended art plan. A label at the corner of the plan can identify the client.
- A documentation sheet recording vital data on a work of art—its condition, authenticity, value, and provenance. (See Chapter 15, page 157 for a sample documentation sheet.) Instead of showing a blank sheet, you might reconstruct one from a previous client's job to make it more interesting to look at and so that you can indicate one more client's name.
- A photograph of art hanging on the wall with a label next to it and below it a sample label showing what information would be included.

DOCUMENTS FROM EMPLOYEE INVOLVEMENT PROGRAMS

These employee programs, often vital to the success of an art program, need to be described and explored early in your consultation. Visual aids can illustrate the process and persuade your prospect that involving employees is both important and feasible.

Photographs of Employee Art Selection. I like to have two five-by-seven-inch photographs on the same page demonstrating the process of employee art selection, plus a sample sheet from my graphics resource book showing preselected works of art for employee offices.

Photo 1 A group of employees selecting the art for their area, standing around an art cart while an art consultant and installer hold up a work for them to look at.

Photo 2 An employee sitting at his or her desk meeting with a consultant to choose art for the office.

Tip: Very often big companies have their own in-house newsletter. By contacting the human resource department prior to your employee meetings, you may be able to arrange for an article on the art program. The staff photographer can take some shots of employees selecting their art. The resulting article and photographs can be used by you as marketing materials. You can also pay the photographer extra to shoot some color 35mm slides for you to use in slide presentations.

Letter Announcing Art Program to Employees. I bring a sample of a letter from a former client, describing the art program to his employees. I always offer to draft this letter for my new client. Letting him read one by another president helps him visualize sending a letter to his own employees with such pleasant news. The art program will go ahead for other reasons, but you have offered your client the chance to develop employee goodwill without any additional expense.

Art Tours, Newsletter Art Tips, Etc. In the same way, any documents and photographs showing other components of your employee involvement programs will make the process seem more real to your new client.

Right: *A sample letter to employees*

WESTERN FINANCIAL MANAGEMENT COMPANY

100 Spear Street
Los Aptos, CA 91401
415/513-9101

INTEROFFICE CORRESPONDENCE

DATE: December 5, 20__

TO: ALL EMPLOYEES

FROM: ARTHUR BANCROFT

I'm pleased to announce that we have decided to acquire some art for our new offices. We have settled on an art poster program, because this will give everyone an opportunity to be involved in choosing which pieces will hang in his or her area.

The program, provided by Fine Art Consultants, consists of graphic posters created by famous artists for their museum and gallery exhibitions. A brief history of the poster art form is attached to this memo.

At the time of installation, a Fine Art Consultants representative will visit each area with a group of posters for everyone to review. There are many beautiful works to choose from, and we hope you'll all find something you like. Please take a few minutes to participate in selecting a work of art for your area.

**HEPPART,
HAMILTON
& SHAW**

500 Pearson Avenue
Cupertino, CA 95461
408.495.2948

INTEROFFICE CORRESPONDENCE

RE: ART PROGRAM

When planning the move into our new offices, we decided that works of art would be acquired for display in the corridors and reception areas. An art committee (consisting of Tom Sturgeon, John Hamilton, and myself) was appointed, and over the past six months we have been working with Fine Art Consultants, an art consulting firm, to acquire a modest company collection.

Most of the works we have purchased are by well-known contemporary artists, with a sprinkling of antique Japanese, Chinese, and Indian artifacts. We hope you will each find some favorites, and that you may come to like even the "not so favorites." Most of all, we hope you will feel the collection as a whole is a welcome addition to our offices.

On September 13, consultants from Fine Art Consultants will be installing the art work. They will be pleased to answer any questions you may have, and at the end of the installation an informal tour will be given for anyone who is interested.

(signed)

George Shaw

COPIES OF FINANCIAL OR LEGAL DOCUMENTS

If you regularly offer leasing or other types of financial options, have a schedule of comparisons so that the prospect can review the issue in a simple, straightforward way. Clients may also want to see a sample agreement before they go ahead.

COPIES OF PR MATERIAL

Keep copies of any newsletters, catalogs, annual reports, or art program statements created by your clients to highlight their art programs. People like to see what others are doing.

An article on your services or on a client's art program can be a valuable marketing tool because people are more inclined to read an article than a brochure. Have a good quality reproduction made of any significant press you or your client receives on behalf of the art program. A stat can be made of any newspaper article and then good photocopies or prints can be made from the stat. This is an investment well worth making.

If you run an ad campaign for a special target audience, such as developers, keep a copy of the ad in your presentation case to remind your clients where they may have heard about you. For more on public relations and advertising, see Chapter 19.

ARTICLES ON CORPORATE ART

Keep a few good articles on different aspects of the use of art in the workplace to leave behind after a meeting or to send with letters to your clients. (See Chapter 5, page 60, on an effective use of these as enclosures with confirmation letters.)

Left: *A sample memo to employees*

ROBERT B. EGELSTON
CHAIRMAN
THE CAPITAL GROUP, INC.

Our decision to build a small corporate collection started simply with the objective of visually enhancing our working environment. We soon saw, however, that with a certain additional commitment each year, we could move toward something more interesting and perhaps more important and so we embarked on the course that has brought us to this exhibition.

As we gained experience, California art became the primary focus of our collecting activity. The California theme seemed logical because so much art was being made here and because our company has been headquartered in Los Angeles since the early 1930s. We were not trying to put together a complete, definitive collection of the modern California scene, but rather trying to assemble a number of representative pieces which included work done in recent years by both well-established and less well-known artists.

Currently, we are concentrating on a younger group of artists. The flow of their ideas helps keep the collection alive, and their work is usually more affordable.

New ideas are basic to our business, and we are committed to keeping the creative juices flowing within our organization as we look out at a complex and changing world. The process by which professional investors make portfolio decisions from a mix of facts and judgments, and the process by which artists communicate new ways of seeing the world through their work, have some striking similarities. Both spring from an abiding curiosity. Both take what is commonly available and add a special dimension. Both are fragile and often require courage—and encouragement—in expression. In an age where technology is becoming increasingly dominant, integrating the intuitive with the rational takes on more importance. Business decisions are shaped by more than pure rationality. A higher creativity—perhaps at times not apparent—is always at work.

PRINTED BUSINESS MATERIALS

STATIONERY

Your stationery is often the first impression the prospect has of your company. Some art consultants choose a very artsy look, with colored paper and flashy type, trying to convey something of their own personal style. But the purpose of your stationery is to convey your professionalism and the solid image of your firm. The design is most effective when it keeps within the boundaries of corporate standards of good taste.

A few tips: Make sure the paper and logo copy and fax well. When you submit duplicated proposals to members of committees, you want the copies to be legible and to make a good impression.

Before you decide on a design, type a letter and a proposal on paper with a mock-up letterhead to see if the design works well with an actual typed document.

Avoid corporate taboo colors such as purple and pink.

Left: *Sample art program statement. When the collection of The Capitol Group, Inc., was shown in the lobby gallery of Security Pacific's headquarters in Los Angeles, Robert B. Egelston prepared this statement for the exhibition catalog.*

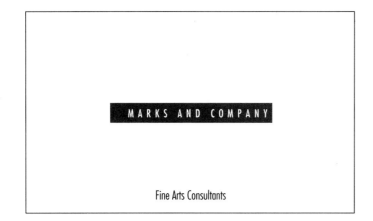

Right: *This business card functions as a mini-brochure, with the company name and service on the front cover, and a more complete list of services inside.*

MARKS AND COMPANY

Fine Arts Consultants

JOHN MARKS/DIRECTOR

Providing services to corporations and public sector organizations

Art consulting
Exhibition programs
Public relations projects
Public arts programs
Art program management
& training

300 East Colorado Phoenix, Az. 85014 Telephone: 602.266.5469 Fax: 602. 266.5467

BUSINESS CARDS

Perhaps the most important marketing tool you can have is a business card that functions as a mini-brochure (see example on facing page). In the corporate world, cards are exchanged in all kinds of business and social situations. If your card stands out and has capsule information about your services, people won't be as apt to forget you and what you do. I make it a practice to give a card to each executive and employee in whose office I install art so that they can call me if they notice any environmental changes affecting the work. The card also serves for future reference should a colleague of theirs need art consulting services, though I don't suggest this to them directly. (See Chapter 4, Generating Leads, page 49, for other uses of your business card as a marketing tool.)

BROCHURES

As the art consulting profession has matured, brochures have become more common as a marketing tool. A good brochure can differentiate you from the competition and can establish your credentials. It's a useful way to introduce your service, although it's rarely effective used during a meeting, and a sale is almost never made on the basis of a brochure alone. It will be most effective when the client has a chance to peruse it on his own time. It can either be sent ahead before the first meeting with a prospect or left behind after the meeting.

CONTENTS OF A BROCHURE

Here's a list of the possible contents in a firm brochure. Not all need to be included. Brochures are best when they are short and to the point.

- Logo or other image of your firm's identity
- Statement describing your firm
 - Its reputation
 - Its standards of quality
 - Its credentials
- Range of services
 - Special focus
 - Key features and benefits
- How you work, how you charge
- Scope of your business
 - Size
 - Location
 - Other cities
- Staff and resources
 - Credentials and relevant experience
- Client base
- Ask for action—"Call for a complimentary first meeting"

Perhaps the biggest mistake a consultant makes when producing a brochure is to try to include everything, as if the brochure were going to be taking his or her place. It's better to think of it as a teaser, a door opener, a brief image or quality statement.

A consultant from the Boston area sent me her brochure and asked me to critique it since she was dismayed that no one ever seemed to read it. When she handed it to prospects during personal meetings, they glanced at it and set it down. It was a demonstration piece on what not to do in a brochure:

- The color was mauve and gray. The gray was too light; and mauve and purple are considered feminine colors, repulsive to many businessmen.
- The type—nine point or less—was difficult for most people over forty to read.
- So much copy was jammed into the space, it made the *New York Times* look like a third-grade reader. The paragraphs were so long that you never even wanted to *start* reading them.

When you are starting out, don't create a fancy brochure. I recommend waiting until you've been in business at least two years before committing yourself to a permanent printed piece. A classic pitfall of start-up brochures is that both the copy and the design are overdone to compensate for the lack of clients. Once you have a track record, you can let the list of your clients speak for you. The brochure will be more understated and consequently more successful. Another reason to wait is to get more marketplace experience and a clear idea of the best positioning for your service.

I must confess I fell into this trap myself when I was first starting out. I thought leasing art to companies would be a service in great demand, and I created an expensive brochure based on this concept. After less than six months, I realized that, while leasing was a viable strategy for some companies, for many it was not. With a little more market testing, I could have created a brochure with leasing as a special feature rather than the main focus. The brochure had to be scrapped after only six months of use.

A versatile format for a brochure that is still effective once you are established is a quality presentation folder. You can buy these at stationery stores or have a printer order them in bulk for you. Either have the cover printed with your logo or have a special presentation label created with your stationery suite, and apply the label to the folder.

The inside of the folder has two pockets and a cross-hatch for a business card.

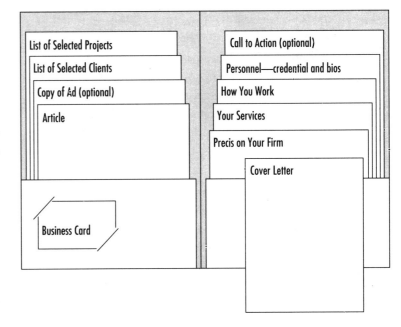

Above: *Contents of a presentation folder, left side: Article; Copy of Ad (optional); List of Selected Clients; List of Selected Projects; slots to hold business card on flap.*

Right side: Cover Letter; Precis on Your Firm—reputation and scope of business, size, location, cities, etc.; Your Services— range, unique or special features; How You Work—approaches, resources, compensation; Personnel— credentials and bios; Call to Action (optional)— suggesting the next step: "Call for a complimentary meeting."

What to Omit. What you don't put into a brochure is almost as important as what you do put in. Here are some common pitfalls.

- Pictures of art that the client may identify with your offering. It's best not to use pictures of art in a specific way. It can be in the background of a photograph—art on the wall—but you are selling advice, not art, and when art is highlighted, it conveys the wrong impression. If the client doesn't like the piece, he may reject you as a consultant.

"At first, I used to send prospects a full-color catalog of our publications, but I found they pinpointed me as a catalog person. Their minds would close and no matter what I said I couldn't convince them differently. Now I just send the minimum amount of information until I can meet with them and see what direction they are heading."
—*Jeanne Temple, art consultant*

- A lengthy discourse on the philosophy of your firm. By all means share this information with your employees, but clients don't want to read pedantic copy on your commitment to the higher values of fine art.
- A history of your firm. The reader doesn't care how or why you got started; they want to know who you are today and what you can do for them now.

- Long, tedious resumes that include every job you ever did, the name of your college and spouse and pet goldfish. Put only key information relevant in some way to the job at hand.
- Bulky text. Read the copy and ask after each sentence, "So what?" Eliminate everything that is not important to the reader.
- All art jargon.
- All intangible features that do not directly benefit the client.
- Boastful, overly promotional copy stating that the art program will accomplish things you cannot really guarantee; for example: "An art program will enhance the quality of the workplace, making your employees more productive workers."

NOTES FOR GALLERIES

Marketing materials can be so important in conveying a professional image that I recommend the director take an active part in developing them. Beware of too much emphasis on your inventory.

Many entry-level art consultants do not have the financial means to purchase a quality wardrobe or the other items required to portray a successful image. Set some guidelines and give them a clothing allowance toward two outfits. A brief case and art portfolios can be purchased by the gallery and given to the consultant to use.

■ ■ ■

Publicity and Advertising

"All I know is what I read in the papers." —*Will Rogers*

Publicity and advertising are usually thought of in tandem, since they both deal with how someone's image is projected in public. But they are very different; one approach must achieve public exposure without directly paying for it, usually by an effort of goodwill and accomplishment, while the other simply pays to get a name before the public. In many businesses, both avenues are essential. In corporate art consulting, however, one is of value, the other seldom is.

PUBLICITY

Next to recommendations from satisfied clients, the best marketing tool is a newspaper or magazine article featuring you or your services. Like a pleased client who gives you a referral, publicity has the authority of a third-person's endorsement. It has far greater persuasive power than advertising or any other marketing tool, such as a brochure.

> I prefer to send a reprint of a feature article with my first letter to a prospect, rather than my brochure. It always gets more attention.

People seem to have an insatiable curiosity about what is written about others. The meteoric rise of *People* magazine and television shows with similar formats attests to this phenomenon. The amazing thing about publicity is that people tend to forget its source, even if it's an article about yourself that you sent them. The impressions are lodged in their minds, but they may not remember how they've heard about you. The result is that they have a sense of familiarity with you and your service before they meet you. This familiarity translates into confidence, an important factor in selling anything to anybody.

PUBLICITY IS EASY TO GET

The general media are still interested in the concept of art in the workplace. The business press loves soft news about unusual things that companies are doing, especially if the art program is special and goes beyond serving a decor need. For instance, the *San Francisco Business Times* recently set up a column to deal with art and business issues. So send a press release to the business section of your local newspaper on any newsworthy event that involves both art and business, such as the opening of a lobby exhibition, the completion of an art program with an interesting employee angle, or even additions to your staff if someone interesting has joined your firm.

Corporations often don't realize how easy it is to get publicity for art programs. Meet with members of the company's PR department and propose working with them to get some media coverage.

The press is also receptive to stories about small business entrepreneurs doing interesting things.

There are many different publicity angles an art consultant can pursue. The techniques of a publicist are easy to learn and can be valuable in promoting your business as well as the projects of your clients. Once you know how to seek a feature article, you'll be surprised how easy it is to get publicity.

> *"Remember, the media need you as much as you need them."*
> —Tim Clark, publisher, San Francisco Business Times

Fine Art Publicity, which I wrote with Barbara Webb, contains all the public relations techniques and strategies a consultant or gallery needs.

Remember that the real usefulness of promotional articles is not so much when they appear or where they appear but after they appear, when you can send reprints to potential clients.

There are many trade magazines, such as *Facilities Design and Management* and *Designers West*, that are not usually available at newsstands but that will consider articles on the subject of corporate art. They can be researched at the library in the *Gale Directory of Publications*, an annual guide to periodicals. (For full citations of all books and periodicals mentioned on this page, see Appendix.)

Tip: One way to begin to get press is by first getting art trade publicity, which is very easy, and then using it to gain access to general media. Press people are just as vulnerable as anybody else to the seductions of publicity, so when they see someone covered by the press of his or her own field, they assume that person is an authority.

At least once a year, each of the following magazines has an editorial focus on corporate art issues: *Art and Auction*, *Art Business News*, *ARTnews*, and *Decor*. Call the one that is appropriate for you and find out when it is planning its corporate issue and how you might fit in, either by writing an article or by supplying information on some unusual projects you are working on.

TOOTING YOUR OWN HORN

The first step in seeking publicity on yourself is to create a backgrounder—a general press release on you and your business. This is sent out to media people when you want to interest them in doing a feature article, and it may also be given to any of them who contact you. You should also have available two black-and-white photographs of yourself, one a five-by-seven-inch head and shoulder shot and the other an eight-by-ten-inch, three-quarters shot of you with a piece of art in a corporate context. One of these photographs can then be included in your press material whenever the situation seems appropriate.

ADVERTISING

In the corporate art consulting field, advertising is not as effective a marketing tool as publicity for two reasons:

1 In a personal referral business, which art consulting definitely is, a potential client is not likely to use the yellow pages or a newspaper or magazine to find his consultant. He usually asks someone he trusts to advise him. Or he may call a company whose offices he likes to ask who did their art program. Rarely, if ever, will he browse through the paper looking for an art advisor.

2 Usually only once in his career will an executive be responsible for engaging an art consultant. When you think of the odds of his seeing an ad for art consulting services at the exact moment he needs the service—it's a long shot at best. Simply stated, ads are a waste of time and money.

WHEN ADS ARE A GOOD IDEA

Advertising may be helpful when you want to reach a special target audience, such as the hospitality trade or developers who have multiple projects. For these situations, there are special interest magazines, such as *Facilities Design and Management*, but even then an advertising campaign is most effective when it is supported by publicity and followed up with direct mail or telemarketing.

YELLOW PAGES

In most cities, art consultants are still listed in the yellow pages along with art galleries. It is worthwhile to have a minimal listing in the directory so that a prospect or his executive secretary can easily find you. Large yellow pages ads are a waste of money.

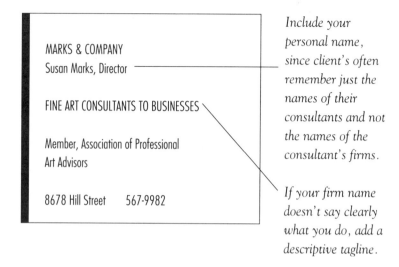

MARKS & COMPANY
Susan Marks, Director

FINE ART CONSULTANTS TO BUSINESSES

Member, Association of Professional
Art Advisors

8678 Hill Street 567-9982

Include your personal name, since client's often remember just the names of their consultants and not the names of the consultant's firms.

If your firm name doesn't say clearly what you do, add a descriptive tagline.

NOTES FOR GALLERIES

Tag all your local advertising with a line saying you also provide fine art consulting services to companies. One director of a gallery and frame shop I know also includes the note: "leasing of art available." This additional information seems to attract start-ups and new businesses in the area.

Companies usually look first for their consultants locally, so it may not be effective to tag national advertising.

■ ■ ■

Strategies for Tough Times

"Never fear the want of business. A man who qualifies himself well for his calling, never fails of employment."

—*Thomas Jefferson*

The basic strategies for difficult economic times is to work harder, to focus your energy on the areas that have the greatest potential for success, and to be flexible in the services you provide and creative in finding ways to help your clients stretch their art budgets.

An economic recession has occurred every decade since the 1780, and I see no reason to believe that current federal and international monetary policies will prevent this cycle from continuing in the future. Besides, minirecessions may occur at any time in specific industries or communities, depending on local economic factors. It's wise for every person in business to know where he or she is at a given time in relation to these cycles, and to have some strategies for dealing with a business slowdown. Many of these same strategies will stand you in good stead with clients who, for whatever reason, need to scale down their projects.

KEEPING AN EYE ON ECONOMIC INDICATORS

When a company hits hard times, whether for internal or external reasons, the frills are the first to be cut back or eliminated. Although the use of art in companies has become an established trend, art is still considered a frill by most corporate collectors. You need to know the state of health of your clients' companies in particular and their industries in general, so that you will know where to place your marketing energy.

Business-oriented newspapers and periodicals, such as the *Wall Street Journal*, *Forbes*, and *Business Week*, are valuable sources of information, but the business section of your own daily paper can also be a gold mine and the information is often more pertinent to your community.

MY OWN ECONOMIC EDUCATION

In 1974, just two years after starting my art consulting practice, the country was hard hit by a business recession. My first two years had been booming, but suddenly everywhere I went my clients wanted to cut back on their art programs.

The president of one company said to me, "How can I justify an expensive art program when I'm asking everyone to agree to a wage freeze? We're recycling paper, using all sorts of cost-cutting measures, and it's very likely I'll have to lay off some people in December."

The idea of trying to convince him of his need for art in the face of people losing their jobs was unthinkable. Overnight I became a student of economics, developer of strategies for tough

WHAT YOU CAN LEARN FROM THE DAILY NEWSPAPER

Read the business section of your daily newspaper to keep up with information important to your business.

INDICATORS TO WATCH FOR	EFFECTS	STRATEGIES
HIGH INFLATION	Cost of money is high. Companies emphasize short-term returns and postpone long-term investments such as art.	Get flexible. Offer lease-purchase financing, combination purchase and loans, rotating exhibits.
BUSINESS CYCLE RECESSION	Unemployment increases. Businesses postpone capital investments.	Concentrate on industries that are doing well.
HIGH COST AND SCARCITY OF COMMERCIAL REAL ESTATE	Very low vacancy rates. Movements of large companies to outlying areas. Smaller companies and professional firms delay moving.	Focus on getting the remaining companies to spruce up their existing offices with an art program.
LOW COST AND ABUNDANCE OF COMMERCIAL REAL ESTATE	Rental rates decline, vacancies increase. Companies will choose this time to move. They often can expand or upgrade the quality of their offices and not increase their monthly rent.	Focus on professional companies—lawyers, stockbrokers, etc. (Larger companies take two or three years to plan a move.) Mid-size companies are more flexible.
CORPORATE COMPLAINTS OF UNFAVORABLE CITY TAXES OR OTHER OPERATING RESTRICTIONS	Companies consider relocating to other areas—often it takes a few years to see the results of these unfavorable conditions.	Large companies are hit hardest, and they often move in these conditions. Make contact with the companies before they relocate so that you have an inside track to helping them.
MERGERS AND TAKEOVERS	Often collections are sold, or whole new corporate images are developed.	Three or four months after the change takes effect, contact the new management.
COMPANIES THAT HAVE GOOD CORPORATE CULTURES	They are usually interested in the quality of their work environment.	Good potential for art program.
COMPANIES THAT ARE DOING WELL	They often have surplus funds. Your existing clients who have had a good year may have extra funds to spend in November and December.	Contact them.
COMPANIES AND INDUSTRIES THAT ARE DOING POORLY	They don't have surpluses to spend on art.	Avoid them.
OTHER ECONOMIC FACTORS THAT MAY AFFECT YOUR CLIENTS, SUCH AS THE FALL OF THE DOLLAR	Sometimes a specific current trend will have an important effect on the art consulting business. For instance, the dollar's decline creates a great boon in attracting international tourism here, resulting in tremendous expansions of our hotel and hospitality industries.	Ask your banker or the bank's economic advisor what the key economic factors are affecting businesses in your region.

times, and I expanded our leasing programs to include rental-loan opportunities as well as rotating exhibitions, since these were not solely dependent on the sale of art.

NEWS ITEMS, BOTH TAKEN FROM THE SAN FRANCISCO CHRONICLE:[30]

THE GOOD NEWS:

L.A. LAW FIRMS TARGET S.F.

Los Angeles law firms have quietly been moving up the coast and settling satellite offices in San Francisco's Financial District. About five firms have offices here, and at least two more major Los Angeles firms…are believed to be searching for space…

THE BAD NEWS:

CHIP FIRMS TELL MORE BAD NEWS

By Don Clark
Chronicle Staff Writer

Advanced Micro Devices said yesterday that it will lay off up to 1,000 U.S. workers, while rival National Semiconductor Corp. said it expects a "significant" second quarter loss. These gloomy, back-to-back announcements continue a string of bad news emanating from Silicon Valley. On Wednesday, the Semiconductor Industry Association said its key indicator of future sales activity fell sharply in October to the lowest point in three years…

STRETCHING TIGHT BUDGETS

Even a company in good financial shape may be cash poor when it is making a major move, because so many basic systems of the business are being upgraded at once. The decision-maker may be sold on a quality program, but may not be able to implement it all at once. The term matrix planning refers to art programs that employ more than one strategy to stretch the available budget or to get more mileage out of a collection, and the following matrix plans will be useful at such times as well as during an economic slowdown.

LEASE PURCHASE

Programs can be arranged so that some art is leased and some is purchased. I recommend leasing expensive pieces and purchasing the inexpensive pieces, such as posters and graphics. Good sources for leasing are office furniture leasing companies. Some cities now have special art leasing companies. The tax benefits of leasing change periodically; as an art advisor it's good to stay up with the current legislation. See the Resource Directory in the Appendix for companies that offer art financing.

LEASE-LOANS OR LOANS OF "NOT FOR SALE" WORKS

Some museums have programs whereby companies make a contribution to the museum and minor works are put on loan to the company.

Other sources for loans might be sculpture foundries, secondary art dealers, and even private collectors.

Whatever the arrangement, the consultant can still receive a fee for curating, facilitating, and maintaining the loans.

> **A word of advice:** The best pieces to borrow are works for public areas. Artwork in private offices tends to get shuffled around too much during interoffice moves. Employees get attached to the art in their offices and just take the work with them when they move. If smaller works are put on loan, install security mounts and attach a descriptive note to the backing of each piece stating that the work is on loan to the company and may not be moved without the permission of the loan agent.

TERM FINANCING

You may be able to make arrangements with major suppliers—a framer, for instance—to provide financing for sixty or ninety days, or in some cases even longer.

STEP PURCHASE

Set priorities for the company's art program and design a step-purchase program through which the art work is purchased in groups according to a predesigned plan. A variation on this is to purchase less expensive works first, perhaps graphics and drawings, and later rotate them to employee work areas when you purchase the more expensive works.

EXPANSION PLANNING

If the company plans to expand every year or two, purchase a certain percentage of the collection as investment art to be sold or traded to fund future expansion. For this approach, I recommend blue-chip graphics. They have an established international market, and it is easy to advertise them to collectors and secondary market dealers. It is a much more difficult and personal procedure to find a buyer for an original painting and the financial benefit may be less because of the necessity of consigning the work to a gallery or an auction house.

PRODUCT DISPLAY

Some companies have colorful histories and products or memorabilia that lend themselves easily to making an interesting display. The company will need your curatorial services to see that the exhibits are effective.

> *Chevron USA has an oil museum with an exhibit showing the history of domestic oil use. Wells Fargo Bank has a history museum displaying artifacts of the Old West, gold mining tools, and stage-coaches, as well as photographs and documents depicting the bank's frontier history. Two interesting variations on this type of exhibit are Iroquois Brands' exhibition of their company collection of Iroquois indian artifacts, and the Federal Reserve Bank's block-long exhibition in San Francisco of economic history.*

ROTATING EXHIBITION

A way to delay the purchase of a major art piece for a public area is to put a different work on exhibit every month. The work can be rotated from the company's collection or borrowed from a gallery, museum, or even an artist. The consultant collects a fee for making the arrangement, creating a little write-up on the artist, handling the installation, and overseeing the loan.

CLUSTER ACQUISITIONS

Another useful approach is to plan to buy several works either by one artist or centered around a common theme or done in the same medium so that the works can be displayed together as a mini-exhibition some time in the future. Bank of America has followed this approach in many of its collection acquisitions. As a result the bank can draw lobby exhibits from its own collections as well as loan interesting educational shows to other institutions.

■ ■ ■

Chapter Notes

CHAPTER ONE

1. Director of Artventures, San Francisco, CA.
2. *Honest Business*. New York City, NY: Random House, 1981, p. 20.

CHAPTER THREE

3. Quoted in Mitchell Kahan's Introduction to *Art Inc.*, *American Paintings from Corporate Collections*. Montgomery, Alabama: The Montgomery Museum of Fine Art, 1979, Note # 40.
4. Quoted in Mitchell Kahan's Introduction to *Art Inc.*, cited above, Note # 45.
5. Quoted in "The Inside Story." *San Francisco Business Times*. August 22, 1988, p. 24.
6. Quoted in Mitchell Kahan's Introduction to *Art Inc.*, cited above, Note # 49.
7. *Corporate Art*. New Brunswick, NJ: Rutgers University Press, 1990, p. 49.

CHAPTER FOUR

8. In this chapter, I have drawn on material from Christian Frederiksen's marketing seminars. Chris is not only my good friend, but also a superb fine arts management consultant, as well as a CPA! (Frederiksen & Co., P.O. Box 2906, San Francisco, CA 94126.)
9. "Special Report: Working Relations between Corporations, Advisers, and Consultants, Part 2." *Corporate ARTnews*, a division of *ARTnews*, Volume 7, Number 10, February 1991, p. 6.
10. A facsimile based on a sample, courtesy of Business Extension Bureau, San Francisco, CA.

CHAPTER FIVE

11. *Guerrilla Marketing*. Boston, Mass: Houghton Mifflin Company, 1984, p. 73.

CHAPTER SIX

12. Carey Ellis Company of Houston, Texas.

13. Quoted by Mary Anne Craft, "Special Report: Working Relations between Corporations, Advisers, and Consultants, (Part 2)." *Corporate ARTnews*, a division of *ARTnews*. Volume 7, Number 10, February 1991, p. 5.

14. Vice President of Scali, McCabe, Sloves, Inc., of New York City, NY.

15. Cited by Marianna Nunes in the *San Francisco Business Times*, June 12, 1989, p. 28.

CHAPTER TWELVE

16. President of Artventures, San Francisco, CA.

CHAPTER THIRTEEN

17. "Public Art." *Encyclopedia of Architecture, Design, Engineering and Construction, Volume 4*. New York City, NY: The American Institute of Architects, John Wiley & Sons, p. 115.

18. Taken from Shirley Reiff Howarth's *ARTnews International Directory of Corporate Art Collections*. New York City, NY: ARTnews and International Art Alliance, Inc., 1989.

19. *Going Public: A field guide to developments in art in public places*. Amherst, MA: Arts Extension Service, University of Massachusetts, in cooperation with the National Endowment for the Arts, 1988.

20. President of Fine Arts Services, Los Angeles, CA.

21. Quoted in *Going Public*, cited above, p. 66.

22. Quoted in *Going Public*, cited above, p. 77.

23. Adapted from the budget checklist in *Going Public*, cited above, p. 78.

CHAPTER SIXTEEN

24. Quoted in Charles A. Riley's article, "Do the Right Thing." *Art and Auction*. November 1990, p. 263.

25. Quoted by Gerald Stiebel in "Do the Right Thing," cited above, 262.

26. Quoted in "Do the Right Thing," cited above, p. 265.

CHAPTER SEVENTEEN

27. *Growing a Business*. New York City, NY: Fireside, 1987.

28. *Running a One-Person Business*. Berkeley, CA: Ten Speed Press, 1989.

29. *A to Z of Sales Management*. New York City: NY: American Management Association, 1982.

CHAPTER TWENTY

30. Excerpts from pieces by Herb Greenberg and Don Clark in the *San Francisco Chronicle*, November 11, 1988, reprinted by permission.

APPENDIX:

APPENDIX

We hope this Appendix will provide the reader with useful information, but it should be understood that the publisher is not engaged in rendering legal or other professional services. If legal advice or other expert assistance is required, the services of a competent attorney or professional person should be sought. While we have tried to make sure the information is accurate, neither the author nor the publisher can be held accountable for errors or omissions.

Contracts and Forms

CONTRACT FOR THE RENTAL OF AN ARTWORK

AGREEMENT made as of the _____ day of _____, 20__, between _____ _____ (hereinafter referred to as the "Artist"), located at _____ and _____ (hereinafter referred to as the "Renter"), located at _____ _____.

WHEREAS, the Artist is a recognized professional artist who creates artworks for rental and sale; and

WHEREAS, the Renter wishes to rent and have the option to purchase certain works by the Artist; and

WHEREAS, the parties wish to have the rentals and any purchases governed by the mutual obligations, covenants, and conditions herein;

NOW, THEREFORE, in consideration of the foregoing premises and the mutual covenants hereinafter set forth and other valuable considerations, the parties hereto agree as follows:

1. **Creation and Title.** The Artist hereby warrants that the Artist created and possesses unencumbered title to the works of art listed and described on the attached Schedule of Artworks ("the Schedule").

2. **Rental and Payments.** The Artist hereby agrees to rent the works listed on the Schedule at the rental fees shown thereon and the Renter agrees to pay said rental fees as follows: $_____ per _____.

3. **Delivery and Condition.** The Artists shall be responsible for delivery of the works listed on the Schedule to the Renter by the following date: _____. All costs of delivery (including transportation and insurance) shall be paid by _____. The Renter agrees to make an immediate written objection if the works upon delivery are not in good condition or appear in any way in need of repair. Further, the Renter agrees to return the works in the same good condition as received, subject to the provisions of Paragraph 4.

4. **Loss or Damage and Insurance.** The Renter shall be responsible for loss or damage to the rented works from the date of delivery to the Renter until the date of delivery back to the Artist. The Renter shall insure each work against all risks for the benefit of the Artist up to ___ percent of the Sale Price shown in the Schedule and shall provide Artist with a Certificate of Insurance showing the Artist as the named beneficiary.

5. **Term.** The term of this Agreement shall be for a period of _____ months, commencing as of the date of the signing of the Agreement.

6. **Use of Work.** The Renter hereby agrees that the rental under this Agreement is solely for personal use and that no other uses shall be made of the work, such other uses including but not being limited to public exhibition, entry into contests, and commercial exploitation.

7. **Framing, Cleaning, Repairs.** The Artist agrees to deliver each work ready for display. The Renter agrees not to remove any work form its frame or other mounting or in any way alter the framing or mounting. The Renter agrees that the Artist shall have sole authority to determine when cleaning or repairs are necessary and to choose who shall perform such cleaning or repairs.

8. **Location and Access.** The Renter hereby agrees to keep the works listed on the Schedule at the following address: _____, which may be changed only with the Artist's written consent, and to permit the Artist to have reasonable access to said works for the purpose of taking photographs of same.

9. **Copyright and Reproduction.** The Artist reserves all reproduction rights, including the right to claim statutory copyright, on all works listed on the Schedule. No work may be photographed, sketched, painted, or reproduced in any manner whatsoever without the express, written consent of the Artist. All approved reproductions shall bear a copyright notice composed of

the following elements: the word Copyright or the symbol for copyright, the Artist's name, and the year of the first publication of the artwork.

10. Termination. Either party may terminate this Agreement upon fifteen (15) days written notice to the other party. This Agreement shall automatically terminate in the event of the Renter's insolvency or bankruptcy. Upon termination, the Artist shall refund to the Renter a pro rata portion of any prepaid rental fees allocable to the unexpired rental term, said refund to be made after the works have been returned to the Artist in good condition.

11. Return of Works. The Renter shall be responsible for the return of all works upon termination of this Agreement. All costs of return (including transportation and insurance) shall be paid by _____.

12. Option to Purchase. The Artist hereby agrees not to sell any works listed on the Schedule during the term of this Agreement. During the term the Renter shall have the option to purchase any work listed on the Schedule at the Sale Price shown thereon. This option to purchase shall be deemed waived by Renter if he or she fails to make timely payments pursuant to Paragraph 2. If the Renter chooses to purchase any work, all rental fees paid to rent that work shall not be applied to reduce the Sale Price. Any purchase under this paragraph shall be subject to the following restrictions:

(A) The Artist shall have the right to borrow any work purchased for up to sixty (60) days once every five years for exhibition at a nonprofit institution at no expense to the Renter-Purchaser, provided that the Artist gives 120 days advance notice in writing prior to the opening and offers satisfactory proof of insurance and prepaid transportation.

(B) The Renter-Purchaser agrees not to permit any intentional destruction, damage, or modification of any work.

(C) If any work is damaged, the Renter-Purchaser agrees to consult with the Artist before restoration is undertaken and must give the Artist the first opportunity to restore the work, if practicable.

(D) The Renter-Purchaser agrees to pay the Artist any sales or other transfer tax due on the full Sale Price.

(E) The Renter agrees to make full payments of all sums due on account of the purchase within fifteen days after notifying the Artist of the Renter's intention to purchase.

13. Security Interest. Title to, and a security interest in, any works rented or sold under this Agreement is reserved in the Artist. In the event of any default by the Renter, the Artist shall have all the rights of a secured party under the Uniform Commercial Code, and the works shall not be subject to claims by the Renter's creditors. Renter agrees to execute and deliver to the Artist, in the form requested by the Artist, a financing statement and such other documents which the Artist may require to perfect its security interest in the works. In the event of purchase of any work pursuant to Paragraph 12, title shall pass to the Renter only upon full payment to the Artist of all sums due hereunder. The Renter agrees not to pledge or encumber any works in his or her possession, nor to incur any charge or obligation in connection therewith for which the Artist may be liable.

14. Attorney's Fees. In any proceeding to enforce any part of this Agreement, the aggrieved party shall be entitled to reasonable attorney's fees in addition to any available remedy.

15. Non-Assignability. Neither party hereto shall have the right to assign this Agreement without the prior written consent of the other party. The Artist shall, however, retain the right to assign monies due to him or her under the terms of this Agreement.

16. Heirs and Assigns. This Agreement shall be binding upon the parties hereto, their heirs, successors, assigns, and personal representatives, and references to the Artist and the Renter shall include their heirs, successors, assigns, and personal representatives.

17. Integration. This Agreement constitutes the entire understanding between the parties. Its terms can be modified only by an instrument in writing signed by both parties.

18. Waivers. A waiver of any breach of any of the provisions of this Agreement shall not be construed as a continuing waiver of other breaches of the same or other provisions hereof.

19. Notices and Changes of Address. All notices shall be sent to the Artist at the following address:

_____ and to the Renter at the following address:
_____. Each party shall give written notification of any change of address prior to the date of said change.

20. Governing Law. This Agreement shall be governed by the laws of the State of _____.

IN WITNESS WHEREOF, the parties have signed this Agreement as of the date first set forth above.

Artist _____ Renter _____

Schedule of Artworks

Title	Medium	Size	Rental Fee	Sale Price
1._____	_____	_____	_____	_____
2._____	_____	_____	_____	_____
3._____	_____	_____	_____	_____

FINE ART LEASE

THIS AGREEMENT is entered into this _____ day of _____, 20___, by and between _____ of _____ hereinafter referred to as "LESSOR," and _____ of _____ hereafter referred to as "LESSEE."

IT IS UNDERSTOOD THAT LESSOR is the owner of certain work(s) of art as set forth in Exhibit "A," attached hereto and incorporated herein by this reference, hereinafter referred to as "ART OBJECT" referring to one or more works of art. The aggregate fair market value of said art object is $_____. LESSEE is desirous of leasing said art object in accordance with the terms, conditions and covenants hereinafter contained. _____(Agent, address)_____ _____ is acting as agent for the LESSOR with respect to negotiations for this lease.

It Is Therefore Agreed As Follows:

I. Term

Lessor hereby leases to Lessee, and Lessee hires from Lessor the art object described and set forth in Exhibit "A," for a period of _____ years commencing on the _____ day of _____, 20___ and terminating on the _____ day of _____, 20___.

II. Rent

In consideration for said lease Lessee agrees to pay to Lessor the sum of $_____ payable without deduction or offset, to _____(Agent, address)_____, or any such place as may be designated from time to time by Lessor, as follows:

A. $_____ upon execution of this agreement.

B. In quarterly/annual installments of $_____ payable on the _____ day of each quarter/year, and continuing until paid in full.

Above: This contract was taken from Tad Crawford's *Business and Legal Forms for Fine Artists*, with the author's permission. (See Bibliography for full citation.)

Interest computed at the rate of 1% per month shall be added to the amount due if payment is not received by Lessor within ten (10) days of the due dates hereunder.

III. Security Deposit

As an additional consideration for the execution of this lease, Lessee agrees to pay to Lessor the sum of $_____ (which is the equivalent of one-fourth (1/4) of one year's rent hereunder) which shall be retained by Lessor until the expiration of the leased term or the expiration of any extension thereof; and provided Lessee is not then in default and shall have delivered up the leased art object to Lessor in the time and manner in this Lease provided, Lessor will repay to Lessee said sum of $_____. Lessee shall have no right to apply any of said sum of $_____or any portion thereof, to any of the other rentals or charges payable hereunder.

IV. Personal Property Taxes

Lessee agrees to pay before delinquency all Personal Property taxes levied or assessed upon the leased art object during the term of this lease.

V. Installation And Removal

A. Lessor shall transport, install and remove the art object at the expense of the Lessee, in accordance with the scheduled plan and subject to the cost schedule and payment terms set forth in Exhibit "B" which is attached hereto and incorporated herein by this reference. Exhibit "B" shall also contain the address of the premises where the art object shall be installed.

B. It is expressly agreed that the art object shall not be moved from the place originally installed without the prior written consent of the Lessor first had and received. If for any reason it is necessary that the art object must be moved from the place it was originally installed, Lessee shall request Lessor to re-install such art object at Lessee's expense. Provided however, that Lessor shall not permit the reinstallation of any art object in such a manner as Lessor in his sole discretion believes would be detrimental to the condition or continued value of such art object.

VI. Use Of Leased Art Object

Lessee agrees to use and maintain the art object solely in the manner in which originally installed, except that such use and maintenance may be altered with the prior written consent of Lessor. Lessee shall not permit any use of the art object which will allow the art object to be affixed to the premises where installed in such a way as to become a fixture.

VII. Possession And Title

Lessee shall have the right to possession of the art object during the term of this lease. Title to the art object shall be and remain with Lessor at all times.

VIII. Insurance

Lessee shall insure the art object for an amount not less than the aggregate value as set forth in Exhibit "A" attached hereto against all risk or damage or loss to the property except as hereinafter excluded.

A. Loss or damage caused by normal wear and tear, gradual deterioration, insects, vermin or inherent vice.

B. Loss or damage caused by or resulting from hostile or warlike action in time of peace or war including actions of insurrection, rebellion, revolution or civil war.

C. Loss or damage caused by any weapon of war employing atomic fission or radioactive force whether in time of peace or war.

Lessor and (Agent)_____ shall not be liable for any damage or liability of any kind or for any damage or injury to persons or property from any cause whatsoever by reason of the use and enjoyment of the leased art object by Lessee or any other person with the consent of or holding under said Lessee, and Lessee with indemnify and save harmless Lessor and (Agent)_____ from all liability whatsoever on account of any such damage or injury and from all liens, claims and demands arising out of the use of the leased art object whether or not caused by negligence of, or breach of an obligation by Lessee (unless

such damage, injury, lien, claim or demand shall be caused solely by the gross negligence of Lessor).

Lessee shall, at its cost and expense, maintain general public liability insurance against claims for personal injury, death or property damage occurring upon, in or about the area in which said art object is installed, such insurance to afford protection to the limit of not less than One Hundred Thousand Dollars ($100,000.00) in respect to injury or death of one person, and to the limit of not less than Three Hundred Thousand Dollars ($300,000.00) in respect to any one accident, and to the limit of not less than Fifty Thousand Dollars ($50,000.00) in respect to property damage.

Lessee may, at its option, bring its obligation to insure under this Article VIII, within the coverage of any so-called "blanket" policy or policies of insurance which it may now or hereafter carry, by appropriate amendment thereof; provided, however, that the interest of Lessor and (Agent)_____ shall thereupon be as fully protected as they would be otherwise if this option to Lessee to use blanket policies were not affected. All such policies of insurance shall be issued in the name of Lessee, Lessor and (Agent)_____ and for the mutual and joint benefit and protection of the parties, and such policies of insurance or copies thereof shall be delivered to Lessor and (Agent)_____ and as often as any such policy or policies shall expire or terminate, renewal or additional policies shall be procured and maintained by Lessee in like manner and to like extent. All such policies shall contain a clause or endorsement to the effect that they may not be terminated or materially amended except after the (10) days' written notice thereof to Lessor.

IX. Assignment And Subletting

Lessee shall not assign this Lease or any interest therein, or any right or privilege appurtenant thereto, or sublet the art object or any portion thereof, without the written consent of the Lessor first had and obtained, and a consent to one assignment or subletting by Lessor shall not be deemed to be a consent to any subsequent assignment or subletting. Any such assignment or subletting without such consent shall be void and shall, at the option of the Lessor, terminate this lease. This lease shall not, nor shall any interest therein, be assignable as to the interest of Lessee by operation of law, without the written consent of Lessor.

X. Repairs And Maintenance

A. Lessee shall notify Lessor and Carrier immediately should damage to the art object be discovered upon delivery.

B. Lessee shall maintain the art object in clean and safe conditions at all times and shall not cause, or allow to be caused, any condition which will impair or endanger the safety or condition of the art object.

C. Should repairs be required, or should mechanical maintenance be necessary for the proper operation of the art object, Lessor shall conduct any such repair or maintenance at the expense of the Lessee.

D. Should loss, damage or deterioration be noted, Lessee shall inform Lessor in detail immediately.

E. Lessee shall not undertake to transport, move, clean or repair the art object without the written consent of Lessor first had and received.

XI. Liability And Damage

Lessee shall be responsible for any damage or loss or whatever kind suffered by the art object while in Lessee's possession, and shall pay to Lessor the value of each such art object as may be damaged or destroyed as set forth in Exhibit "A."

XII. Transfers And Encumbrances

Lessee shall not pledge, lend, create a security interest in, or part with possession of the art object, or attempt in any manner to dispose thereof, or remove the art object from the place it is installed, or suffer any liens or legal process to be incurred or levied thereon.

XIII. Termination

Upon default in the payment of any installment of rent hereunder, or upon breach of any of the conditions or covenants of this lease to be observed or performed by Lessee, or if during the term of this Lease bankruptcy or insolvency proceedings are commenced by or against Lessee, or if a receiver is appointed for the business of the Lessee, or if Lessee discontinued business at premises where the art object is installed, Lessor shall have the option, without notice or demand, to terminate this lease and to immediately obtain possession of the leased art object. Termination hereunder shall in no way release Lessee from the obligation to pay to Lessor any damages sustained by Lessor.

XIV. Attorneys' Fees And Court Costs

In the event Lessor is obliged to engage the services of an attorney for the purpose of collecting any rents or other charges required to be paid by Lessee after written notice, as hereinabove provided, Lessor shall be entitled to such reasonable attorneys' fees as Lessor may have incurred, whether or not such matter results in litigation, and in the event of any other litigation between the parties arising out of or under this Lease, the prevailing party shall be entitled to the allowance of reasonable attorney's fees and court costs as a part of the judgment in such action.

XV. Notices

Any and all notices or demands by or from either party to the other shall be in writing set by registered or certified mail, postage prepaid, addressed as follows:

A. TO LESSOR: At _____ with a copy thereof to (Agent, address)_____, or such other place as Lessor may designate in writing.

B. TO LESSEE: At _____ or such other place as Lessee may designate in writing.

XVI. Successors And Assigns

Subject to the provisions of Article IX thereof, all rights and liabilities herein given to or imposed upon the respective parties hereto shall extend to and bind the several respective heirs, successors, administrators, executors and assigns of said parties.

XVII. Representations

No representations have been made by either Lessor or Lessee or any agent of either of them, other than those specifically set forth in this Lease.

IN WITNESS WHEREOF Lessor and Lessee have duly executed this lease on the day and year first above written.

Lessor Lessee

_____ _____

SAMPLE LOAN AGREEMENT

FOR BORROWER: _____

This agreement is by and between LENDER _____,
BORROWER _____, and BORROWER'S AGENT
(Agent)_____ and set forth the conditions governing the loan of the
below listed art objects by Lender through (Agent)_____ to Borrower
for the Art Exhibition listed below. Each party agrees that all the following conditions
are terms of the art loan between all parties.

EXHIBITION: _____

LENDER: _____

ADDRESS: _____

CREDIT: _____

(Exact form of Lender's name for exhibition label and catalog)

LOAN PERIOD: From _____ To _____

ARTIST: _____ NATIONALITY:_____

TITLE: _____ MEDIUM: _____

DATE: _____ SIGNED: _____

SIZE: Painting, Drawing (without frame or mat): H _____ W _____ D _____

FRAMING: _____ (All works will be returned in
their original frames and mats unless other arrangements are made with the Lender).

CATALOG AND PUBLICITY: Where can we obtain photographs of this work for
catalog and publicity purposes? _____ May we repro-
duce this work in the catalog and for publicity purposes in connection with the
exhibit? _____

INSURANCE: (See conditions on reverse of this Loan Agreement.)

INSURANCE VALUATION: $_____

COVERAGE: _____ (Unless otherwise specified,
the Borrower will insure the amount specified above throughout the period of the
loan.)

SELLING PRICE, IF ANY: $_____

SHIPPING: Recommended Procedure _____

Unless (Agent)_____ is notified to the contrary in writing before the
close of the exhibition, the work will be returned to the lender's address given above.

SAMPLE LOAN AGREEMENT *(Continued)*

CONDITIONS GOVERNING LOANS

1. Borrower agrees to exercise the utmost care and safekeeping of the art objects covered by this agreement.

2. Should damage to the loaned works be discovered upon delivery, or should loss, damage or deterioration be noted during the loan period, Borrower shall inform Lender in detail immediately. Borrower shall not undertake to transport, clean, or repair the loaned object without the written consent of Lender.

3. Loaned art objects shall remain in the possession of Borrower for the time specified on the face of this loan agreement.

4. Unless Lender expressly elects to maintain its own insurance coverage, and notifies Borrower in writing of such election, Borrower will insure this loan wall-to-wall under its fine arts policy, naming Lender and (Agent)_____ as additional assureds, for the amount indicated on the face of this loan agreement, against all risks of physical loss or damage from any external cause while in transit and on location during the period of the loan.

 The policy referred to may contain the standard fine arts exclusions from coverage for loss or damage due to wear and tear, gradual deterioration, moths, vermin, inherent vice or damage sustained due to such causes as hostile or warlike action in time of peace or war, nuclear or radioactive force, any repairing, restoration or retouching process.

 If Lender elects to maintain his own insurance, Borrower must be supplied with a certificate of insurance naming Borrower and (Agent)_____ as additional assureds or waiving subrogation against Borrower and (Agent)_____ from any liability in connection with the loaned property. Borrower and (Agent)_____ accept no responsibility for any error or deficiency in information furnished to Lender's insurers or for lapses in coverage.

5. Borrower agrees to pay Lender any such fee of which he or his agent, (Agent)_____ , has been notified in advance as a condition of the Lender's agreement to the loan.

Each of the following parties agrees to all of the above terms and conditions of this loan agreement.

_____ _____
Lender Date

_____ _____
Borrower

_____ _____
Authorized Agent

Please return three signed copies of this agreement to (Agent)_____ .
An executed copy will be returned to you.

Sample Art on Approval Form

A form like this can be printed and made into gummed pads. You can fill it out at the gallery and leave a copy when you take the art out on approval. Although many galleries will have their own approval invoices, this form guarantees that you have all the information you need at the presentation. You can check the pieces that are approved, and then simply return a copy of the form to the gallery, indicating which works are purchased. Finally, it helps establish your professionalism and credibility with new galleries. They are more likely to lend you work on approval if you have something official to leave them.

ART ON APPROVAL

[YOUR FIRM NAME
ADDRESS
TELEPHONE NUMBER]

The works of art listed below are being borrowed on approval for our client: _____

The art is insured for its listed market value while on approval.

Pickup and delivery arrangements: _____

Billing: When art is approved please bill the client c/o [YOUR FIRM NAME]

Source _____

Address _____

State _____ Zip _____

Phone _____

Contact person _____

If Artist, gallery _____

Art to be returned by _____

Artist	Title/Description	Media	Date	Edition	F	UF	Mkt. Value	Discount	Net Price	Action/Deliver	APP.

REQUEST FOR PERMISSION TO REPRODUCE WORKS OF ART

Rayovac Corporation requests permission to reproduce the works of art created by you, as enumerated on the reverse of this sheet, now in the collection of Rayovac Corporation, subject to the terms noted below.

Works of art may be reproduced for non-commercial use by Rayovac in catalogs and check lists for distribution to its employees and others requesting information and documentation on the Rayovac collection. In addition to in-house reproduction, permission is granted to Rayovac to authorize reproduction in catalogs and check lists produced by museums to which the works may be loaned. Reproduction may also include use of the work in non-commercial television and film, and for slides for non-commercial use by museums and/or Rayovac Corporation in employee education programs.

Rayovac recognizes you as the copyright holder (or will recognize another owner, if you so specify). Rayovac will refer any commercial reproduction requests (e.g., reproduction in calendars, advertising or greeting cards, etc.) to you or another copyright owner you may specify.

Rayovac will not reproduce works of art in any altered, or obscured form, nor will it authorize others to do so without first receiving permission from you or the copyright holder to do so. (Works in color may, however, be reproduced in black and white, and a reproduction of a detail of a work of art shall be so identified.)

Permission To Reproduce Is Requested For
The Following Works Of Art:

I consent to the use of my works of art, as listed above, by Rayovac Corporation and by others licensed by Rayovac, for the purposes outlined on the other side of this document, and subject to the restrictions stated there. It is understood, however, that any requests received by Rayovac for the right to reproduce a work of mine for any other purpose shall be referred to me, or if the copyright is held by another person or organization (as noted below), to such other copyright holder. Notice of copyright shall appear with any reproduction of my work.

_____	_____
Artist's signature	Copyright owner (if other than artist)
_____	_____
Artist's address	Copyright Owner's address
_____	_____
City, State, Zip	City, State, Zip
_____	_____
Telephone number	Date

Sample Form for Permission to Reproduce Works of Art

Here is the front page of a form prepared by Rayovac Corporation requesting permission from an artist to reproduce a work in its collection under certain limited circumstances. On the reverse (not shown) is simply a description of the works in question. The form is reproduced here by the kind permission of Rayovac Corporation of Madison, Wisconsin.

Resource Directory

■ ARCHIVAL PRESERVATION & PRESENTATION

Archivart
7 Caesar Place
Moonachie, NJ 07074
Phone: 201-804-8986
Fax: 201-935-5964

Conservation Materials
P.O. Box 2884
Sparks, NV 89431
Phone: 702-331-0582

Conservation Resources
8000-H Forbes Place
Springfield, VA 22151
Phone: 703-321-7730/800-634-6932

Gaylord Brothers
P.O. Box 4901
Syracuse, NY 13221-4901
Phone: 800-634-6307

Light Impressions Corp.
439 Monroe Avenue
Rochester, NY 14607
Phone: 716-271-8960

The Hollinger Corporation
P.O. Box 8360
Fredericksburg, VA 22404
Phone: 703-898-7300
Fax: 703-898-8073

University Products
517 Main Street
Holyoke, MA 01041-0101
Phone: 800-628-1912

■ ART ASSOCIATIONS

American Academy and Institute of Arts & Letters
633 W. 155th Street
New York, NY 10032
Phone: 212-368-5900
Fax: 212-491-4615

American Craft Association
1225 Eye Street, NW, Suite 500
Washington, DC 20005
Phone: 202-682-4715

American Craft Council
72 Spring Street
New York, NY 10012
Phone: 212-274-0630
Fax: 212-274-0650

American Institute of Graphic Arts
1059 Third Avenue
New York, NY 10021
Phone: 212-752-0813

American Society of Interior Designers
730 Fifth Avenue
New York, NY 10019
Phone: 212-265-2090

Art Dealers Association of America
575 Madison Avenue
New York, NY 10022
Phone: 212-940-8590
Fax: 212-940-8776

Association of Private Art Dealers
605 3rd Avenue, Suite 1501
New York, NY 10158
Phone: 212-750-5888

Business Committee for the Arts
1700 Broadway
New York, NY 10019
Phone: 212-765-5980

National Association of Women Artists
Building 41 Union Square West
New York, NY 10003
Phone: 212-675-1616

National Institute of Appraisers
Box 69301
Los Angeles, CA 90069
Phone: 213-289-1148

National Sculpture Society
75 Rockefeller Plaza
New York, NY 10019
Phone: 212-582-5564

The American Federation of the Arts
41 E. 65th Street
New York, NY 10021
Phone: 212-988-7700

The American Society of Appraisers
Box 17265
Washington, DC 20041
Phone: 800-ASA-VALU
Fax: 703-742-8471

The Appraisers Association of America
60 E. 42nd Street
New York, NY 10017
Phone: 212-867-9775

The National Antique & Art Dealers Association
32 E. 57th Street
New York, NY 10022
Phone: 212-355-0636

■ ART CONSULTING ASSOCIATIONS

Association for Corporate Support of the Arts
2-5-1 Yurakucho
Tokyo, 100 Japan

Association of Corporate Art Advisors
Box 764
Philadelphia, PA 19105
Phone: 215-848-5791

Association of Corporate Art
Curators Box 11369
Chicago, IL 60611-0369
Phone: 414-229-6243
Fax: 414-229-6154

Association of Professional Art Advisors, Inc.
2150 W. 29th Avenue, Suite 500
Denver, CO 80211
Phone: 303-433-4446
Fax: 303-458-0002

National Association of Corporate Art Management
201 S. Craig Street
Pittsburgh, PA 15213
Phone: 412-687-4200

■ ART LAW & LEGAL SERVICES

Contact one of these two groups to find the organization nearest you.

California Lawyers for the Arts
San Francisco Office:
Fort Mason
Building C, Room 255
San Francisco, CA 94123
Phone: 415-775-7200
Fax: 415-775-1143

Santa Monica Office:
1549 11th Street, Suite 200
Santa Monica, CA 90401
Phone: 310-395-8893
Fax: 310-395-0472

Volunteer Lawyers for the Arts
One E. 53rd Street
New York, NY 10022
Phone: 212-319-2787
Fax: 212-223-4415

■ AUCTION HOUSES

Butterfield & Butterfield
220 San Bruno Avenue
San Francisco, CA 94103
Phone: 415-861-7500
Fax: 415-861-8951

Christie's
502 Park Avenue
New York, NY 10022
Phone: 212-546-1000
Fax: 212-980-8163

Grogan & Company
890 Commonwealth Avenue
Boston, MA 02215
Phone: 617-566-4100

Phillips Fine Art Auctioneers
406 E. 79th Street
New York, NY 10021
Phone: 212-570-4830
Fax: 212-570-2207

Sotheby's
1334 York Avenue
New York, NY 10021
Phone: 212-606-7000
Fax: 212-606-7107

■ BARRIERS & TRAFFIC CONTROL DEVICES

Lawrence Metal Products, Inc.
Box 400-M Dept. SW
Bayshore, NY 11706
Phone: 516-666-0300

■ CUSTOMS BROKERS

Grace International Customs Brokers, Inc.
145-119 Guy R. Brewer Blvd.
Jamaica, NY 11434-5279
Phone: 718-723-6400
Fax: 718-949-5066

W. R. Keating & Company
150-16 132nd Avenue
Jamaica, NY 11434
Phone: 718-481-5400
Fax: 718-528-0871

■ DISPLAY EQUIPMENT

Kenneth Lynch & Sons
Box 488
Wilton, CT 06897-0488
Phone: 203-762-8363
Fax: 203-762-2999

Multiplex Display Fixture Company
1555 Larkin Williams Road
Fenton, MO 63026
Phone: 314-343-5700/800-325-3350
Fax: 314-326-1716

Roberts Colonial House, Inc.
570 W. 167th Street
South Holland, IL 60473
Phone: 708-331-6233
Fax: 708-331-0538

■ FINE ART INSURERS

All Risk Associates, Ltd.
299 Broadway
New York, NY 10007
Phone: 212-964-3995
Fax: 212-267-3192

Fine Arts Risk Management, Inc.
225 W. 34th Street, Suite 1715
New York, NY 10122
Phone: 212-268-4770
Fax: 212-268-4507

Frenkel & Company, Inc.
123 William Street
New York, NY 10038
Phone: 212-267-2200

Huntington T. Block Insurance
1120 20th St. NW
Washington, DC 20036
Phone: 800-424-8830, 202-223-0673
Fax: 202-331-8409

Marsh & McLennan
1166 Avenue of the Americas
New York, NY 10036-2774
Phone: 212-345-6000

American Institute for Conservation of Historic & Art Works
(free referral service)
1717 K St. NW, Suite 301
Washington, DC 20006
Phone: 202-452-9545

■ FOUNDERS & FABRICATORS

Allied Bronze Ornamental Metal
2511 Hunters Point Avenue
Long Island City, NY
Phone: 718-361-8822

American Plating Company
3527 Park Avenue
St. Louis, MO 63104
Phone: 314-776-0542

Excalibur Bronze Sculpture Foundry
85 Adams Street
Brooklyn, NY 11201
Phone: 718-522-3330
Fax: 718-522-0812

Fine Arts & Metal
825 N. 10th Street
San Jose, CA
Phone: 408-292-7628
Fax: 408-292-7690

Fine Arts Sculpture Centre
4975 Waldon Road
Clarkston, MI 48348
Phone: 810-391-3010
Fax: 810-391-4093

International Sculpture Center
1050 17th St. NW, Suite 250
Washington, DC 20036
Phone: 202-785-1144

Johnson Atelier
60 Ward Avenue Extension
Mercerville, NJ 08619
Phone: 609-890-7777

Kern-Rockenfield
345 Devoe Street
Brooklyn, NY 11211
Phone: 718-486-7878

McEnglevan Industrial Furnace Mfg.
708 Griggs Street
P.O. Box 31
Danville, IL 61832
Phone: 217-446-0941
Fax: 217-446-0943

Medallic Art Company/The Protocol Group, Inc.
Old Ridgebury Road
Danbury, CT 06810
Phone: 203-792-3001
Fax: 203-798-6312

Modern Art Foundry, Inc.
18-70 41st Street
Long Island City, NY 11105
Phone: 718-728-2030

Paul King Foundry Sculpture
92 Allendale Avenue
Johnston, RI 02919
Phone: 401-231-3120
Fax: 401-232-7124

Upscale Welding
860 Wallingford Road
Cheshire, CT 06410
Phone: 203-250-8208

Roman Bronze Works, Inc.
96-18 43rd Avenue
Corona, NY 11368
Phone: 718-429-4402

Sculpture House Casting, Inc.
155 W. 26th St.
New York, NY 10001
Phone: 212-645-9430

Shidoni
Bishop's Lodge Road
Tesuque, NM 87574
Phone: 505-988-8001
Fax: 505-984-8115

Southern Illinois University Art Department
Carbondale, IL 62901
Phone: 618-453-5288

Tallix Foundry
3 Dogwood Road
Peekskill, NY 10566
Phone: 914-739-8014

Tallix Inc.
175 Fishkill Avenue
Beacon, NY 12508
Phone: 914-838-1111

Treitel-Gratz Company, Inc.
13-06 Queens Plaza S
Long Island City, NY 11101
Phone: 718-361-7774
Fax: 718-392-8281

■ GALLERY EQUIPMENT

Acoustiguide Corporation
1301 Avenue of the Americas
New York, NY 10019
Phone: 212-974-6600

Helmut Guenschel, Inc.
10 Emala Avenue
Baltimore, MD 21220
Phone: 410-686-5900/800-852-2525
Fax: 410-687-9342

Lynch Industries, Inc.
1601 Sherman Avenue
Pennsauken, NJ 08110
Phone: 609-661-0205

Oro Manufacturing Company
P.O. Box 5018
Monroe, NC 28110
Phone: 704-283-2186

Structural Concepts Corporation
17237 Van Wagoner Road
Spring Lake, MI 49456
Phone: 616-846-3300
Fax: 616-846-7460

Syma Structures, Inc.
457 W. 45th Street
New York, NY 10036
Phone: 212-245-5226

■ INFORMATION & RESEARCH SERVICES

Art Loss Register
13 Grosvenor Place
London SW1X 7HH, UK
Phone: 71-235-3393
Fax: 71-235-1652

Art Trak
2916 McKinney Avenue
Dallas, TX 75204
Phone: 214-979-0009
Fax: 214-969-1851

ArtFact
1130 Ten Rod Road, #E104
North Kingstown, RI 02852
Phone: 401-295-2656
Fax: 401-295-2629

Centrox Corp.
145 East 57th Street
New York, NY 10022
Phone: 212-319-4800
Fax: 212-819-4620

Encompass Fine Art Systems
5424 North 74th Street
Scottsdale, AZ 85250
Phone: 602-945-7616
Fax: 602-263-7924

Telepraisal
Box 20686
New York, NY 10009
Phone: 212-614-9090
Phone: 800-645-6002
Fax: 212-780-9539

■ INSTALLATION MATERIALS

Allcraft Tool & Supply Co., Inc.
45 W. 46th St.
New York, NY 10036
Phone: 212-840-1860

Arthur Brown & Bro., Inc.
2 W. 46th Street
New York, NY 10036
Phone: 212-575-5555

B. F. Goodrich Company
500 S. Main Street
Akron, OH 44313
Phone: 216-374-2000

Borden Inc. - Home & Professional Products Group
180 E. Broad St.
Columbus, OH 43215
Phone: 614-225-4000

Brookstone Company
Vose Farm Road
Peterborough, NH 03458
Phone: 603-924-7181

Display Works
Cincinnati, OH 45202
Phone: 513-381-1343

Fitch Creations, Inc.
Box 111
Chapel Hill, NC 27514
Phone: 919-542-4000

Glidden Coatings and Resins
925 Euclid
Cleveland, OH 44115
Phone: 216-344-8000

Harrington & King
15 Essex Road
Paramus, NJ 07652
Phone: 201-368-1800

Homasote Company
P.O. Box 7240
West Trenton, NJ, 08628
Phone: 609-883-3300

Lake Shore Markers
1817 Poplar
Erie, PA 16512
Phone: 800-458-0463

Masonite Corporations
1 South Wacker Drive, 36th Fl.
Chicago, IL 60606
Phone: 312-750-0900

McMaster-Carr Supply Company
P.O. Box 4355
Chicago, IL 60680
Phone: 708-834-9600

Scott Plastics Company
7524 Commerce Place
Sarasota, FL 34243
Phone: 813-355-5171

South Company, Inc.
210 N. Brinton Lake Road
Concordville, PA 19331
Phone: 215-459-4000

Specialty Jute Products & Development, Inc.
Box 337
Fairforest, SC 29336
Phone: 803-576-4880

Styro Materials
2519 Walnut Street
Denver, CO 80205
Phone: 303-297-0397

Teledyne Rodney Metals
1937 Sterling Avenue
P.O. Box 757
Elkhart, IN 46515
Phone: 219-295-5525

The American Plywood Association
P.O. Box 11700
Tacoma, WA 98411
Phone: 206-565-6600

United States Gypsum
125 S. Franklin Street
Chicago, IL 60606
Phone: 312-606-4000

■ **LIGHTING SYSTEMS & CONSULTANTS**

Angelo Bros. Company
12401 McNulty Road
Philadelphia, PA 19154
Phone: 215-671-2000

Edison Price Lighting
409 E. 60th Street
New York, NY 10022
Phone: 212-838-5212
Fax: 212-888-7981

Halo Lighting-Cooper Lighting
400 Busse Road
Elk Grove Village, IL 60007
Phone: 708-956-8400

USI Lighting-Prescolite
1251 Doolittle Drive
San Leandro, CA 94577
Phone: 510-562-3500

Swivelier Company
33 Route 304
Nanuet, NY 10954
Phone: 914-623-3471
Fax: 914-623-1861

■ **NATIONAL TRAVELING EXHIBITION ORGANIZATIONS**

American Craft Enterprises
21 S. Eltings Corner Road
Highland, NY 12528
Phone: 800-836-3470
Fax: 914-883-6130

American Federation of Arts
41 E. 65th Street
New York, NY 10021
Phone: 212-988-7700
Fax: 212-861-2487

The American Institute of Graphic Arts
164 Fifth Avenue
New York, NY 10010
Phone: 800-548-1634

Blair-Murrah Exhibitions
Vintage Hill Orchard
Sibley, MO 64088
Phone: 816-249-9400/816-650-9500
Fax: 816-249-9300

Curatorial Assistance
113 E. Union Street
Pasadena, CA 91103
Phone: 213-681-2401
Fax: 818-449-9603
Circulates the Polaroid photography exhibitions as well as other traveling exhibits.

Gallery Association of New York State
Box 345
Hamilton, NY 13346
Phone: 315-824-2510
Fax: 315-824-1683

Independent Curators, Inc.
799 Broadway, Suite 205
New York, NY 10003
Phone: 212-254-8200
Fax: 212-477-4781

International Center of Photography
1130 Fifth Avenue
New York, NY 10128
Phone: 212-860-1775
Fax: 212-360-6490

International Museum of Photography & Film at George Eastman House
900 East Avenue
Rochester, NY 14607
Phone: 716-271-3361
Fax: 716-271-3970

Laundau/Traveling Exhibition Services
1625 Thayer Avenue
Los Angeles, CA 90024
Phone: 310-474-5155
Fax: 310-475-8212

Library of Congress Traveling Exhibition Department
Washington, DC 20540-8800
Phone: 202-707-5223
Fax: 202-707-9063

Mid-America Arts Alliance/Exhibits USA
912 Baltimore Avenue, #700
Kansas City, MO 64105
Phone: 816-421-1388
Fax: 816-421-3918

Museum of American Folk Art
61 W. 62nd Street
New York, NY 10023
Phone: 212-977-7170
Fax: 212-977-8134

Museum of Modern Art
11 W. 53rd Street
New York, NY 10019
Phone: 212-708-9480

Smithsonian Institution
1100 Jefferson Drive SW, Quad 3146
Washington, DC 20560
Phone: 202-357-3168
Fax: 202-357-4324

Southern Arts Federation
1811 14th Street NE, Suite 400
Atlanta, GA 30309
Phone: 404-874-7244
Fax: 404-873-2148

Visual Arts Resources
164 W. Broadway
Eugene, OR 97401
Phone: 503-485-1230

Visual Studies Workshop, Inc.
31 Prince Street
Rochester, NY 14607
Phone: 716-442-8676
Fax: 716-442-1992

▪ PERIODICALS

The following publish articles on corporate interiors and corporate art programs.

Art and Auction, 250 W. 57th Street, New York, NY 10019.

Architectural Digest, 5700 Wilshire Boulevard, Los Angeles, CA 90036

Architectural Record, 1221 Avenue of the Americas, New York, NY 10020.

Arts and Architecture, The Schindler House, 835 North Kings Road, Los Angeles, CA 90069.

Contract, 1515 Broadway, New York, NY 10036.

Corporate Design, 850 Third Avenue, New York, NY 10022.

Designers Magazine, 114 East 42nd Street, New York, NY 10017.

Designers Report, 17 West 20th Street, New York, NY 10011.

Designers West, 50 East 89th Street, New York, NY 10028.

Facilities Design & Management, 1515 Broadway, New York, NY 10036.

Interior Design, 850 Third Avenue, New York, NY 10022.

Interiors, 1515 Broadway, New York, NY 10036.

Progressive Architecture, 600 Summer Street, Stamford, CN 06904.

▪ PROGRAMS IN MUSEUM STUDIES

The following sources can provide information on programs available in your area.

Museum Studies International
The Office of Museum Programs
Smithsonian Institution
Washington, DC 20560

Committee on Museum Professional Training
Museum Studies Program,
University of Delaware
301 Old College
Newark, DE 19716
(302) 831-1251

■ SEMINARS/CONFERENCES

Abbott & Company
3315 Sacramento Street, Suite 114
San Francisco, CA 94118
Phone: 415-383-3242
Corporate art consulting and fine art public relations seminars for art professionals, art marketing, and art history.

ARTnews World Art Market Conference
48 W. 38th Street
New York, NY 10018

National Association of Corporate Art Management
1723 Murray Avenue, No. 27
Pittsburgh, PA 15217
Phone: 412-242-9711

■ SHIPPERS & HANDLERS

Allied Van Lines Special Products Division
300 Park Plaza
Naperville, IL 60563
Phone: 708-717-3688

Airfloat Systems, Inc.
Box 229
Tupelo, MS 38802
Phone: 800-445-2580
Fax: 800-562-4323

Allied Van Lines
Box 4403
Chicago, IL 60680
Phone: 312-549-0120

ART MOVE Ltd.
Unit 3 Grant Road
London, SW11 2NU
Phone: 071-585-1801
Fax: 071-223-0241

Artpak Transport
49-20 Fifth Street
Queens, NY 11101
Phone: 718-729-0800/800-683-4278
Fax: 718-937-5860

Art Services, Inc.
8221 Melrose Avenue
Los Angeles, CA 90046
Phone: 213-653-9033
Fax: 213-655-8943

Artech Fine Art Services
2609 First Avenue
Seattle, WA 98121
Phone: 206-728-8822/800-278-3241
Fax: 206-284-3743

Artex Inc.
7117 Maple Avenue
Takorna Park, MD 20912
Phone: 301-270-5590

Atlantic
1001 Wilso Drive
Baltimore, MD 21223
Phone: 410-368-4008
Fax: 410-368-4006

Atthowe Fine Arts Services
926 32nd Street
Oakland, CA 94608
Phone: 510-654-6816
Fax: 510-654-2632
20'x42' presentation space with
10' ceilings & track lighting.

Auer Express & Moving Company
1721 Park Avenue
New York, NY 10035
Phone: 212-427-7800

Authentic Frame & Art Services
251 Heath Street
Boston, MA 02130
Phone: 617-566-1155
Fax: 617-566-1621

Bekins Van Lines
330 South Manneheim Road
Hillside, IL 61625
Phone: 800-878-2374

Racine Berkow Associates
375 West Broadway
New York, NY 10012
Phone: 212-226-2411
Fax: 212-966-6954

James Boarlet
21-41 45th Road
Long Island City, NY 11101
Phone: 718-392-9770
Fax: 718-392-2470

Boston Truck
194 First Street
Cambridge, MA 02142
Phone: 617-547-9655

**Cirker's Hayes Storage
Warehouse, Inc.**
305 E. 61st Street
New York, NY 10021
Phone: 212-838-2525
Fax: 212-486-3188
Viewing room for artwork,
by appointment only.

Robert W. Cisco
416 Common Street
New Orleans, LA 70130
Phone: 504-522-2712

Contemporary Installations
449 North Oak Street
Inglewood, CA 90302
Phone: 310-673-7200
Fax: 310-673-7492

Cook's Crating
3124 E. 11th Street
Los Angeles, CA 90023
Phone: 213-268-5101
Fax: 213-262-2001

D.A.D. Trucking
76 Varick Street
New York, NY 10013
Phone: 212-226-0054
Fax: 212-226-1070

**Day & Meyer,
Murray & Young Corporation**
1166 Second Avenue
New York, NY 10021
Phone: 212-838-5151

Eagle Transfer Corporation
40 Leight Street
New York, NY 10013
Phone: 212-966-4100

Ferrari Lorenzi USA
400 East 54th Street
New York, NY 10022
Phone: 212-826-8261
Fax: 212-826-8355

Fine Arts Express Southwest
7440 Whitehall
FortWorth, TX 76118
Phone: 817-589-0855
Fax: 817-284-1376
Presentation space is available.

Fine Arts Express Southwest
465 W. 38th Street
Houston, TX 77018
Phone: 713-691-5461
Fax: 713-691-0123

Gander & White
33-31 Greenpoint Avenue
Long Island City, NY 11101
Phone: 718-784-8444
Fax: 718-784-9337

Grosso Art Packers
1400 York Avenue
New York, NY 10021
Phone: 212-734-8879
Fax: 212-288-9009

Hahn Bros.
190 Christopher Columbus Drive
Jersey City, NJ 07302
Phone: 201-432-8488
Fax: 201-432-9547
60 East 42nd Street, #427
New York, NY 10165
Phone: 212-926-1505
Fax: 212-972-1278

Hedley's
30 Thompson Street
New York, NY 10013
Phone: 212-219-2877
Fax: 212-219-2826

The ICON Group Inc.
417 N. Sangamon
Chicago, IL 60622
Phone: 312-733-4266
Fax: 312-733-6496

Len Art
6620 Leland Way
Hollywood, CA 90028
Phone: 213-466-4390

**Hansen Brothers
Moving & Storage Company**
10750 Aurora
Seattle, WA 98133
Phone: 206-365-4454

Mayflower Transit Company
Box 107
Indianapolis, IN 46206
Phone: 317-875-1000

Mayflower Fine Arts Division
4836 SE Powell Boulevard
Portland, OR 97286
Phone: 503-777-4181
Fax: 503-775-8443

**Morgan & Brother Manhattan
Storage Company, Inc.**
510 W. 21st Street
New York, NY 10011
Phone: 212-633-7800
Fax: 212-255-0336

**North American Van Lines—
HVP Division**
Box 988
Fort Wayne, IN 46801
Phone: 800-231-3162
Fax: 219-429-2497

Ollendorff Fine Arts
21-44 44th Road
Long Island City, NY 11101
Phone: 718-937-8200
Fax: 718-937-6274

Parma Movers, Inc.
3584 W. 67th Street
Cleveland, OH 44102
Phone: 216-651-4747
Fax: 216-651-6960

Quaker Storage & Moving Co, Inc.
901 Poplar Street
Philadelphia, PA 19123
Phone: 215-236-5800
Presentation space can be arranged.

Santini Bros, Inc.
447 W. 49th Street
New York, NY 10019
Phone: 212-265-3317

U.S. Art Company
16 Randolph Street
Boston, MA 02118
Phone: 800-872-7826
Fax: 617-338-5337

United Van Lines
1 United Drive
Fenton, MO 63026
Phone: 314-343-3900

W. R. Keating & Company
150-16 132nd Avenue
Jamaica, NY 11434
Phone: 718-481-5400
Fax: 718-528-0871

Handling Art During Installation

The following is excerpted from *Good Show*, by Lothar P. Witteborg, published by the Smithsonian Institution and reprinted with their permission. This material has as its prime source *The Care and Handling of Art Objects*, by Robert P. Sugden, published by the Metropolitan Museum of Art in New York in 1946.

PAINTINGS

1 Do not move or carry more than one painting at a time, regardless of size. Always carry a painting with one hand underneath and the other at the side, both at points where the frame is solid. Never carry a painting by the top or by the stretcher.

2 Large (i.e., large enough to be awkward for one person) paintings should always be carried by two persons.

3 Try not to stack paintings one on top of the other.

4 Separate paintings with a composition sheet (foamcore, cardboard, or a compboard, etc.) if stacking is absolutely unavoidable. Stack the largest painting first, followed by smaller ones in descending order, with no more than five paintings in any one stack. Each composition sheet must cover completely the larger of the two paintings it separates.

5 Paintings standing on the floor must rest on pads or padded wooden strips.

6 If paintings are moved on a side truck, glass truck or dolly, separate the paintings as above and rest them on a pad. Paintings should not extend beyond the edge of the truck, or dolly.

7 Do not move large, heavy paintings on a side truck unless the truck's supporting framework is high enough: that is, at least two-thirds of the height of the painting. The weight of the painting must be borne by the frame resting against the truck support: it should never be borne by the stretcher alone.

8 Before the truck is moved, lash the painting in place using pads at the points where the rope touches the frame. Two persons must accompany each loaded moving hand truck. One person must be experienced in the handling of art objects.

9 When dismantling an exhibition, do not remove hanging devices—wires, hooks, etc., from the frames or panels unless otherwise instructed by the organizer.

10 Avoid direct contact with painted surfaces at all times. Do not attempt to remove slight scratches, rubbed spots, or dirt marks with your hand, a cloth, or by any other means.

Where varnish on a painting is in poor condition, even gentle pressure will leave a mark that may call for treatment of the entire surface.

11 Wear white cotton gloves to avoid damaging finger marks when working with light-colored, matte-finish or gilded frames. Clean hands are not enough in this case as perspiration spots so easily spoil a frame's appearance.

12 Report any damage that appears to be of recent origin, no matter how slight it seems to be. Get in the habit of examining every painting to determine condition.

13 If paint flakes or frame parts become detached, save all the pieces. Repairs are much easier of all parts are available.

SMALL OBJECTS (CERAMICS, GLASS, ENAMELS, ETC.)

1 Never handle any object unnecessarily. Always work with proper supervision.

2 Move only one object at a time and carry it with one hand underneath. Unpack over a padded table so that detached parts will not be lost or damaged.

3 Never lift small, fragile objects by handles, rims, or other projections for these parts may have been broken before and repaired. Hold the body of the piece gently but firmly. Check each object in and out of the padded tray in your gallery cart when it consists of more than one part.

4 Always use padded trays for moving small objects. Do not move them by hand except for placement in trays. Use sufficient cotton or padding within the tray to prevent contact of one object with other objects. Whenever possible, place objects so that they do not project above the top of the tray.

5 Make sure that hands are clean. Use gloves or tissue when handling objects with glazed, polished metal, or other highly finished surfaces since such materials show finger marks, which are difficult to remove. Apply this rule to matte finishes and painted decorations as well. Smooth-surfaced objects are hard to handle with gloves or tissue; therefore, extra care is necessary.

6 Do not move trays by hand from one part of the building to another. Use a gallery cart. Speed and jarring motion should be strictly avoided. Take time to do the job properly.

7 When moving small sculptures, always place them on pads and make sure they are carefully supported so their weight is evenly distributed. Leave space between objects to avoid chipping and scratching.

8 Ivories and small wood carvings are affected by sudden changes of atmosphere; therefore, do not work with such pieces near open windows or doors, particularly during winter months or wet weather.

9 Arms, armor and most metal objects are subject to damage in many ways. Such objects should not be handled by inexperienced persons. Always handle with gloves, as finger marks cause rust. Also, avoid exposure to dampness or high humidity.

10 Jewelry is usually very fragile; therefore, never place cotton in direct contact with it. Cotton can catch on delicate parts and may loosen settings, causing loss of stones. Wrap jewelry first in tissue and then in cotton, if added protection is needed. Ivories, enamels and old glass should be treated in the same way, wrapped first in tissue, and then in cotton. There must be strict supervision when working with jeweled objects.

LARGE SCULPTURE

1 The movement of large sculpture is a technical problem. Do not attempt it with too little help or without competent direction. Haste in handling may result in injury to the handlers or damage to the object.

2 Do not carry heavy sculpture by hand, even if you are able to lift it. Sculpture should always be moved on padded trucks, supported and, if necessary, tied to prevent harmful movement while the truck or dolly is in motion.

3 Sculpture should always be examined before handling. Know-

ing the points of weakness in advance is important to the safe movement of the object. If there are any doubts about how an object is to be moved or handled, call the lender or the organizer for advice.

WOODWORK AND FURNITURE

1 Always move woodwork or furniture on trucks or dollies. Never slide or push such objects along the floor, as legs or bases can be easily broken.

2 Always lift chairs under the seat rail, never by the backs or arms. Carry tables and other furniture by the solid parts of their framework, not the ornamentation.

3 Cover upholstered furniture in transit, as delicate fabrics are difficult to clean. Do not touch the upholstery on the arms, seats or backs of chairs or sofas. Cover upholstery with clean sheets until the exhibit is ready to open.

4 Never stack furniture when moving it.

5 Unlocked drawers, cabinet doors, folding table tops and all other movable parts must be held in place to prevent damage in transit. Tie these parts to the main part of the furniture, using pads where the rope touches the wood.

6 Remove marble tops for transit and transport them in a vertical position on a side truck. Do not carry marble horizontally since it may break of its own weight.

7 Wood paneling is seldom as strong as it looks. Sufficient help and proper supervision are needed in carrying it.

As with all objects being unpacked and moved to your exhibit area, save all parts that may have become broken or detached. Also, avoid haste in handling objects and avoid speed with hand trucks loaded with objects. Report every bit of damage that appears to be new.

TAPESTRIES, RUGS AND LARGE TEXTILES

1 Never lift mounted textiles so that all of the weight is borne by the fabric alone. Use the supporting bar, roller or stretcher for lifting.

2 Cover and protect textiles until they are ready to be installed. Retain and mark the cover so the same one can be used when repacking or storing.

3 Avoid stretching, tugging and pulling. Textiles that seem to be sturdy are frequently old, worn or repaired and they can tear easily. Use the same care in handling contemporary textiles that you use with older ones.

4 Remove screw eyes, wires and other projections (unless told otherwise by the lender) before rolling textiles on supporting bars. Roll tapestries, large textiles and rugs evenly, avoiding wrinkling and creasing. If the textile has a lining, roll the lined material face out.

5 Rugs, tapestries and large textiles on wrapped rollers should not be picked up by one person or grasped at the middle of the bar. Use two persons, one supporting each end, for greater protection while moving a roll of textile.

6 Do not pile rolled or folded textiles one on top of another unless it is absolutely necessary. This practice results in broken threads that are virtually impossible to repair.

7 Observe strict safety rules when installing and removing large textiles from exhibitions. There should always be another person at the foot of each ladder to steady it.

COSTUMES AND SMALL TEXTILES

1 Handle mounted textiles by the stretcher or frame. Slight pressure on the fabric can cause serious damage.

2 Do not fold textiles, laces, costumes, etc., unless given permission to do so. If it is necessary to fold them, place tissue paper in the folds to prevent creasing.

3 Clean hands are essential in working with textiles. Many fabrics are so fragile that cleaning is virtually impossible.

4 Cover costumed mannequin until the exhibit is ready to open. Also leave covers on when the mannequins are moved. Always lift the mannequin by its framework when moving it in order to avoid soiling or tearing the costume.

5 After removing textiles and costumes from exhibitions, be sure that all pins are removed to prevent possible rust stains as well as blood stains from scratched fingers. This procedure should be followed also for contemporary textiles and costumes.

DRAWINGS, WATERCOLORS, PRINTS, MINIATURES AND RARE BOOKS

Works in this group are among the most fragile and easily damaged in the museum. Treat these objects with care and consideration. Do not handle them unless it is your job to do so, and then only if you are experienced.

1 Handle as little as possible and only with clean hands. Never touch material of this kind with wet, sticky or dirty fingers. If your hands perspire, wear white cotton gloves.

2 When moving unmounted material, lift each sheet by the upper corners so it hangs free without buckling. Use great care to avoid bending, cracking and tearing. Support such works on clean cardboard when carrying them by hand, or carry them in glassine envelopes.

3 Never stack prints or drawings one on top of another unless they are matted or are separated by cellophane, glassine or tissue paper. Do not allow newsprint, printed matter, sized papers, or other paper of poor quality to come into direct contact with the objects. Always cover works awaiting installation, framing or transportation with acid-free tissue paper to exclude dust and dirt.

4 Do not permit works on paper to be shuffled or rubbed against each other. It is extremely difficult to repair damage done in this manner.

5 Do not expose prints, drawings, watercolors and illuminated manuscripts to direct or indirect sunlight or to fluorescent lamps (unless they have been fitted with a UV filter), whether on exhibition, awaiting installation or in storage.

6 Many book and manuscript bindings that may appear to be in good condition are actually fragile. Never take a chance. Always handle these objects with extreme care. Leather bindings and old leather objects are easily stained. Do not handle these objects unless it is necessary.

7 Turn the pages on old books from the upper, outer corners, if and when it is necessary to open the book and turn the pages. Moistened fingers are extremely harmful to paper.

8 Always seek professional advice from the lender on how to display old books and manuscripts. If the books are from your own collection, consult a librarian.

The same care indicated for art objects should apply to historic objects, ethnographic and archaeological objects, and to delicate natural history specimens such as insects, eggs, bird and mammal mounts, shells, botanical models and fragile geological specimens. ·

Master Toolbox

A CHECKLIST

Toolbox

Hammer (claw)

Nail set & nail punch

Nails, concrete nails, & security mounts

Awl

Level (6 inches long)

Battery powered hand drill & drill bits

Assorted nails

Assorted metal screws

Assorted wood screws

Assorted bolts & nuts

Steel measuring tape (12')

Metal rule or T-Square (24")

Chalkline

Brace & bits

Phillips screwdriver (one)

Regular screwdrivers (four)

Assorted screw eyes

Assorted washers

Frame fasteners

Brass cleaner

Plexi cleaner & rags

Soft cloth rags

Glass cleaner & paper

Mat knife (with extra blades)

X-Acto knife (with extra blades)

Pencils

Folding luggage carrier

Needle-nose pliers

Side-cutting pliers

Roll of picture wire (large)

Roll of fine copper wire (small)

Solvent

Rubber cement

Roll of monofilament (clear)

Fishing line (20 lb. test)

White glue

Pushpins

Ball of twine

Adjustable wrench

Flexible cord

Assorted erasers

Work aprons

Garbage bags

Masking tape (1-inch roll)

Cloth for artwork to sit on

White cotton gloves

Crosscut saw

Hacksaw (with extra blades)

Bucksaw & miter box

Assorted sandpapers

4-in-hand rasp file

Box of dressmaker's pins (with rounded heads)

Heavy duty stapler (with extra staples)

Dust pan with hard brush

Sable brushes for cleaning art (2" and 4")

Wire stripper

3M heavy duty double-faced foam tape (1-inch)

Letter of cleaning instructions to give to the office manager for the cleaning crew

Special materials for this job? (Plexi labels, etc.)

BIBLIOGRAPHY CONTENTS:

Bibliography

USEFUL REFERENCE BOOKS

American Prints in the Library of Congress: Catalogue of the Collection. Baltimore: Johns Hopkins, 1970.

Atkins, Robert. *Artspeak—A Guide to Contemporary Ideas, Movements, and Buzzwords*. NY: Abbeyville Press, 1990.

Baetjer, Katherine. *European Paintings in the Metropolitan Museum of Art by Artists Born In or Before 1865*. NY: The Metropolitan Museum of Art, 1980.

Commissioning a Work of Public Art: An Annotated Model Agreement. NY: New York City Bar Association Committee on Art Law, 1989.

Conningham, Frederic A. *Currier & Ives Prints: An Illustrated Check List*. NY: Crown Publishers, Inc., 1975.

Cruickshank, Jeffrey, and Pam Korza. *Going Public: A Field Guide to Developments in Art in Public Places*. Amherst: The Arts Extension Service and the Visual Arts Program of the National Endowment for the Arts, 1988.

Fusco, Peter, and H. W. Janson. *The Romantics to Rodin: French 19th Century Sculpture from North American Collections*. Los Angeles: L.A. County Museum of Art, 1980.

Licht, Fred. *Sculpture: 19th and 20th Centuries; A History of Western Sculpture*. Greenwich, CT: New York Graphic Society, 1967.

Osborne, Harold (ed.). *The Oxford Companion to Art*. Oxford, England: Clarendon Press, 1970.

Reeve, James K. *The Art of Showing Art*. NY: The Consultant Press/PAC, 1986.

Rheims, Maurice. *19th Century Sculpture*. NY: Abrams, 1977.

Rosen, Randy. *Prints, The Facts and Fun of Collecting*. NY: Dutton, 1978.

Stewart, Basil. *A Guide to Japanese Prints and Their Subject Matter*. NY: Dover Publications, 1979.

Warner, Glenn. *Building a Print Collection*. NY: Van Nostrand, 1980.

Witteborg, Lothar. *Good Show! A Practical Guide for Temporary Exhibitions*. Washington, DC: Smithsonian Institution Traveling Exhibition Service, 1981.

Zigrosser, Carl, and Christa M. Gaehde. *A Guide to the Collecting and Care of Original Prints*. NY: Crown Publishers, Inc., 1969.

DICTIONARIES & DIRECTORIES

American Art Directory. NY: R. R. Bowker Co., 1980.

Benezit, E. *Dictionaire...des Peintres, Sculpteurs, Dessinateurs et Graveurs*. Paris: Librairie Grund, 1976 (latest edition).

The Brittanica Encyclopedia of American Art. Chicago and NY: Encyclopedia Brittanica Educational Corps. and Simon & Schuster.

Bryan, M. *Dictionary of Painters and Engravers*. Port Washington, NY: Kennikat Press, 1964 (new revised edition).

Directory of Corporate Art Collections. NY: ARTnews and International Art Alliance, revised 1986.

Gale Directory of Publications and Broadcast Media. Gale Research Inc. 835 Penobscot Bldg. Detroit, MI 48226. Toll-free: 800-877-4253.

The Guild. NY: Kraus Sikes Inc. (published annually).

Krantz, Les. *The California Art Review: An Illustrated Survey of the State's Museums, Galleries, and Leading Artists*. Chicago: American References Publishing Co., 1989.

MacKay, James. *The Dictionary of Western Sculptors in Bronze*. Suffolk: Barron, Antique Collector's Club, 1977.

Mayer, Ralph. *A Dictionary of Art Terms and Techniques*. NY: Thomas H. Crowell, 1969 (Appollo Edition).

Osborne, Harold (ed.). *The Oxford Companion to Art*. Oxford: Clarendon Press, 1970.

Seventeenth, Eighteenth & Nineteenth Century Dictionary of America Painters, Sculptors & Engravers. Green Farms, Conn.: Mantle Fielding.

Who's Who in American Art. NY & London: Jacques Cattel Press, R. R. Bowker Co. (published biennially).

ART CARE & HANDLING

Clapp, Anne F. *Curatorial Care of Works of Art on Paper*. NY: Lyons & Burford, Publishers, 1987.

Dolloff, Francis W., and Roy L. Perkinson. *How to Care for Works of Art on Paper*. Boston: Museum of Fine Arts, 1985.

Dudley, Dorothy H., et al. *Museum Registration Methods*. 3d ed. Washington DC: American Association of Museum, 1979.

Keck, Caroline K. *A Handbook on the Care of Paintings*. NY: Watson-Guptil, 1967.

———. *How to Take Care of Your Paintings*. NY: Scribner, 1978.

———. *Safeguarding Your Collection in Travel*. Nashville: AASLH Press, 1970.

Mason, Donald L. *The Fine Art of Art Security: Protecting Public & Private Collecting Against Theft, Fire and Vandalism*. NY: Van Nostrand Reinhold Co., 1979.

Moore, Alma Chestnut, *How to Clean Everything*. NY: Simon & Schuster, 1978.

Rowlison, Eric B. *Rules for Handling Works of Art*. Adelaide, Australia: The Art Galleries Association of Australia (available from the Museum of Modern Art, NY).

Shelley, Marjorie. *The Care and Handling of Art Objects*. NY: The Metropolitan Museum of Art, 1987.

Snyder, Jill. *Caring for Your Art*. NY: Allworth Press, 1990.

Stolow, Nathan. *Conservation Standards for Works of Art in Transit and on Exhibition*. Geneva, Switzerland: UNESCO.

Stout, George L. *The Care of Pictures*. NY: Dover Publications, 1975.

Sugden, Robert P. *The Care and Handling of Art Objects*. NY: The Metropolitan Museum of Art.

Zigrosser, Carl, and Christa Gaehde. *A Guide to the Collecting and Care of Original Prints*. NY: Crown Publishers, 1965.

MANAGEMENT & MARKETING

Abbott, Susan, and Barbara Webb. *Fine Art Publicity: The Complete Guide for Galleries and Artists*. Stamford: The Art Business News Library, 1991.

Art Law. Boston: Little, Brown & Co., 1988.

Crawford, Tad. *Business and Legal Forms for Fine Artists*. NY: Allworth Press, 1990.

Directory of Personal Image Consultants. NY: Editorial Services Co.

Fenton, John. *A to Z of Sales Management*. NY: AMACOM pb., 1987.

Hanan, Mack. *Consultative Selling*. 3d ed. NY: American Management Association, 1985.

Hawken, Paul. *Growing a Business*. NY: Fireside, 1987.

Kamaroff, Bernard. *Small-Time Operator*. Laytonville, California: Bell Springs Press, 1987.

Kelly, Kate. *How to Set Your Fees and Get Them*. NY: Visibility Enterprises, 1986.

Levinson, Conrad. *Guerrilla Marketing—Secrets for Making Big Profits from Your Small Business*. Boston: Houghton Mifflin Company, 1984.

Miller, Robert B., and Stephen E. Heiman. *Conceptual Selling*. Berkeley: Miller-Heiman, Inc., 1987.

———. *Strategic Selling*. Berkeley: Miller-Heiman, Inc., 1987.

Persky, Robert. *The ARTnews Guide to Tax Benefits*. NY: AA News Books and the Consultant Press, 1987.

Peters, Thomas J. and Nancy Austin. *A Passion for Excellence*. NY: Random House, 1985.

Peters, Thomas J. *In Search of Excellence*. NY: Warner Books, 1982.

Phillips, Michael, and Salli Rasberry. *Honest Business*. NY: Random House, 1981.

———. *Marketing Without Advertising*. Berkeley: Nolo Press, 1986.

Schwartz, Arnold L. *Dynamic Professional Selling*. NY: G. P. Publishing, 1989.

Whitmyer, Claude, Salli Rasberry, and Michael Phillips. *Running a One-person Business*. Berkeley: Ten-Speed Press, 1989.

SELECTED READING ON CONSULTING & COLLECTING

Abbott, Susan. "Generating Leads for Corporate and Business Sales—Part 2." *Art Business News*: March 1988.

———. "Corporate Art: Movement in Flux." *Art Business News*: February 1989.

———. "How to Beat Tough Times, Tight Corporate Budgets." *Art Business News*: February 1989.

Carlin, John. *How to Invest in Your First Works of Art: A Guide for the New Collector*. NY: Yarrow Press, 1990.

"Corporate Collecting: A 1986 Survey of America's Most Active Corporate Collection." *Art & Auction*: October 1986.

"Corporations and the Arts." *ARTnews*: May 1979.

Craft, M. A. "The Corporation as Art Collector." *Business Horizons*: June 1979.

Glueck, Grace. "What Big Business Sees in Fine Art." *The New York Times*: 26 May 1985.

Haacke, Hans. "Working Conditions." *Art Forum*: June 1981.

Harris, Helen. "The Master Conservators." *Town and Country*: December 1980 & January 1981.

Heartney, Eleanor. "Combined Operations." *Art in America*: June 1989.

Lueck, Thomas J. "More Corporations Becoming Working Museums." *The New York Times*: 15 September 1985.

Martorella, Rosanne. *Corporate Art*. New Brunswick & London: Rutgers Univ. Press, 1990.

Mullaney, T. "Museum Ethics—Changing the Rules." *New Art Examiner*: 1982.

Sowder, Lynn, and Nathan Bravlick. *Talk-back/Listen: The Visual Arts Program at First Bank System 1980–1990.* Winnipeg, Manitoba: Winnepeg Art Gallery, 1990.

Stephens, Suzanne. "An Equitable Relationship." *Art in America:* May 1986.

Wolmer, Bruce. "Corporate Art Collecting Is Different." *ARTnews:* May 1981.

PERIODICALS

American Artist, 1 Collor Ct., Marion, OH 43302.

Art Diary, Giancarlo Politi, ed., Via Farini 68, 20159 Milan, Italy.

Art and Auction, 250 West 57th St., NY 10107.

Art Business News, 19 Old Kings Highway S., Darien, CT 06820.

Art Forum, Editorial & Bus. Off., 667 Madison Ave., NY 10021.

Art in America, 850 3rd Ave., NY 10022.

Art International, Via Maraini 17-A, Lugano, Switzerland.

Art Newsletter, 122 East 42nd Street, NY 10168.

Art Now, Chicago/NY/California, 144 N. 14th St., Kenilworth, NJ 07033.

Art Week, 1305 Franklin St., Oakland, CA 94612.

Art World, Bruce Duff Hooten, ed., 1295 Madison Ave., NY.

ARTnews, Box 969, Farmingdale, NY 11737.

Arts Canada, Society for Art Publications, 3 Church St., Toronto, Ontario.

Arts Reporting Service, Chas. C. Mark, ed., P.O. Box 40937, Washington, DC 20016.

Artspace, Southwestern Contemporary Arts Quarterly, Box 4547, Albuquerque, New Mexico 87106.

Atlanta Art Papers, 2816th St., NW, Atlanta, GA 30309.

Collector-Investor, 740 Rush St., Chicago 60611.

Decor, 408 Olive St., St Louis, MO 63102.

Designers West, 8914 Santa Monica Blvd. (penthouse), Los Angeles, 90069.

Facilities Design and Management, 1515 Broadway, NY 10036.

Flash Art, Solart Communications, Inc., 141 E. 56th Str., NY 10022.

International Auction Records, Switzerland, v. 1963–1981.

Journal of the Print World, Rt. 2, Meredith, NH 03253.

Locus (N.Y.) and locally published Gallery/Artist Directories.

National Arts Guide, Chicago.

New Art Examiner, 230 E. Ohio, Chicago 60611.

Print Collectors Newsletter, 16 E. 82nd St., NY 10028.

Print, 6400 Goldsboro Rd., N.W., Washington DC.

Sotheby New York Catalogue Subscription, 980 Madison Ave., NY 10021.

Technology & Conservation, The Technology Organizations, Inc., 1 Emerson Place, Boston, MA 02114.

The ARTnewsletter, ARTnews, 5 West 37th Street, NYC 10018

GENERAL READING IN ART

Albright, Thomas. *Art in the San Francisco Bay Area 1945–1980.* Berkeley & Los Angeles: University of California Press, 1985.

American Prints in the Library of Congress: Catalogue of the Collection. Baltimore: Johns Hopkins, 1970.

Arnason, H. H. *History of Modern Art,* 3d ed. NY: Abrams, 1986.

Art Inc: American Paintings from Corporate Collections. Montgomery: Montgomery Museum of Fine Arts in Association with Brandy Wine Press, 1979.

Baetjer, Katherine. *European Paintings in the Metropolitan Museum of Art by Artists Born In or Before 1865*. NY: The Metropolitan Museum of Art, 1980.

Baker, Kenneth. *Minimalism*. NY: Abbeville Press, 1989.

Battcock, Gregory, ed. *Minimal Art: A Critical Anthology*. NY: E. P. Dutton & Co., Inc., 1968.

————, ed. *Super Realism: A Critical Anthology*. NY: E.P. Dutton & Co., Inc., 1975.

————. *The New Art*. NY: E.P. Dutton, Inc., 1968.

Berger, John. *Ways of Seeing*. NY: BBC and Penguin Books, 1977.

Blaug, Mark, ed. *The Economics of the Arts*. London: Westview Press, 1976.

Burnham, Bonnie. *The Art Crisis*. NY: St. Martins Press, 1975.

Burnham, Sophy. *The Art Crowd*. NY: David McKay Co., Inc., 1973.

Calas, Nicolas, and Elena Calas. *Icons & Images of the Sixties*. NY: E.P. Dutton & Co., Inc., 1971.

Canaday, John. *Metropolitan Seminars in Art*. NY: Metropolitan Museum of Art, 1960.

————. *What is Art: An Introduction to Painting, Sculpture and Architecture*. NY: Alfred A. Knopf, 1980.

Carlin, John. *How to Invest in Your First Works of Art: A Guide for the New Collector*. NY: Yarrow Press, 1990.

Chipp, Herschel. *Theories of Modern Art: A Source Book by Artists & Critics*. Los Angeles: University of California, 1971.

De la Croix, Horst, and Richard G. Tansey. *Gardner's Art Through the Ages*. 6th ed. NY: Harcourt Brace Jovanovich, Inc., 1975.

Diana Crane. *The Transformation of the Avant-garde: The New York Art World, 1940–1945*. Chicago: University of Chicago Press, 1988.

Eells, Richard. *The Corporation and the Arts*. NY: MacMillan, 1967.

Ferguson, Bruce, Joan Simon, and Robert Smith. *Abstraction in Question*. Sarasota, Florida: John & Mabel Ringley Museum of Art, 1989.

Fusco, Peter, and H.W. Janson. *The Romantics to Rodin: French 19th Century Sculpture from North American Collections*. Los Angeles: Los Angeles County Museum of Art, 1980.

Gablik, Suzi. *Has Modernism Failed?* NY: Thames & Hudson, 1984.

Gingrich, Arnold. *Business and the Arts, An Answer to Tomorrow*. NY: Paul S. Eriksson, 1969.

Hambidge, Jay. *The Elements of Dynamic Symmetry*. NY: Brentano's, 1926.

Henri, Adrian. *Total Art: Environments, Happenings & Performances*. NY: Praeger Publ., 1974.

Hertz, Richard, ed. *Theories of Contemporary Art*. Englewood Cliffs, N.J.: Prentice-Hall, 1985.

Hoy, Anne H. *Fabrications: Staged, Altered, & Appropriated Photographs*. NY: Abbeville Press, 1988.

Hughes, Robert. *The Shock of the New*. NY: Alfred A. Knopf, 1981.

Hunter, S., and J. Jacobus. *American Art of the 20th Century*. Englewood Cliffs: Prentice Hall, Inc., 1979.

Hunter, Sam. *Art in Business: The Philip Morris Story*. NY: Abrams, 1979.

Janson, N.W. *History of Art*. 2d ed. NY: Abrams and Prentice Hall, 1977.

Jeanne Siegel, ed. *Artwords: Discourse on the 60s and 70s*. Ann Arbor, Michigan: UMI Research Press, 1985.

———. ed., *Artwords 2: Discourse on the Early 80s*. Ann Arbor, Michigan: UMI Research Press, 1988.

Jones, Frederic H. *Interior Design Graphics*. Los Altos: William Kaufman, Inc., 1983.

Kahan, Mitchell, ed. *Art Inc.: American Paintings from Corporate Collections*. Montgomery: Montgomery Museum of Fine Arts, 1979.

Keen, Geraldine. *Money and Art: A Study Based on the Times-Sotheby Index*. NY: G. P. Putnam's Sons, 1971.

Krauss, Rosalind. *Passages in Modern Sculpture*. NY: Viking Press, 1977.

Krens. *Refigured Painting: The German Image 1968–1988*. NY: Solomon Guggenheim Museum; Munich: Prestal-Verlag, 1986.

Kuspit, Donald. *The New Subjectivism: Art in the 1980s*. Ann Arbor, Michigan: UMI Research Press, 1988.

Levin, Kim. *Beyond Modernism: Essays on Art from the '70s and '80s*. NY: Harper & Row, 1988.

Licht, Fred. *Sculpture: 19th and 20th Centuries: A History of Western Sculpture*. Greenwich: New York Graphic Society, 1967.

Lippard, Lucy. *Pop Art*. NY: Praeger Publ., 1966.

———. *Changing*. NY: E.P. Dutton, 1971.

Lucie-Smith, Edward. *Late Modern—Visual Art Since 1945*. NY: Praeger Publ.

———. *Art Now from Abstract Expressionism to Superrealism*. NY: William Morrow and Co., 1977.

———. *American Art Now*. NY: William Morrow & Co., Inc., 1985.

MacLanathan, R. *The American Tradition in the Arts*. NY: Harcourt, Brace & World, Inc., 1968.

Mahsun, Carol Anne. *Pop Art & The Critics*. Ann Arbor, Michigan: UMI Research Press, 1987.

Manhard, Marcia, and Tom Manhard, eds. *The Eloquent Object*. Tulsa, Oklahoma: Philbrook Museum of Art, 1987.

Marrow, Marva. *Inside the L.A. Artist*. Salt Lake City: Peregrine Smith Books, 1988.

Martorella, Rosanne. *Corporate Art*. New Brunswick & London: Rutgers Univ. Press, 1990.

Menen, Aubrey. *Art & Money: An Irreverent History*. NY: McGraw-Hill Book Co., 1980.

Morgan, H. Wayne. *New Muses: Art in American Culture, 1865–1920*. Norman,

Oklahoma: University of Oklahoma Press, 1978.

Nelson, George. *How to See*. Boston: Little, Brown & Co., 1977.

Netzer, Dick. *The Subsidized Muse, Public Support for the Arts in the U.S.* London: Cambridge University Press, 1978.

Newhall, Beaumont. *The History of Photography*, 5th ed. NY: Museum of Modern Art, 1988.

Newsom, Barbara Y., and Adele Z. Silver, eds. *The Art Museum as Educator, A Collection of Studies as Guides to Practice and Policy*. Berkeley: University of California Press, 1978.

Plagens, Peter. *Sunshine Muse: Contemporary Art of the West Coast*. NY: Praeger Publ., 1974.

Rheims, Maurice. *19th Century Sculpture*. NY: Abrams, 1977.

Robins, Corinee. *The Pluralist Era: American Art, 1968–1981*. NY: Harper & Row, 1984.

Rose, Barbara. *American Art Since 1900*. NY: Praeger Publ., 1968.

———. *Readings in American Art Since 1900*. NY: Praeger Publ., 1970.

———. *American Painting—The Twentieth Century*. NY: Rizzoli International Publications, Inc., 1986.

———. *Autocritique: Essays on Art and Anti-Art 1963–1987*. NY: Wiedenfeld & Nicolson, 1988.

Rosen, Randy, Calvin Tomkins, Marcia Tucker, et al. *Making Their Mark: Women Artists Move into the Mainstream, 1970–1985*. NY: Abbeville Press, 1989.

Rosen, Randy. *Prints: The Facts and Fun of Collecting*. NY: Dutton, 1978.

Rosenberg, Harold. *The Anxious Object*. NY: Collier, 1964.

Schuman, Wm. & R. Stevens. *Economic Pressures and the Future of the Arts*. Charles C. Moskowitz Memorial Lectures NYU. NY: MacMillan, The Free Press, 1979.

Sculpture Inside Outside, intro. by Martin Friedman. NY: Rizzoli; Minneapolis: Walker Art Center, 1988.

Stewart, Basil. *A Guide to Japanese Prints and Their Subject Matter*. NY: Dover Publications, 1979.

Taylor, Joshua. *America As Art*. Washington, DC: Smithsonian Institute Press, 1976.

Tomkins, Calvin. *Post-To-NEO: The Art World of the 1980s*. NY: Henry Holt, Inc., 1989.

Vintage Contemporary Artist Series. NY: Vintage Books, Random House.

Wallis, Brian, et al., eds. *Modern Dreams*. Cambridge, Mass.: MIT Press, 1989.

Wallis, Brian, ed. with foreword by Marcia Tucker. *Art After Modernism: Rethinking Representation*. NY: New Museum of Contemporary Art, 1984.

Ward, John L., *American Realist Painting, 1945–1980*. Ann Arbor, Michigan: UMI Research Press, 1988.

Warner, Glenn. *Building a Print Collection*. NY: Van Nostrand Reinhold Co., 1980.

Weaver, Mike, ed. *The Art of Photography 1839–1989*. New Haven: Yale University Press, 1989.

Index

Susan Abbott is an internationally recognized authority on corporate art consulting with more than thirty years' experience in the field. Formally trained as an art historian, with graduate work in prints and drawings at UCLA, she began her career in the fine arts at the Los Angeles County Museum of Art, and eventually became the Associate Director of exhibitions for Gemini G.E.L.

She founded Abbott & Company in 1971 to provide fine art marketing and management consulting to galleries, publishers, and museums. As a leading corporate art consultant, she assisted Fortune 500 companies, such as First Interstate Bank, Chevron U.S.A., Transamerica Corporation, Occidental Life, Dillingham Development Company, and Saga Administrative Corporation, in acquiring and exhibiting art and in developing art-related public relations programs.

She has been a frequent speaker on art business issues and has conducted corporate art training seminars in the U.S., Canada, and overseas. Abbott is co-author of *Fine Art Publicity: The Complete Guide for Galleries and Artists* (Allworth Press).

Fine Art Publicity: The Complete Guide for Galleries and Artists
by Susan Abbott and Barbara Webb (softcover, 8½ × 11, 190 pages, $22.95)

Legal Guide for the Visual Artist, Fourth Edition
by Tad Crawford (softcover, 8½ × 11, 272 pages, $19.95)

The Artist-Gallery Partnership: A Practical Guide to Consigning Art, Revised
Edition *by Tad Crawford and Susan Mellon (softcover, 6 × 9, 216 pages, $16.95)*

The Law (in Plain English)™ for Galleries, Second Edition
by Leonard DuBoff (softcover, 6 × 9, 208 pages, $18.95)

Licensing Art and Design, Revised Edition
by Caryn R. Leland (softcover, 6 × 9, 128 pages, $16.95)

Caring For Your Art: A Guide for Artists, Collectors, Galleries, and Art
Institutions, Revised Edition *by Jill Snyder (softcover, 6 × 9, 192 pages, $16.95)*

Business and Legal Forms for Fine Artists, Revised Edition
by Tad Crawford (softcover, includes CD-ROM, 8½ × 11, 144 pages, $19.95)

The Business of Being an Artist, Revised Edition
by Daniel Grant (softcover, 6 × 9, 272 pages, $18.95)

The Artist's Guide to New Markets: Opportunities to Show and Sell Art Beyond
Galleries *by Peggy Hadden (softcover, 5½ × 8½, 248 pages, $18.95)*

The Fine Artist's Guide to Marketing and Self-Promotion
by Julius Vitali (softcover, 6 × 9, 224 pages, $18.95)

The Fine Artist's Career Guide
by Daniel Grant (softcover, 6 × 9, 304 pages, $18.95)

Artists Communities, Second Edition
by the Alliance of Artists' Communities (softcover, 6¾ × 10, 240 pages, $18.95)

Uncontrollable Beauty: Towards a New Aesthetics
edited by Bill Beckley with David Shapiro (hardcover, 6 × 9, 448 pages, $24.95

The End of the Art World
by Robert C. Morgan (paper with flaps, 6 × 9, 256 pages, $18.95)

Sculpture in the Age of Doubt
by Thomas McEvilley (paper with flaps, 6 × 9, 448 pages, $24.95)

Beauty and the Contemporary Sublime
by Jeremy Gilbert-Rolfe (paper with flaps, 6 × 9, 208 pages, $18.95)

Please write to request our free catalog. To order by credit card, call 1-800-491-2808 or send a check or money order to Allworth Press, 10 East 23rd Street, Suite 210, New York, NY 10010. Include $5 for shipping and handling for the first book ordered and $1 for each additional book. Ten dollars plus $1 for each additional book if ordering from Canada. New York State residents must add sales tax.

To see our complete catalog on the World Wide Web, or to order online, you can find us at *www.allworth.com*.